Cartographies of Time

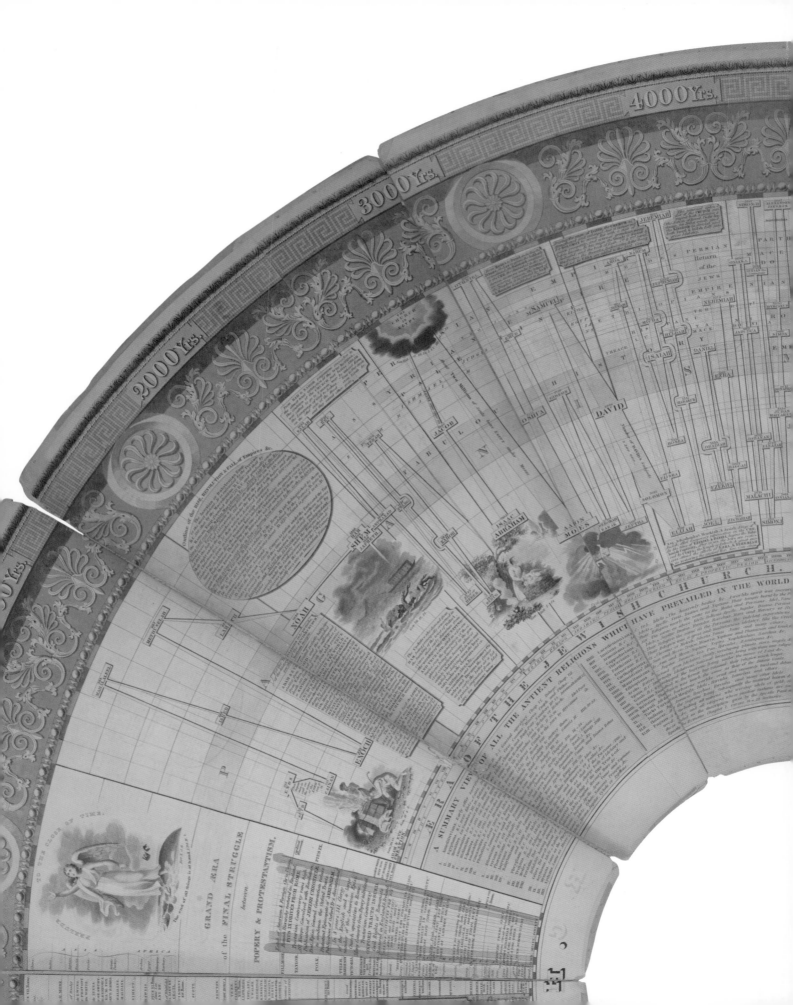

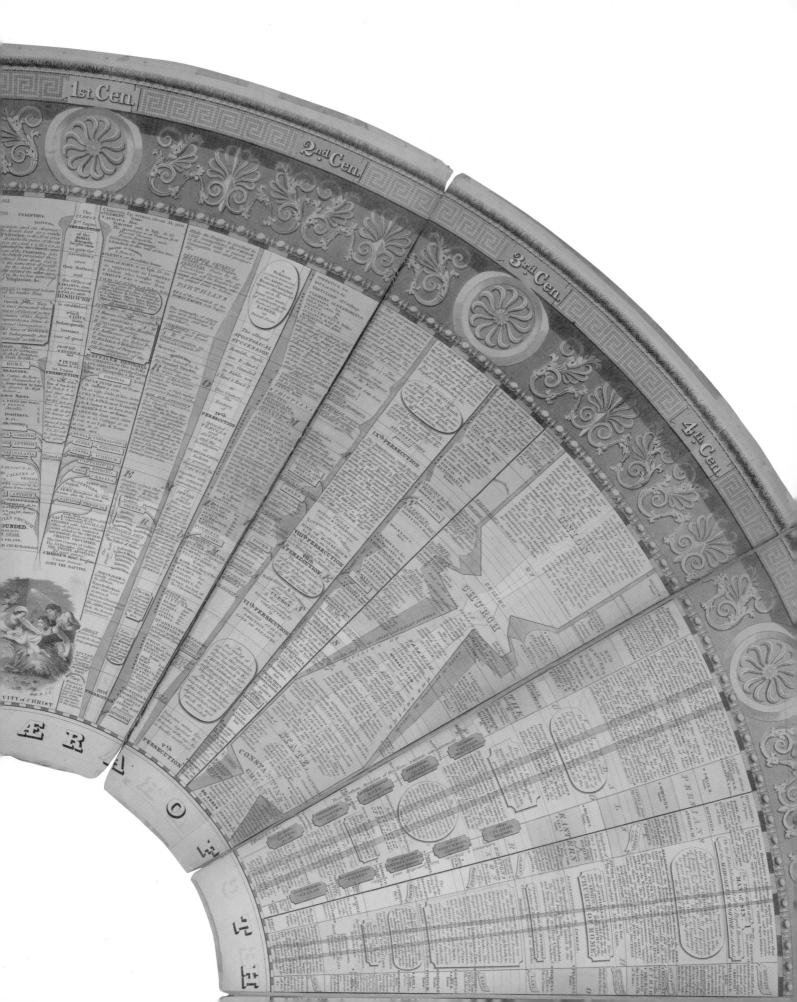

Published by
Princeton Architectural Press
37 East Seventh Street
New York, New York 10003

Visit our website at www.papress.com.

The Library of Congress has catalogued the hardcover edition as follows:
Rosenberg, Daniel, 1966–
Cartographies of time / Daniel Rosenberg and Anthony Grafton.—1st ed.
272 p. ill. (chiefly col.), col. maps ; 28 cm.
Includes bibliographical references.
ISBN 978-1-56898-763-7 (alk. paper)
1. Chronology, Historical. 2. Chronology, Historical—Maps. 3. History—
Philosophy. I. Grafton, Anthony. II. Title.
D11.5.R64 2009
902'.02—dc22

2008052892

Managing Editor: Jennifer Thompson
Project Editor: Wendy Fuller
Designer: Jan Haux

Special thanks to: Bree Anne Apperley, Sara Bader, Nicola Bednarek Brower,
Janet Behning, Fannie Bushin, Megan Carey, Carina Cha, Russell Fernandez,
Linda Lee, Diane Levinson, Gina Morrow, John Myers, Katharine Myers,
Margaret Rogalski, Dan Simon, Andrew Stepanian, Paul Wagner, Joseph Weston,
and Deb Wood of Princeton Architectural Press —Kevin C. Lippert, publisher

Cartographies of Time

Daniel Rosenberg and Anthony Grafton

Princeton Architectural Press, New York

Contents

Acknowledgments

My deep thanks go to Sina Najafi, Sasha Archibald, Brian McMullen, and Tal Schori, my collaborators on the *Timeline of Timelines* that appeared in issue 13 of *Cabinet: A Quarterly of Art and Culture*. This book would surely never have come to be were it not for their genius. The same goes for Susan Harding, Marco Harding, Joseph Masco, and the entire *Histories of the Future* group. I first began to collect timelines while participating in a seminar that Susan organized at the University of California Humanities Research Institute. In the years since, I have been collecting debts— to the Center for Critical Analysis of Contemporary Culture at Rutgers University, the Huntington Library, the Clark Library at the University of California–Los Angeles, the Clark Art Institute, MASS MoCA, Argos, the Slought Foundation, the Museo Rufino Tamayo, the Center for Eighteenth-Century Studies at Indiana University, the Max Planck Institute for the History of Science in Berlin, the National Endowment for the Humanities, and the Oregon Humanities Center. My thanks to the wonderful librarians who have assisted me at these institutions, especially in the Knight Library at the University of Oregon, the Library Company of Philadelphia, and the Department of Rare Books and Special Collections at Princeton University, where the greatest part of the research for this project was conducted, especially Stephen Ferguson, Donald Skemer, AnnaLee Pauls, Andrea Immel, John Blazejewski, and Charlene Peacock.

I wish also to thank Alletta Brenner, Theresa Champ, Mike Witmore, Daniel Selcer, Jonathan Sheehan, Arielle Saiber, Sophia Rosenfeld, Miryam Sas, Pamela Jackson, Ken Wissoker, Amy Greenstadt, Steven Stern, Jamer Hunt, Justin Novak, Frédérique Pressmann, Elena Filipovic, Pip Day, Nato Thompson, Dror Wahrman, Michel Chaouli, Martin Jay, Randolph Starn, Eviatar Zerubavel, John Gillis, Harold Mah, Joel Smith, Sheila Schwartz, Neil de Grasse Tyson, Maya Lin, Christoph Fink, Katie Lewis, Jacqui Glanz, Anne Glanz, Astrit Schmidt-Burkhardt, Jim Shaw, Steven Shankman, Barbara Altmann, Julia Heydon, Georgia Barnhill, Michael Paulus, Roy Goodman, Vicki Cutting, James Fox, Lesli Larson, and Eliz Breakstone, as well as the past and present EMods of the University of Oregon, including Andrew Schulz, David Castillo, Fabienne Moore, Diane Dugaw, Amanda Powell, James Harper, Lisa Freinkel, Leah Middlebrook, and Nathalie Hester. Mark Johnson was an insightful editor for the original proposal for this project. Jeff Ravel did a brilliant job editing my article "Joseph Priestley and the Graphic Invention of Modern Time" for *Studies in Eighteenth-Century Culture*. Thanks to my colleagues in the Robert D. Clark Honors College, and especially to Joseph Fracchia, David Frank, and Richard Kraus, and in the Department of History at the University of Oregon including Jeff Ostler, Martin Summers, John McCole, George Sheridan, Randall McGowen, and David Luebke, and to Carla Hesse, who has guided me with care for many years. Thanks also to the Andrew W. Mellon Foundation and to the University of Oregon, who together provided me the opportunity to go to Princeton University to collaborate on this book; to the Princeton University Humanities Council and Carol Rigolot, Cass Garner, and Lin DeTitta; to Barbara Leavey and the Center for Collaborative History and the Department of History;

and to Anthony Grafton, whose collaboration, vision, and advice have opened new vistas for me.

My personal thanks to Harry Rosenberg, Barbara Filner, Joshua Rosenberg, Gwendolen Gross, Jacob Rosenberg, Carina Rosenberg, Jack Paris, Judy Cheng Paris, Su-Lin Nichols, Bill Nichols, Charlie Nichols, Will Nichols, and above all to my partner, Mai-Lin Cheng, whose contributions to this project are without measure. My efforts are dedicated to the memory of Amy Jean Kuntz.

—Daniel Rosenberg

Many benefactors, friends, and colleagues have made my work on *Cartographies of Time* not only possible but immensely pleasurable. Heartfelt thanks to the Andrew W. Mellon Foundation—above all to Harriet Zuckerman, Joseph Meisel, and William Bowen—for their imaginative and generous financial support. Funds from the Mellon Foundation and the Max Planck Institute for the History of Science in Berlin made possible the workshop on chronology in Berlin at which this enterprise was conceived. Lorraine Daston, who cosponsored and hosted the workshop, has my warmest thanks, for her hospitality, for many other kindnesses over the years, and for her erudite and penetrating advice. Further funding from the Mellon Foundation made it possible for Daniel Rosenberg to spend the academic year 2006–7 at Princeton, and for me to devote much of that year to working with him. Carol Rigolot, Cass Garner, and Lin DeTitta in the Council of the Humanities and Barbara Leavey and Judy Hanson in the Department of History made the complex practical arrangements for our collaboration. Their efficiency, speed in action, and warm hospitality are beyond praise. The extraordinary staff of Princeton's Department of Rare Books and Special Collections—Ben Primer, Stephen Ferguson, Paul Needham, Donald Skemer, and AnnaLee Pauls—have assembled remarkable resources in Princeton for the study of chronology. Their intelligence, resourcefulness and generosity made the bulk of our research possible, and they have done an extraordinary job of producing many of the photographs for this book. Our friend Robert Darnton, formerly director of Princeton's Center for the Study of Books and Media, allowed us to present an early version of our findings at a special meeting of the Center's works-in-progress seminar. Those in attendance responded with warm enthusiasm and helpful criticism to what turned out to be the very first draft of this book: the chronologists whom we study in this book would have recorded that occasion in capital letters and red ink.

Thanks, finally, to scholars around the world who take an interest in the creativity and quirks of early modern erudition, and whose advice, criticism, and exemplary scholarship have been crucial: Daniel Rosenberg, *primus inter pares*, for the curiosity, passion, and store of learning that have made our collaboration such a joy; and Ann Blair, Jed Buchwald, Max Engammare, Mordechai Feingold, Peter Miller, Philipp Nothaft, Nick Popper, Ingrid Rowland, Wilhelm Schmidt-Biggemann, Jeff Schwegman, Nancy Siraisi, Benjamin Steiner, Walter Stephens, Noel Swerdlow, and the late Joseph Levine.

—Anthony Grafton

Time in Print

What does history look like? How do you draw time?

While historical texts have long been subject to critical analysis, the formal and historical problems posed by graphic representations of time have largely been ignored. This is no small matter: graphic representation is among our most important tools for organizing information.[1] Yet, little has been written about historical charts and diagrams. And, for all of the excellent work that has been recently published on the history and theory of cartography, we have few examples of critical work in the area of what Eviatar Zerubavel has called *time maps*.[2] This book is an attempt to address that gap.

In many ways, this work is a reflection on lines—straight and curved, branching and crossing, simple and embellished, technical and artistic—the basic components of historical diagrams. Our claim is that the line is a much more complex and colorful figure than is usually thought. Historians will probably appreciate this aspect of the book fairly easily. We all use simple line diagrams in our classrooms—what we usually call "timelines"—to great effect. We get them, our students get them, they translate wonderfully from weighty analytic history books to thrilling narrative ones.

But simple and intuitive as they seem, these timelines are not without a history themselves. They were not always here to help us in our lectures, and they have not always taken the forms that we unthinkingly give them. They are such a familiar part of our mental furniture that it is sometimes hard to remember that we ever acquired them in the first place. But we did. And the story of how is worth telling, because it helps us understand where our contemporary conceptions of history come from, how they work, and, especially, how they rely on visual forms. It is also worth telling because it's a good story, full of twists and turns and unexpected characters, soon to be revealed.

Another reason for the gap in our historical and theoretical understanding of timelines is the relatively low status that we generally grant to chronology as a kind of study. Though we use chronologies all the time, and could not do without them, we typically see them as only distillations of complex historical narratives and ideas. Chronologies work, and—as far as most people are concerned—that's enough. But, as we will show in this book, it wasn't always so: from the classical period to the Renaissance in Europe, chronology was among the most revered of scholarly pursuits. Indeed, in some respects, it held a status higher than the study of history itself. While history dealt in stories,

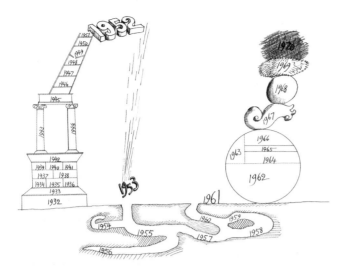

[1]

1932–1970 "calendar," Saul Steinberg,
Untitled, 1970

Ink, collage, and colored pencil on paper, 14
½ x 23 inches, Beinecke Rare Book and
Manuscript Library, Yale University © The
Saul Steinberg Foundation/Artists Rights
Society (ARS), New York

chronology dealt in facts. Moreover, the facts of chronology had significant implications outside of the academic study of history. For Christians, getting chronology right was the key to many practical matters such as knowing when to celebrate Easter and weighty ones such as knowing when the Apocalypse was nigh.

Yet, as historian Hayden White has argued, despite the clear cultural importance of chronology, it has been difficult to induce Western historians to think of it as anything more than a rudimentary form of historiography. The traditional account of the birth of modern historical thinking traces a path from the enumerated (but not yet narrated) medieval date lists called annals, through the narrated (but not yet narrative) accounts called chronicles, to fully narrative forms of historiography that emerge with modernity itself.[3] According to this account, for something to qualify as historiography, it is not enough that it "deal in real, rather than merely imaginary, events; and it is not enough that [it represent] events in its order of discourse according to the chronological framework in which they originally occurred. The events must be…revealed as possessing a structure, an order of meaning, that they do not possess as mere sequence."[4] Long thought of as "mere sequences," in our histories of history, chronologies have usually been left out.

But, as White argues, there is nothing "mere" in the problem of assembling coherent chronologies nor their visual analogues. Like their modern successors, traditional chronographic forms performed both rote historical work and heavy conceptual lifting. They assembled, selected, and organized diverse bits of historical information in the form of dated lists. And the chronologies of a given period may tell us as much about its visions of past and future as do its historical narratives.

White gives the example of the famous medieval manuscript chronology called the *Annals of St. Gall*, which records events in the Frankish kingdoms during the eighth, ninth, and tenth centuries in chronological order with dates in a left hand column and events on the right. [*figs.* **2–3**] To a modern eye, annals such as these appear strange and antic, beginning and ending seemingly without reason, mashing up categories helter-skelter like the famous Chinese encyclopedia conjured by Jorge Luis Borges. Here, for example, is a section covering the years 709 to 734.

709. Hard winter. Duke Gottfried died.
710. Hard year and deficient in crops.
711.
712. Flood everywhere.

Annals of St. Gall, Monastery of
St. Gall, Switzerland, mid-eleventh
century

713.

714. Pippin, mayor of the palace died.

715.

716.

717.

718. Charles devastated the Saxon with great destruction.

719.

720. Charles fought against the Saxons.

721. Theudo drove the Saracens out of Aquitaine.

722. Great crops.

723.

724.

725. Saracens came for the first time.

730.

731. Blessed Bede, the presbyter, died.

732. Charles fought against the Saracens at Poitiers on Saturday.

733.

734.[5]

From a historiographical point of view, the text seems to be missing a great deal. Though it meets a very minimal definition of narrative (it is referential, it represents temporality), it possesses few or none of the characteristics that we normally expect in a story, much less a history. The *Annals* make no distinction between natural occurrences and human acts; they give no indication of cause and effect; no entry is given more priority than another. Below the level of years, references to time are strangely gnomic: in the year 732, for example, the text indicates that Charles Martel "fought the Saracens on Saturday," but it does not specify *which* Saturday. Above the level of the year, there is no distinction among periods, and lists begin and end as nameless chroniclers pick up and put down their pens. But this should not be taken to suggest that the St. Gall manuscripts are without meaningful structure. To the contrary, White argues, in their very form, these annals breathe with the life of the Middle Ages. The *Annals of St. Gall*, White argues, vividly figure a world of scarcity and violence, a world in which "forces of disorder" occupy the forefront of attention, "in which things *happen to* people rather than one in which people *do* things."[6] As such, they represent a form closely calibrated to both the interests and the vision of their users.

Parallel observations have been made by scholars of non-Western historiography such as the great Indian historian Romila Thapar. Thapar has long emphasized that genealogy and chronicle are not primitive efforts to write what would become history in other hands, but powerful,

graphically dense ways of describing and interpreting the past.[7] And in recent years, historians of premodern Europe like Roberto Bizzocchi, Christiane Klapisch-Zuber, and Rosamond McKitterick have begun to pay due attention to the graphically sophisticated ways in which genealogical forms—especially the tree—have developed and been used in the historiography of both the premodern and the modern West.[8]

Addressing the problem of chronology, and especially the problem of visual chronology, means going back to the line, to understand its ubiquity, flexibility, and force. In representations of time, lines appear virtually everywhere, in texts and images and devices. Sometimes, as in the timelines found in history textbooks, the presence of the line couldn't be more obvious. But in other instances, it is more subtle. On an analog clock, for example, the hour and minute hands trace lines through space; though these lines are circular, they are lines nonetheless. As the linguist George Lakoff and the philosopher Mark Johnson have argued, the linear metaphor is even at work in the digital clock, though no line is actually visible. In this device, the line is present as an "intermediate metaphor": to understand the meaning of the numbers, the viewer translates them into imagined points on a line.[9]

Our idea of time is so wrapped up with the metaphor of the line that taking them apart seems virtually impossible. According to the literary critic W. J. T. Mitchell, "The fact is that spatial form is the perceptual basis of our notion of time, that we literally cannot 'tell time' without the mediation of space."[10] Mitchell argues that all temporal language is "contaminated" by spatial figures. "We speak of 'long' and 'short' times, of 'intervals' (literally, 'spaces between'), of 'before' and 'after'—all implicit metaphors which depend upon a mental picture of time as a linear continuum.... Continuity and sequentiality are spatial images based in the schema of the unbroken line or surface; the experience of simultaneity or discontinuity is simply based in different kinds of spatial images from those involved in continuous, sequential experiences of time."[11] And it may well be that Mitchell is right. But recognizing this can only be a beginning. In the field of temporal representation, the line can be everywhere because it is so flexible and its configurations so diverse.

The histories of literature and art furnish an abundant store of examples of the complex interdependence of temporal concepts and figures. And—as in the case of the digital clock—in many instances metaphors that appear to draw their force from a different source in fact contain an

The Parian Marble is the oldest
surviving Greek chronological table:
this piece of it, called the Marmor
Purim, has been in Oxford since the
late seventeenth century. The unknown
author, working in 264/3 BCE, traced
the central events in history since
the accession of King Cecrops in
Athens in, by his computation, 1581/0
BCE. The Marble offers dates for the
Flood (that of Deucalion, not Noah),
the introduction of agriculture by
Demeter, and the fall of Troy, as well
as many more recent events. Written
tables which covered a similar period
and range of topics were among the
chief sources from which Eusebius
drew his material for ancient Greek
history.

implicit linear figure. This is the case even in the famous
passage from Shakespeare where Macbeth compares time
to an experience of language fragmented into meaning-
less bits:

> To-morrow, and to-morrow, and to-morrow,
> Creeps in this petty pace from day to day,
> To the last syllable of recorded time,
> And all our yesterdays have lighted fools
> The way to dusty death. Out, out, brief candle!
> Life's but a walking shadow, a poor player,
> That struts and frets his hour upon the stage,
> And then is heard no more: it is a tale
> Told by an idiot, full of sound and fury,
> Signifying nothing.[12]

As the critic J. Hillis Miller writes, "For Macbeth, time
is a sequence of days that stretches out in a line leading to
its cessation at death, figured as a series of syllables making
a sentence or strings of sentences, for example a speech by
an actor on the stage. Time, for Macbeth, exists only as it
is recorded. It is a mad nonsensical tale, an incoherent nar-
rative. Such a narrative is made of pieces that do not hang
together, a series of syllables that do not cohere into words

and sentences."[13] Yet even for Macbeth, though the past and
the future have lost all meaning, the passage of time is orderly
and linear, and each meaningless human life covers a pre-
cisely measurable segment of it, an "hour upon the stage."

In the graphic arts, the same holds true: from the
most ancient images to the most modern, the line serves
as a central figure in the representation of time. The linear
metaphor is ubiquitous in everyday visual representations
of time as well—in almanacs, calendars, charts, and graphs
of all sorts. Genealogical and evolutionary trees—forms of
representing temporal relationships that borrow both the
visual and the verbal figure of "lineage"—are particularly
prominent.[14] And, of course, similar observations may be
made about our ways of representing history.

The timeline seems among the most inescapable meta-
phors we have. And yet, in its modern form, with a single
axis and a regular, measured distribution of dates, it is a
relatively recent invention. Understood in this strict sense,
the timeline is not even 250 years old. How this could be
possible, what alternatives existed before, and what com-
peting possibilities for representing historical chronology
are still with us, is the subject of this book.

It should be said from the beginning that the relative
youth of the timeline has little to do with technological

[5–6]

The Merton College copy of the *Chronicle* of Eusebius, as translated into Latin and adapted by Jerome; transcribed in the mid-fifth century in Italy in red, green, and black ink on 156 leaves. It is bound with the *Chronicle* of Marcellinus Comes.

constraints. Though technology plays an important role in our story, it doesn't drive it. The principal issues here are conceptual. In the late eighteenth century, when the timeline began to flourish in Europe, sophisticated technologies of printing and engraving had long been available, as had techniques for geometrical plotting and projection far more complex than were necessary for such simple diagrams.

What is more, by the eighteenth century the problem of giving visual form to chronological information had also been around for a very, very long time. [*fig.* 4] From the ancient period to the modern, every historical culture has devised its own mechanisms for selecting and listing significant events. The Jews and Persians had their king lists; the Greeks, their tables of Olympiads; the Romans, their lists of consuls, and so forth. The oldest surviving Greek chronological table, a list of rulers, events, and inventions, was carved on marble in 264/3 BCE. The most elaborate Roman one, a set of lists of consuls and triumphs created under Augustus, stood in the Forum. And, just as Lakoff and Johnson would have us believe, among these many devices the line appears repeatedly as both a visual form and a verbal metaphor. And yet, in all of these cultures, amid all of these forms, the simple, regular, measured timeline that is so second nature today, remains in the background. As a

norm, as an ideal standard of what history *looks like*, the timeline does not appear until modernity.

Ancient and medieval historians had their own techniques of chronological notation. [*figs.* **5–6**] From the fourth century, in Europe, the most powerful and typical of these was the table. Though ancient chronologies were inscribed in many different forms, among scholars the table form had a normative quality much as the timeline does today. In part, the importance of the chronological table after the fourth century can be credited to the Roman Christian scholar Eusebius. Already in the fourth century Eusebius had developed a sophisticated table structure to organize and reconcile chronologies drawn from historical sources from all over the world. To clearly present the relations between Jewish, pagan, and Christian histories, Eusebius laid out their chronologies in parallel columns that began with the patriarch Abraham and the founding of Assyria. The reader who moved through Eusebius's history, page by page, saw empires and kingdoms rise and fall, until all of them—even the kingdom of the Jews—came under Rome's universal rule, just in time to make the Savior's message accessible to all of humanity. By comparing individual histories to one another and the uniform progress of the years, the reader could see the hand of providence at work.

[7]

Fall of Troy, *Chronicle* of Eusebius,
fifteenth century

Eusebius created his visually lucid *Chronicle* just when he and other Christians were first adopting the codex, or bound book, in place of the scroll. Like other Christian innovations in book design, the parallel tables and lucid, year-by-year, decade-by-decade order of the *Chronicle* reflected the desire of early Christian scholars to make the Bible and the sources vital for understanding it available and readily accessible for quick reference. The *Chronicle* was widely read, copied, and imitated in the Middle Ages. And it catered to a desire for precision that other popular forms—like the genealogical tree—could not satisfy.

Eusebius's chronological tables proved remarkably durable, and as humanists in the fifteenth and sixteenth centuries took a new interest in establishing chronological intervals, they won renewed attention. [*fig.* 7] Modern editions of Eusebius were among the first printed books, and they were among the most important reference works in the collection of any early modern humanist scholar.[15] The fifteenth-century Florentine bookseller Vespasiano da Bisticci—a brilliant impresario of scribal book production—marketed a revised form of Eusebius's work with great success to scholars and general readers. Humanists like Petrarch became fascinated by the historical and cultural distances that separated them from ancient writers whom they admired and from their own posterity. Petrarch carefully indicated the present date in letters he addressed to the ancients Cicero and Virgil and to future readers to emphasize the length of the interval that separated him from them: "Written in the land of the living; on the right bank of the Adige, in Verona, a city of Transpadane Italy; on the 16th of June, and in the year of that God whom you never knew the 1345th." And, in setting these chronological distances, he found help in the ancient model given by Eusebius.[16]

During the Renaissance, scholars developed new kinds of visual organization, and adapted old forms, sometimes long neglected, for the format of the printed book. But until the mid-eighteenth century, the Eusebian model—a simple matrix with kingdoms listed across the top of the page and years listed down the left- or right-hand columns—was dominant. This visual structure suited the concerns of Renaissance scholars well. It facilitated the organization and coordination of chronological data from a wide variety of sources. It provided a single structure capable of absorbing nearly any kind of data and negotiating the difficulties inevitable when different civilizations' histories, with their different assumptions about time, were fused. It was easy to produce and correct and allowed for quick access to data—which the printers improved by adding alphabetized

indices and other aids. Above all, it still served as a detailed diagram of providential time. From a graphic point of view, it was a chronological *Wunderkammer*, presenting Christian world history in many small drawers.

Still, experiments continued. Some were graphic, like the effort to lay out all the main historical events on a calendar that stretched not from the Creation or Abraham to the present but from January 1 to December 31, with important events in the past stacked up day by day, through the year. Some were technical. In antiquity and the Middle Ages, chronologers accepted older lists of rulers and events and did their best to integrate them into larger wholes. In the Renaissance, historians became more ambitious and critical. Teachers and theorists claimed, over and over again, that chronology and geography were the two eyes of history: sources of precise, unquestionable information, which introduced order to the apparent chaos of events.

In geography, the visual metaphor fit beautifully. Armed with new knowledge about the Earth's surface, Renaissance mapmakers updated the ancient maps created by Ptolemy in the second century to include the Americas, the Indian Ocean, and much else. At the same time, techniques of mapping made advances, with striking results for both science and politics. By the seventeenth century, the map had become a key symbol not only of the power of monarchs but of the power of knowledge itself. Cartography was a model of the new applied sciences; at once complex and precise, it also gave an impression of immediacy and realism.

At the level of detail, chronology followed a similar path. In the same period, astronomers and historians—such as Gerardus Mercator, now famous as a cartographer—began collecting astronomical evidence—records of dated eclipses and other celestial events mentioned by ancient and medieval historians. They began to plot events not just against long series of years, but against lunar and solar eclipses that could be dated precisely to the day and the hour. Chronologies became precise and testable in a new sense, and the new passion for exactitude was reflected in efforts to represent time in novel ways. The early modern world saw some remarkable, if often short-lived, experiments in the creation of "graphic history," from the vivid images of wars, massacres, and troubles produced as a coherent series by entrepreneurs and artists in Geneva in 1569–70 to the massively illustrated histories and travel accounts turned out by the house of Theodore de Bry in Frankfurt.[17] To many writers of the period, such as Walter Raleigh, the chronological dimension of history was central. As Alexander Ross put it

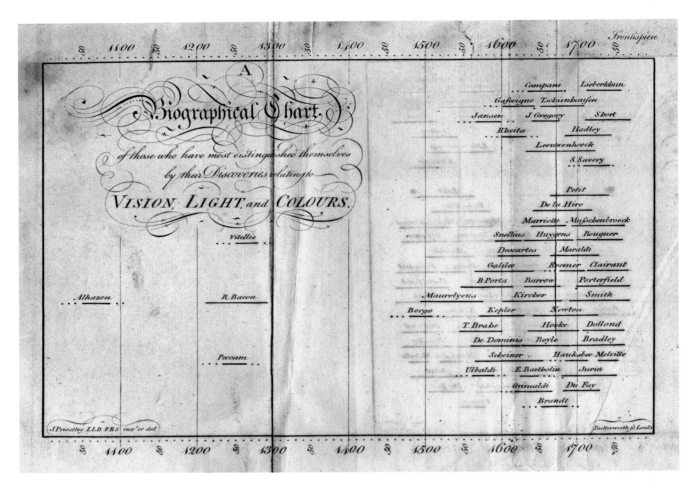

Frontispiece

[8]

This small chart, on the model of his path-breaking *A Chart of Biography* (1765) appeared in Joseph Priestley's *The History and Present State of Discoveries Relating to Vision, Light, and Colours* (1772). It allows the reader to see at a glance which scientists lived when and gives an overall view of scientific activity in the area of optics since the year 1000.

in his 1652 continuation of Raleigh's *History of the World*, "History, indeed is the Body, but Chronologie the Soul of Historical Knowledge; for History without Chronologie, or a Relation of things past, without mentioning the Times in which they were Acted, is like a Lump or Embryo without articulation, or a Carcass without Life."[18]

Toward the end of the seventeenth century, technical developments in printing spurred further innovation, while new techniques of engraving made practical larger and more detailed book illustrations. Some chronologists began to take cues from cartographers, with beautiful results. Ultimately, though, the direct application of the geographic metaphor in the field of chronology proved awkward. Despite great advances in research techniques and the exploration of many new forms, representations of time mostly continued to look very much as they had a millennium earlier when the chronographic table was first employed.

It was not until the middle of the eighteenth century that a common visual vocabulary for time maps caught on. But the new linear formats of the eighteenth century were so quickly accepted that, within decades, it was hard to remember a time when they were not already in use. The key problem in chronographics, it turned out, was not how to design more complex visual schemes—the approach of

many would-be innovators in the seventeenth century— but, rather, how to simplify, how to create a visual scheme to clearly communicate the uniformity, directionality, and irreversibility of historical time.

Among the most important events of this period was the publication in 1765 of the *Chart of Biography* by the English scientist and theologian Joseph Priestley. [*fig.* **8**] At the level of basic technique, there was little that was new in Priestley's chart. It was a simple measured field with dates indicated along the top and bottom like distances on a ruler. Within the main field of the chart, horizontal lines showed when famous historical figures were born and died: the length and position of each person's life was indicated by a mark that began at their date of birth and ended at their date of death. The *Chart of Biography* was a strikingly simple diagram, and yet it proved a watershed.[19] Though it followed centuries of experimentation, it was the first chart to present a complete and fully theorized visual vocabulary for a time map, and the first to successfully compete with the matrix as a normative structure for representing regular chronology. And it came just at the right time. Priestley's chart was not only effective in displaying dates, it also provided an intuitive visual analogue for concepts of historical progress that were becoming popular during the eighteenth

Laurence Sterne published his famous satirical novel, *The Life and Opinions of Tristram Shandy, Gentleman*, in nine volumes over the course of the 1760s, just as Joseph Priestley was publishing his great historical timelines. The novel is purportedly the autobiography of its central character, Tristram Shandy, but the narration hinges on Tristram's inability to tell the story without digression. Like Priestley, Sterne was interested in the graphic representation of time: in the novel, Tristram offers a set of diagrams representing the narrative pattern of the first four volumes of his story.

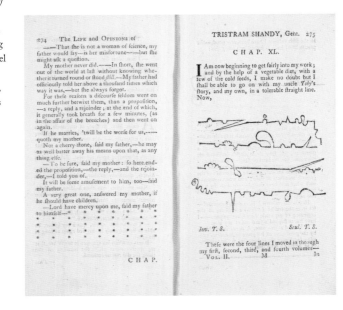

century. In Priestley's chart, historical thought and new forms of graphic expression came into dialogue, and each had much to offer the other.

But as Priestley recognized, his innovations posed problems too: historical narrative is not linear. It moves backward and forward making comparisons and contrasts, and branches irregularly following plots and subplots. Part of the advantage of the matrix form was that it facilitated the scholar's understanding of the many intersecting trajectories of history. The form of the timeline, by contrast, emphasized overarching patterns and the big story. This proved a great advantage in some respects, but not all. And Priestley readily admitted this. For him, the timeline was a "most excellent mechanical help to the knowledge of history," not an image of history itself.[20]

Nor was Priestley the only eighteenth-century writer to reflect on the limits of the linear metaphor. [*fig.* **9**] During the same years that Priestley published his *Chart of Biography* and its sequel, *A New Chart of History*, the novelist Laurence Sterne was publishing his remarkable satire on linear narrative, *The Life and Opinions of Tristram Shandy, Gentleman*, replete with cooked diagrams mapping the course of Tristram's life story. Like Priestley, Sterne understood the linear representation of time as a complex

and artificial construction. But for Sterne, its problems outweighed its advantages. Sterne writes:

> Could a historiographer drive on his history, as a muleteer drives on his mule,—straight forward;—for instance, from *Rome* all the way to *Loretto*, without ever once turning his head aside either to the right hand or to the left,—he might venture to foretell you an hour when he should get to his journey's end:—but the thing is, morally speaking, impossible; for, if he is a man of the least spirit, he will have fifty deviations from a straight line to make with this or that party as he goes along, which he can no ways avoid. He will have views and prospects to himself perpetually soliciting his eye, which he can no more help standing still to look at than he can fly.[21]

For all of their differences, the works of both Priestley and Sterne point to the technical ingenuity and the intensity of the labor required to support a fantasy of linear time.

The timeline offered a new way of visualizing history. And it fundamentally changed the way that history was spoken of as well. Yet it in no way closed off other visual and verbal metaphors and mechanisms of representation. The nineteenth century, which saw the extension of the timeline

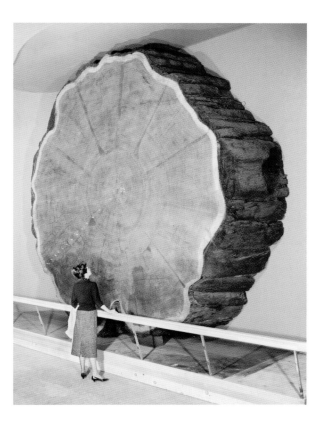

Cross section of a giant sequoia at the American Museum of Natural History in New York City, photographed in the 1950s. When the tree was felled in California in 1891, it stood 331 feet tall and measured 90 feet around at the base. This section contains 1,342 annual rings, dating the tree to the mid-sixth century. As currently exhibited, the rings are marked at intervals of 100 years and inscribed with notable historical events including the invention of the refracting telescope used by Galileo (1600), the founding of Yale College (1700), and Napoleon seizing power in France (1800).

into many new areas of application, also saw the resurgence of other temporal figures that had interacted and competed with linear imagery for many centuries. Throughout the medieval and early modern periods, for example, the statue that Nebuchadnezzar dreamed of in Chapter 2 of the book of Daniel, and that Daniel explicated as depicting the four great empires that would rule the world in turn, could and did serve as an armature for world history. And with the religious revivals of the eighteenth and nineteenth centuries, figures of Nebuchadnezzar's statue spread again like wildfire. But, in this new resurgence, something was different. Nineteenth-century visionaries used timelines to elucidate their allegories and to give them precision. They became experts in visual code shifting, translating back and forth between the bare lines of Priestley and his emulators and the vivid images of the apocalyptic traditions.

During the mid-nineteenth century, a strong positivist tendency also emerged in chronography, especially in the areas where technical devices could be used to measure and record events of historical significance. [*fig.* **10**] The development of photography, film, and other imaging technologies in the nineteenth and twentieth centuries permitted the recording of time-sequenced phenomena, and ever more precise instruments and methods, such as the chronophotographic apparatuses of Étienne-Jules Marey and Eadweard Muybridge on the one hand and the tree ring analysis of Andrew Ellicott Douglass on the other, made visible for the first time events taking place at very high and low speeds. Researchers such as these opened new possibilities for the study of the past. They also in some ways encouraged people to think that historical events might be recorded and represented in truly objective ways.

But, while the convention of the timeline came to seem more and more natural, its development tended also to raise new questions. [*fig.* **11**] In some cases, filling in an ideal timeline with more and better data only pushed it toward the absurd. Jacques Barbeu-Dubourg's 1753 *Chronologie universelle*, mounted on a scroll and encased in a protective box, was 54 feet long. Later attempts to reanchor the timeline in material reference, as in the case of Charles Joseph Minard's famous 1869 diagram, *Carte figurative des pertes successives en hommes de l'armée française dans la campagne de Russie 1812–1813* (Thematic map displaying the successive casualties of the French army in the Russian campaign 1812–1813), produced results that were beautiful but ultimately put into question the promise of the straight line.

The visual simplicity of Minard's diagram is paradigmatic—as is the numbing pathos of its articulation across

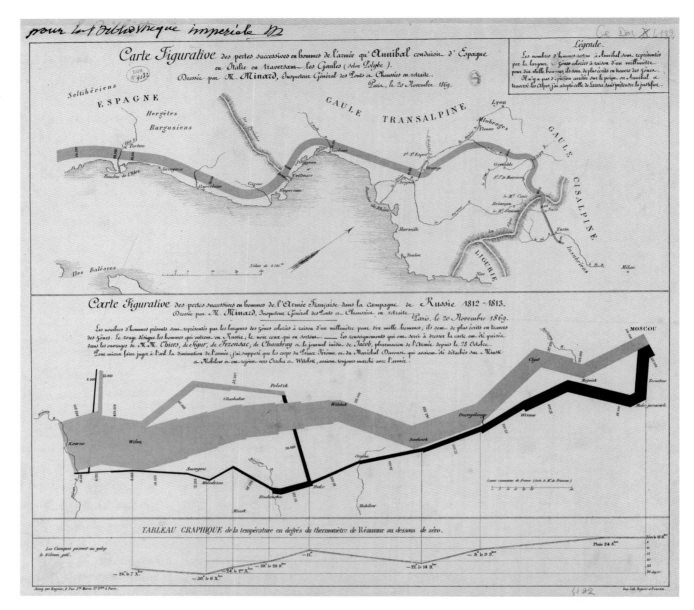

[11]

In the 1860s, the French engineer Charles Joseph Minard devised a number of new and influential infographic techniques. Among the most famous of his charts from this period is the 1869 *Carte figurative des pertes successives en hommes de l'armée française dans la campagne de Russie 1812–1813 comparées à celle d'Hannibal durant la 2ème Guerre Punique.* The two diagrams, published together, show the size and attrition of the armies of Hannibal in his expedition across the Alps during the Punic wars and of Napoleon during his assault on Russia. The colored band in the diagrams indicates the army's strength of numbers—in both charts, one millimeter in thickness represents ten thousand men. The chart of Napoleon's march includes an indication of temperature as well.

Charles Renouvier, diagram in which
uppercase letters represent actual
events, lowercase letters events that
did not happen, from 1876

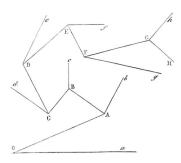

the space of the Russian winter. At the same time, through color, angle, and shape, Minard's chart marks the centrality of the idea of *reversal* in the thinking and telling of history. Minard's chart may be more accurate than Priestley's, not because it carries more or better historical detail but because it reads in the complex, sometimes paradoxical way in which a real story is told. The same could be said for the branching time map in Charles Renouvier's 1876 *Uchronie (l'utopie dans l'histoire): Esquisse historique apocryphe du développement de la civilisation européenne tel qu'il n'a pas été, tel qu'il aurait pu être* (Uchronia [utopia in time]: An outline of the development of European civilization, not as it was, but as it could have been), which depicts both the actual course of history and alternative paths that might have been if other historical choices and actions had been taken. [*fig.* **12**] Other philosophers took an even more critical position. At the end of the nineteenth century, the French philosopher Henri Bergson decried the metaphor of the timeline itself as a deceiving idol.[22]

Reflection on the question of deep time, too, engendered self-consciously estranging forms of temporal mapping, as in the several billion year long timeline of future history that the philosopher and science fiction writer Olaf Stapledon used as the structure for his metahistorical parable, *Last and First Men*, from 1930.[23] [*fig.* **13**] Stapledon knew that it is hard to envision human history in terms of billions of years. He also knew that projected on a timeline, his vision would look almost natural. Stapledon employed the intuitive form of the timeline to shake up his readers' assumptions about the values implied in the very scale of our historical narratives. And in recent years similar devices have been used effectively by environmentalist groups such as the Long Now Foundation. [*fig.* **14**] Throughout the past two centuries, from Francis Picabia to On Kawara and from J. J. Grandville to Saul Steinberg, visual artists have interrogated and poked fun at our presuppositions about graphic representation of historical time. Works such as theirs point to both change and persistence in the problem of chronological representation—to the vitality of the forms created by Eusebius and Priestley and to the conceptual difficulties that they continue to present.

In *Cartographies of Time*, we offer a short account of how modern forms of chronological representation emerged and how they embedded themselves in the modern imagination. In doing so, we hope to shed some light on Western views of history, to clarify the complex relationship between ideas and modes of representation, and to offer an introductory grammar of the graphics of historical representation.

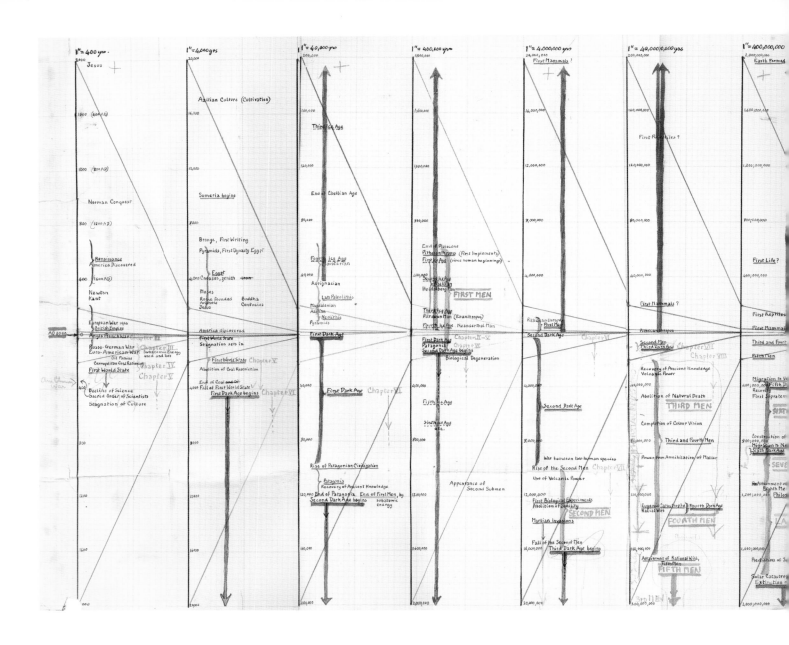

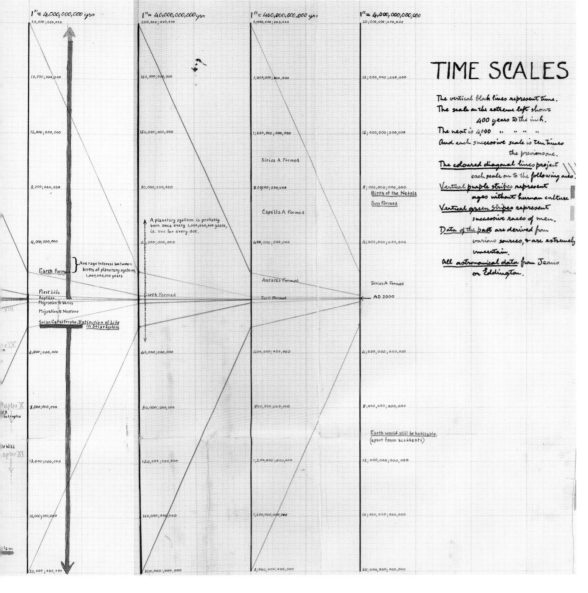

Manuscript timeline for Olaf Stapledon's classic 1930 science fiction novel, *Last and First Men: A Story of the Near and Far Future*. Stapledon's book gives an evolutionary history of humanity over two billion years and eighteen great biological and cultural revolutions. The published work includes a set of timelines drawn to different scales, from the historical to the cosmological. His manuscript timeline works the same way: the vertical black lines represent time; the line at the far left is drawn to a scale of 400 years to the inch; the next is 4,000 years to the inch, and each successive scale is ten times the previous. Colored diagonal lines project each scale onto the following ones. Vertical purple stripes represent ages without human culture. Vertical green stripes indicate successive races of men.

Special Collections and Archives, University of Liverpool Library. Courtesy of John Stapledon.

[14]

The Long Now Foundation, comparative time scales of the concept of the long now, 1999

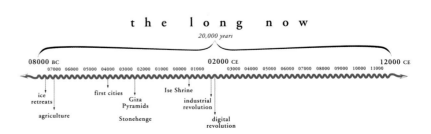

Time Tables

[1]

The fall of Troy dominates this opening in the *Chronicle* of Eusebius.

The story of the timeline begins in the ancient world. [*fig.* 1] Greek and Roman scholars drew up lists of priests, Olympic winners, and magistrates, some of which were carved in stone, others recorded in books. But it was the fourth-century Christian theologian Eusebius of Caesarea who designed and composed the *Chronicle* that became the model for later timelines for centuries to come. Eusebius set out to establish the place of Christianity in the history of the world told, in part, by the Jewish and Christian scriptures. But he also planned to synchronize with this central narrative the histories of several other nations that had maintained their own records and had their own conventions of chronology, and that had figured prominently in the history of ancient Israel or the modern church.

Eusebius, who read the Bible in Greek, knew and used the *Hexapla*, a six-column polyglot Bible that another Christian scholar, Origen, had compiled in the third century. By lining up the original Hebrew, word for word, with other columns that provided a Greek transliteration and four different Greek translations, Origen enabled Christian readers to see where their Greek Bible, which they had inherited from the Greek-speaking Jews of Alexandria, differed from the Hebrew Bible used by Jews in Palestine. This very long, very famous edition probably filled twenty complete manuscripts. It proved the critical potential of rows and columns—formats that had been much harder to use in rolls, the original books of the ancients, than they were in the codex books that Christians favored. This format provided Eusebius, as it had Origen, with a simple device for processing complex information. Nineteen parallel columns, one to a nation, traced the rise and fall of the ancient Assyrians, Egyptians, and Persians, as well as the Greeks and the Romans, who still ruled the world.

Eusebius coordinated all these histories, making clear, for example, that the Greek philosopher Thales and the Hebrew prophet Jeremiah had been near contemporaries.[1] By working down and across his tables, the reader could find out exactly which events of scripture history were contemporary with particular events in pagan Greek or Egyptian antiquity. Ancient readers, who were familiar with illustrated texts of many kinds, from epic poems to mathematical works, recognized this feature as what made Eusebius's work distinctive. In the sixth century, Cassiodorus, a late Roman scholar, described the *Chronicle* as "an image of history"—a genre that combined form and content, page layout and learning, in a new way.[2] Eusebius's image of history taught one central lesson. Over time, the multiple kingdoms that had ruled parts of

Jerusalem falls, and Rome unifies the world. From this page of the *Chronicle* on, only one empire appears.

the world disappeared. History funneled down into a single story, that of how Rome unified the world just in time to give the Messiah access to all peoples. The *Chronicle*, in other words, was more than a highly legible record. It was a dynamic hieroglyph of providential history.

Translated into Latin and revised by Jerome in the fifth century, the *Chronicle* found a long series of copyists, continuators, and imitators through late antiquity and the Middle Ages. [*fig.* 2] Over and over again, scholars brought the content of the *Chronicle* up to date, while scribes made adjustments in its format. The fifteenth-century Florentine citizen-scholar Matteo Palmieri is now best remembered for his treatise on the duties of citizens. In his own day, as the great bookdealer Vespasiano da Bisticci recalled, his additions to the *Chronicle* made his name: "In Latin he added to the *De Temporibus* of Eusebius the events of more than a thousand years, taking up the work where S. Jerome and Prosper had left it. It is evident that he must have had great trouble in his researches to give an account of what happened in those ages of obscure writers. Both he and his work became famous. He made many copies of it so that it was found in all parts of the world."[3]

In the fifteenth and sixteenth centuries, printers added features that manuscript versions had lacked. In the front matter of the first edition of Eusebius's work, the Milanese publisher Boninus Mombritius boasted that no scribe could copy such an intricate and extensive work accurately, keeping the tables in order and putting all the kings in their places. Erhard Ratdolt, who printed his edition in Venice in 1483, added a special device made possible by the uniform pagination of printed books: an index of names. In the words of a poem by the press corrector who drew up the index,

So you won't wander, helpless, through this book,
Unable to find events and history,
We've made an index. Just go there and look,
The page you need won't be a mystery.[4]

In 1512 the Paris publisher Robert Estienne assigned one of his correctors, Jehan de Mouveaux, to make a new edition even more appealing. Mouveaux alphabetized the Ratdolt edition's index and added a poem of his own claiming credit for the innovation—only to lose it six years later, when Estienne reprinted the edition with Mouveaux's index but without his name. A vast scribal database, the *Chronicle* regularly attracted the attentions of people like Mouveaux, whom we would now call content providers—anonymous

[3–5]

Three different editions of Eusebius's *Chronicle* appear here. Jean de Mouveaux, who edited the second one in 1512, cannibalized the index of the first. Its anonymous creator was avenged when Mouveaux's own publisher, Estienne, reprinted his index in a 1518 edition but removed the poem in which Mouveaux had claimed credit for the innovation.

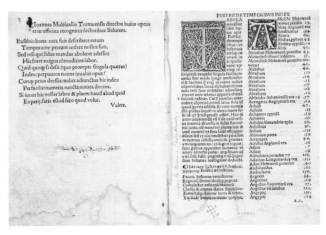

or little-known figures who still played important roles in reconfiguring and extending the text.

Mouveaux also emulated the medieval chroniclers and scribes who had updated the *Chronicle*, adding a printed supplement containing such headline news as the discovery of the New World. [*figs.* **3-5**] Yet, like previous continuators, he made no effort to represent the proliferation of kingdoms in the last few centuries in the design of his new material. Instead of starting new parallel columns, he collapsed the histories of modern kingdoms and cities into a single sequence with the earlier history of the Roman Empire. Mouveaux used no visual conventions—except red ink to indicate new popes and emperors—to convey the dramas he reported, which included everything from the deaths of scholars and the rise and fall of prophets to wars and invasions.

The new devices did not all work well. [*figs.* **6-10**] Depicting time on paper posed complex and demanding problems for printers, as it had for the scribes who worked with Eusebius, and they did not always respond as creatively. For all the improvements that the *Chronicle* received in print, it also looked more mechanical, and became harder to read, than its handwritten predecessors. Where the scribes had arranged lists of rulers and texts about events on an open field, the printers used horizontal and vertical lines to divide each page into small boxes. These did more to fragment and obscure information than to show the connections between events. Though the *Chronicle* went through many editions, its later editors did little to make it more striking or more user-friendly. They did, however, bring the work to many more readers, making them familiar with the parallel-column format.

Yet some of the chronicles composed after printing was invented, including Carthusian Werner Rolevinck's best-selling *Fasciculus temporum* (Bundle of dates) of 1474 and Nuremberg humanist Hartmann Schedel's lavishly illustrated 1493 *Nuremberg Chronicle*, offered readers more complex and vivid images of the past. Schedel and Rolevinck both knew, as readers of Eusebius did, that "from their inception universal histories were conceived as graphic enterprises."[5] They used a wide range of graphic devices, old and new, to portray the course of history.

The *Fasciculus temporum*, a fifty-page linear chart that moved from the Creation to the present, set out to give readers an overview of world history: a readable visual presentation that they could treat as both a memory system and as the spark for religious meditation. [*fig.* **11**] Rolevinck used a system of coordinated circles to locate

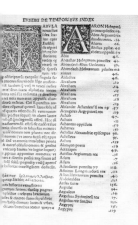

[6–7]

The end of Matteo Palmieri's fifteenth-century supplement to Eusebius's work and the beginning of Jean de Mouveaux's 1512 addition. Both men assume—as Eusebius had—that the world was now a single,

Roman one, even though Palmieri lived in Tuscany, a region split among medieval city-states, and Mouveaux in the proudly independent kingdom of France.

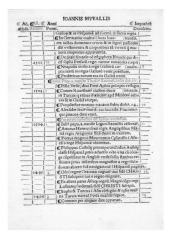

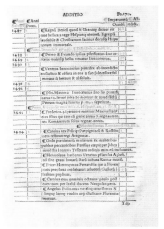

[8–10]

Jean de Mouveaux's supplement included reports of many kinds: from crosses that fell from the sky onto people's garments to the arrival of

men from the "new island" across the Atlantic to the French invasion of Italy in 1494 and the execution of Savonarola in Florence four years later.

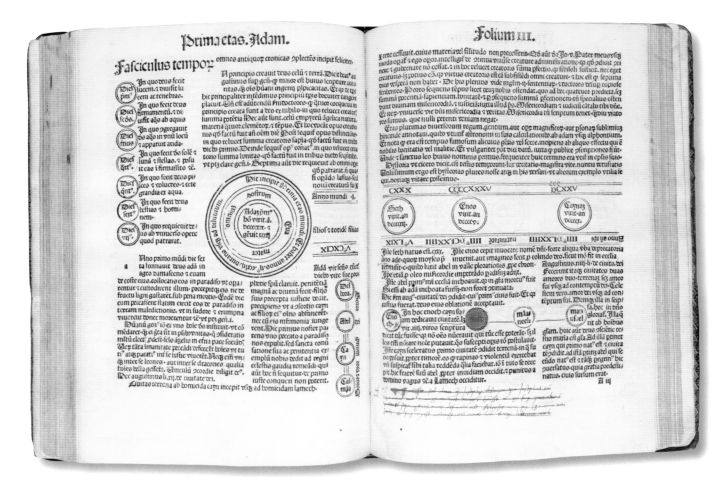

[11]

Werner Rolevinck's fifteenth-century
Fasciculus temporum.

biblical, classical, and modern rulers and writers in the flow of historical time—a system so complicated that the first printer who grappled with it botched the job, producing an unintelligible text; later printers reassured readers that they had followed the author's manuscript. And the results were most impressive: a neatly designed, powerfully horizontal line of time plunging forward from the Creation to the present. Around it neatly arranged and coordinated name bubbles and extracts from historical texts put meat on the book's numerical bones.[6]

Schedel, by contrast, portrayed many of his hundreds of actors as the literal fruit of elaborate genealogical trees. [*figs.* 12-13] He illustrated his work with a Ptolemaic map of the world, dazzling perspective renderings of ancient and modern cities, and even handsome comic-strip images of the wild races of cannibals and dog-headed men that had been reported in India since ancient times. Though his book could not match the visual clarity and precision of Rolevinck's, it offered far more detailed visual and verbal descriptions of the past.

Though both Rolevinck and Schedel composed their works with print in mind, both drew design elements from the world of medieval manuscripts. [*figs.* 14-18] Many scholars and scribes had added new expedients to those devised by Eusebius. In the late twelfth century, the Parisian teacher Peter of Poitiers composed a vividly colored visual history of the Old Testament for the use of students. He used a system of lines and circles to clarify the temporal and genealogical relations between the Hebrew patriarchs and kings. Written not in normal codices but on handsome parchment scrolls, copies of Peter's work could run nine or more feet long and were designed to be displayed in classrooms.[7]

With its illustrations of Noah's Ark, the Tower of Babel, and the city of Nineveh, the *Fasciculus temporum* reproduced the conventions of older world chronicles and biblical commentaries. [*fig.* 19] But Rolevinck fused this form with Peter of Poitiers' system, turning the vertical format 90° and chopping what had been continuous lines of descent into the normal page breaks of a codex. He then interspersed morsels of text, after the manner of Eusebius, so that the reader could fix the dates for passages from the Bible and the historians that, read on their own, floated in a chronological vacuum.

The Middle Ages saw multiple versions of biblical genealogy take shape, especially the so-called Tree of Jesse, based on Isaiah 11:1–3, which traced the ancestry of Jesus. [*figs.* 20-21] In the same centuries, noble families began to

The central visual metaphor of the early sections of Hartmann Schedel's *Nuremberg Chronicle* was the tree, to which he affixed images of the Jewish patriarchs, the rulers of Greece and Rome, and many others. This page depicts the descendants of Noah's son Japhet. Yet Schedel lived in a world buffeted by reports of strange, even monstrous peoples far to the East—reports that went back to ancient Greek sources. He found room for them, but could not place them on part of the tree that went back to Adam, since the Bible did not give them a place in its genealogies.

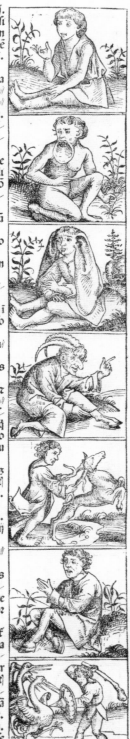

OE homib⁹ diuerſaꝝ formaꝝ dicit Pli. li. vij. ca. ij. Et Aug. li. li. � ca. viij. Et Iſidorus Ethi. li. xi. ca. iij. oia ꝗ ſequitur in in dia. Cenocephali homines ſunt canina capita habētes cū latratu loquūtur aucupio viuūt. vt dicit Pli. qui omnes veſcūtur pellibus animaliū.

Cicoples in India vnū oculum hūt in fronte ſup naſum bij ſolas ferarū carnes comedūt. Ideo agriofagite vocātur ſupꝛa naſomonas confineſꝗ illoꝛū homines eſſe: vtriuſꝗ nature inter ſe vicibus coeūtes.

Calliphanes tradit Ariſtotiles adijcit dextram māmam ijs virilem leuam muliebꝛem eſſe quo hermofroditas appellamus.

Ferunt certi ab oꝛiētis pte intima eſſe homines ſine naribus: facie plana eꝗli totius coꝛpis planicie. Alios ſupioꝛe labꝛo oꝛbas. alios ſine linguis ꝛ alijs cō creta oꝛa eſſe modico foꝛamine calamis auenaꝛ potū hauꝛiētes.

Item homines habentes labiū inferius. ita magnū vt totam faciem contegant labio doꝛmientes.

Item alij ſine linguis nutu loꝗntes ſiue motu vt monachi.

Pannothi in ſcithia aures tam magnas hūt. vt contegant totum coꝛpus.

Artabꝛite in ethiopia ꝓni ambulāt vt pecoꝛa. ꝛ aliqui viuūt p annos. xl. quē nullus ſuꝑgreditur.

Satiri homūciones ſunt aduncis naribus coꝛnua i frontibus hūt ꝛ capꝛaꝛ pedibus ſimiles qualē in ſolitudine ſanctus Antonius abbas vidit.

In ethiopia occidentali ſunt vnipedes vno pede latiſſimo tam veloces vt beſtias inſequantur.

In Scithia Ipopedes ſunt humanā foꝛmaꝛ eꝗnos pedes habentes.

In affrica familias quaſdā effaſcinātiū Iſigonus ꝛ Memphodoꝛus tradūt quaꝛ laudatōe intereāt ꝓbata. areſcāt arboꝛes: emoꝛiātur infantes. eſſe eiuſdem generis in tribalis et illirijs adijcit Iſogon⁹ ꝗ viſu quoꝗ effaſtinent iratis ꝓcipue oculis: quod eoꝛū malū facilius ſentire puberes notabili⁹ eſſe ꝗ pupillas binas in oculis ſingulis habeant.

Item hoies. v. cubitoꝛ nūꝗ infirmi vſꝗ ad moꝛtez Hec oia ſcribūt Pli. Aug. Iſi. Preterea legit i geſt⸵ Alexādri ꝗ i india ſunt alij hoies ſex man⁹ hūtes. Itē hoies nudi ꝛ piloſi in flumine moꝛātes. Itē hoies manib⁹ ꝛ pedib⁹ ſex digitos habentes. Itē apothami i aꝗs moꝛantes medij hoies ꝛ medij caballi.

Item mulieres cū barbis vſꝗ ad pect⁹ ſ capite plano ſine crinibus.

In ethiopia occidētali ſūt ethiopeſ. iiij. oclos hūtes In Eripia ſunt hoies foꝛmoſi ꝛ collo gruino cū roſtris aialium hoimꝗ effigies mōſtriferas circa extremitates gigni mime miꝛu. Artifici ad foꝛmanda coꝛpora effigieſꝗ celandas mobilitate ignea.

Antipodes. āt eē. i. hoies a ꝑria pte terre vbi ſol oꝛit qñ occidit nob aduerſa pedib⁹ ñris calcare veſtigia nulla rōe credēdū ē vt ait Aug. 16. de ci. dei. c. 9. Ingēs tñ h pugꝶ lꝛaꝝ ꝓtracꝗ vulgi opioez circūfundi terre hoies vndicꝗ couerſiſꝗ iter ſe pedib⁹ ſtare et cūctꝶ ſilem eē celi vticē. Ac ſili mo ex ꝗcūꝗ pte mediā calcari. Cur āt ñ decidāt: miꝛeꝝ ꝛ illi nos ñ decidere: nā eñ repugnāte: ꝛ quo cadāt negāte vt poſſint cadere. Ñã ſic ignis ſedes nō ē niſi i ignib⁹: aꝗꝛū niſi i aꝗs. ſpūs niſi in ſpū. Ita terre arcentibus cūctis n: ſi in ſe locus non eſt.

Peter of Poitiers' splendid late-twelfth-century scroll shows the genealogy of the Savior, who appears at the top, supported by a great seven-branched candlestick and flanked by explanatory text.

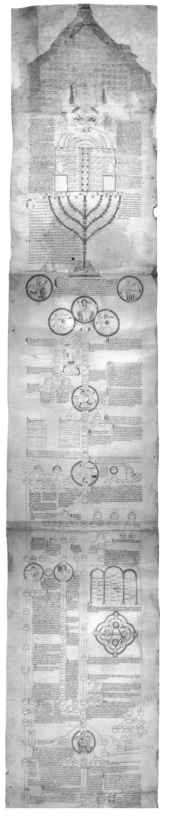

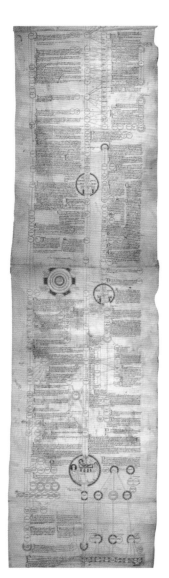

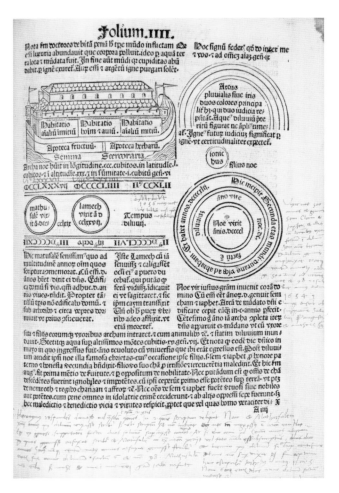

The elegance of Werner Rolevinck's layout in *Fasciculus temporum* is clear from this opening image, which shows Noah's Ark and the rainbow that followed the Flood.

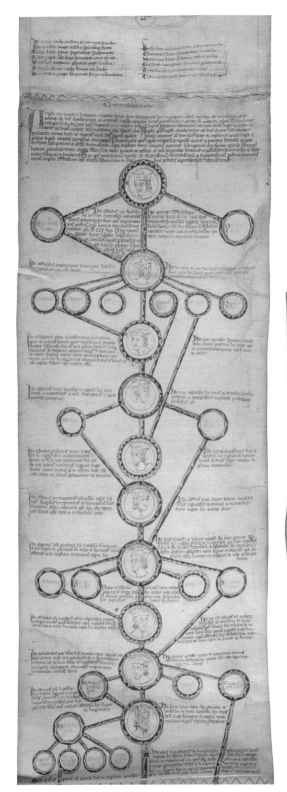

In contrast to Peter of Poitiers' work, Princeton MS 57, created in the mid-thirteenth century, is wholly secular. A visually spare, elegant record of English history from Alfred the Great (871–99) to Henry III (1216–72), it includes twenty-three roundel portraits of English kings as well as a range of texts. The seams show how such rolls were created from two or more skins (three, in this case). Where Peter of Poitiers' work was designed as a visual aid for use in the classroom, this roll might have hung in a nobleman's great hall.

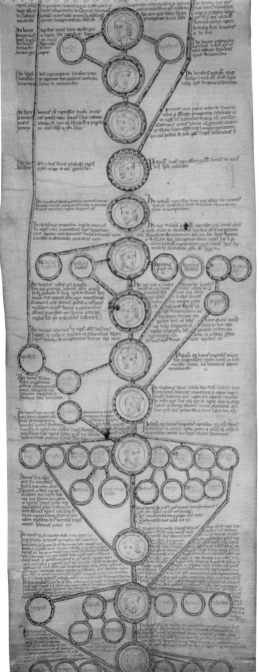

[22–28]

Hartmann Schedel, the days of
Creation from the *Nuremberg
Chronicle*, 1493

structure themselves as vertical "lineages," asserting their purity of blood and descent. Soon scholars began to produce scrolls that represented these family lines. Like the biblical ones, they often adopted the tree as a framework, and hung the generations of families' members like fruit from its branches.[8] These trees could become complex, even chaotic: "As genealogies were amplified in the course of the twelfth century, pushing out in every direction, filling in each sequence with more detail, adding names of younger sons, daughters, and ancestors not previously mentioned, the profile of the family tree became a skeleton of aristocratic society, revealing the multiple threads which crossed and re-crossed, binding regional nobilities into ever more integrated congeries of family relations."[9] Still, some of the scrolls that record them reveal the lucidity and beauty of the format.

Schedel emulated the arboreal format of the genealogies, though he chopped the trees into irregular segments to fit the page openings in his book. He thus used the generations of patriarchs and kings, rather than a simple timeline, as the armature for his history. [*figs.* **22–29**] Schedel also fused even older biblical and chronological conventions with the genealogy format. In his *Nuremberg Chronicle*, he illustrated the creation of the world through a striking series of

seven panels representing the days of Creation. Manuscript illuminators in medieval Paris had used tiny, elegant images to identify the days of Creation in Genesis, but Schedel simplified, enlarged, and dramatized these images in a way that reflected his understanding of the aesthetics of print.

Both Rolevinck and Schedel devised ingenious graphic solutions for problems that had confronted chronologers for centuries. [*figs.* **30–31**] Unhappily aware that the ancient versions of the Bible in Hebrew and Greek differed radically on the interval between the Creation and the Flood (1,656 years and 2,256 years respectively), Eusebius had simply omitted the earliest period of history, the stories told in Genesis, from his *Chronicle*. Rolevinck borrowed a more elegant solution from the world chronicles of the thirteenth century. At the horizontal center of each page he placed what he described as "circles with the right names of persons for each date, and two lines above and below": a double axis.[10] Then he computed the dates that marked off the intervals of this axis and recorded them in two linear series: one, on top, counted forward from the Creation (traditionally called AM, years of the world); one, on the bottom line, counted backward from the birth of Christ (in modern terms, years BCE). Critical readers, Rolevinck explained, could use the latter, newer system to compare

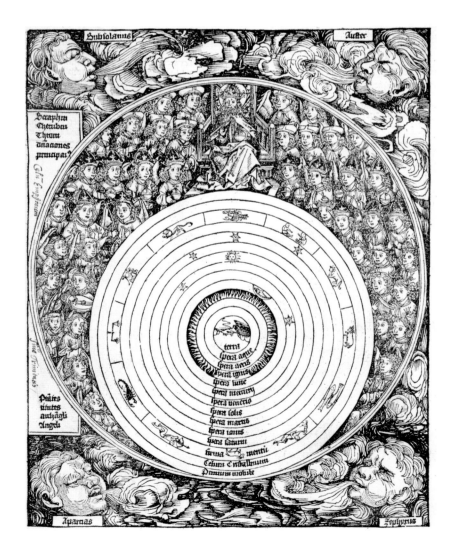

[29]

The band of illustrations on the left of the beginning of Genesis in this twelfth-century Paris Bible depicts the sequence of the Creation, more delicately but less dramatically than Schedel would.

[30]

The destruction of Sodom and Gomorrah, from Rolevinck's *Fasciculus temporum* (Bundle of dates). The reader who has annotated this opening was interested in recomputing Rolevinck's dates, but left no comment on the destruction of the cities.

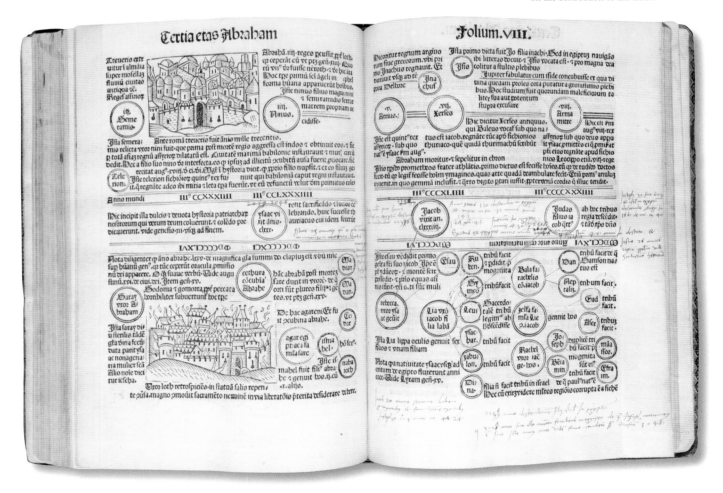

Rolevinck was not the only chronolo-
ger who attempted to create a world
chronicle in the form of a codex
genealogy. The anonymous 1475
Chronicarum et historiarum epitome,
(Epitome of chronicles and histories)
took on virtually the same project. In
Rolevinck's text, horizontal streams
connect seamlessly from page to
page. By contrast, the designer of the
Chronicarum epitome has oriented
his time stream vertically and added
reference letters so that the reader
may correctly connect the genealogical
chains from one page to the next.

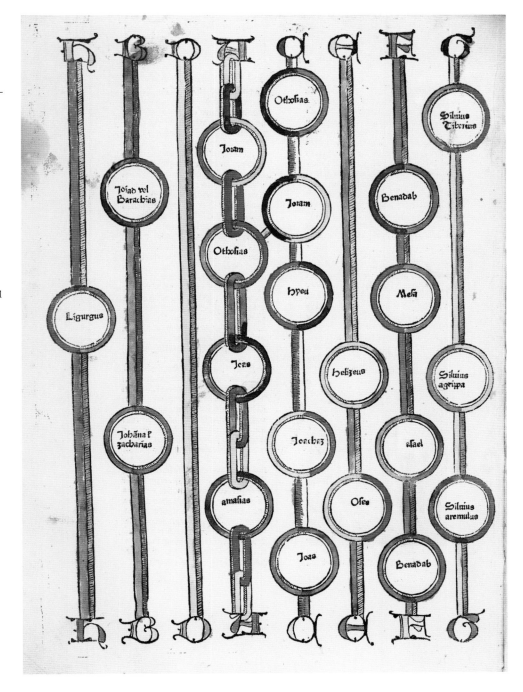

These images from the later pages of Schedel's *Chronicle* dramatize recent events exactly as they were dramatized in the single-page newsletters that spread information from city to city in the early modern world. Here Schedel and his illustrators portray a naked witch riding with a devil, the first such image recorded; the drowning of impious men and women; the 1474 killing of a Christian boy in Trent, supposedly by Jews, who were tortured until they confessed; and the sect led by the Drummer of Niklashausen, a popular prophet, in 1476. The terrible potential of the modern media to spread images that breed hate and disgust is already visible in Schedel's timeline.

the different ancient chronologies. Many followed his advice, entering their computations in the text as they read along. The graphic clarity of his work, Rolevinck argued, made it accessible to anyone—made it an "image of history" and one even more user-friendly than the *Chronicle*: "The method is very simple, and so friendly even to crude rustic minds that it could be represented on a wall."[11]

Schedel—a citizen of Nuremberg, a great merchant city and a prime node on Europe's communications networks—knew that his readers were experiencing history in new ways and through new media. [*figs.* **32–35**] A massive book, heavy with text, the *Nuremberg Chronicle* incorporated many descriptions of events, each consisting of a short text with an illustration. In appearance and content, these vignettes imitated the broadsides then in circulation, on which Schedel's readers—and Schedel himself—depended for breaking news of the fall of Constantinople, the appearance of comets, and the birth of monsters.[12] (Schedel underlined the resemblance by pasting broadsides that appeared after the *Chronicle* into his own copy of the book.[13])

Where the earlier parts of Schedel's *Nuremberg Chronicle* followed the stately tempo of traditional world histories, the later ones, with their gripping images of a naked witch flying, Jews murdering a Christian child, and the events foretold in the Book of Revelation, represented history as a kaleidoscopic mass of places and events, hurtling forward to its end. Schedel even gave readers a few blank pages between their own time and the Apocalypse that they could fill in—and many did—with what he clearly expected to be the short remaining history of the world. Eusebius had warned his readers that humans could not know when time began or when it would end. Schedel, by contrast, set firm borders at both ends of his map of time.

Eusebius expected scribes to find his *Chronicle* hard to reproduce, and inserted instructions in the hope that they would at least do their best. [*figs.* **36–38**] But the demands that chronologers like Rolevinck and Schedel made of those who reproduced their books were greater, as Rolevinck himself admitted:

> It cost me much hard work to lay out the lines of Assyrian and Roman history from various sources. Accordingly, I ask anyone who decides to copy this work to pay close attention to the spaces and the numbers that correspond to them, and make them no longer or smaller than in the model. Otherwise his work will go to waste.[14]

Schedel left the reader three blank leaves to fill in with the events that would take place between the publication of the *Chronicle* in 1493 and the end of time. He also used woodcuts showing the imagery of the Book of Revelation to show the course that would follow. These visions of the future made a dramatic climax to the fast-paced, vividly illustrated later sections of the *Nuremberg Chronicle*.

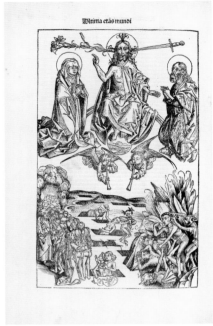

Schedel took even stronger precautions: he laid out his *Nuremberg Chronicle* page by page and image by image, and the contract he made with his publisher, Anton Koberger, stated stringent conditions for cooperation—all involved worked in a room dedicated solely to its production in Koberger's printing shop.[15]

Chronologers needed to balance the competing claims of scholarly honesty, which required Rolevinck to admit that he could not establish a single, absolutely valid chronology for the world, with those of sacred history, which seemed to demand a continuous timeline from Creation to their own day. They had to devise a page design that could accommodate both inflexible lists of minute facts, such as names and dates of rulers, and large blocks of descriptive text. They also hoped to make their information more accessible than scribes could. While some of their inventions, like indexing, served that end, others, like the typographical grid that made Eusebius harder to read, were less successful.

Most important, chronologers wanted to attain a reasonable level of precision while still making the past vivid. Technical changes—for example, numbering leaves or pages and compiling indexes—helped readers find what they needed in the mass of details. Collaboration among authors, artists, and printers solved other problems, resulting in Schedel's crisp new full-page views of Cologne, Venice, Rome, and Nuremberg, which outshine the vivid but tiny city views in some editions of Rolevinck. Yet some problems defied solution: for example, how to provide images for cities for which no drawing or woodcut was accessible, a conundrum that led both Rolevinck and Schedel to use iconic default images for many of the cities that they mentioned, even though they offered up-to-date, detailed views of others. Neither Rolevinck nor Schedel, moreover, managed to work out a way of combining genealogy, a form in which time seems to consist of an irregular series of human generations, with chronology, in which time is regular, uniform, and represented by numbers. Plenty of room remained for new ideas and forms.

In the course of the sixteenth and seventeenth centuries, moreover, the task of drawing up a chronological table gradually became even more demanding than it had been for Eusebius or Rolevinck. By the 1540s European scholars had at their fingertips a massive volume of new information drawn from historiography, paleography, numismatics, astronomy, and other fields. And this information was not limited to the European or Christian traditions; lists of rulers from distant lands such as Egypt, Persia, the Americas,

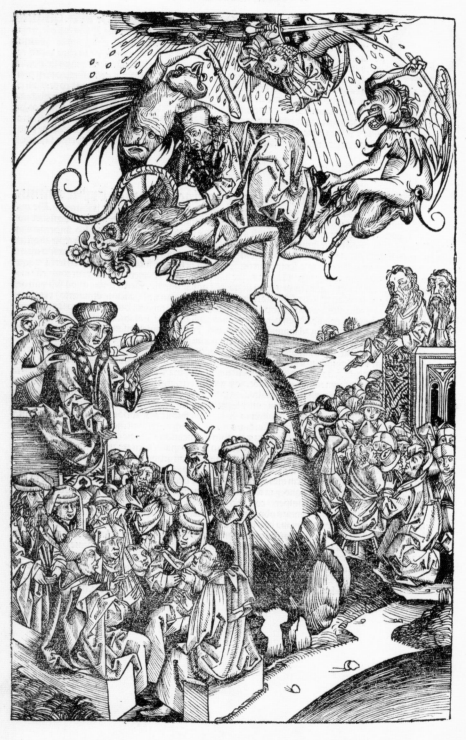

[39]

This genealogy traces the ancestry of the fifteenth-century inhabitants of Europe back to Japhet, one of the three sons of Noah. Annius of Viterbo invented mythical founders for modern nations, drawing their names from the names of their people. For example, the modern Lombards, or Longobards, were descended from Longo and Bardus. Using these methods he offered modern rulers—including his own patrons, the Borgia Pope Alexander VI and the Catholic kings of Spain—proud genealogies. (Alexander turned out to be descended from the Egyptian god Osiris.)

[40–42]

In this strikingly handsome book, published in 1534, Paulus Constantinus Phrygio lays out human history on a horizontal line. Though Phrygio's work expresses the forward movement of history, the relatively weak axis of years along the top of the page makes the actual dates of events

and China arrived in the second half of the sixteenth century and the first years of the seventeenth. Some of the dynasties recorded by these lists had existed before the date where the Bible set Creation, a fact which inspired both the English playwright Christopher Marlowe and the Italian philosopher Giordano Bruno to abandon biblical chronology entirely. They also figured in the calculations of less radical chronologers, who worried endlessly about how to deal with the challenges they posed to the authority of Genesis.[16]

Reconciling such diverse sources required wide knowledge and inventive technique. In theory, the chronologer strove to create a historical framework in which every recorded human act and achievement would have its place. Early modern chronologers promised their readers, as Eusebius had, that they would provide a kind of historical Rosetta stone, a tool that would permit them to translate lists of names and dates from many different sources and languages into a single, coherent version of the past. The urgency of such work, of course, varied greatly in relation to the eschatological position of the reader: for some (straight down to the present day), the study of chronology was motivated by the desire to discover the exact date of apocalypse. Others bore in mind the words of the resurrected Jesus to his followers: "It is not for you to know the times or the seasons, which the Father hath put in his own power" (Acts 1:7). For them, the end of time was not a collective experience of horror and rapture, but something every individual encountered in his own life.

Annius of Viterbo, a Dominican theologian, scholar, and con-man, published in 1498 a set of twenty-four ancient texts equipped with massive commentary. [*fig.* **39**] While he did not fabricate every entry in this very inventive chronology, he did compose most of the works that he claimed were the ancient histories of Egypt, Chaldea, and Persia that Eusebius and other ancient writers had quoted. Annius adorned his book with austere, horizontally oriented genealogical tables—also an alluring mix of history and fantasy—which he used to show that his patrons, the Borgia Pope Alexander VI and the Catholic kings of Spain, could trace their ancestry back to Isis and Osiris. He also found room in early times for the forefathers of the Lombards, the French, and the British.[17]

A generation later, when the German scholar Simon Grynaeus found it too hard to compile a single little "table" organized by Olympiads of "the origins, growth and ends of all states," he persuaded a colleague, the pastor and Hebraist Paulus Constantinus Phrygio, to take on the job.[18] [*figs.* **40–42**] Phrygio not only agreed, he made the table into

hard to follow. Even such turning points as the Crucifixion and the fall of Jerusalem, seen in the last image, are hard to locate. These defects of layout may explain why Phrygio's work was not reprinted. But its content may also have played a part. His lists of early dynasties come from the texts forged by Annius of Viterbo, and his work was received with skepticism by more learned scholars.

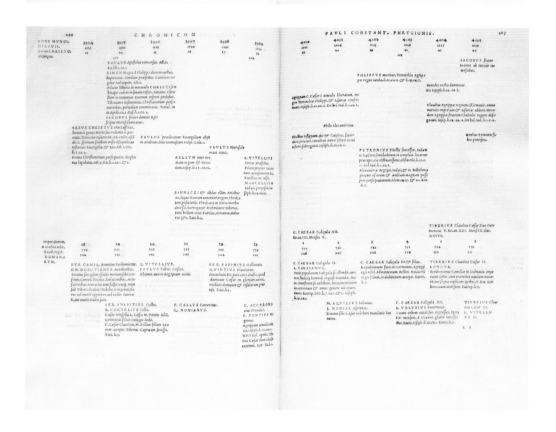

Albrecht Dürer's paper triumphal arch
for Maximilian I. Maximilian used
vivid printed materials like this to
establish the genealogy of his house
and the authority of his imperial
throne, both of which were actually
newer, and shakier, than he was willing
to admit.

a full-scale book. Neater and more abstract than Rolevinck's book or Schedel's, Phrygio's *Chronicum* (Chronicle) laid out history from the Flood to the present on several parallel lines of rulers. Like Rolevinck and Annius, he oriented his timeline horizontally rather than vertically, adding the numbers of years from the Flood to each ruler or event. Phrygio emulated Annius in setting out to show the similarities and connections between ancient and modern times, but he found a way to incorporate far more information while doing so. In the later part of his work, he added on new columns tracing the history of the Holy Roman Empire, the papacy, and the kingdoms of France and Britain as they took shape, one after another. Like Rolevinck, Phrygio saw that a horizontal format made it easier to fit texts of quite different lengths between rows of rulers' names. Unlike many of his predecessors and successors, he also used his chosen format to make an important historical point: that Rome no longer ruled the world. France, for example, was an independent kingdom, not a province of the Roman Empire, and received its own line of rulers. Phrygio's work had elegance, horizontal energy, and willingness to depart from convention. Unfortunately, the book's appearance of lucidity and logic is somewhat belied by its content. Phrygio earned his readers' trust by naming the authors from whom he drew his

information. But many of them were Annius's forgeries. His decision to run the axis of years from the Creation along the top of the pages made his work useless for anyone relying on the Greek text of the Bible, though Rolevinck had already shown how to solve this problem. Still, Phrygio's case shows that authors and printers could mobilize ingenious visual devices in the hope of nailing chronology down in a single, memorable format.

In the second half of the sixteenth century, genealogy would serve other functions as well. Some were as fantastic as those of Annius—especially since respectable scholars earned fees by selling noblemen scholarly looking genealogies that traced their ancestors back to ancient Rome or Egypt.[19] In the Holy Roman Empire, where many princes found it hard to produce male heirs who lived to maturity, simply maintaining a line of succession seemed to be the *arcanum imperii*, the key to political as well as familial success.

Every dynasty put its lineage on show, from the Habsburgs to the rulers of Saxony, and printers deployed a range of images, from the traditional tree to the open hand—long used as a mnemonic device—to help readers follow and master these vital succession lists. [*figs.* **43–44**] Among the most striking of these productions was the wall-sized, multi-panel print of a triumphal arch designed

for Maximilian I by Albrecht Dürer around 1516. Though he never intended for it to be built, the design on paper afforded a spectacular virtual tour of the Habsburgs' ancestry.

Like other Renaissance princes, the Habsburgs proudly cultivated the study of their own genealogy. Controversies swarmed around central links in their ancestral chains, so Maximilian's erudite courtiers, Conrad Peutinger and Johannes Stabius, collected and sifted information from every source they could find. At all costs, they had to show that the Habsburgs descended from an independent line as venerable as that of the kings of France and the rulers of ancient Rome. They did this job with brio, tracing the origins of the Habsburgs back to Clovis, king of the Franks, and those of Clovis back to Hector of Troy. Further lines of inquiry turned up solid genealogical connections between Maximilian's line and the biblical patriarchs (above all, Noah), the Greek gods Saturn and Jupiter, and—in keeping with the Egyptomania fashionable at the time—the god Osiris. When Maximilian learned that his scholars traced his line back to Japhet, the son of Noah, who exposed his father's genitals, he claimed to be shocked.[20] In fact, though, their enterprise was normal, and made effective use of history. The triumphal arch showed anyone who

approached it that Maximilian was not only a great man, but the culmination of world history.

Many writers deployed genealogy in more traditional ways. [*figs.* **45-47**] Since Eusebius and Peter of Poitiers, chronologies and genealogies had served at least two functions: they assembled information of value and tied it to striking and memorable graphics. The Saxon scholar Lorenz Faust offered readers the traditional Tree of Jesse, a magnificent Saxon genealogical tree, and the basic list of Saxon rulers, their names inscribed on the joints of the fingers of one hand and thus easy to master.

In other hands, however, genealogy became a form of precise, intensive scholarship. [*figs.* **48-49**] Reiner Reineck, who taught history at Helmstedt and elsewhere, claimed that genealogy "illuminates all the other parts of history, and without it they bear basically no fruit at all." After all, he pointed out, "anyone can see that histories chiefly deal with the persons who did things, and that they must be separated out into families." Like states, he thought, families had set periods of existence, during which they grew from humble origins to positions of power and then declined and died.[21] Reineck's chronology included dozens of skeletal genealogies. In fact, these became the core of history as he portrayed it. But he stripped away the arboreal

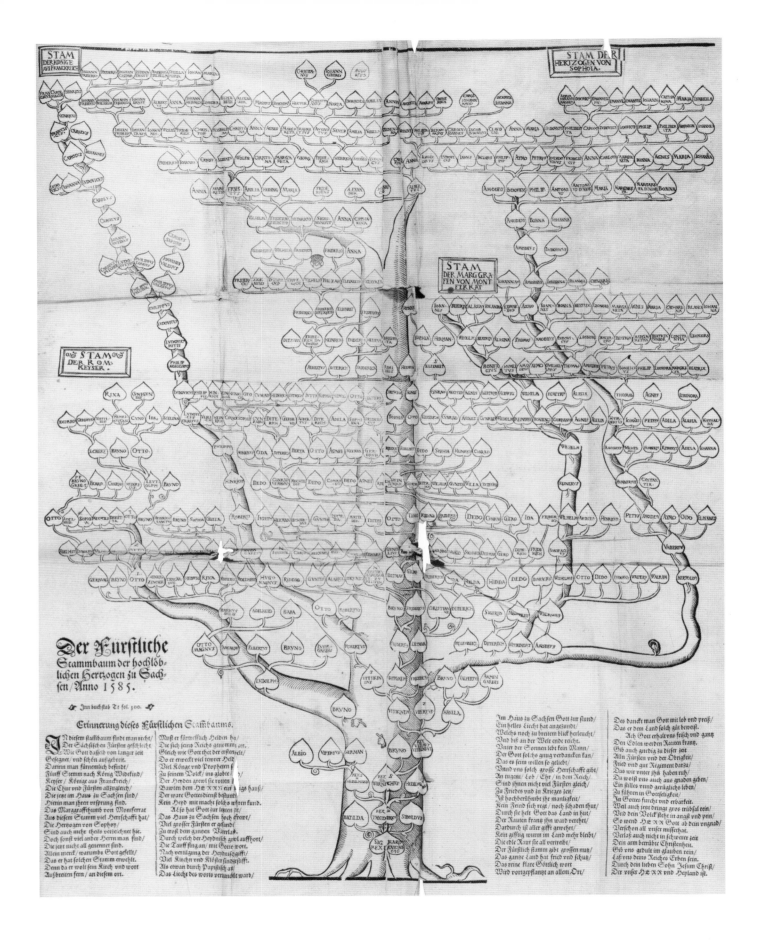

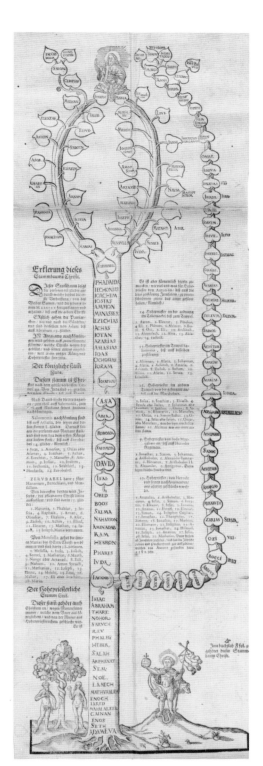

[45–47]

These genealogies of Jesus and the rulers of Saxony—all taken from the same book, Lorenz Faust's *Anatomia statuae Danielis* (An anatomy of Daniel's statue)—illustrate the persistence of medieval conventions deep into the age of print.

[48]

Reiner Reineck, geneological chart from *Suntagma*, Basel, 1572–74. Reineck saw genealogy as the key to understanding the past. In his enormous *Suntagma*, he turned world history into a long series of family trees—in this case, that of the Temenids, the founders of the kingdom of Macedonia.

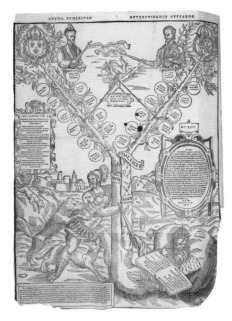

[49]

Elias Reusner, genealogy as chronology, Frankfurt, 1589

[50]

In his 1540 edition of Livy's history of Rome, the historian and music theorist Heinrich Glareanus lays out, in full detail, a Eusebian coordinate system of dates against which readers could follow the events without becoming confused or lost. Chronologies were drawn up for a number of authors, including the epic poet Virgil.

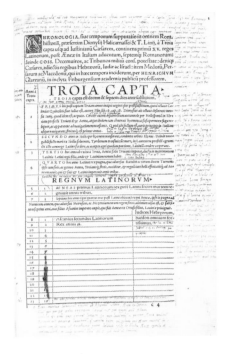

decoration with which Schedel and others had given this presentation visual drama and appeal. For Reineck, genealogy was so important that it needed no adornment. Still others, like the Jena University history professor Elias Reusner, used genealogy as a polemical weapon. By representing the family ties of Henry III, the Catholic king of France, and Henry of Navarre, his Protestant heir, as the branches of a tree trunk, he made clear that no attack—even the vicious one of the Catholic Duke of Guise—could break them. [*fig.* 50] Others, such as the Swiss scholar Heinrich Glareanus, applied the model of the comparative table to new subjects. Glareanus drew up chronologies for individual texts: in the first instance for Livy's history of Rome, written under Augustus and treasured by Renaissance readers from Petrarch to Machiavelli. Livy dated his narrative year by year, making it hard for readers to coordinate his history with other accounts or with the Bible. Glareanus made clear that the founding of Rome and the reign of Salmanassar in Assyria were almost exactly contemporary, and connected the Punic wars to other events in Mediterranean history. As he redid his work for later editions, it became so informative that he circulated it independently as a tabular chronology of Rome. [*fig.* 51] By contrast, the British mathematician and historian Henry Savile applied the Eusebian

format to impose order on a period that no great writer had described, the early Middle Ages.

Graphic innovation and the repurposing of older expedients both flourished, especially when applied to religious ends. [*fig.* 52] Jean Boulaese, a Parisian priest and professor of Hebrew, managed to compose exactly the sort of single, comprehensive table that Grynaeus had found too complex to produce. His wall chart, designed for use by students at the University of Paris in the 1570s, carefully separated biblical history, which began with the Creation, from pagan, which began only after the Flood. And he divided secular history into four distinct periods. By doing so, he made all of human history fit the scheme laid down long before by the biblical prophet Daniel, who had foretold that four empires would rule the world in turn. Many Protestants shared the Catholic Boulaese's faith in this scheme—and agreed with him that they were living in the fourth, or Roman, empire, which would soon come to an end. (Boulaese, an exorcist as well as a chronologer, witnessed many scenes that he took as evidence that the millennium was approaching.[22]) But the names and dates that crowd Boulaese's image made its larger providential order hard to discern. Protestants seeking to teach the same lessons found much more inventive visual models for doing so.

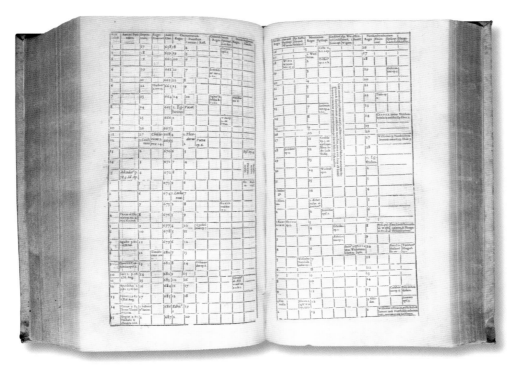

Henry Savile, scholar and scientist, uses the tools of world chronology to lay out the rulers and bishops of early medieval Britain in this 1601 edition from his collection of the medieval historians of Britain.

This dense, crowded table was printed—as Peter of Poitiers' table was drawn and painted four hundred years before—for Parisian university students. By the late sixteenth century, however, the range of peoples and events covered in world history had expanded enormously. Jean Boulaese, the Catholic polemicist who created this crowded time chart for his students, tried to achieve visual clarity by tracing the histories of the church and of secular kingdoms in separate, parallel areas.

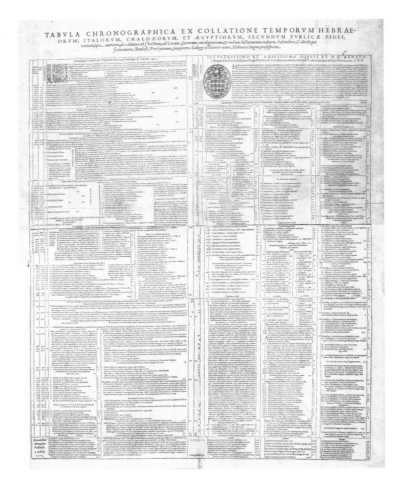

Like many prophetic texts in the second and first centuries BCE, Daniel's work consoled the Jews, predicting the imminent destruction of the pagan empires and the end of the Jews' subjection. The text interpreted the past and predicted the future, treating both as direct expressions of God's will. At one point, an image of a statue appears in a dream to Nebuchadnezzar, king of Babylon. Commanded by the king, Daniel first describes and then explains the statue:

> This image's head [was] of fine gold, his breast and his arms of silver, his belly and his thighs of brass, his legs of iron, his feet part of iron and part of clay.... A stone was cut out without hands, which smote the image upon his feet [that were] of iron and clay, and broke them to pieces. Then was the iron, the clay, the brass, the silver, and the gold, broken to pieces together, and became like the chaff of the summer threshing floors; and the wind carried them away, that no place was found for them: and the stone that smote the image became a great mountain, and filled the whole earth.[23]

This vision neatly combined two complementary time maps or schemes: the vision, derived from Persia, of history as a long strife between good and evil, destined to end in a great battle, and the sense, derived from the Greeks, that the earliest men had been stronger and more virtuous than their descendents, so that each generation, or kingdom, was worse than the one that preceded it.[24] Where Eusebius's parallel columns brought out the divinely imposed order of the past, the statue, with its gradually deteriorating raw materials and impending doom, welded the past to the future and both to a vision of God's plan for mankind.

Eusebius had rejected the idea that chronologers should predict the future, particularly the end of the world. But both in his time and later, many chronologers disagreed. Schedel, as we have seen, incorporated a rough estimate of how long history might last into the *Nuremberg Chronicle*. Rolevinck stated that a truly profound timeline would be a predictive, as well as a pedagogical resource—a measuring stick that could tell the faithful Christian how much time the world had left, as well as how much had already passed: "Human industry, soaring over this work on the wings of interior contemplation, measures not only the past and the present but the future."[25]

Neither Rolevinck nor Boulaese, however, hit upon the most dramatic way to lay out the schema of time as Daniel had. [*fig.* **53**] In 1585, Lorenz Faust published his *Anatomia statuae Danielis* (An anatomy of Daniel's statue). An unknown artist supplied the book with a folding woodcut,

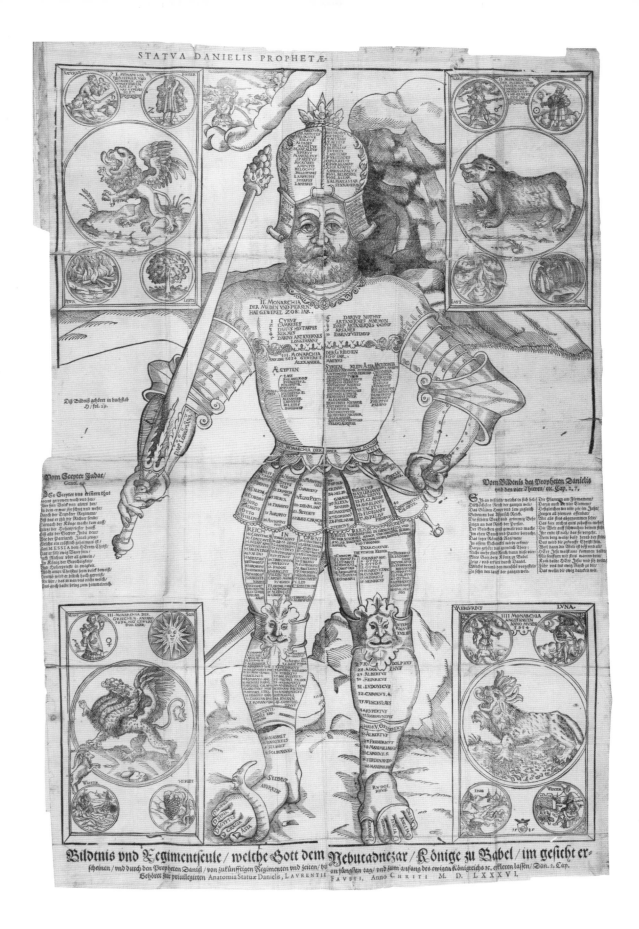

The stunning figures by the followers of the twelfth-century Calabrian abbot Joachim of Fiore weave biblical past, Christian present, and a transformed future into a single, complex vision. In the diagram at right, the triple exes on the tree trunk mark off generations of thirty years each. The diagram at left shows the three intersecting states or ages of world history.

which represented the statue and gave it the features of the ruler of Saxony, August I. The corners of the image showed the four beasts whose struggles, according to another part of Daniel's text, represented the succession of empires. Inscribed on the statue's helmet, armor, and legs are the names of the rulers of the four kingdoms. In the text that Faust keyed to the image, he followed out the anatomy metaphor in detail, making clear how every part and organ of the statue's body corresponded to a historical person or event:

> Anatomy means the dissection of the members of a human body, as practiced by the anatomists and physicians when they dissect a dead body and examine all its internal organs, vessels and joints. By doing so they become able to make better judgments and give better advice about illnesses. This little book is called an anatomy of the statue of Daniel, because the king of Babylon had a revelation in the form of a great statue of a human being of the four empires on earth. All the members of the image are examined and treated so that the reader may grasp the condition and situation of each one, and come to know it.[26]

The coordination of organs and rulers was precise: Darius of Persia, for example, was assigned to the lung because under his regime, the Jews could breathe freely for once; Heliogabalus, whose body was thrown in a sewer, was neatly matched with "the exit from the rear."

Faust energetically wielded a range of graphic devices to make his work comprehensive. Jean Bodin, an influential French theorist of universal history, argued in 1566 that Daniel's four empires could not be mapped onto the modern history of the world, since the real Roman Empire had long since ceased to exist, while the Turkish Empire—for which Daniel's vision offered no counterpart—was larger and more powerful than the Holy Roman Empire of the Habsburgs. Faust's image rebuts Bodin's thesis visually. He shows the statue's right leg transforming itself from the Eastern Roman Empire to the Turkish. At the same time this hybrid limb crushes an evil-looking, serpent-like figure that clearly stands for the Turkish sultan. At once illogical and powerful, the image assigns the Ottoman Empire a place in Daniel's design, but also shows that it is inferior to the Roman. Faust's decision to give the statue the face of his own sovereign was perhaps a suggestion that virtuous kings might hasten the coming of the rule of Christ on Earth. Faust used every imaginable resource, in other words, to help the reader both commit the past to memory and frame the proper state of mind in which to anticipate the future.

Part of Michael Eytzinger's complex reference system that condensed the major lineages of human history into tables and used letters and numbers to identify and find them, this was one of five folding charts from his 1579 *Pentaplus regnorum mundi* meant to epitomize human history.

[57]

The patriarch Seth, as an ancient Jewish story had it, created pillars of brick and stone on which he engraved the perfect knowledge granted by God to the earliest humans. In Eytzinger's version, they hold the key to the mysteries of time.

[58]

Václav Budovec z Budova, a Bohemian scholar of the early seventeenth century, seems to have been the first to represent history as a clock face in his *Circle of the Lunar and Solar Clock* from 1616.

Other writers and artists emulated Faust. At the Altdorf Academy, which served the youth of Nuremberg, images of Daniel's statue were used as textbooks. Their powerful visions of the past and future could imprint the details of world history on the minds of the young and give them a clear sense of the short, dramatic future that awaited humanity. Like contemporary readers of the Rapture Index found at RaptureReady.com, early modern students and princes learned to understand the past and foretell the future from these tables, pictures, and objects.

More than one ingenious chronologer found visual resources outside the realm of biblical texts and images and used them to portray the past. [*figs.* **54-55**] In the twelfth century, the Calabrian abbot Joachim of Fiore was inspired by prophetic visions. Possessed by the belief that numerical symmetries offered the key to understanding the Old Testament and the New, and fascinated by the prophecies and horrors of Revelation, Joachim came to see history as falling into three *etates* or "states"—an Old Testament state of God the Father, a New Testament state of God the Son, and a third state in which the Holy Spirit would have dominion over all. The details of his system and its specific derivation from scripture matter less for our purposes than the striking forms in which he envisioned time:

interlocking rings and great trees, marked off in thirty-year generations, which melded the uniform, year-by-year time of the world chronicles with the more irregular genealogical version of time. Joachim's images were oriented at least as much toward the future as the past. They convinced many readers that in the thirteenth century the "new men" of the mendicant orders, the Franciscans and Dominicans, would transform the church. Though Joachim himself would have disapproved of this understanding of his trees, this influence reveals both the radical character and the synoptic power of his maps of time.[27]

In the age of print, such visions—usually biblical in origin, but eclectic in form—multiplied. Michael Eytzinger—historian, cartographer, and author of *Zeitungen*, or news reports—decorated his history of the sixteenth-century religious wars in Flanders with a cyclical image that represented the world as a theater of purely human, material causes and effects. Figures arranged like the actors in a parade, moving in a circle, acted out his theory. Prosperity led to excessive greed, and that in turn to war, which caused devastation, which induced men to make peace, which in turn gave rise to prosperity.

In his *Pentaplus regnorum mundi* (A fivefold table of world history) of 1579, by contrast, Eytzinger emulated

DE INTELLECTV
PENTAPLI,
PARS PRIMA.

2. A · C · IE · S ORDINATA 24.
19. TER . RI bilis VTC A st Rorū M 18.
5. EL . ECTAVT . SOL 4.
15. PVLCHRA VTL. V . N . A 14

Gnomon postreman̄e se mundi vertit ad horam.
Mox CHRISTVS veniens aurea secla dabit.

Joachim, searching for historical symmetries and original, powerful images of them. [*fig.* **56**] He compressed all of the dynasties, ancient and modern, onto five fold-out tables that allowed the reader to easily look up the dates at which kings and officials had flourished and to correlate them with one another.

Behind the data on these sprawling charts lurked a deeper order. The key to Eytzinger's vision of history was a single illustration depicting two columns inscribed with letters. [*fig.* **57**] These in turn symbolized the two columns on which, according to the Jewish historian Josephus, Seth, the son of Adam, had engraved all knowledge before the Flood, and thus preserved it from destruction.[28] The letters were the initials of the Jewish Patriarchs. When properly rearranged, however, they spelled out the name of Eytzinger's own patron, the Holy Roman Emperor Maximilian II. In his view, this was clear evidence of the emperor's standing as the ruler of the last days, though when Eytzinger, and the world, outlived Maximilian, he cheerfully folded the next emperor, Rudolf II, into his story line.

Even more ingenious, and far more up-to-date in his choice of visual metaphors, was the Bohemian nobleman Václav Budovec z Budova, a citizen of that locus classicus of mystical beliefs, the Prague of the emperor Rudolf II.

[*fig.* **58**] He replaced the organic, if oddly symmetrical, trees of Joachim with a more modern, mechanical image. In 1616 Budovec published a chronology in which large clock faces represented the history of the Old and the New Testaments. The "lunar clock," which corresponded to the former, was low and dark, since humanity had had only indirect access to knowledge before the Incarnation. The "solar clock," by contrast, was bright, like the revelations that the Savior had brought with him. Its infallible hand stood near midnight—a vivid image for the approach of the end of time, and one strikingly echoed, centuries later, in the ticking-clock diagram that has graced the cover of the *Bulletin of the Atomic Scientists* from its first appearance as a magazine in the uneasy days immediately after the Second World War. In 1620, the Battle of White Mountain would show that Budovec had been right. His own world, if not the great one, was swept away, and he was taken prisoner and put to death.

Not all efforts to correlate events with a deeper, more cosmic order of causes depended on the Bible. [*fig.* **59**] In ancient Mesopotamia, astrologers had used their art to predict the fates of kingdoms before they applied it to individuals, and for centuries Greek, Roman, Persian, and Muslim astrologers followed their example. Everyone—or

SPECULUM MUNDI.

RES MEMORABILES.

[60–62]

Petrus Apianus created what amounted to an astronomical computer, with revolving paper devices for finding the positions of the planets. He also showed how to compute the dates of past eclipses—in this case the lunar eclipse that accompanied Alexander the Great's defeat of Darius at Gaugamela—and used diagrams to show how full they were. From Daniel on, many writers divided all of history after the Flood into four successive empires, Assyrian, Persian, Greek, and Roman: at Gaugamela, power passed from the second to the third. Apianus was the first of many scholars who attempted to re-date this battle, since it marked the moment at which history reached halftime.

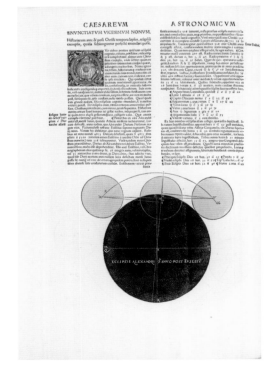

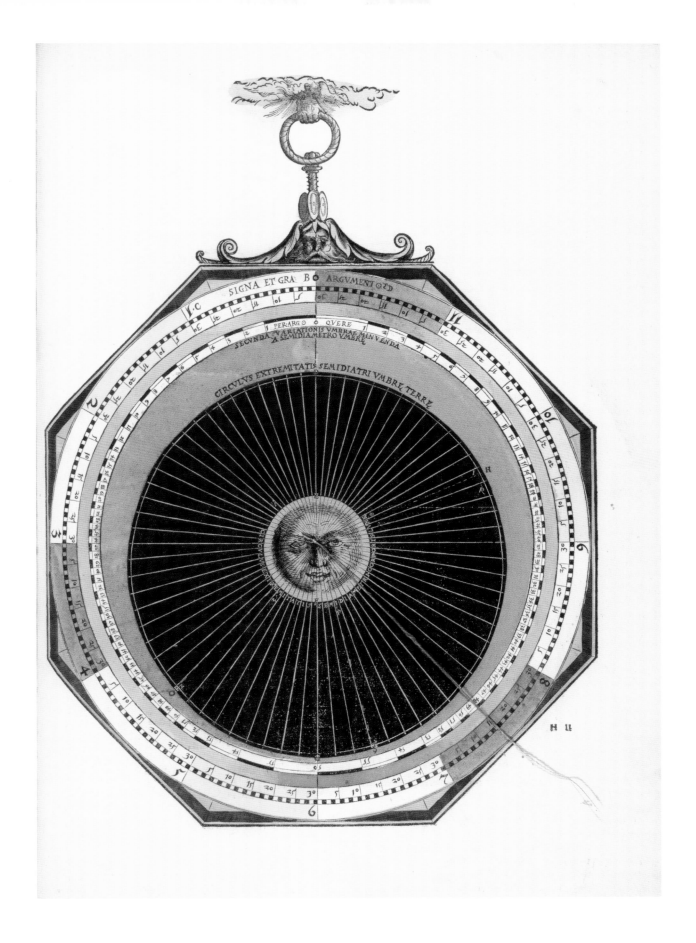

[63]

This table is part of the list of dated eclipses around which Gerardus Mercator built his 1569 *Chronology*—one of the first to rest on astronomical foundations.

[64–66]

This handsome chronology by Giovanni Maria Tolosani, which appeared in 1537, incorporated much astronomical information. He also laid out his material with great precision, making clear, for example, exactly how the founding of Rome fit into the Greek Olympiad system and the history of the Assyrian kings who destroyed Jerusalem. Unfortunately, the richer content made it hard to read: even the transition from Judaism to Christianity disappears behind the neatly printed columns of data.

at least everyone in the learned world—knew that Saturn and Jupiter, the two planets farthest from the earth, met every twenty years. Medieval and Renaissance astrologers and chronologers drew up tables that correlated such great events as the birth of Jesus and the rise of Charlemagne to these "great conjunctions."[29] Johann Heinrich Alsted, an influential professor at the Calvinist University of Herborn and the author of massive encyclopedias, used the conjunctions of Jupiter and Saturn to predict that the world would go through a time of troubles between 1603 and 1642. Many of Alsted's readers were English, and his predictions may well have helped to inspire them to overthrow King Charles I and set up a Puritan state in the 1640s and 1650s. The time chart was now powerful enough to help change a society.

From the 1530s on, new astronomical tools and skills came into play in chronology, and these also suggested new forms for the visual presentation of the past. [*figs.* **60–62**] Astronomers realized that they—rather than the historians who worked only with texts—could offer absolute dates for some major historical events. In 1540 Petrus Apianus, scholar, astronomer, and printer, published his *Astronomicum Caesareum*, a magnificent analog computer in book form that presented and explained working paper models for the

movements of the planets, the moon, and the sun. He knew that a lunar eclipse occurred before the Battle of Gaugamela (331 BCE), where Alexander the Great definitively defeated Darius, king of Persia—the battle that made Alexander the most powerful ruler in the Mediterranean world. In this case and others like it, he argued, astronomy could correct erroneous dates that had crept into the historical record. Apianus provided not only dates—which were, in fact, off by a few years—for the Gaugamela eclipse and a few others, but diagrams of them, which reconstructed them in schematic form, showing their extent of totality.

The use of astronomical data caused a revolution in the way chronologers worked. [*fig.* **63**] Since antiquity, all astronomers whose works were known in the West—Greeks and Chaldeans, Latins and Arabs—had based their tables and computations on the same fixed point, the moment when an otherwise unknown king, Nabonassar, took the throne of Babylon, February 26, 747 BCE (in this period, as cuneiform records have revealed in the nineteenth and twentieth centuries, systematic astronomical observation began in Mesopotamia). [*figs.* **64–66**] In 1537 Giovanni Maria Tolosani, a Dominican with a sense of humor (he pretended to be a Frenchman named Johannes Lucidus Samotheus, "John the Bright Boy," descended from Annius

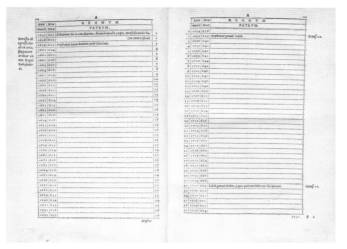

[67-68]

Like the Catholic Tolosani, the Protestant scholar Johann Funck, who brought out his *Chronologia* in 1545, used astronomical data to link biblical with classical history. Like Tolosani's work, his remained a year-by-year chronicle, and one that stuck even more closely than Tolosani's had to the model of Eusebius.

of Viterbo's imaginary Samothes, ancestor of the Gauls) introduced astronomical evidence into his neat, legible set of chronological tables. Tolosani argued that Nabonassar was another name for Salmanassar, a king of Assyria mentioned in the Bible. He recrafted Eusebius's *Chronicle* in his handsomely printed book, inserting information from medieval Christian calendar literature next to the lists of rulers.

The greater complexity of Tolosani's format made it less effective than Eusebius's at dramatizing the moments at which history really turned, such as the Crucifixion and the fall of Jerusalem. But Tolosani's connection between astronomy and the Bible made an impact nonetheless. Astronomers and chronologers realized that they could now fuse disparate chronologies far more precisely than Eusebius had, to the day and even to the hour from the era of Nabonassar. Three years after Apianus called for history to be corrected with astronomical data, Copernicus incorporated the identification of Nabonassar with Salmanassar into his epoch-making book, *De revolutionibus orbium coelestium* (On the revolutions of the heavenly spheres). We do not know if he read Tolosani, who hated and attacked his heliocentric theory, but we do know that Tolosani's and Copernicus's shared thesis put chronology on a new footing.

Other chronologers also followed Tolosani's lead. [*figs.* **67-68**] One of the first was as staunch a Protestant as Tolosani was a Catholic. Johann Funck, whose father-in-law Andreas Osiander wrote the preface for Copernicus's book, produced a Eusebian comparative chronicle that pivoted on the accession of Nabonassar, as Tolosani's did. Like Tolosani's, too, Funck's 1545 *Chronologia* remained traditional in many ways, with vast empty pages for the early centuries of world history, as well as a handsome list of invented Frankish kings, drawn from the historical work of Joannes Trithemius.

A generation later Gerardus Mercator—whose chief interests lay in the supremely visual field of cartography—drew up a new map of time. [*figs.* **69-71**] He built his work on an astronomical core: a list of dated eclipses that he provided for the reader in his introduction. And he showed greater graphic ingenuity than his rivals when it came to forging a timeline that actually reflected the new precision of astronomical dating. Most of the table of world history in Mercator's *Chronology* moved year by year, at a steady pace. But wherever he had more detailed information at his disposal—as he did for the biblical story of the Flood and for later events accompanied by dateable eclipses—he slowed the table down, almost cinematically. For periods

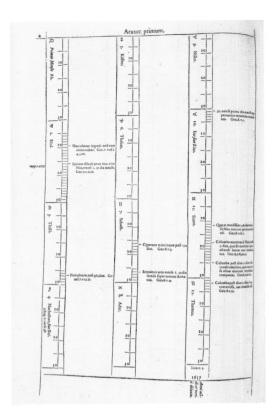

[69–70]

More inventive visually than his rivals in chronology, the great geographer Gerardus Mercator laid out a timeline, as many others had, that ran from the Creation to the present. Unlike his rivals, however, Mercator played with the pace at which time passed, slowing his timeline to follow the story of the Flood and record later battles. Wherever possible—as here, where he uses dateable eclipses to fix the chronology of Greek history—Mercator ties events not to a list of years but to a list of signs of the zodiac, which track the sun's passage through the sky day by day. Then, when he has no more precise astronomical information to offer, he provides a normal, year-by-year axis for history.

[71]

Ever inquisitive, ever willing to innovate, Mercator added a section to his chronicle in which he inquired whether ancient Egypt might have existed before the world was destroyed by water, as Plato's account seemed to suggest.

Astronomer Paulus Crusius's
extraordinarily severe triangular table,
rendered in ink in this version, reduces
history to intervals.

of a year or two, time moved month by month, as the sun passed through each sign of the zodiac, while Mercator added precise annotation of the dates and times of eclipses and other celestial phenomena. Mercator's book offered visual proof of the remarkable level of precision that historical chronology could now reach.

A decade later, another scholar-astronomer, Paulus Crusius, produced the most rigorous of all historical tables, a triangular set of dates for epochs and events meant to be read in two directions and confined to those points between which he could set down exact intervals of months and days. [*fig.* **72**] Here, for the first time, a chronologer drew up a literal time map, one that clearly traced all the highroads of dateable history across the vast, dark space of the past: a London Underground map of history itself, as starkly exact as it was schematic. Historical time—at least from the first millennium BCE onward—had now been captured. Crusius's austere, rigorous treatment of time found few readers—but one of them was Joseph Scaliger, who based his own chronology on Crusius's meticulous preparatory work. [*fig.* **73**] By 1606, when Scaliger included an ancient list of Babylonian and Persian kings in his great handbook, *Thesaurus temporum* (The treasury of chronology), most readers recognized at once that the strange names of Babylonian kings included in it could not be the fantasies of another Annius, strange though they sounded. The dates assigned to them fit the chronological structure Mercator, Crusius, and others had erected with the precision of a key in a fine Swiss lock. Yet Scaliger's book created another, harder problem for chronologers. He discovered and published a list of ancient Egyptian kings, recorded by a priest named Manetho. The earliest dynasty began, Scaliger thought, not only before the Flood, but before the Creation. Yet he insisted that this list, too, was genuine. Controversy soon flared, and astronomy could not restore consensus, since no observations old enough to be relevant to the earliest periods of history were known.

Most chronologers remained confident that they could trace the history of the world back to its beginnings, dating the Creation to the day and hour. [*figs.* **74–75**] It was in that spirit that the Anglican archbishop James Ussher began his chronology with the famous assertion that the Creation took place at nightfall preceding Sunday, October 23, 4004 BCE. His proposal differed only in detail from those made by dozens of others, especially Protestants, in the same period.[30] Yet no two of the chronologers agreed exactly, and uncertainty about the principles of chronology and the extent to which astronomy gave them certainty began to spread.

SEQVVNTVR DYNASTIÆ MAGNORVM ORIENTIS
IMPERIORVM APPENDICES.

DYNASTIA ASSYRIORVM, POSTQVAM AB ASSYRIIS
DEFECERVNT.

* * * * *

PHVL.
TEGLATH-PHALASAR.
IAREB.
SARGON.
SALMAN-AṢAR.
SENACHERIB.
AṢAR-HADDON.

DYNASTIA BABYLONIORVM, POSTQVAM ANNO
XX ARTYCÆ A MEDIS DEFECERVNT.

REGVM XX.

DYNASTIA SECVNDA PERSARVM POST CAEDEM
ARTABANI VLTIMI ARSACIDARVM.

REGVM XXVIII.

[73]

Joseph Scaliger was the first modern chronologer to publish ancient lists of rulers, such as the list of kings of Babylon and Persia that circulated with Ptolemy, shown here, and the Egyptian priest Manetho's lists of Egyptian dynasties. These documents, which Scaliger rightly took to be genuine, remain central to chronology to this day. Even before Scaliger found this material, he had ingeniously shown that Nabonassar was not the Assyrian king Salmanassar, as earlier chronologers had thought, but an independent ruler of Babylon.

[75]

After Ussher, marginal dating in an authorized Bible, London, 1701

	The Julian Period.	The year before Christ.
	I	

THE ANNALS
OF THE
OLD TESTAMENT,
From the beginning of the World.

IN the beginning God created Heaven and Earth, *Gen. 1. v. 1.* Which beginning of time, according to our Chronologie, fell upon the entrance of the night preceding the twenty third day of *Octob.* in the year of the Julian Calendar, 710.

Upon the first day therefore of the world, or *Octob.* 23, being our *Sunday,* God, together with the highest Heaven, created the Angels. Then having finished, as it were, the roofe of this building, he fell in hand with the foundation of this wonderfull Fabrick of the World, he fashioned this lowermost Globe, consisting of the Deep, and of the Earth; all the Quire of Angels singing together, and magnifying his name therefore, [*Job.* 38. *v.* 7.] And when the Earth was void and without forme, and darknesse covered the face of the Deepe, on the very middle of the first day, the light was created; which God severing from the darknesse, called the one day, and the other night.

On the second day [*October* 24 *being Monday*] the firmament being finished, which was called Heaven, a separation was made of the waters above, and the waters here beneath enclosing the earth.

Upon the third day [*Octob.* 25, *Tuesday*] these waters beneath running together into one place, the dry land appeared. This confluence of the waters, God made a Sea, sending out from thence the rivers, which were thither to return again [*Eccles.* 1. *verf.* 7.] and he caused the Earth to bud, and bring forth all kinds of herbs and plants, with seeds and fruits: But above all, he enriched the garden of Eden with plants; for among them grew the tree of Life, and the tree of Knowledge, of good and evil. [*Gen.* 2. *verf.* 8, 9.]

On the fourth day [*Octob.* 26. *which is our Wednesday*] the Sun, the Moon, and the rest of the Stars were created.

On the fifth day [*Octob.* 27. *Thursday*] Fish and flying Fowl were created, and endued with a blessing of encrease.

And upon the sixth day [*Octob.* 28. *which is our Friday*] the living creatures of the earth took their creation, as well going, as creeping creatures. And last of all, man was made and created after the image of God, which consisted principally in the divine knowledge of the minde, [*Colof.* 3. *verf.* 10.] and in the naturall and proper sanctity of his will, [*Ephef.* 4. *verf.* 24.] And he forth-with, when all living creatures, by the Divine Power, were brought before him, as a Lord appointed over them, gave them their names, by which they should be called. Among all which, when he found none to help him like to himself, left he should be destitute of a fit companion, God taking a rib out of his side, whiles he slept, fashioned it into a woman, and gave her to him for a wife, establishing withall, a law of marriage between them; then blessing them, he bade them wax and multiply, and gave them dominion over all living creatures, and for them all he provided a large proportion of food and sustenance to live upon. To conclude, sin being not yet entered upon the world, *God beheld all that he had made, and, behold, it was exceeding good. And so was the evening, and so was the morning of the sixth day,* [*Gen.* 1. *verf.* 31.]

Now upon the seventh day, [*Octob.* 29. *which is, with, us Saturday,*] when God had finished

B nished

| | | 4004. | 710. |

MOSES,	Year before the Common Year of CHRIST	
		4004
	Jul. Per.	0710
	Cyc. Sun	0010
	Dom. Letter	23
SIS.	Cyc. Moon	0007
	Indiction	0005
	Creation from Tifri	0001

...uit-tree yielding fruit after his ... whose seed *is* in it self, upon the ... : and it was so.

In *Annals of the Old Testament* from 1650, the erudite seventeenth-century archbishop James Ussher gave exact dates for the Creation and the rest of biblical and ancient history. By including dates in the margins according to the year of the world, the Julian period, and the year before Christ, he was practicing what had become the normal form of chronology. His work became famous—and his credulity notorious—because from the 1680s on printers equipped English Bibles with the timeline Ussher had established. Readers who had forgotten the traditions of chronology, or found them comic, failed to realize that Ussher had studied the past in much the same way as his contemporaries.

The Jesuit astronomer Giambattista Riccioli, who taught at Bologna for many years, compiled the *Almagestum novum* (New almagest) in 1651—a manual of ancient and modern astronomy so precise and technically insightful that Sir Isaac Newton used it as his standard reference book. [*fig.* **76**] In 1669 Riccioli also published a *Chronologia* of more than a thousand folio pages. Its title page shows how the makers of timelines understood their craft. At the edges of the image, Chronology and History appear, personified. Clio, the historians' muse, stands flat-footed on her pedestal, holding her trumpet in one hand and a dim taper in the other and looking a bit depressed. Chronology, by contrast, treads boldly on the bones of the mighty dead. The beam that shoots from her torch arches up and backward to reveal magnificent historical lilies, while busy little Jesuit bees buzz about in the intellectual service of the Farnese family, which supported their research.

Chronology's bodice has slipped, revealing her bosom. This is not the result of chance or even a quixotic effort to endow the driest of subjects with erotic appeal. Chronology's disordered dress identifies the sun and the moon—that is to say, astronomy, the science of their movements—as the natural source of her superior scholarly powers. It would be hard to imagine a stronger emblematic statement of the

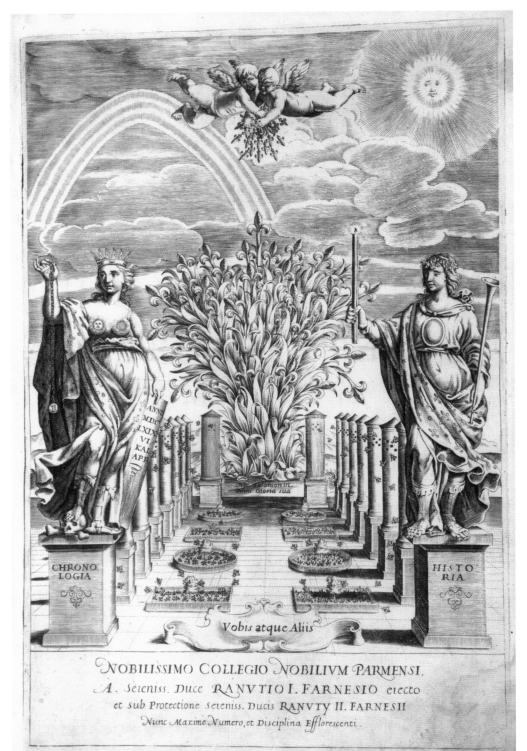

CHRONO
LOGIA

HISTO
RIA

Vobis atque Aliis

NOBILISSIMO COLLEGIO NOBILIVM PARMENSI,
A. Sereniss. Duce RANVTIO I. FARNESIO electo
et sub Protectione Sereniss. Ducis RANVTY II. FARNESII
Nunc Maxime Numero, et Disciplina Efflorescenti.

In this baroque image from
Giambattista Riccioli's 1669
Chronologia, Chronology rules,
dominating the pallid figure of Clio,
the muse of history.

esteem that chronology enjoyed in baroque Italy—except, perhaps, for the very scale of Riccioli's book, printed at a time when it had become distinctly hard to finance the publication of massive scholarly folios. Yet Riccioli admitted that he could not trace a single line of dates from Creation to the present. The biblical versions differed, and astronomy could not adjudicate between them. Riccioli's text did not keep the bold promise made by its frontispiece.

In fact, the foundations of chronology were beginning to show deep cracks. In 1655, a French Protestant named Isaac la Peyrère had thrown chronology and theology into a crisis by arguing, in a formal Latin treatise, that Genesis actually told two stories: that of the whole human race, and the shorter one of the Jews. He noted that the Chinese, the Egyptians, and others had civilizations long before the Jews. Moreover, he portrayed the Flood not as a universal catastrophe, but a local event. La Peyrère found himself under house arrest and forced to convert to Catholicism, and dozens of orthodox scholars, both Catholic and Protestant, competed to refute his work.[31] But only a couple of years later, another Jesuit, Martino Martini, brought Europeans the news that Chinese history really had begun before the Flood. Martini studied at Rome with Athanasius Kircher—who believed, tacitly following the Calvinist Scaliger, that Egypt existed before the Flood. When he arrived in China and read the kingdom's annals, he was not surprised to find that they too began too early to fit the chronology of Genesis. The Chinese, moreover, unlike the Europeans, had preserved eclipse observations that confirmed their ancient history. Certainty—and a full, coherent timeline—seemed more and more distant. Riccioli's magnificent visual boast about the power of Chronology and her torch was a desperate effort to shore up a structure that seemed to be collapsing.

Graphic Transitions

In retrospect, it seems obvious that the structures chronologers invented in the sixteenth century would fall apart in the seventeenth: there was simply no way to negotiate the differences among so many historical traditions, and astronomy could not adjudicate nearly as many disputed points as Apianus or Scaliger hoped. [*fig.* 1] At the time, however, most scholars remained optimistic, and continued to try to devise a single chronological equivalent to Ptolemaic and modern world maps. Though they found individual problems insoluble, their enterprise as a whole retained great energy and appeal, and innovation never ceased. Already in the sixteenth century, chronologers had begun experimenting with new tabular forms and applications. Some even tried to provide graphic expressions of chronological data: charts that not only listed information, but represented it in ways that made it easy to grasp. The Lutheran theologian Lorenz Codomann, for example, synchronized the lives of the biblical patriarchs in a tabular format similar to that used in the modern road atlas. His table, printed in 1596, lists the names of the patriarchs twice, once horizontally across the top of the page and once vertically in the left margin. By lining up names from two axes on the table, the reader could instantly find the age of one biblical figure at the birth or the death of another. Though its design is tabular, Codomann's table

edges in the direction of a more fully graphic form of representation, which makes the chronology of the patriarchs clearer than any single table could. Since he fills boxes only when he has information to put in them, the table functions as a kind of accidental bar chart: on it, columns of data are as long as the lives of the figures they represent. As such, they provide not only a tool for calculating specific ages and dates, but also a view of the entire, unbroken tradition by which historical knowledge was understood to have been passed down to Moses.

Similarly, the French chronologer Joannes Temporarius used graphics to deal with a problem that long bothered everyone who tried to draw the history of the world from the Bible. [*figs.* 2-3] According to Genesis, only Noah's family survived the Flood. Yet within a few generations, they and their descendants repopulated the world, so effectively that men tried to build "a city and a tower, whose top [may reach] unto heaven."[1] Was such explosive population growth even possible? Europeans whose own society still regularly suffered the blows of plague and famine found it hard to believe, but Temporarius found the account plausible. At the top of his diagram, a horizontal axis represents the first period of time after the Flood, divided into twenty-year intervals. To the left, a vertical axis lists the

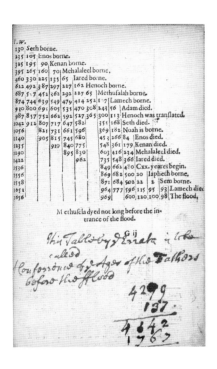

Lorenz Codomann, *Chronographia: A Description of time, from the beginning of the world, unto the yeare of our Lord, 137. Divided into six periodes. Wherein the several histories, both of the Old and the new Testament are briefly comprised, and placed in their due order of yeares*, London, 1596. This handsome and visually intuitive chart enables the reader to follow the lives of each of the biblical patriarchs, the dates of which are coordinated so that it is possible to immediately tell how old other biblical figures were when one of them was born or died. These facts had to be teased out of the account in Genesis, and were hard to glean from traditional, single-axis chronologies.

generations of Noah's descendants. By following the table both horizontally and vertically, the reader could watch the population as it grew, generation by generation. Similar questions had arisen about whether the Jews could have multiplied as quickly during their time in Egypt as the biblical account suggested, and Temporarius answered them with another visual display of demographic growth. Yet if Temporarius was experimenting with something like modern bar charts, he applied them only to countable individuals. He juxtaposed linear graphic forms with chronological information, but he did not graph time itself. Temporarius was a radical when it came to the substance of chronology. He dismissed the traditional story of Rome's founding by Romulus, and its traditional dating, as a mere myth, fashioned centuries after the events. But he found no way to give his most innovative ideas about historical time graphic form.[2] It took longer than might have been expected for chronologers to progress from creating tables that *contained* information, such as those of Eusebius, Codomann, or Mercator, to charts that *expressed* information graphically.

For all the problems that chronologers could not solve, their timelines invited eager and active reading. Chronography—a genre that sought, but could never obtain, encyclopedic fullness of coverage—fostered intensive

interaction between readers and their books. Many owners filled their printed chronologies with further information, turning them into palimpsests, hybrid books that were both printed and manuscript. One area in which this interaction proved especially lively was that of the actual calendar. For centuries, Christian scholars had struggled to master and improve the set of techniques known as the "computus." Using their fingers as calculators, they computed when during the year the moveable feasts of the church, such as Easter, would take place, and they could do so for many years in advance. The computus was always controversial. In the early Middle Ages, Christians in the British Isles and elsewhere fought bitterly over the date when Easter should fall. Since the value used for the length of the solar year was slightly too long, massive error had built up over time, and by the fifteenth century, the calendar had fallen into considerable disorder. Calendar reformers worried that the Jews, who knew when Passover should take place, mocked the Christians for celebrating their most important ritual on the wrong day.[3]

In the sixteenth century, the combination of the astronomers' newly precise approach to historical time and the Protestant Reformation transformed the calendar. [*fig.* **4**] Through the Middle Ages, the religious year had been a

In 1596 Joannes Temporarius, an
inventive chronologer, adopted the
new form of the bar chart in his *Proofs
of Chronology* to show how ancient
populations grew.

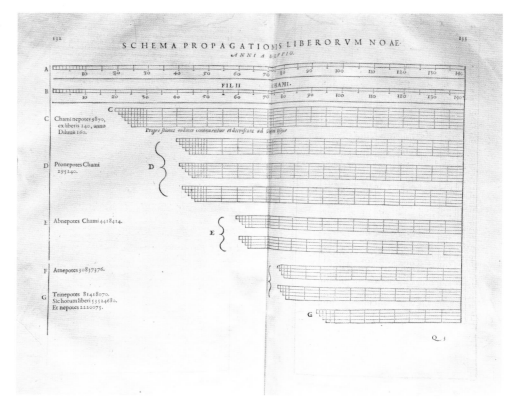

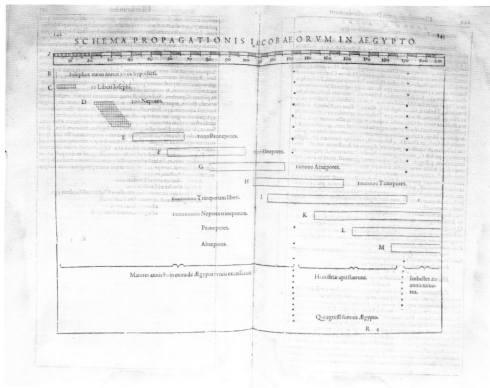

Johann Funck's historical calendar, based on an earlier one by Christian Massaeus, gave readers the calendar dates, in modern terms, on which the great events of Old and New Testament history took place.

VETERIS TESTA- MENTI.		Ro ma nor	Ma ce do nu	Ægi pty or	He bra or	NOVI TESTA- MENTI.
	A	26	30	5		
Esra ad profectionem se suosq. sparat 1.Esr.7. Noah tectum Arcæ deponit. Gene.8.	b	27	1	1		PHARMVTI VIII. NISAN I. Hebr. Ægyptiorum. orum.
	c	28	2	2		+ CHRISTVS prædicit discipulis passionem suam &c. Matth.20.
	d	29	3	3		
	e	30	4	4		
	f	31	5	5		
APRILIS 4 Ro- XANDICVS 5 manoru. Macedonu.	g	1	6	6		
	A	2	7	7		
	b	3	8	8		
	c	4	9	9		IESVS in Bethania cum Lazaro cœnat Ioan.12.
AGNVS ad futurum phase eligendus erat. IOSVA Iordanē transijt.Iof.4.	d	5	10	10		CHRISTVS Hierosolymam anna inuectus
	e	6	11	11		
ESRA a fluuio Ahaua mouet 1.Esr.8.	f	7	12	12		IESVS AD Sepulturam unctus, IVDAS quærit quomodo eum traderet.
	g	8	13	13		
AGNVS comeitus ad Vesperam.	A	9	14	14		DOMINVS hac nocte instituto Testamento captus est.
Prima pascha & exitus de Ægypto.	b	10	15	15		CHRISTVS PASSVS & sepultus.
SABBATVM SANCTVM.	c	11	16	16		CHRISTVS SABBATVM in sepulchro egit
PHARAO submersus diluculo. Exod.14.	d	12	17	17		CHRITVS diluculo resurrexit, ulctis Satana Morte & Inferno &c.
Manipulus primitiarum offerabatur, a quo ad festū Pentecostes dies numerabantur. Leui.23.	e	13	18	18		
	f	14	19	19		
	g	15	20	20		
	A	16	21	21		
	b	17	22	22		
	c	18	23	23		
	d	19	24	24		Thomas agnoscit Christum Dominum & DEVM Ioan.14.
	e	20	25	25		
	f	21	26	26		
	g	22	27	27		
	A	23	28	28		
	b	24	29	29		
	c	25	30	30		
	d	26	1	1		PACHONI IX. IAIR qui & ZIV II. Ægyptiorum. Hebreorum.
	e	27	2	2		

Two copies of the *Calendarium historicum* (Historical calendar) drawn up by the Wittenberg Hebraist Paul Eber show both Eber's signature lists of great events that had taken place between the Creation and the present, day by day through the year, and the layers of information that owners added. The first owner noted the birth of his son; the second, starting from a page that identified March 15 as the second day of Purim, the feast of Anna Perenna at Rome, the day of Julius Caesar's murder, and the birthday of Frederick of Saxony in 1504, added a note on the additional blank page facing this that Moses led the Jews out of Egypt and Attila the Hun died on this one very busy day.

cycle of feasts and fasts, deeply familiar and unchanging. The birthdays and martyrdoms of saints, real and imaginary, thronged the calendar and gave more than half of its days a sacred meaning. But the Protestant Reformers denounced most of the saints and all of their feasts, and set out to infuse the year with a sacred character of a new kind. In Protestant cities, scholars and astronomers cooperated with the Reformers, doing their best to establish on which days in the past the great dramas of the Old and New Testaments had actually taken place. They drew up calendars in which each day received its meaning from a new source.

In 1550, the Wittenberg Hebrew professor and preacher Paul Eber published a *Calendarium historicum* (Historical calendar). [*figs.* **5–8**] Eber eliminated the saints and instead noted the great events in Jewish, pagan, and Christian history that had taken place on each date in the year. Though ample blank space for notes remained on many pages, some owners had their calendars interleaved with blanks so that they could add still more information. The calendar, which had traditionally charted the current year, thus became a map of the past as well, one wrapped cyclically around the 365-day solar year rather than ordered as a line from Creation to Apocalypse.[4]

Standard Eusebian chronologies also attracted handwritten addenda of many kinds. [*figs.* **9–10**] The historian Glareanus took notes on passages in his chronology of Livy that needed correction. Some of these he dictated or showed to Gabriel Hummelberg, a student who worked with him in Freiburg at the end of the 1540s. Hummelberg's exhaustive—and exhausting—but legible notes give a rich sense of how Glareanus worked, collecting evidence from sources as soon as the press made them available, and using it to enhance new editions. And the British scholar Gabriel Harvey, who taught rhetoric and Greek at Cambridge, made his copy of Glareanus's work into a record of his conversations about chronology with the great jurist Jean Bodin, who advised him on which chronologies he could trust. The Renaissance's time maps look alien and formidably technical now. In their own day, though, they stimulated lively conversation among cutting-edge intellectuals.

By the seventeenth century, older visual conventions continued to find uses in many contexts. The Eusebian form had been in print so long that it had become intuitive and widespread, as had the tradition of updating it to keep up with contemporary events. Editors of ancient historical texts continued to equip their editions with Eusebian tables. Sometimes these appeared much farther afield, as in

[7–8]

Paul Zillinger, a late-sixteenth-century citizen of Regensburg, made his copy of Eber's *Calendarium historicum* (Historical calendar) into a grand historical workbook. In one long entry he recorded the details of the great procession that had taken place when the Holy Roman Emperor Rudolf II came to his city.

[9]

Heinrich Glareanus, annotated copy of his chronicle of Livy, Basel, 1540

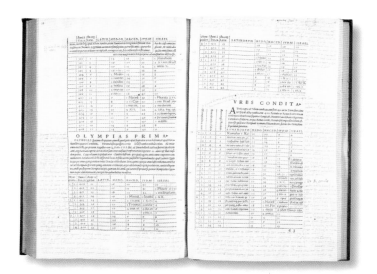

[10]

Gabriel Harvey, annotated copy of Glareanus's chronicle of Livy, handwritten notes added in the 1580s to book printed at Basel, 1555

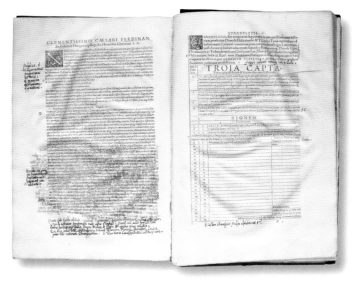

Ubbo Emmius, who taught history
and chronology at the Frisian
University of Groningen, carried out
unusual graphic experiments with
his timeline. He showed that history
could be represented in very few pages,
by setting the proper intervals—and
also that vertical timelines could be as
legible as they were handsome.

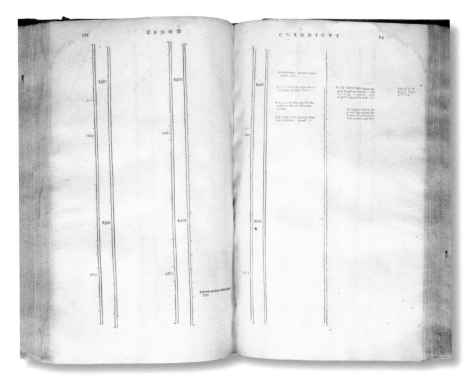

a 1687 English translation of Confucius, which deploys the Eusebian form, barely modified.

Experimentation often took place on the small scale, as when the Frisian chronologer Ubbo Emmius concluded his massive *Opus Chronologicum novum* (A new treatise on chronology) with tables of world history that moved at different paces. [*fig.* 11] In these otherwise conventional tables, the reader could examine the whole span of time, either compressed onto a few pages or laid out at length, on scales so simple—and, in their early years, so bare of historical content—that they have a strangely modernist elegance.

The most popular general chronology of the seventeenth century—the *Theatrum historicum* (Historical theater) of the Giessen scholar Christoph Helwig, first published in 1609—was announced as a "new system" that would enable readers to grasp the whole vast cosmos of universal history from Creation to the present, thanks to its lucid and legible divisions of time. [*figs.* 12–13] Hurling all his metaphors into one basket, Helwig promised his readers that his work would connect events like the links of a chain and serve as an Ariadne thread through the labyrinth of time. What he offered readers was, in effect, a Eusebian chronicle in parallel columns, richer than Eusebius's work in detail and visually distinctive because he divided the flow of time into equal periods—first fifty years, and then one hundred, at a time. For many readers in the sixteenth and early seventeenth centuries, time *looked like* a table—preferably one subdivided into squares by horizontal axes. And this was as true for the time of a single life as for a great age of history.

At the same time, though, antiquarians crafted another, more dynamic image of time. Collectors like the seventeenth-century Danish scholar and archaeologist Ole Worm systematically brought together in spaces called "Museums" or "Kunst und Wunder-Kammern" (Cabinets of Art and Wonder) thunder stones and crab shells, alligators and starfish, as well as beautiful works of craft, statues and automata that challenged onlookers to find the border between life and art, and the tools and weapons with which humans had extended their power over nature. Samuel Quiccheberg, who helped to create the Munich Kunstkammer and wrote the first treatise about these museums, made clear that his "theater" should include both real "miraculous and rare animals, such as rare birds, insects, fish, shells and the like" and, next to them, "sculpted animals of metal, plaster, clay, and any artificial material, so that art makes them all appear alive."[5] He also called for small-scale models of machines for drawing water, sawing wood, and pulling ships, so that "the examples of these little machines

[12]

Christoph Helwig took some unpopular positions in his *Theatrum historicum* (Historical theater); for example, he believed in the historical truth of Scaliger's Egyptian dynasty list. But it seems to have been the layout of his multicolumn chronology—the basic checkerboard first used by Eusebius more than a century before—that made readers buy edition after edition of his work. Helwig's book was so stuffed with information no previous chronologer had included—for example, the succession lists of rabbis—that particular details could be hard to find.

ANNI Christi vulg.	INDICTIO	IMPERATORES.	PAPÆ	CONCILIA	COMITIA Imperialia.	ACADEMIÆ.	JURECONsulti	VIRI Docti
F 1	4 9		10		1501. Norim.	1502. VViteber-gensis ab Electorè Friderico, die Lu-ca.	Felin. Sandaus. IASON obit 1519. Philippus Decius. Marius Salamo-nius.	I. Keisersberge Ang. POLIT R. Abra. Sa aut 5 Iechafia Fr. P. MIRE
2	5 10		11 (d.16.					Phil. Beroald
3	6 11		d. 8. Pius III.					RAPH. VOL
4	7 12		2 Iulius II.		1505. Coloni.			Conradus Ce
5	8 13		3 bellator.			1506. Franco-furtensis ad Via-drum, ab Electore Ioachimo I. die 17. Aprilis.		Phil. COMI
6	9 14		4		1507. Côstant.		Lancell. Politus.	Era. Roterode
7	10 15	Veneti Imperatori se oppo-nunt, iisq; bellum infertur ab	5				Iohan. Crottus.	
8	11 16	Imperatore & Pontifice &	6		1509. Worm.		N. Everhardus de Mittelburg.	
9	12 17	Gallia rege Chytr.	7		1510. August.			
1510	13 18		8					
G 1	14 19		9		1512. Trevirés. & Coloniens.		Rochus Curtius. Petrus Paulus Ca-risius Consentinus, Pictav. Ludov. Gomesius, Hispanus. Ferd. Loazsus, Hisp. I. Franc. de Ripa. Vir ZASIUS. Robert ni ARAN	Bapt. Mantu Paulus Sonci Baptista Egn Petrus Crini Cæl. Rh. dign Albertus Cra R. El. I. vita Marsilius Fic Albertus Du obit anno 15
2	15 10		10					
3	1 21	Veneti, Galli & Helvetii ab	mens. 3. d. 21.					
4	2 22	Imperatore victi, Chytr.	2 Leo X.					
5	3 13		3					
6	4 14		4					
7	5 15		5		1517. Mogunt. 1518. August.	1517. Complu-tensis à Franc. Ximenio Archie-piscopo Toletano.		
8	6	menses 4. dies 26.	6					
9	7 8		7					
1520		CARO-LUS V.						
H 1	9 9		mens. 8. d. 20.		1521. Worma-ciensia, ubi Lutherus.	Middana.	1 A, Salerni. Lancell. Gelliaul. Carolus Ruinus Regiensis. Hippol. de Marsilits.	Aldus Manna Christ. Longo I. REVCHI Polyd. Virgiliu Iohan. Firnel. P. Galatinus. Vlricut Hutt Santes Pagnin P. Æmilius, Iohannes Sch
2	10 4		1 Hadrian VI.					
3	11 5	eligitur 18. Iunii, Sleid.	mens. 8. d. 6.		1523. Norib.			
4	12 6		2 Clemens		1524. Norib.			
5	13 7	Prælio vincit & capit regem	3 VII.		1525. August.	1526. Marpur-gens. Schola, Stumpf. Funcc. Midd. anno se-quenti confirma-ta, Privilegia, tamen longè pòst demium adepta.		
6	14 8	Gallia, posteà dimittit, Sleid.	4		1526. Spirens.			
7	15 9		5 Roma à Ca-sarianu di-repta, Sleid.				Fran. Nicomitius. Lud. Gozadinus. I. OLDENDOR-PIVS.	
8	1 10		6					
9	2 11	Obsidio Vienna à Solyman-no Turca.	7		1530. Augusta-na, ubi Con-fessio.			
1530	3 12		8					
I 1	4 13		9				Fr. Curtius. G. BVDÆVS Pa-risiensis. I. Ant. Rubeus, Ti-cini obit 1544. M. Blancus. Æmil Ferretrus. And. ALCIATVS Mediolanensis obit 1548.	Marcell. Pala Iob. Aventinu Henric. Glar Otho Brunfel Euricius Cor Beatus Rhen EOBAN. H And. Vesalius Iob. Cuspinia
2	5 14		10		1532. Ratisb.			
3	6 15		mens. 10. d. 7		1534. 1535.			
4	7 16		1 Paulus III.		1538. Convê-tus particula-res Confluen-tia & Worma-tia & Smal-caldia.			
5	8 17		2					
6	9 18		3					
7	10 19		4					
8	11 20		5					
9	12 21		6					
Θ 1540	13 22		7					
K 1	14 23	Trajicit in Africam Carolus,	8		1541. Ratisb.	1544. Regio montana, ab Al-be, duce Borussia, 17. Aug.	Augustin. Beroius. ICtus Canonum. Ludovicus Catius, opposuit se Alciato. Fr. DVARENVS, obit 1559. Eguinarius Baro, obit 1558.	Paul. Iovius. I. Ludov. Vive Nicol. Copern Th. PARAC Hieron. Card Hieron. Fraca Franciscus Va P. Bembus. P. Fagius. Sebast. Münst
2	15 24	sed infeliciter.	9		1542. Spirens.			
3	1 25		10		1542. Norib.			
CCCC 4	2 26		11		1543. ibidem.			
5	3 27		12		1544 Spirens.	1548. Ienensis, 25. Ian.		
6	4 28	Bellum Smalcaldicum, Sleid.	13		1545. Worm.	1549. Dilling. & Ossunensis in Hisp. Adrian. Roman.		
7	5 29		14		1545. Ratisb.			
8	6 30		15		1548. Augu-stana.			
9	7 31		d. 28.					
1550	8 32		1 Iulius III.					

ME

					SCOTI, Dyn. 4.	GALLI, Dyn. 4.	HISPAN. Dyn. 4.	POLON. Dyn. 9.	DANI, Dyn. 9	ANGLI, Dyn. 9.	VNGARI, Dynast. 6.	BOHEMIÆ Dyn. 8.	SVECI.	LANDGRAV. Hassiæ.	Duc. Holsat.	Turc. Ottem.

ECCLESIÆ Doctores. — PONTIficii Doctores. — SACRAMENTArii. — Alii Fanatici Hæresiarchæ.

(partial):

MARTINUS LUTHERUS — côtra indulgen. anno 1517.

MELANTH. LAVRENTIVS — ...

I. Tezelius. C. Wimpina. Silv. Prierias. La. Hochstrat.

Eras. Roterod. Ambr. Catharinus. Th. Murnar. I. ECCIVS. Th. Cajetanus Cardinalis. Hier. Emser.

I. Cochlaus. I. Distenberg. Iod. Glichtovaus. Ioh. à Daventria. P. Canisius.

H. Alexand. Alb. Pighius & Eccius obit. Au. Steuchus. P. Malvenda. C. Contarenus. I. Hofmeister Iac. Latomus scribit.

Zuuinglius coepit anno 1519. Schl.

Anno 1521. And. Carolstad. Bodestein, prim vioxoðhaþegc annis 24 Zuuinglius & Oecolampadius scribunt.

Leo Iuda. Conr. Pellicanus.

Zuuinglius perit. & paulò pòst Oecolampadius obit.

Carolstadius obit.

Anabaptista. N. Storck. Th. Müzer.

Islebius Antinomus.

Caspar Schuuenckfeldt.

[13]

Christopher Helwig's chronology followed a Eusebian model—but also made clear just how many important people and institutions had taken shape in more recent times, and adapted the model to include them. By placing the list of Holy Roman emperors on the left and using large type for Charles V, the Renaissance emperor who tried to defend Christendom against the challenge of Martin Luther, he made clear that the empire mattered, but also that it did not, as traditional historiography claimed, dominate the world. Works like this were widely used for teaching history in schools and universities.

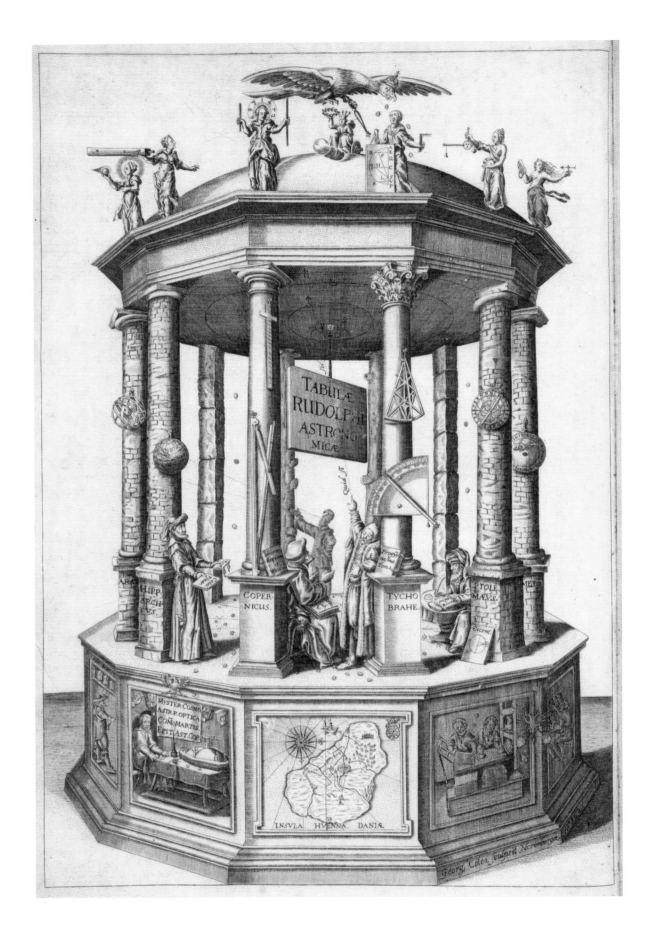

Johannes Kepler's imaginative
structure and the astronomers who
populate it state a powerful thesis
about knowledge and time. The oldest
astronomer—a Babylonian who
stands by a column that is almost
still a tree—is clearly portrayed as
part of the primitive world and doing
approximate work. As the astronomers
come closer to the present, their
pursuits become more sophisticated
and the columns next to them more
ornate and classical. Copernicus
and Tycho Brahe—and, of course,
Kepler—represent the culmination
of an architectural timeline for
astronomy.

or structures might make it possible to create other, larger ones in the proper way, and gradually to invent better ones."[6] Impresarios of wonder like Quiccheberg traced a history of nature itself, one that showed how human effort had transformed, and improved on, the original order of things. For all its crowded walls and heavily loaded shells, the house of wonders provided visitors with a distinctive, legible map of time and change.

The earliest chronologers—not only Eusebius, but his own older sources, whose works have been lost—devoted much of their space to dating and documenting human inventions. In the Renaissance, historians like Jean Bodin and the Greek scholar Louis Leroy made these stories vital landmarks in their time maps. These men argued, with Eurocentric brio, that gunpowder, the compass, and the printing press had all been invented in modern, not ancient, times. They did so in the teeth of the widely held belief that the ancients—especially the Egyptians and Babylonians—had reached a pinnacle of wisdom never to be attained again. They and their readers, who included Francis Bacon and other prophets of modernity, hoped to prove that European modernity, the last age of history, had a legitimacy of its own. The moderns, at least in some ways, had seen more and gained greater power over nature

and over other humans, than even the wisest of the ancient Greeks and Romans had.[7]

By early in the seventeenth century some scholars were beginning to enrich the technical study of chronology with thoughts like these. [*fig.* 14] The great astronomer Johannes Kepler, for example, wrote almost as much about chronology as he did about the planets. In the *Tabulae Rudolphinae* (Rudolphine tables) in which he summed up, in quantitative form, the results of his lifetime of work with planetary motion, he also included chronological tables which laid out the main results of his research on ancient calendars and dating systems. For the title page of this great book, Kepler designed an image that crystallized the historical development of astronomy.

For generations, most scholars had believed that God revealed true knowledge about everything in nature—including the planets and their movements—to Adam and the other patriarchs. Human sins, and the Flood they caused, had partly or wholly extinguished this perfect knowledge, but precise study of the texts that remained had recovered portions of it. Astronomers, however, knew that their science had developed relatively late. Even the legendary Egyptians and Babylonians did not seem to have recorded any eclipses or other dateable phenomena until

In his *Universal History*, Francesco
Bianchini used eclectic images both
as sources for and depictions of the
early stages of history. His title page
emphasized the ancient statues, reliefs,
and artifacts that he saw as more
reliable sources than the calendar
cycles beloved of earlier chronologers
(and one of which is depicted here,
almost buried under other sources of
evidence).

well into the first millennium BCE—the period after the
accession of Nabonassar in 747 BCE. And even Ptolemy, the
greatest Greek astronomer, offered less precise data and less
sophisticated models than the modern masters of the art:
Copernicus, Tycho Brahe, and Kepler.

The structure that Kepler drew up to serve as a symbol
of his achievement—a sort of elegant gazebo—amounted
to a virtual Kunst-und Wunderkammer. Though circular in
form, it told a linear story of change over time: of prog-
ress in astronomy. At the back of the cupola, a Babylonian
astronomer examines the heavens, sighting through his fin-
gers. He stands next to a column that represents a crude,
early stage in the development of architecture: a tree, its
limbs roughly cut off. On the sides, the greatest ancient
astronomers, Hipparchus and Ptolemy, who came later,
do more sophisticated work; Hipparchus displays tables,
while Ptolemy sits and writes. They are flanked by columns
that are smooth, but have no decoration or distinction:
simple cylinders of brick, more finished but no handsomer
than their predecessor's tree. In the foreground, finally,
Copernicus and Tycho debate the arcana of astronomy next
to the most vivid symbols architecture could provide for
elegance and sophistication: smooth stone columns, topped
respectively with Doric and Corinthian capitals.

In Kepler's image, the canonical orders of ancient
architecture point to a moral about the achievements of
the moderns. Taken together, the building and its inhabit-
ants told a single, coherent story: that of how human effort
had conquered, if not the sphere of the stars, at least the
mathematical rules that governed their movements. Kepler,
moreover, did not confine his thoughts about cultural
development to astronomy. He noted that the various arts
and sciences had often flourished together for brief, dis-
tinct periods, and suggested that it was not the influence of
the planets in conjunction, but that of new developments
in communication—above all printing—that caused these
bursts of creativity.[8]

Over the course of the seventeenth century, some
astronomers realized that their art, which had brought so
much precision to the history of the first millennium BCE,
could not help them much with earlier periods, since no
dateable eclipses or conjunctions accompanied the Flood
or the building of the Tower of Babel. The Bible itself,
moreover, came under threat, at least as the most authori-
tative source for world history. Chronologers worried that
the chronologies of Egypt, China, and the New World
extended beyond the period that the Bible allowed between
Creation and the coming of Jesus, and they had no good

[16–17]

Bianchini's illustrations lumped together people and objects from a variety of reliefs and vessels. He argued that these preserved true, if chronologically imprecise, records of human history. Unlike Schedel or Rolevinck, Bianchini saw the pictures that accompanied his timeline not as decorations or as aids to memory, but as crucial sources.

DECA PRIMA.
Immagine Prima.

1 e 6 Lucerna antica appreſſo l'auttore, ed altra lucerna pubbli-
cata da Pietro Santi Bartoli.
2 Frammento di baſſo rilievo appreſſo il Panvinio de Lud. Circ.
3 4 Medaglione appreſſo l'Angeloni in Commodo.
5 Figura di ſuperſtizione Americana appreſſo Teodoro de Bry.

CAPITOLO PRIMO.

Della Creazione del Chaos, e della ordinazione del Mondo.

I. *He la tradizione del Mondo da Dio creato, primie-
ramente confuſo nel Chaos, indi ordinato nelle
ſue parti, ſia ſtata comunicata anticamente an-
cora a' Gentili, ſi deduce dalla pompa, e da' ſa-
crifizj del Circo Romano. II. E dalle memorie più
antiche de gli ſcrittori profani d'Aſia, e di Gre-*
cia. III. Si pruova eſſere pervenuta alla notizia de gli abitatori dell'

I 2 *In-*

reasons to reject these accounts. In fact, the Jesuits in China had received papal permission to use the Greek Bible, since the Chinese found its long chronology more plausible and respectable than the shorter Hebrew one. Meanwhile, growing interest in the history of the earth began to suggest that it might have come into existence so long ago that the biblical account of Creation could no longer be taken literally.

No wonder, then, that another Jesuit, Francesco Bianchini, did his best to reconstruct chronology on a new foundation. An expert astronomer, Bianchini helped, as other Jesuits had, to equip churches with apertures and scales of measurement that turned them into vast instruments with which to observe the movement of the sun—according to Copernican principles.[9] The more he knew about astronomy, however, the more clearly he saw that it could not resolve the problems of chronology for the earliest centuries of history, as Apianus and Mercator, Scaliger and Ussher had hoped. There were simply not enough firm correlations between historical events and astronomical observations to rid history of its contradictions and inconsistencies: the discipline must, in the end, remain imprecise where the oldest dates were concerned. "The conjecture of an historian," Bianchini remarked, "is not the decree of a magistrate."[10] Accordingly, he turned at the end of the

seventeenth century to another sort of expertise—that of the antiquaries.

Lurking in archaeological sites in and around Rome, Bianchini became convinced that the modest material remains he and others found there, rather than astronomical data unconnected to historical or biblical events, afforded the best foundation on which to build a solid chronology. [*figs.* **15–17**] The ancients, he argued, "in trying to make the idea of history true and solid, decided to express it with figures that were designed more to prove a fact than to give aesthetic pleasure." And the results of their work—primary sources in the most elemental sense, since they came from the ancient world itself—offered solid knowledge of a sort that astronomical tables could not: "In the judgment of our age, the rituals, individuals, and periods that they represented in metals and on stone seem to be the most authoritative witnesses and illustrations of the events that they say took place."[11] True, the chronology that these relics yielded would lack the precise dates with which traditional timelines had been marked off. But it would also have aesthetic and informational qualities that they lacked.

Bianchini made his new history of the world a mosaic, pieced together from antiquities that he interpreted with great imaginative freedom. In Bianchini's hands, a bas-relief

Romae in Musaeo Domini Abbatis Ioannis Dominici Pennaechi

[18]

Here Bianchini uses art to transform a modest archaeological find—an ancient vessel that contained human and animal figures—into a spectacular virtual museum. He took it as a record of ancient religion, which, in turn, commemorated the Flood. The ancient priests had used a hydraulic device to float the little box, a memorial to the Ark, and thus to instill piety in the ordinary people as they carried out their yearly rituals in memory of the Flood.

Johann Heinrich Alsted included what amounted to a chronology of culture, a long list of inventors and their inventions, in his 1628 chronology. He ranged widely, noting the creation of everything from poetic genres to periods. But he did not try to correlate inventions to particular periods and societies, as Kepler did: this list is just a list.

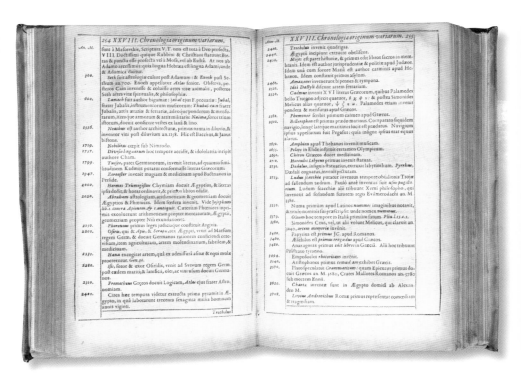

of an ancient circus turned into a "figured chronology" of ancient beliefs about the Creation. When the ancients paraded the images of their gods through the circus, in front of the chariots of the competitors, they showed that they remembered, at least, that God had created the universe. Another set of images provided a clue to the Egyptian origins of agriculture. The figure of Mercury or Thoth, holding a caduceus, showed that God had revealed the arts and crafts to humanity, and in Egypt first.

Most thrilling of all—and most dramatically represented—is a broken vase full of human and animal figurines and a little wooden box. [*fig.* **18**] This Bianchini took as a hydraulic device that the ancients had used in their yearly feasts on the anniversary of the Flood—which the Greeks, like the Jews, had never forgotten. The little figures some of which held their hands over their faces, clearly represented humans trying to escape the deluge. By making the box float inside the vessel, the priests would have amazed the people and inspired reverence—the only mood appropriate to a commemoration of the near-destruction of the human race.[12] For a century and more, the Kunst- und Wunderkammer had offered a visual history of culture. Now, Bianchini turned chronology itself into a virtual Kunst-und Wunderkammer. Only the study of objects, not

that of the stars, could provide a meaningful account of time—a science not of dates, but of cultural development.

The antiquaries were not the only chronologers of culture. [*figs.* **19-21**] Many scholars responded to the vast surge of printed information, ancient and modern, that threatened to overwhelm their libraries, bibliographies, and notebooks by devising a field of inquiry that they called "literary history."[13] Literary historians like Daniel Georg Morhof made a formal effort to collect the primary and secondary sources for every field of human activity and drew up manuals for less energetic readers, teaching the tricks needed to stay up-to-date—early modern counterparts to Pierre Bayard's *How to Talk About Books You Haven't Read*.[14] In German universities, professors gave courses on the subject, reading out lists of titles from great libraries and commenting on their authors and their contents.

By the middle of the seventeenth century, literary history took visual form. Johann Heinrich Alsted drew up a fascinating, though visually undistinguished, cultural chronology that gave dates for the first pyramid, the first obelisk, the first labyrinth, and the first musical instrument, among many other firsts. Peter Lambeck, a Protestant scholar from Hamburg who converted to Catholicism and became librarian of the Holy Roman Emperor's collections in

Peter Lambeck traced the development of a single cultural form, literature, from the beginning to the present. For early centuries he offered few entries, and many of them dealt with works attributed to Adam and other patriarchs, which Lambeck described as late forgeries. For later periods, by contrast, a closely printed cloud of entries revealed that certain places and times—late Repblican and Imperial Rome, for example—had been high points in human creativity.

Vienna, explored many of the great libraries of Europe. He knew how vast they were, and how hard it was for scholars to sort and assess their contents—especially for university teachers who tried to give accurate short accounts of them in their courses. Lambeck, accordingly, set out to compose the first formal history of literature. A traditionalist where form was concerned, he equipped his book with elaborate tables that showed the development of all kinds of writing, from Creation to the present.

Later, when eighteenth-century writers such as Voltaire and Joseph Priestley began to compose verbal and visual histories of culture, they drew together the threads that Bianchini, Lambeck, and others had spun: without them, they could not have woven their historical tapestries. The earlier enterprises had encountered serious problems. Lambeck, for example, had retained the uniform, columnar form of Eusebian chronology, while assigning more space to the last centuries of history before the Incarnation than to those that immediately followed the Creation. Yet he was too conservative to abridge the early centuries radically, and ended up devoting virtually blank columns to them. When dealing with later periods, by contrast, he crowded so many writers, from so many traditions, into a restricted space that it became impossible to follow the literary developments

he hoped to clarify. For all the power and prescience of Lambeck's effort to give culture itself a graphical expression, he ended up, like so many of his predecessors, tabulating information rather than giving it a form that made it easy to grasp.

In the second half of the seventeenth century, as the possibility of fixing the Creation, the Flood, and the founding of Rome to rigorously established dates seemed to recede, some chronologers transferred their ingenuity entirely to the pedagogical part of their enterprise: to fixing the traditional set of dates that schoolboys had to master to images so memorable that they would become unforgettable. Johannes Buno, who taught in Lüneburg, devoted himself for half a century to devising textbooks that wrapped the standard narrative of ancient and medieval history in striking images and coded cues to short texts. History, he explained, was a vast ocean, and the student needed the proper navigational equipment in order to avoid shipwreck. Ideally, he explained, the student would memorize "the whole order of time, as it were, reduced into a single body and set out in particular periods or segments, and whenever important events were mentioned, he would immediately be able to work out to which period or segment they belong."[15]

The seventeen centuries of the
Common Era are each represented
by a single figure such as a bear or
a vessel of oil. Johannes Buno used
unforgettable figures, curious details,
and riddles to forge a chronography
that could also serve as a virtual
memory theater, a handy system for
memorizing names and dates. In each
of his images, it is possible to follow
the numbers and tie the individuals
he portrays to their precise points in
historic time.

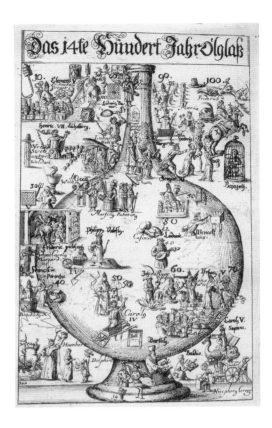

Buno had just the graphic tools for this job. [*figs.* **22–24**]
For the four millennia that stretched between the Creation,
in 4004 BCE, and the coming of Jesus, he found four com-
prehensive images: an eagle, a set of planks, a camel, and
a dragon. Each image summed up a vital aspect of the
millennium it stood for (the planks, for example, referred
to Noah's ark, and the camel to the camels on which the
Jews had made their Exodus from Egypt). But each also
provided a vivid, memorable background, on which Buno
placed images of important men and women. Each indi-
vidual carried out his proper task: Seth held his two pil-
lars, for example, while the astronomer Ptolemy scanned
the skies. And each one's identity was reinforced, for pur-
poses of memorization, by a rebus. Two eels devouring one
another, next to Alexander the Great, would remind the
student of his name ("Die Ahle essen 'nander" [the eels eat
each other]).[16]

Buno's work found some use, from the Pietist orphan-
age in Halle to the court at Heidelberg. But it also occa-
sioned sharp criticism. Gottfried Leibniz—who was not
only a great philosopher and scientist, but also a sophis-
ticated historian—disapproved of Buno's whole method.
Some of the images, he complained, were connected to
the people and events they represented "not only by some

natural relationship but in a completely arbitrary way."
What really bothered him, though, was that Buno had
departed from the linear structure that was essential for
a timeline: "in each image, different figures are not set out
in chronological order, but in order to gain space they are
thrown into confusion. Yet chronological order is the most
important goal of this kind of presentation, and it reveals
the connections between events."[17] The recent proliferation
of facts and visual models had not improved the timeline,
Leibniz thought, but undermined it. Some teachers agreed,
and told their students to memorize Buno's facts and ignore
the secondary elaborations.

By the end of the seventeenth century, the Neapolitan
jurist Giambattista Vico and other historians were already
at work disassembling structures like these while striving
to create a more meaningful chronography of culture. True,
Vico included a traditional Eusebian table of the years
from the Flood to the Second Punic War in his *Scienza
nuova* (New science), which reached its final form in the
edition of 1744. But he confessed that, "In fact these people
and events did not exist at the times and places commonly
assigned to them, or never existed at all."[18] The ancient
Egyptians and Persians, in his view, had known almost
nothing about early history. Their first ancestors had been

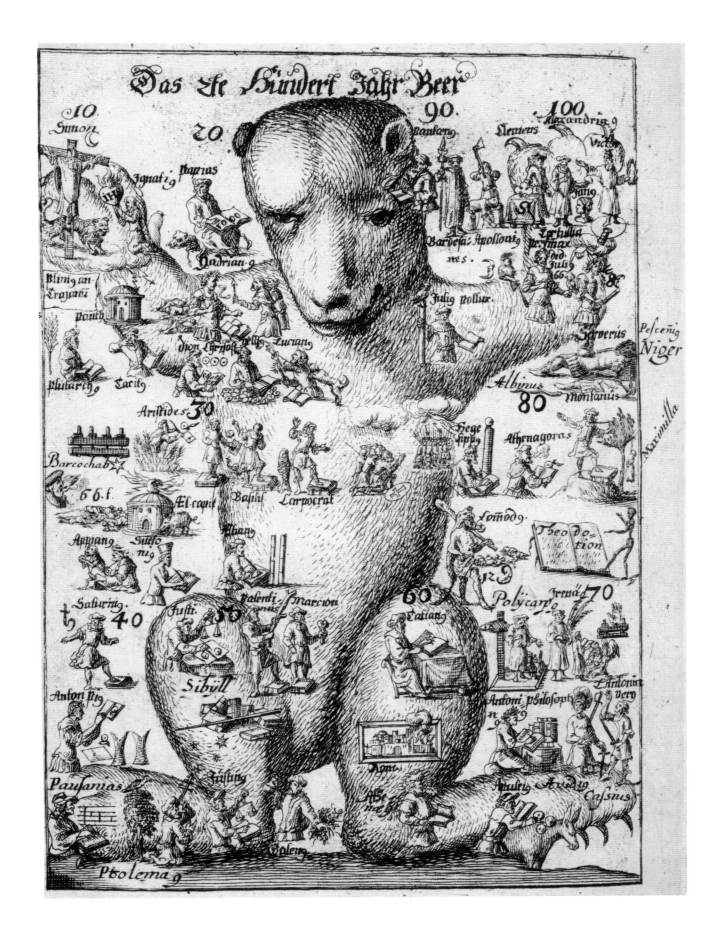

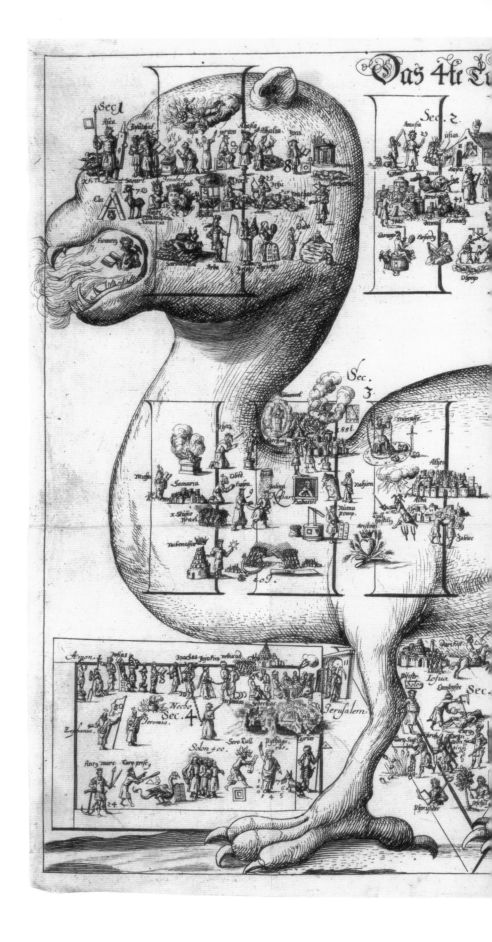

In Johannes Buno's 1672 universal history, each millennium before the birth of Christ is figured by a large allegorical image such as the dragon of the fourth millennium depicted here.

Descritta sopra le tre Epoche de' Tempi degli Egizj, che dicevano, tutto il Mondo innanzi essere scorso per tre Età, degli Dei, degli Eroi, e degli Huomini. A

Ebrei B.	Caldei C.	Sciti D.	Fenci E.	Egizj F.	Greci.	Romani.	Anni del Mondo.	Anni di Roma.
Diluvio Universale.							1656.	
	Zoroasto, o Re, o po de' Caldei. G.						1756.	
	Nebrod, o Confusione delle Lingue I.				Giapeto, dal quale provengono i Giganti H. Un stir quale Prometeo ruba il fuoco dal Sole.h.		1856.	
				Dinastie in Egitto	Deucalione. L.			
Chiamata d'Abramo.				Mercurio Trimegisto, il vecchio, ovvero Età degli Dei d'Egitto. M	Età dell'oro, ovvero Età degli Dei di Grecia. N.			
					Elleno figliuolo di Deucalione, nipote di Prometeo, prenipote di Giapeto, per bre suoi figliuoli spargi nel la Grecia tre Dialetti. O.		2082.	
					Campi Egizie mena dedua Colonie nell' Attica, delle quali poi Teseo compon Atene. P.		2448.	
Iddio da la legge scritta a Mosè.					Cadmo Fenice funda Tebe in Beozia, ed introdu ce in Grecia le lettere volgari. Q.	Saturno, ovvero Età degli Dei del Lazio. R.	2491.	
				Mercurio Trimegisto, il giovine, o Età degli Eroi d'Egitto. S.	Danao Egizio scaccia gl' Inachidi dal Regno d' Argo. T. Pelope Frigio regna nel Peloponneso.		2553.	
	Nino regna con gli Assiri.				Eraclidi sparsi per tutta Grecia, che vi fanno l'età degli Eroi. V. Coribo in Creta, Saturnio, ovvero Italia, ed in Asia, che vi fanno Regni di Sauriketi. V.	Aborigeni.	2682.	
							2533.	
			Sidone che Tiro e a fondar Cartagine.		Minosse Re di Creta, primo Legislatore delle Genti, e primo Console dell' Egeo.		2752.	
				Tiro celebre per la navigazione, e per le colonie.	Orfeo, con simboli l'Età de' Poeti Teologi. Y. Ercole, con cui è al colmo il Tempo Eroico di Grecia. Z.	Arcadi.		
			Samianente scrivo i liceno in lettere volgari. Xa.		Giasone dal principio alle guerre navali con quella di Ponto. Tanro Sendie Ageno, a vir ordina l' Areopago.	Ercole appo Evandro nel La zio, ovvero Età degli Eroi d' Italia.	2800.	
					Guerra Trojana. Bb.		2820.	
Ragna di Assiri.					Errori degli Eroi, ed in ispecie d'Ulisse, e di Enea.	Regno d' Alba.	2850.	
							2904.	
				Sesostride regna in Tebe. Cc.	Colonie Greche in Asia, in Sicilia, in Italia. Dd.		2949.	
					Licurgo da le leggi a' Lacedemoni.		3120.	
					Giuochi Olimpici, prima ordinati da Ercole, poi ristrenuti, e restituiti da Ifitile. Ee.		3223.	
						Fondazione di Roma. Ff.		
					Omero, il quale vivena in tempo, che non si sino anco ritrovate le lettere volgari, el quale non vidde l'Egitto. Gg.	Numa Ee.	3290.	35.
				Psammetico apre l'Egitto a i Greci di Jonia, e di Caria. Hh.	Esopo, Moral Filosofo Volgare. Ii.		3334.	
	Coro regna in Asiria co' Persiani.				Sette Savj di Grecia, de' quali uno, Solone ordina la libertà popolare d' Atene; l' altro, Talete Milesio da'l'incominciamento alla Filosofia con la fisica.Kk.		3406.	
					Pittagora, di cui sono due Livri, che nominano il verso fatti sopra in Roma. Ll.	Servio Tullio Re. Mm.	3468.	132.
					I Pisistratidi Tiranni cacciati da Atene.		3491.	
						I Tarquinj Tiranni cacciati da Roma.	3493.	245.
					Esrodiato, Ercole, Ippocrate. Oo.		3500.	
		Letteratura Zi di Scizia.Pp.			Guerra Peloponnesiaca. Tucidide, il qual scrive, che fin a' suo padre i Gre ci non sapperò nulla delle Antichità loro proprie, onde si darà a scrivere gli estat guerri. Qq.		3530.	
					Socrate da principio alla Filosofia Morale ragionale. Platone tiene nella Metafisica. Atene ridotta da tutte l'arte della più colta Umanità. Rr.			
					Senofonte, con portar l'armi greche nelle viscere della Persia, fa pronto a saper con qualche cer tezza le cose Persiane. Ss.	Legge delle XII. Tavole.	3573.	303.
						Legge Publilia. Tt.	3618.	416.
					Alessandro Magno rovinata nella Macedonia la Monarchia Persiana ed Aristotile, che vi si porta in persona, scorta di lei, fanno comune avenuti dette Tavole delle cose dell' Oriente.		3660.	
						Legge Petilia. Vv.	3661.	417.
						Guerra di Taranto, ove l' in avvennero a conoscer tra loro i Romani e i Greci; il qual put predisse essa sapere tra insieme circostanza. Yy.	3708.	490.
						Guerra Cartaginese inando, da cui comincia la Storia crita Romana a Livio; il qual pur predisse essa sapere tra insieme circostanza. Yy.	3841.	533.

Dom. Ant. Vaccaro I.

Sesone Sculp.

[25–26]

Giambattista Vico, the lonely, prescient Neapolitan scholar who hoped to make history into what he called a "new science," retained the traditional Eusebian chronological table in his study of world history. But in his text he dismissed his own table as a tissue of errors inherited from the pagans and argued that historians should use a philosophical, not a chronological, method to recreate the development of human society.

barbarians, terrified by the thunder and lightning that followed the Flood. Since they had no solid records of their early history, they simply invented them, making them as long as their vanity demanded. Traditional chronology, from Eusebius to the present, was built on these fragile foundations. Hence Vico's contempt for his own table as well as those of others.

For Vico, as the complex baroque image that served as the frontispiece of his work suggests, only philosophy could sort the past into its true periods, not by juggling the dates transmitted by ignorant pagans, but by interpreting their myths. [*figs.* **25–26**] The wand on top of the altar suggests that pagan religion began in divination; the torch shows that marriage was the first institution; and the plow reveals that "the fathers of the early pagan peoples were history's first strongmen."[19] The task of chronography, Vico argued, was not to identify the exact eras at which kings had supposedly ruled, but to distinguish the stages of development through which human culture had passed—and by doing so, to make clear, against the conventional wisdom, that the human race had become wiser as time passed. In his view, Homer was not the sophisticated, philosophical poet that allegorists had thought they read, but a primitive bard who had written for semibarbarous Greeks at the beginning of

their history. Chronographics had lost its original function as the key to the Bible, but had gained a new one as the record of culture and its transformations.

A New Chart of History

Chapter 4:

For all of the advances in chronological scholarship in the early modern period, the graphic ambitions of the chronologers proved hard to fulfill. The textbooks said over and over again that chronology and geography were the two eyes of history. But if this were the case, the early modern history student was liable to end up with serious problems of depth perception. During the fifteenth and sixteenth centuries, geographical maps became more sophisticated and precise, as cartographers abandoned the venerable and durable form of the Ptolemaic map for new conventions and added vast amounts of previously unknown information.

Like cartography, the study of chronology changed rapidly in this period. Early modern chronologers employed new techniques from fields as disparate as astronomy and numismatics and labored tirelessly to incorporate into their schemes new information drawn from all over the world. But, until the eighteenth century, the field of chronology did not undergo a *visual* revolution comparable to the one that took place in geography. The contrast was so striking that, as late as 1753, French physician and amateur chronologer Jacques Barbeu-Dubourg could still write,

> Geography is a pleasant and gratifying study. It places before
> us an image of the world entire, which we may traverse quickly

and return to with pleasure. In it, the world is familiar: we see the world's peoples; we measure distances at a glance of an eye or with a compass in hand; we trace the contours of the map so deeply in our imagination that they can never be fully erased. The same cannot be said for chronology, a field so dry, difficult, and thankless that it offers nothing more to the spirit than a multitude of ugly dates that overwhelm and frustrate the memory and are then easily forgotten.[1]

This from a man with a passion for historical dates.

Even before the coming of the printing press, chronology was a book-heavy field, dependent on the collection and organization of many precise and discrete pieces of information. Print technology facilitated the storage, reproduction, and dissemination of information in many forms, but it was particularly well suited to the needs of chronology, where exact reproduction was a necessity, the accumulation of data was paramount, and big, overstuffed reference books were in high demand. In the fifteenth and sixteenth centuries, new dating techniques led to significant advances in chronology—Apianus, for example, sought to establish firm chronological footholds by correlating data from astronomy with received historical accounts—but many of the most striking advances of the period relied

on innovations in information organization. And, in the following two centuries, the impact of such innovations intensified. In contrast to the type-dominated chronology books of the fifteenth and sixteenth centuries, seventeenth-century chronologies relied heavily on fine engraving, which enabled greater and greater feats of data compression, a more fluid mixture of image and text, and nearly unlimited variations in script, layout, and proportion. As a result, during the second half of the seventeenth century, the precedent of Jean Boulaese, who attempted to condense much of Eusebius into a single chart, was widely pursued.

Among the most influential of the synoptic works of the later seventeenth century were the *Tables historiques, chronologiques, & généalogiques* (Historical, chronological, and genealogical tables) published in the 1670s in two volumes by the French protestant lawyer Jean Rou.[2] [*fig.* 1] The work comprised a series of engraved tables that condensed huge amounts of chronological and genealogical information on several oversized pages. Influential as they were to become, Rou's charts were not immediately imitated in France. His first volume, on ancient history, was a great success, but his second volume on modern history, including the period of the Reformation, proved so controversial that it was banned, and Rou was forced to take refuge in the Netherlands.[3]

Though it would be decades before Rou's approach was attempted again in France, in England, it was taken up almost immediately in *A View of Universal History* by Francis Tallents, a nonconforming minister and teacher in the provincial town of Shrewsbury in the West Midlands near the border of Wales. Through Tallents's book, Rou's format passed into wider use, especially in the English dissenting academies, institutions established from the end of the seventeenth century to serve students excluded from Oxford and Cambridge on religious grounds. (And it was in these very academies that Joseph Priestley, the famous scientist and theologian who would revolutionize the field of chronography in the 1760s, first encountered them.)[4]

Eventually, in 1729, the abbé Nicolas Lenglet du Fresnoy, author of numerous pedagogical treatises—including the popular *Méthode pour étudier l'histoire* (Method for studying history)—published a similar work in France, the *Tables chronologiques de l'histoire universelle* (Chronological tables of world history).[5] To Lenglet du Fresnoy, the need to push the boundaries of synoptic representation seemed urgent. By the early eighteenth century, the field of published historiography was huge and rapidly growing: he estimated that it had already surpassed 30,000 volumes. Calculating on the basis of his own prodigious

Détail. Historiq; Genealogiq; et Chronologiq; de tout ce qu

ANS			
du Monde	avant I-C	de la P. Iul.	
1	4053	661	HIST.re en particulier
			Creation du Monde, d'ADAM et sa feme EVE I.re Etat de lad' histoire sc. souz les Patriarches N. 37. D. 2543 et I.re AGE du M.de D. 1656 —
2	4052	662	CAIN laboureur 1.er né d'Adam mort en 701
3	4051	663	Henoch autre que l'enleve du Ciel ABEL 2.e fils d'Adam et pasteur tué en 130 par son fr. Cain
131	3923	791	Irad
236	3818	896	Maviael
326	3728	986	Mathusael
396	3658	1056	Lamec qui eut
			d'Ada et de Sella ses deux femmes
461	3593	1121	Iabel et Iubal. Tubalcain et Noëma sa sœur
623	3431	1283	
688	3366	1348	Invente des tentes Invente de la musiq. Invente des arts de fer
875	3179	1535	
987	3057	1647	Henoc agé de 365 ans est enlevé de Dieu en un lieu inconnu aux hommes, a cause de sa pieté
1057	2997	1717	Noé étant agé de 500 ans reçoit de Dieu l'ordre de bastir l'arche dez 100 ans avant le Deluge
1557	2497	2217	
1559	2495	2219	Noé agé de 600 ans entre dans l'arche avec les siens et alors comença le DELUGE ce qui fait le II.Age du Monde de 382 ans
1656	2398	2316	Sortie de Noé hors de l'arche apres y avoir demeuré en tout 375 iours
1657	2397	2317	Sem Cham et Iaphet commencent a cultiver la Terre
1658	2396	2318	
1659	2395	2319	Noé plante la vigne et etant pris de vin est mocqué de son fils Cham qui pour cela est maudit de luy en la personne de son fils Chanaan participant
1671	2383	2331	de son crime
1694	2360	2354	
1724	2330	2384	
1754	2300	2414	
1788	2266	2448	Partage de la Terre entre les enfans de Noé, par lequel IAPHET eut pour sa part l'Asie occidentale depuis les Monts Taurus IECTAN dont les 13 fils furent les ppaux conduct
			et Aman et toute l'Europe ; CHAM la Syrie, l'Arabie, et toute l'Afrique, et SEM toute l'Asie orientale des Colonies envoyes par le Monde
1818	2236	2478	Elmodad, Saleph, Azarmot, Iare Aduram, Usal, Decla, Ebal Abimaël, Saba, Ophir Hevila Ioba
1850	2204	2510	
1854	2200	2514	Construction de la Tour de Babel, dans la campagne de Sennaar
1873	2176	2533	Confusion des Langues en 72 sortes, l'Hebraiq. demeurant a la posterité d'Heber. Ruine de la Tour de Babel. et ÆRE des Cháldeens ou de Babilone
1879	2175	2539	Comencem.t de la I.re Monarchie du Monde ass. des Assyriens souz Nembrot arriere fils de Noé
1909	2145	2569	
			III AGE du Monde de 505 ans 1979 ARAM 2001 NACHO
2039	2015	1699	Naissance d'Abraham en la ville d'Ur en Chaldée celebre par les Mathematiciens qui y demeuroient 2048 LOT melcha
			2049 Sara
2108	1946	2768	Abraham agé de 70 ans sort d'Ur ville de sa Nais.ce par l'ordre de Dieu pour aller demeurer en Carran ville de Mesopotamie
2114	1940	2774	Abraham par l'ordre de Dieu, sort de Carran se separant de son frere Nachor, et va demeurer en la Terre de Chanaan avec sa
2124	1930	2784	femme Sara et son neveu Lot, ou Dieu luy promet de donner cette terre a sa posterité, et duy comencent les 430 ans escoulez
2130	1916	2798	depuis cette promesse jusqu'au don de la Loy souz Moyze en la Montagne de Sinai
			Septieme apparition de Dieu à Abraham avec les 2 Anges, prediction de la ruine de SODOME, effet d'icelle, Changem.t de
2139	1915	2799	la femme de Lot en statue de Sel. Inceste de ses deux filles avec luy et institution de la Circoncision
2144	1910	2804	Fuite d'Agar et d'Ismaël agé de 20 ans, et sa soif au desert où il est asisté d'un Ange
2159	1895	2819	
2163	1891	2823	Commandem.t du sacrifice d'Isaac à Abraham agé de 125 ans lequel est empesché par l'Ange sur la Montagne de Maria
2179	1875	2839	Mariage d'Isaac agé de 40 ans avec Rebecca fille de Batuel son cousin germain
2197	1857	2857	
			LIA et RACHEL toutes 2 femmes de Iacob
2276	1778	2936	Iacob ayant extorqué a son frere la Benediction Patern.le s'enfuit vers son Oncle Laban, en Mesopot.ie et voit en chem'l'échelle de Dieu
2283	1771	2943	Iacob epouse ses 2 Cousines Germaines Lia et Rachel 5 ans apres la mort de sa mere Rebeca desquelles il a 8 enfans et
			4 de leurs deux servantes Bala et Zelpha, outre une fille nommée Dina violee depuis par Sichem
			de Lia de Lia de Lia
			2283 RUBEN 1 2284 SIMEON 2 2284 LEVI 3
2296	1758	2956	Iacob s'enfuit de la maison de son Oncle et Beaupere Laban, et luite toute une nuict avec l'Ange
2306	1748	2966	Ioseph ayant donné de l'envie à ses freres est vendu par eux aux Madianites qui le vont vendre en Egypte à Putiphar à l'age de 17 ans
2316	1738	2976	Ioseph est sollicité par la feme de Putiph. puis emprisonné, et ayant expliqué les songes tant des autres prisonniers que du Roy, est delivré au bout de 3 ans CAATH
2328	1726	2988	Icy autour, sont les 7 années de famine predites auparauant dans la prison pour Ioseph
2329	1725	2989	Voyage de Iacob en Egypte avec toute sa famille, c'est la I.re année des 215 de la demeure des Isr. en Egypte iusqu'à leur delivrance lors de l'Exode
2330	1724	2990	Naiss.ce de Iob arriere fils d'Esaü, S.t homme celebre par sa patience, ayant souffert 7 ans durant les derniers maux
2333	1721	2993	les 7 ans de famine predits par Ioseph finissent cette année que ledit Ioseph nourrit gratuitem.t tout le peuple des restes du bled qu'il avoit fait serrer
			2386 AMRAM
2399	1655	3059	Les Tentations de Iob agé de 70 ans
			I.re SERVITVDE ass. en EGIPTE
2451	1603	3111	Commencem.t de la servitude du P. d'Isra' en Egypte souz Pharao Amenophis II. c'est la I.re des 4 sortes de servitude
2464	1590	3124	Moyze 3 moys apres sa naiss.ce est exposé sur le Nil et sauvé par l'ordre de Thermutis fille du Roy, puis mis en nourrice chez sa ppre mere 246. AARON MOYS
2491	1563	3151	Naiss.ce de Iosué
2503	1551	3163	Fuite de Moyze hors d'Egypte en la terre de Madian, où il epouse Sephora fille de Iethro Sacrificateur et Prince du Pays
2543	1511	3203	Moyze gardant les Troupeaux de son Beaupere sur le M. Sinai, reçoit de Dieu ordre de retourner en Eg. demander la liberté du P. à Pharao qui l'ayant refusé arriuerent les

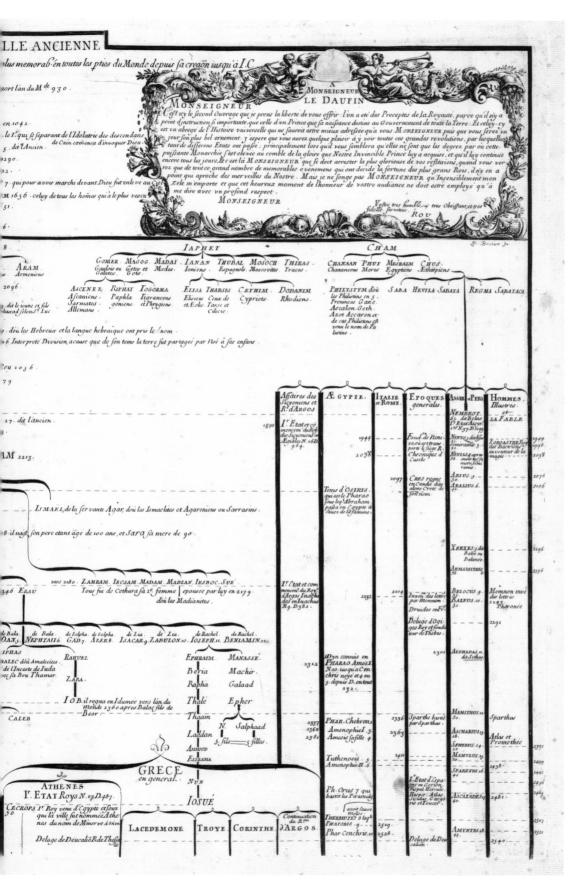

In 1672 the first volume of Jean Rou's elegantly engraved *Tables historiques, chronologiques, & généalogiques* on ancient history was received with acclaim in Paris, but after his modern history tables appeared in 1675, his works were banned for their perceived Protestant content. In 1682 the philosopher Pierre Bayle lamented that Rou's tables had become almost impossible to find.

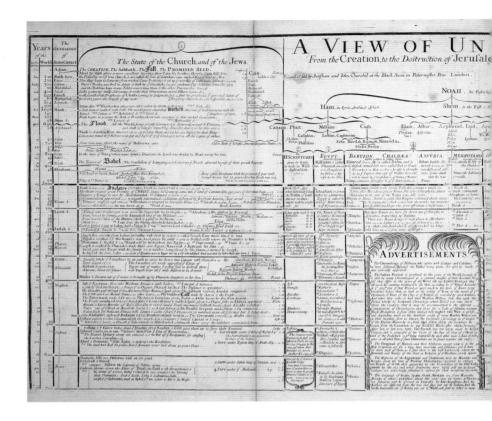

speed and endurance in reading—he sometimes read for fourteen hours a day—Lenglet du Fresnoy estimated that a diligent student could not hope to read more than 1,800 works of history without making unacceptable sacrifices in memory and comprehension. And, to assure good value for the intellectual labor, he recommended reading no more than 1,200 such works in a lifetime, a number which might allow a person to think "a little about what he reads."[6] Lenglet du Fresnoy was among the greatest eighteenth-century promoters of the study of chronology, but in his work, we can already detect its declining status. Even as he emphasized the importance of chronology, Lenglet du Frensnoy lamented that it was so little valued in relation to the prestigious field of history.[7]

During the late seventeenth century some chronographies grew; others shrank. [*figs.* **2–4**] Fine engraving techniques made tiny fonts practical, and by the 1680s the French writer Guillaume Marcel was publishing political and ecclesiastical chronologies in pocket size. Marcel's model was copied across Europe. In England, it was adopted by William Parsons, a former officer in the invading army of the Prince of Orange now an entrepreneur who saw a potential money-maker in this clever, portable object. The study of history, he reasoned, was popular enough and the

subject matter messy enough that many people might like to have a small chronological cheat sheet to use while they read. Heavy tomes on chronology were all well and good, but what use were they to the regular reader?

Parsons's chronography was finely tuned to the contemporary uses of books. [*figs.* **5–7**] For his first edition of 1689, he commissioned forty-three plates from the engraver John Sturt, simplified Marcel's complex layout and symbolic scheme, and reduced its size even further. As Parsons hoped, his new format was a commercial success, and many editions followed, selling 4,000 copies in about a decade.[8] Though Parsons prized miniaturization, he noticed that in some ways the tiny first edition sacrificed too much to considerations of size. The paper was too thin to write on easily, and there was precious little space in which to add annotations. He chose thicker, higher quality paper for his second edition and printed on only one side of each page, leaving the reverse free for notation.

The importance of new printing and engraving techniques in the chronographies of the later seventeenth century is evident too in lavish productions such as the charts from the *Lumen historiae sacrae* (Illuminations of sacred history) by Danish antiquarian Jens Bircherod, which blend figurative and allegorical elements with mountains of data.[9]

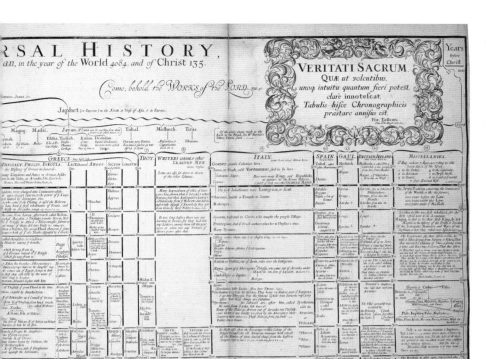

In his 1685 *A View of Universal History*, the nonconforming English minister and teacher Francis Tallents took up the same visual vocabulary used by Jean Rou a decade earlier. Tallents's tables were somewhat smaller, but, like Rou's, they performed an impressive feat of data compression. In these tables, dates are not regularly spaced. During the early ages of the world, especially, historical time appears to expand and contract according to the rhythms of generations and of important events.

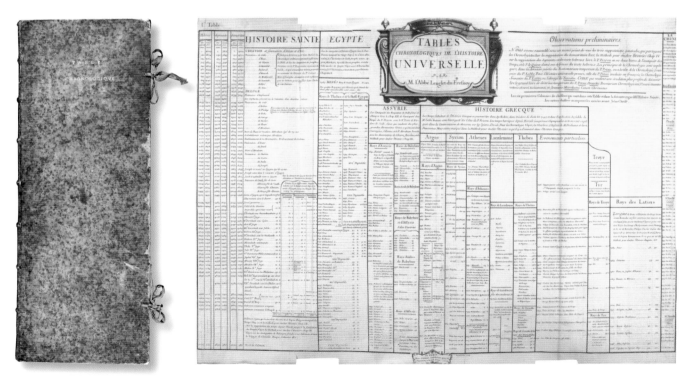

Nicolas Lenglet du Fresnoy, cover and interior of *Tables chronologiques de l'histoire universelle*, Paris, 1729

William Parsons, *Chronological tables of Europe, from the Nativity of our Saviour to the Year 1703: Engraven on 46 copper-plates, and contriv'd in a small compass for the pocket: Being of great use for the reading of history, and a ready help to discourse*, London, 1707. Parsons's chart book included a fold-out key inside the front cover so that users could easily understand the compressed notations on interior pages, as here, on the page for the sixteenth century.

William Parsons's pocket-sized *Chronological tables* (1707) sitting atop Johann Georg Hagelgans's huge *Atlas historicus.* (1718)

The *Lumen historiae sacrae veteris &
novi testamenti per tabulas chronologicas*
from 1687 by the Danish antiquarian
Jens Bircherod begins with a set of
several chronological tables, each
organized differently. Though smaller
than the charts of Rou and Tallents,
Bircherod's are finely engraved,
combining large amounts of data and
pictorial and decorative elements.

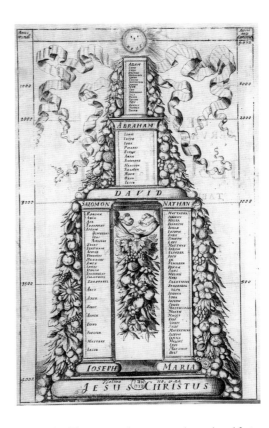

[*figs.* **8–9**] In one chart, Bircherod figures the genealogy of
Jesus as an inscription upon a neoclassical monument fes-
tooned with ribbons, fruit, and flowers. In another, the edi-
fice of the Church forms a column in a Eusebian table. In a
third, a table is interlaced with pictorial representations of
the Creation. The chronological scales of Bircherod's tables
vary, but each is sharply drawn, with a fine sense of both aes-
thetics and the practical demands of information design.

Even as chronographies became more visually precise
and delicate, they continued to attract the bent nibs of their
readers. [*fig.* **10**] A notable instance of manuscript anno-
tation occurs in the Princeton University copy of *Discus
chronologicus* (Chronological disc) created by the prolific
German engraver Christoph Weigel around 1723. As its
name implies, the *Discus* has the form of a circle. At heart,
however, it is a Eusebian table, with columns for dates and
rows for nations—only the columns here are radii, and the
rows are concentric bands. The circular structure created
challenges for annotators. In the classic Eusebian table,
there is usually ample space for writing, as well as room
for interleaving and additions at the end. But the closed
circular form created by Weigel left little room for hand-
writing. As a result, the owner of this chart squeezed his
or her notes on contemporary events into whatever blank

spaces were available. The notes begin, as they should, in
the slim wedge designated for the eighteenth century, then
creep over into the chronologically distant but graphically
continuous first century CE.

Other eighteenth-century scholars and engravers fol-
lowed even more adventurous graphic paths. [*fig.* **11**] In
1718, German engraver Johann Georg Hagelgans pub-
lished a political and military *Atlas historicus* (Historical
atlas) that treated the Eusebian format in an imaginative
new way. Like Lenglet du Fresnoy, Hagelgans blew up the
page beyond folio size.[10] Then, in the matrix created by the
traditional row and column format, he drew thousands of
tiny images of soldiers, statesmen, and political figures from
biblical times to the present. Hagelgans's tables were full
of surprising visual twists. Chronological grid lines frame
perspective images of biblical and historical scenes, and all
over, trompe l'oeil openings reveal detailed tableaux hiding
beneath the surface of the chart. Despite the huge scale
of the work, Hagelgans aimed to be as visually efficient
as possible. His *Atlas* came with a list of eighty symbols
that indicated such details as the ways that kings died and
how crowns were acquired. This permitted him to nearly
do away with text while preserving and enlivening the old
Eusebian matrix.

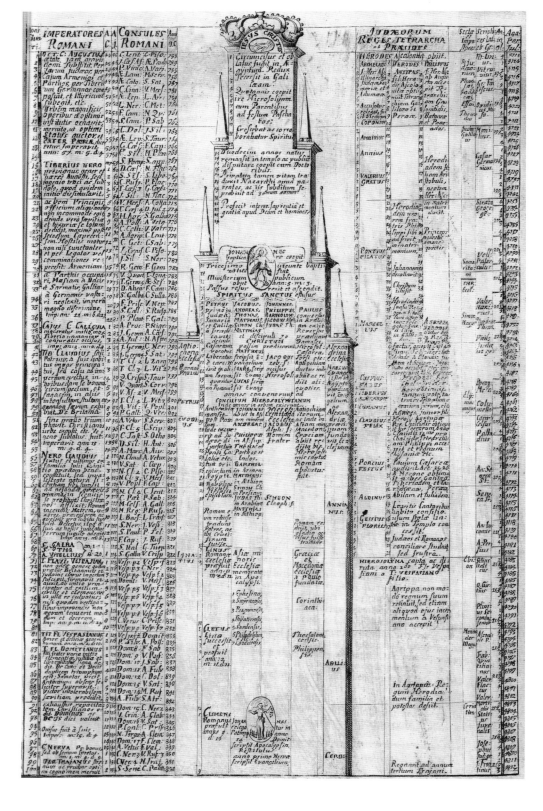

Traditional columns and elegant
obelisks represented as part of a vast
monument appear side by side in
Bircherod's chronology of Roman
history.

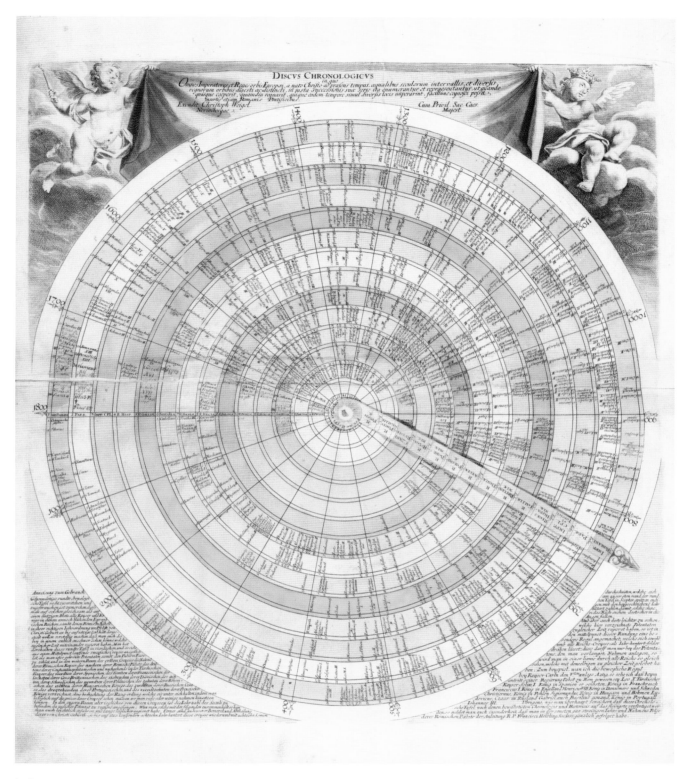

[10]

The aptly named *Discus chronologicus* published in the early 1720s by the German engraver Christoph Weigel is a volvelle, a paper chart with a pivoting central arm. The basic organization of data is inherited from Eusebius, but here the layout is circular with rings representing kingdoms and radial wedges representing centuries. The names of kingdoms are printed on the moveable arm. On this Princeton University copy a reader has inscribed events from contemporary history in the blank spaces of the eighteenth-century wedge, at one point carrying over into the contiguous space of the first century CE.

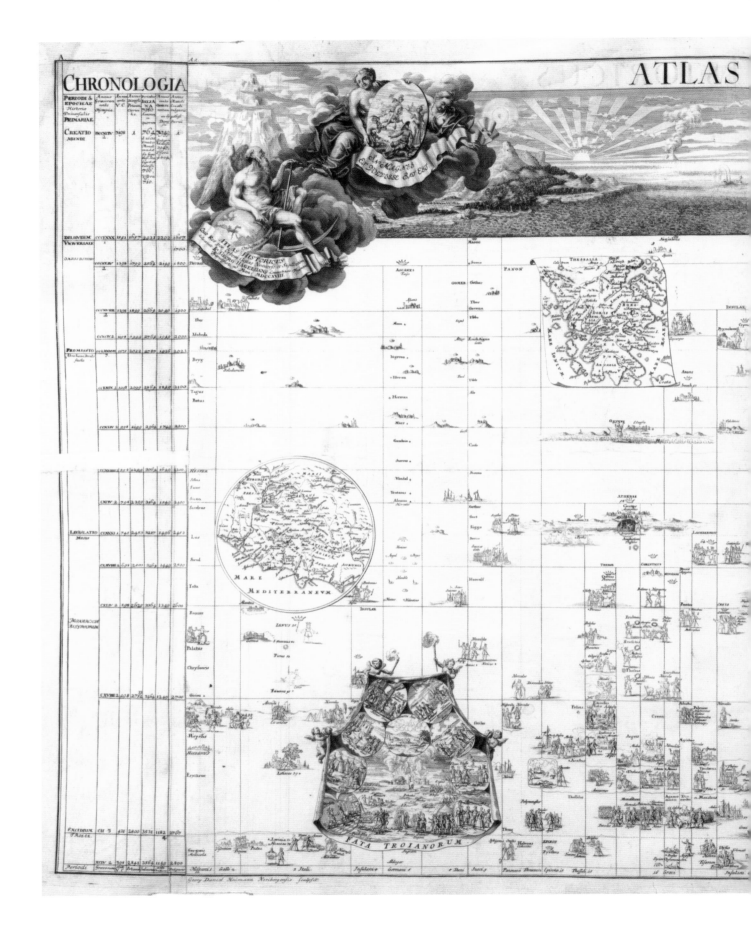

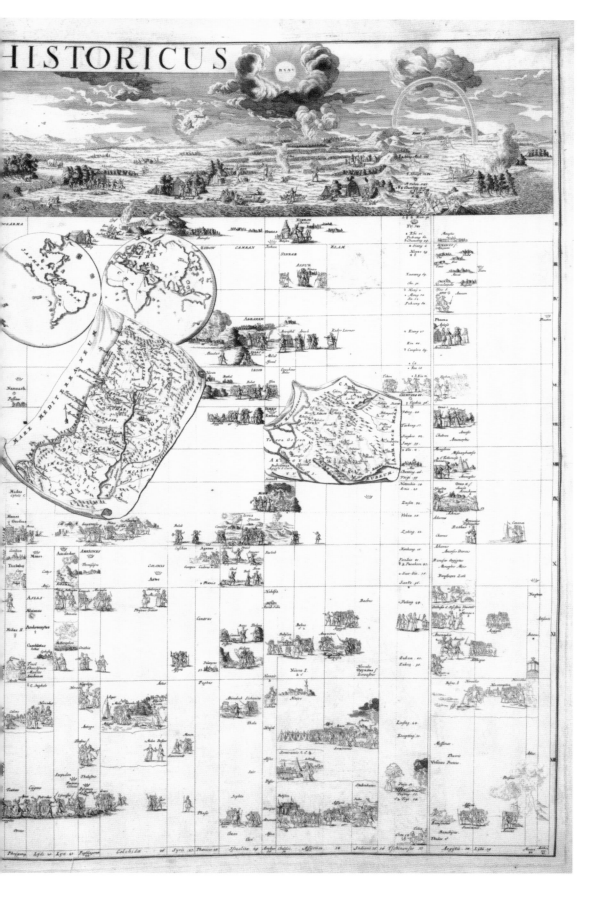

HISTORICUS

[11]

The chronological chart of the Creation and the first epoch of world history from the *Atlas historicus* published by the Frankfurt engraver Johann Georg Hagelgans in 1718 pushed the limits of what could be expressed in the classic tabular format of Eusebius. Though Hagelgans maintained the familiar historical matrix in the background, his enormous charts burst through everywhere with images, maps, and data.

Other works, such as the "historical maps" of the Italian poet and scholar Girolamo Andrea Martignoni, dispensed with Eusebian format altogether.[11] [*figs.* **12–14**] In several finely engraved charts published in 1721, Martignoni made a striking visual analogy between geographic space and historical time. Though he calls them maps, Martignoni's works are not historical maps in the conventional sense of geographical snapshots from different moments in history: they are chronological charts presented in a cartographic form. While, at a glance, they seem to depict a circular territory with a great lake at the center and rivers running to and fro, on examination, these rivers and land masses turn out not to be landscape features but temporal metaphors—territories of history and rivers of time. The streams at the top of the chart represent the nations conquered by the Roman Empire; those at the bottom, the nations that emerged from it; and the great lake at the center, the empire itself.

Like Hagelgans, Martignoni attempted, as much as possible, to suppress text on his chart. His aim was to draw the reader into a visual experience of information. And, just as in Hagelgans's work, here the results are mixed: the charts are often awkwardly symbolic, particularly when coded icons are combined. When a king dies while still on the throne, the event is marked by a tiny skull; when two thrones are joined by marriage, this is marked by a ring; when a king dies and a queen succeeds him, a skull appears next to a ring, to a somewhat sinister effect. But the true difficulties of Martignoni's chart are of a different order. Geographical space, it turns out, obeys different rules of contiguity and continuity than does historical time. Conquests of distant lands, complicated dynastic alliances, marriages, remarriages, and so forth, pose tricky problems for the geographic metaphor. On Martignoni's map, rivers often pass over other rivers, others double back, landforms are repeated, and laws of gravity and fluid mechanics are everywhere defied.

Martignoni's work offered one of the first systematic visualizations of the stream-of-time metaphor, but it was far from the last. Later chronographers would take a simpler approach, using the image of the river to demonstrate only the greater movements of history, not the fine details that led Martignoni into so many eddies and backwaters. None of this is to devalue the attempt. Like Hagelgans, Martignoni stretched what could be shown in a single view to the very limit. Though a riot of visual contradictions, his work suggested what might be possible if a map of time could be drawn in a consistent manner.

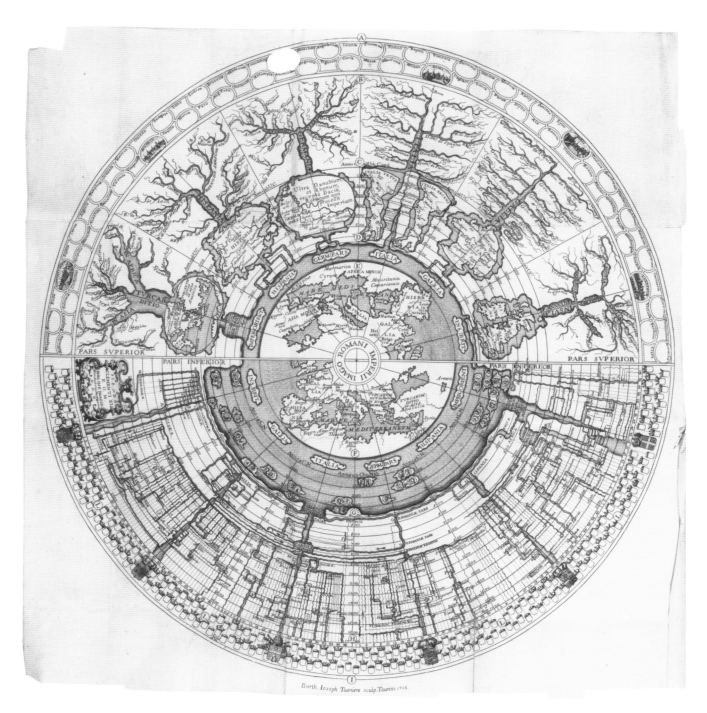

[12]

Girolamo Andrea Martignoni,
Spiegazione della carta istorica dell'Italia
(Historical map of Italy), Rome, 1721

[13–14]

The historical charts published by the
Italian scholar and poet Girolamo
Andrea Martignoni in 1721 imitated
cartographic forms. What appear
at first to be world maps are in fact
hybrid charts combining geographic
and chronographic information. The
large rivers here are rivers of time.
Martignoni's model was not widely
copied, but it vividly illustrates the
eighteenth-century pursuit of a new
visual vocabulary for the time map.

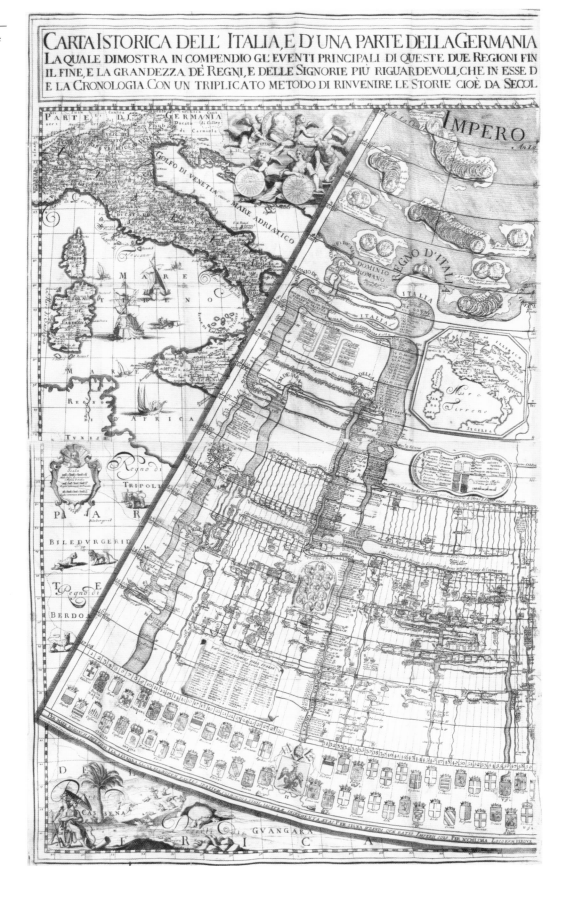

DALLA NASCITA DI GIESÙ CRISTO ALL'ANNO MILLESETTECENTO

CHÈ DURÒ L'IMPERO ROMANO; E DAPPOI L'ORIGINE, L'ACCRESCIMENTO LA DIMINUZIONE ERIVARONO, I TITOLI DE'DOMINI, LE DIGNITÀ, LA SERIE DEI RÈ, LE ARME, LA GEOGRAFIA O IN SECOLO, DA SUCCESSO IN SUCCESSO, E DA SIGNORIA IN SIGNORIA *Opera di Gio.Andrea Martignone*

For the rest of the eighteenth century, the problem of regularization and measurement dominated new chronographic representation. [*figs.* **15–17**] Not all efforts were equally successful. One of the most ambitious works of the period was the linear *Chronographie universelle* (Universal chronography) published in 1753 by Jacques Barbeu-Dubourg—a friend of Benjamin Franklin and an associate of the Encyclopedists—which extended the tabular approach of Eusebius into the graphic sphere of the eighteenth-century engravers.[12] Following the logic of cartography, Barbeu-Dubourg imposed a rigorously uniform graphic scale on his chart, marked out by linear segments with the look of measuring rods. Visual regularity, in itself, was not new, and some sixteenth- and seventeenth-century works, such as those of Gerardus Mercator and Ubbo Emmius, had ventured in the direction of the measured line. Both of their works were typographically beautiful and simple; and both went on for pages and pages presenting only a time scale with little or no information surrounding it. Still, there is an important difference between their works and that of Barbeu-Dubourg. Although the earlier chronographies define a linear graphic space, they do so in only the rough terms of typography. Barbeu-Dubourg's engraved chart, by contrast, allows the reader to measure

time with great precision—and the second edition of his work from 1838 came equipped with a small brass tool for doing just that.[13]

Barbeu-Dubourg's chart took the principles of regularity and encyclopedism to their logical end: his chart was huge. In fact, at 54 feet long, it was very difficult to display all at once. But Barbeu-Dubourg made a virtue of necessity. Though his *Chronographie universelle* could be purchased as an accordion book that could be unfolded to the full 54 feet, it was designed to be scrolled and viewed one section at a time. To this end, it could be mounted on an apparatus that Barbeu-Dubourg called a "chronographic machine," a custom box fitted with metal scrolls and cranks. Barbeu-Dubourg's time machine was hinged at the center, so that it could be opened on any surface and advanced freely, allowing the user to move with ease backward and forward over great stretches of world history. Though never commercially successful, it achieved perhaps the highest honor of the period, a dedicated entry in the *Encyclopédie* of Diderot and d'Alembert.

The 1750s saw the publication of other important chronographies as well. [*fig.* **18**] In England, at just about the time that Barbeu-Dubourg's machine first appeared, the cartographer Thomas Jefferys released *A Chart of Universal History*, a work that attempted to resolve the difficulties

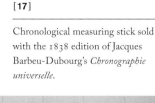

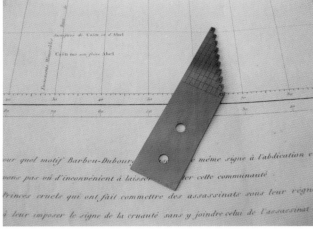

of the cartographic approach in a different way.[14] Like
the *Chronographie universelle*, Jefferys's *Chart of Universal
History* commences from a conventional premise. As in the
tables of Eusebius, on Jefferys's chart nations are named in
a row at the top of the page, while dates descend in a col-
umn down the side. And, just as in the older tables, events
may be located by cross-referencing date against place. But
this is where the similarities end.

In the first place, Jefferys's chart is synoptic: it dis-
plays all of its data in a single, continuous plane, visible
all at once. It is, of course, possible to confine a standard
Eusebian table to one page, and this is what Jean Boulaese
had done when he condensed and reformatted Eusebius as
a broadside. But, beyond abridgment, most such efforts
offered no real functional advantage over the codex format.
Unlike Boulaese—and unlike Helvicus and others who had
produced codex chronicles with uniform pages—Jefferys
did not divide his data into discrete, indexed cells but made
the space of the chart a continuous field. Thus, while the
content of his chart is similar to that of a traditional table,
the force of demonstration is essentially inverted. The older
form directs our attention to the historical content of a
given time/space; Jefferys's new approach directs it to the
temporal boundaries of historical entities and events.

Some of the advantages of the Eusebian format
are clearly sacrificed in Jefferys's approach. Because his
chart is continuous rather than cellular, it does not divide
easily, and so—while it works beautifully as a chart—it
translates less well into the form of a bound book. His
chart is built to be scanned visually like a geographic map,
not indexed by row and column. But the advantages of
Jefferys's approach are equally clear. In contrast to the
Eusebian table, Jefferys's chart not only *gives* dates, it
shows them in a highly intuitive format. Empires such as
that of Alexander the Great, which were geographically
vast but short-lived, look like pancakes, short and wide.
Others such as the Byzantine, which were geographically
compact but long-lived, look like reeds, tall and narrow.
Empires that were both large and long-lived such as the
Roman and Ottoman appear as great colored blocks.
Identically colored fragments scattered here and there
indicate regions belonging to a single empire.

But because Jefferys's chart is not a geographic map,
relative placement can be deceiving. On it, France and
Germany are separated by Italy; and Egypt is sandwiched
between China and South America. Size is also decep-
tive in many cases: Jefferys devotes as much space on the
chart to Italy as he does to India, and more to Spain than to

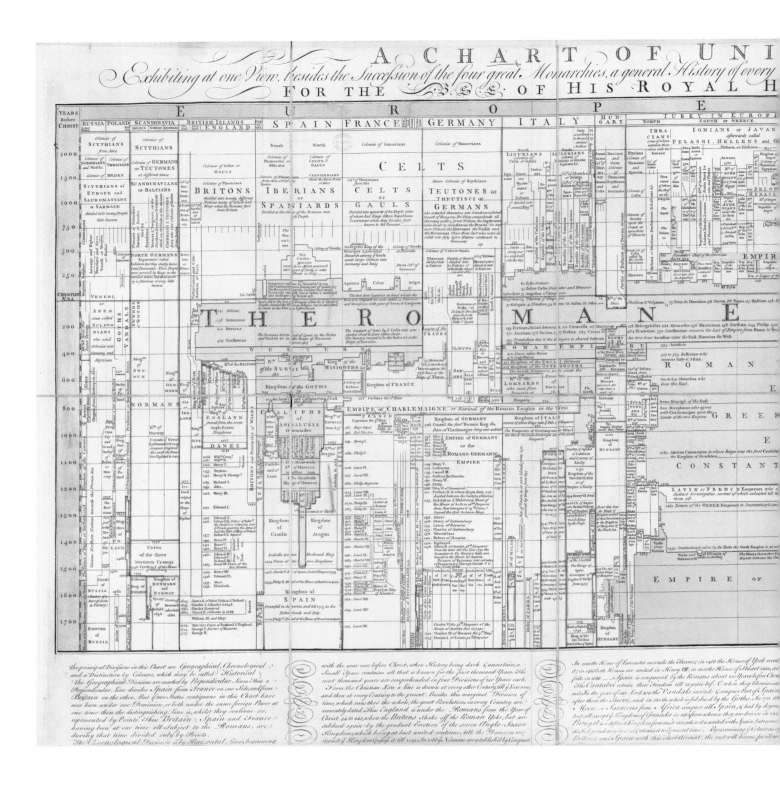

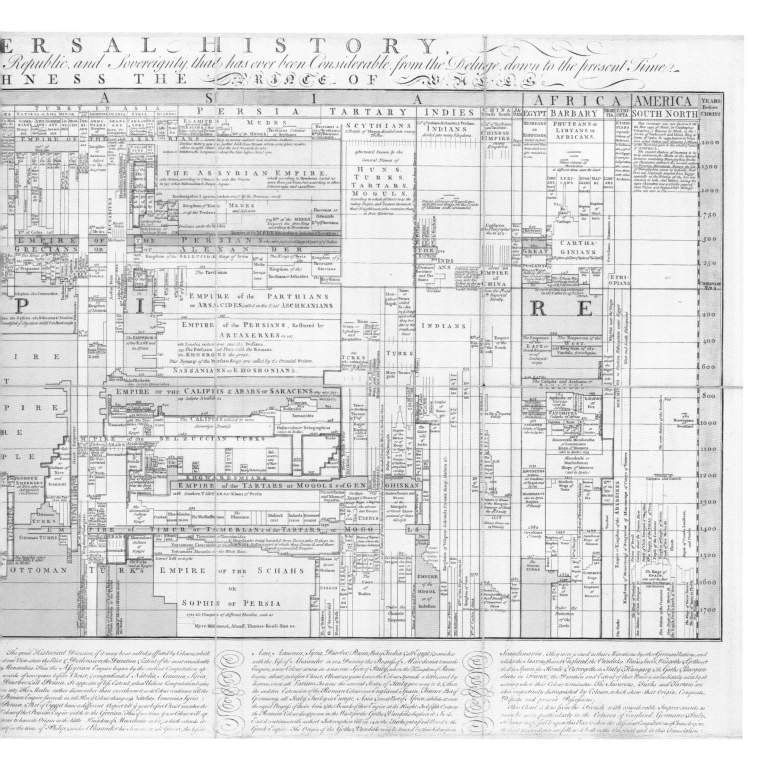

[18]

A Chart of Universal History was published in 1753 by the prolific cartographer-engraver Thomas Jefferys, apparently on a French model. The chart directly influenced Joseph Priestley, though Priestley objected to several elements including its lack of uniform scale. In 1760, Jefferys was named geographer to George III, a post he held until his death in 1771. His greatest achievements include the *General Topography of North America* of 1768.

North and South America combined. The chart is proudly Romanocentric, situating the Roman Empire at the very heart of world history and geography. Even so, it has the powerful effect of demonstrating the impermanence of all empires. In the terms of the chart, geographic nations persist throughout history, but every empire—even the imposing empire of Rome—is an island or an archipelago in time.

Remarkable as it was, the *Chart of Universal History* came and went quickly; a single lonely copy still resides in the British Library. Its greatest impact came not directly but by way of its influence on the scientist and theologian, Joseph Priestley, one of the best-known writers of his day. When Jefferys's chart appeared, Priestley was twenty years old and starting his career. He had yet to embark upon the research that would lead to his discovery of "dephlogisticated air" in 1774 or the ensuing controversy with the French scientist Antoine Lavoisier, who offered a competing explanation for Priestley's discovery and a competing term, "oxygen."

Priestley held a job as a teacher in a provincial dissenting academy where he gave courses on many subjects including history. And, to this end, he read a great deal of history and consulted whatever good reference works he could find, including those of Thomas Jefferys, Nicolas Lenglet du Fresnoy, and Francis Tallents. Out of these teaching years came important works on history, politics, and education, some of which were very widely read, among them his 1788 *Lectures on History and General Policy*. Two of the most enduring were his engraved double-folio charts of chronology, *A Chart of Biography* from 1765 and *A New Chart of History* from 1769.

To anyone who had seen Jefferys's chart, the conceit of Priestley's would have come as no surprise. [*figs.* **19–20**] Priestley appropriated Jefferys's basic layout and some of his visual concepts, but he also innovated in crucial ways. Jefferys brought to the chronographic project the vision of an engraver: his chart demonstrated just how much could be done within the confines of a single page. Priestley, by contrast, brought it the vision of a scientist: he was the first chronographer to conceptualize his charts in terms similar to those of scientific illustration, and he was the first to lay out systematic principles for the translation of historical data into a visual medium.

Priestley's charts were elegant and big—more than three feet wide and two feet tall. The *Chart of Biography* was large enough to accurately register the births and deaths of two thousand famous historical figures, virtually all of them men, across three thousand years in "universal time"; the *New Chart of History* displayed the fates of seventy-eight

important kingdoms and empires during the same period.[15] Both works could be purchased as posters or as scrolls wound up on rollers, and they were aggressively marketed by Priestley's London publisher.

Priestley designed his charts for the curiosity and pleasure of a general reader, but they were also meant to serve the scholar—and Priestley believed that the two aims were well served by the same approach. Faced with these charts, Priestley said, any child could recognize the error of the "tasteless chronologer" who through tortured calculations had managed to separate the lovers Dido and Aeneas by more than three hundred years.[16] A simple visual demonstration, Priestley said, would be enough to put an end to a controversy that had worried commentators on Virgil since the time of Petrarch at least.

Priestley's charts are masterpieces of visual economy. Both the *Chart of Biography* and the *New Chart of History* obey strict graphic conventions. Along their top and bottom edges, the charts are marked at intervals of one hundred years. Between these century marks, small dots indicate decades. Dates inscribed at top and bottom are connected by vertical grid lines to make the chart easy to read. In addition, the *Chart of Biography* is divided into six horizontal bands representing areas of life achievement. The uppermost is devoted to Historians, Antiquaries, and Lawyers; the next, to Orators and Critics; Artists and Poets; Mathematicians and Physicians; Divines and Metaphysicians; and finally, at the very bottom of the chart, Statesmen and Warriors.

The interior of the *Chart of Biography* is filled with about two thousand small solid black horizontal lines representing the lives of famous individuals. When Priestley was certain of dates of birth and death, he began and ended these lines cleanly at the appropriate place on the chart. When he was uncertain, he began or ended a line with an ellipsis. Even these ellipses were carefully drawn: "When it is said that a writer *flourished* at or *about* a particular time, a short full line is drawn about two thirds before and one third after that particular time, with three dots before and two after it; because, in general, men are said to flourish much nearer the time of their death than the time of their birth."[17]

The biographical chart displays a striking simplicity of form. Priestley meant his chart to be an "ocular demonstration" of the mathematical principles that Isaac Newton had applied in his own (posthumously published) chronological writings.[18] There, Newton argued that many chronological controversies could be settled if the distance between generations were estimated according to mathematical averages. One of his followers, John Craig, had even tried

[19]

Joseph Priestley's *A Chart of Biography*
from 1765 was the most influential
timeline of the eighteenth century.
Dates run horizontally at a regular
pace along the top and bottom
margins. More than two thousand
tiny lines show the lives of famous
men. The life lines are divided into
six categories arranged as horizontal
bands: Historians, Antiquarians
and Lawyers; Orators and Critics;
Artists and Poets; Mathematicians
and Physicians; Divines and
Metaphysicians; Statesmen and
Warriors. In the bottom margin of the
chart a list of important kings is given,
from Saul to George III.

Courtesy of the Library Company of
Philadelphia

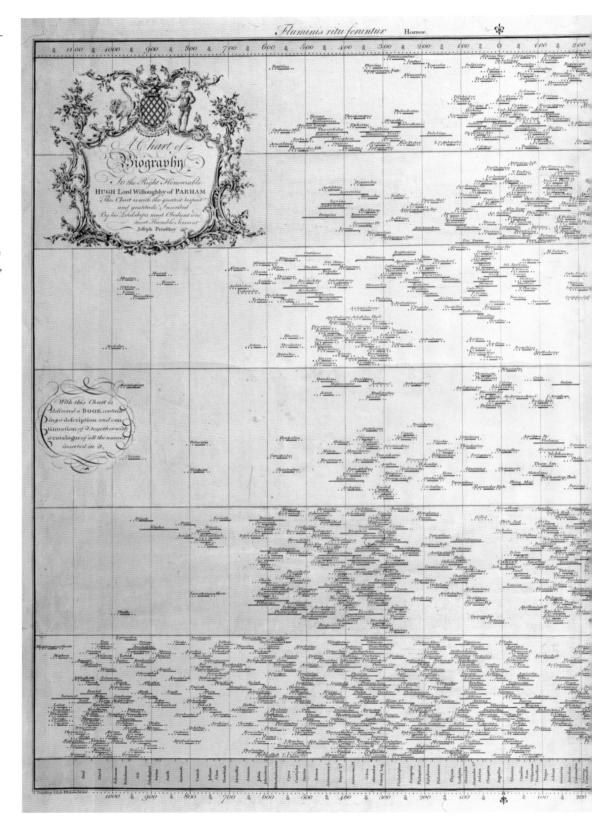

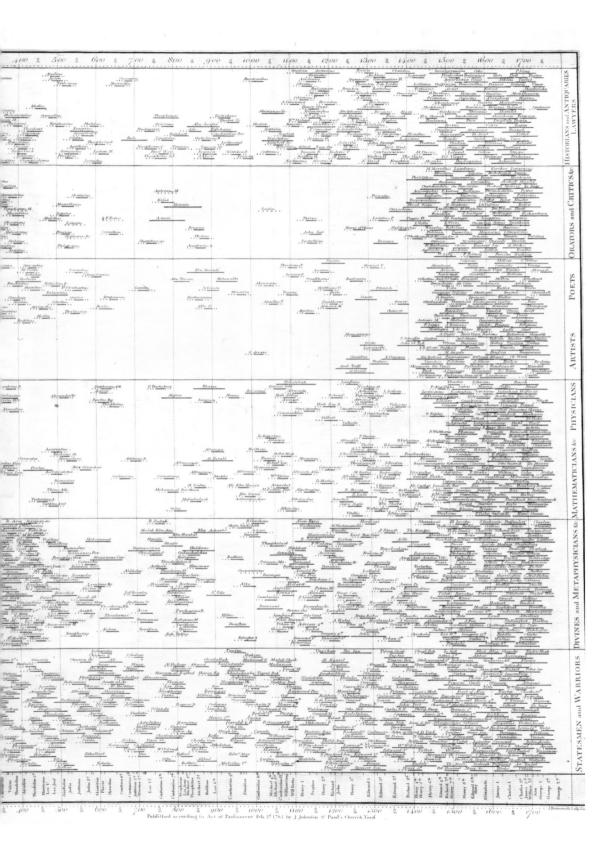

In 1769 Joseph Priestley published *A New Chart of History*, hewing more closely to Thomas Jefferys's model for a historical chart. Priestley regularized the distribution of dates on the chart and oriented it horizontally to emphasize the continuous flow of historical time. Priestley's two charts obeyed the same scale so that data from one could be lifted directly and moved to the other.

Courtesy of the Library Company of Philadelphia

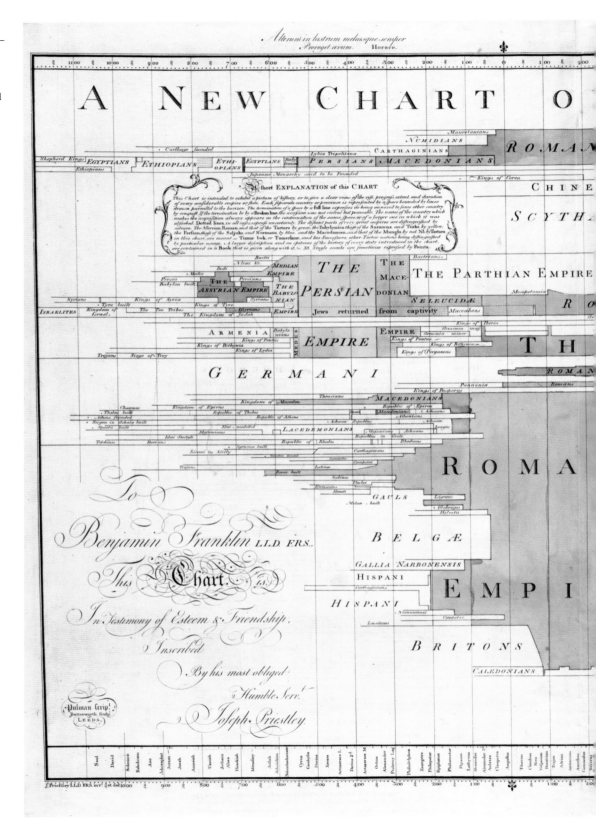

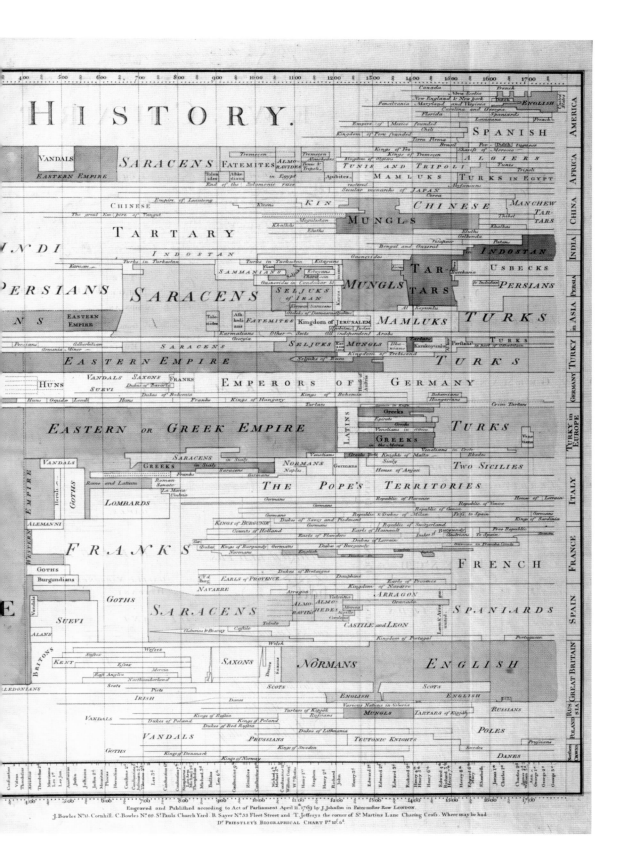

to work out rules to express the rate at which historical sources lost their probative value over time. In Priestley's chart, these averages display themselves everywhere just "as the uniformity of the course of nature requires."[19]

The *New Chart of History* is identical to the *Chart of Biography* in size and scale; it begins and ends at the same dates and has, running along its bottom edge, the same list of rulers beginning with the Hebrews and culminating with the modern kings of England.[20] Priestley hoped that this common scale would make the two charts easy to use together. Though they could not literally be superimposed, they could be placed side by side for comparison, and, as Priestley notes, readers might very easily inscribe on one chart information drawn from the other.[21]

As with the *Chart of Biography*, Priestley promoted the *New Chart of History* as a tool to appeal to the mind directly through the senses. In contrast to chronology books, which required great mental labor, the *New Chart of History* was designed to give the student the feeling of seeing history in action. Priestley writes,

> If the reader carry his eye *vertically*, he will see the contemporary state of all the empires subsisting in the world, at any particular time. He may observe which were then rising, which were flourishing, and which were upon the decline. Casting his eye a little on each side of the vertical line, he will see what empires had lately gone off the stage, and which were about to come on.[22]

Priestley emphasizes that this experience comes *without reading*. He makes only one significant concession to the limitations of the simple linear graphic: following Jefferys, he adds color to the *New Chart of History*, an innovation that allows him to exhibit the unity of empires that "cannot be represented by continuous spaces."[23]

Both of Priestley's charts perform impressive feats of condensation. In fact, they are so dense that they are difficult to reproduce well. And, when displayed one part at a time (electronically, on film, or in print), the aggregating effects of the works can easily be lost. According to Priestley, the charts had the special characteristic of communicating chronological relationships "at one view."[24] In this way, they expressed the potential of the graphic image and amplified the virtues of historical study itself. In the charts, as in history, wrote Priestley, "the whole is before us. We see men and things at their full length, as we may say; and we likewise generally see them through a medium which is less partial than that of experience."[25]

[21]

Harry distracted by a kaleidoscope salesman, from Jefferys Taylor, *Harry's Holiday, or the Doings of One Who Had Nothing to Do*, London, 1818

For decades, Priestley's charts were heavily used, and accounts of them appear throughout the pedagogical literature of the late eighteenth and early nineteenth centuries. [*fig.* 21] They were, according to the *Cambridge Magazine*, an essential part of a gentleman's library. And both the novelist Maria Edgeworth and the physician Erasmus Darwin (grandfather to Charles) recommended them as aids in the education of women.[26] By the early nineteenth century, Priestley's charts had become an easily recognizable part of print culture. An 1818 children's book about the dangers of distraction called *Harry's Holiday* hinges on a young boy's failed attempt to hand copy one of Priestley's charts—a foolish effort which occasions a lecture from his father on the virtues of mechanical reproduction.[27]

But the fictional Harry was far from alone, and manuscript copies of historical charts from the eighteenth century can still be found in libraries and archives. Some of these are rote student work; others, like Harry's, are the product of individual initiative. A manuscript historical chart in the manner of Priestley's *New Chart of History* made around 1800, for example, can be found in the papers of John Dickinson, the first governor of the State of Delaware. And a copy of Priestley's chart of Hebrew chronology from the eighteenth century can still be found slipped inside a Priestley volume held at the Library Company of Philadelphia, an early circulating library established by Benjamin Franklin in 1731. [*figs.* 22-23]

For Priestley, the essential aim of the chronological chart was to give a broad view. From a distance, to use his own analogy, the lines on the *Chart of Biography* should look like "so many small straws swimming on the surface of [an] immense river," bunching and drifting apart as the currents of history change speed.[28] The chart is densest at the far right edge, that is to say, in recent history. This is no accident of design; according to Priestley,

the noblest prospect…is suggested by a view of the crowds of names in the divisions appropriated to the arts and sciences in the last two centuries. Here all the classes of renown, and, I may add, of merit, are full and a hundred times as many might have been admitted, of equal attainments in knowledge with their predecessors. This prospect gives us a kind of security for the continual propagation and extension of knowledge; and that for the future, no more great chasms of men really eminent for knowledge, will ever disfigure that part of the chart of their lives which I cannot draw, or ever see drawn.[29]

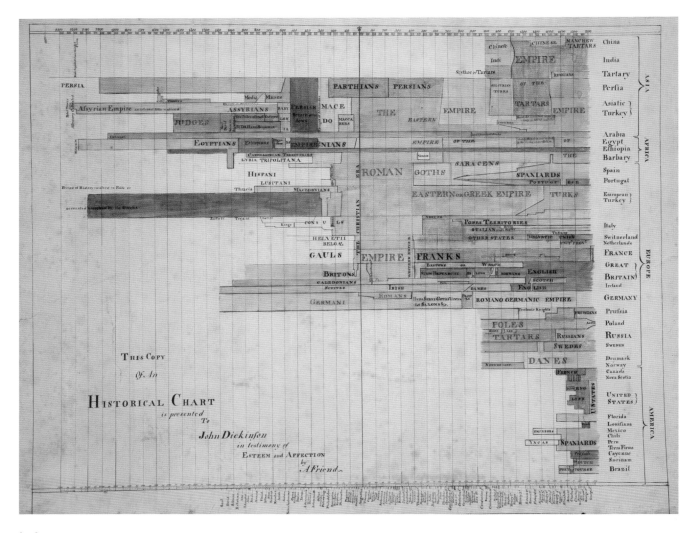

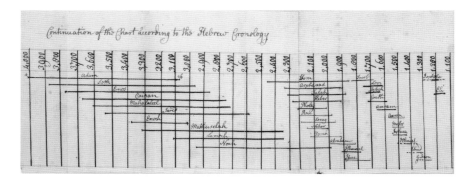

In other words, in Priestley's view, the mass of straws accumulated at the right of the chart represents an actual historical phenomenon, the "acceleration" of the arts and sciences in his own time.[30] On the *Chart of Biography*, Priestley writes, "what a figure must science make."[31] And, indeed, in Priestley's chart something called science literally takes on a figure, perhaps for the first time.

In Priestley's work, the great stages of history are framed in quantitative terms. On the chart, the Renaissance features more great scientists than does the medieval period, and the Enlightenment still more than the Renaissance. But as Priestley notes, such changes are not apparent in every category. While the charts show clearly that there are ages of science and art, they also show that every age is an age of warriors. In Priestley's view, there is a moral to all this. He writes,

> By the several void spaces between…groups of great men, we have a clear idea of the great revolutions of all kinds of science, from the very origin of it; so that the thin and void places in the chart are, in fact, no less instructive than the most crowded, in giving us an idea of the great interruptions of science, and the intervals at which it hath flourished…. We see no void spaces in the division of Statesmen, Heroes,

and Politicians. The world hath never wanted competitors for empire and power, and least of all in those periods in which the sciences and the arts have been the most neglected.[32]

Priestley was interested in individual biographies, but the *Chart of Biography* was meant to depict history in the broadest terms, to show that every life, even the most extraordinary, was best understood in relation to its time.[33] (*see p. 18*) Priestley notes that,

> It is a peculiar kind of pleasure we receive, from such a view as this chart exhibits, of a great man, such as Sir Isaac Newton, seated, as it were, in the circle of his friends and illustrious contemporaries. We see at once with whom he was capable of holding conversation, and in a manner (from the distinct view of their respective ages) upon what terms they might converse.[34]

Priestley's admiration for Newton was boundless, and in other works he discusses at length the achievements of "that great father of the true philosophy."[35] But, on the *Chart of Biography*, Newton does not stand apart from his contemporaries. His line begins and ends simply, just like all of the others.

Though the *Chart of Biography* presented precise information about individual lives, it was the aggregating effects of the chart that Priestley found most remarkable, and its ability to communicate ideas in a purely graphic fashion, without the use of words. Priestley writes,

> It is plain that if a sheet of paper be divided into any equal spaces, to denote centuries, or other intervals, it will be a chart truly representing a certain portion of universal time; and if the time of any particular person's birth and death be known, it is but joining the two points of the chart which correspond to them, and you have a line truly representing the situation of that life, and every part of it, in universal time, and the proportion it bears to the whole period which the chart comprises.... They are the lines...which suggest the ideas; and this they do immediately, without the intervention of words: and what words would do but very imperfectly, and in a long time, this method effects in the completest manner possible, and almost at a single glance.[36]

Though Priestley says that names must be written on the chart, he specifies that their function is merely indexical. The chart functions as a graphical representation of history without a single name being mentioned. In Priestley's words, "it is the *black line* under each name which is to be attended to: the names are only added because there was no other method of signifying what lives the lines stand for."[37]

Priestley's charts mark a crucial transition in the history of chronographic representation. After Priestley, most readers simply assumed the analogy between historical time and measured graphic space, so the nature of the arguments around chronographic representation shifted dramatically. The issue was no longer how to justify the analogy but how best to implement it. Priestley had demonstrated that the elusive time map sought by Martignoni and others was not a map in the conventional sense. And, following Priestley's example, modern chronologers would exploit the visual language of cartography, but in a different idiom.

Early modern cartographers were interested in history, too, and experimented widely with ways of representing history through maps.[38] In 1570, with his foundational work *Theatrum orbis terrarum* (Theater of the world), the cartographer Abraham Ortelius reformulated the old rhetorical formula that made chronology and geography two eyes of history in a way that favored the mapmakers. For Ortelius, geography was not one of the two eyes of history, but its single *oculus*: "All [lovers of histories] will readily

[24–25]

Many publishers created atlases based
on Las Cases's system, among them
C. V. Lavoisne. His *A new genealogical,
historical, and chronological atlas*, 1807,
with its characteristic typeset tables, is
pictured here.

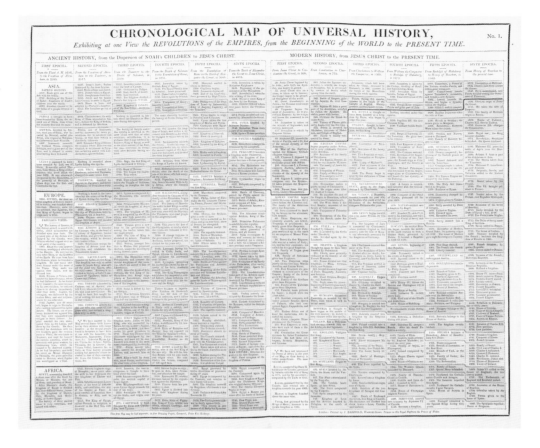

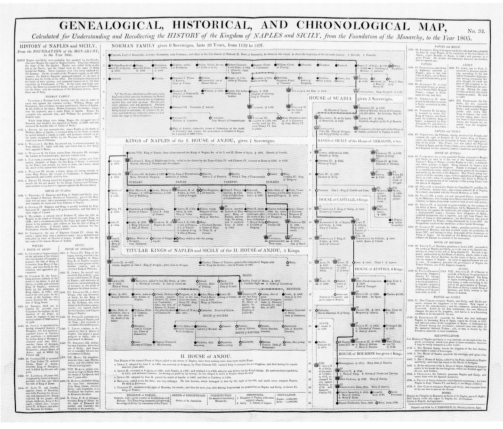

Chapter 4: A New Chart of History　　　　　127

The concept of a historical atlas as a collection of geographical maps showing snapshots of the world at different historical moments is exemplified in Edward Quin's *An Historical Atlas*, first published in 1828. Quin's maps showed how the political world was divided up at different moments of history, and, through the device of clouds rolling back, he indicated how much of the world was known to the West at each stage in history.

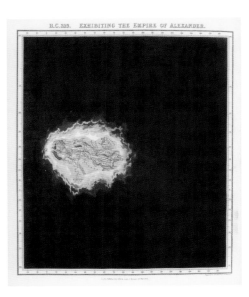

affirm with us how necessary is the knowledge of regions and provinces, of the seas, the location of mountains, valleys, cities, the course of rivers, etc., for attaining [a full] understanding of histories. This is what the Greeks called by the proper name *geography*, and certain learned persons (rightly) call *the eye of history*."[39] The *Theatrum* of Ortelius aimed to aid the study of history by providing maps of terrains discussed in historical texts.

Over the course of the seventeenth century, cartographers produced many variations on the Ortelian theme: collections of maps organized geographically, thematically, and—very occasionally, as in the 1651 *Holy Land* of Philippe de la Ruë—chronologically.[40] In some instances, as in Zacharias Châtelain's famous *Atlas historique* (Historical atlas) published in Amsterdam between 1705 and 1720, maps were juxtaposed with texts on history, date lists, and genealogical trees.[41] The same logic was later amplified in the wildly successful *Atlas Lesage*, first published in 1801 by the French aristocrat Emmanuel-Augustin-Dieudonné-Joseph, comte de Las Cases—a colorful figure who eventually served as one of Napoleon's secretary-memoirists during his exile on St. Helena. [*figs.* **24-25**] The *Atlas Lesage*—so named for the nom de plume of Las Cases—was organized geographically, not chronologically. But each page was loaded with historical information, genealogical trees, and typeset historical schematics.[42]

During the late eighteenth century, especially after Johann Matthias Hase's *Atlas historicus* (Historical atlas) of 1750, it became increasingly common to arrange collections of historical maps chronologically, but it was not until the beginning of the nineteenth century that historical cartographers, such as Christian Kruse, began to depict time at regular historical intervals. In Hase's atlas and others like it, maps are given for important historical events such as great battles and conquests, and so the flow of time is capricious. By contrast, Kruse's *Atlas zur Übersicht der Geschichte aller europäischen Staaten* (Survey atlas of the history of all the European states) of 1802–10 provides one map for each century regardless of how eventful that century may have been.[43]

The works of both Hase and Kruse, like most of the historical atlases that would follow, represented history as a series of discrete moments—though some cartographers such as Edward Quin tried hard to introduce a feeling of temporal flow. [*figs.* **26-28**] Quin's 1830 *Historical Atlas* follows the example of Hase, but his charts ingeniously imply the growth of historical knowledge through images of clouds gradually dispersing from panel to panel. In Quin's

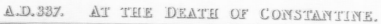

Historical Atlas, the world is shown first in darkness, with clouds obscuring everything outside the Garden of Eden. Gradually, as history reveals more of the world, the clouds roll back. Turning the pages of the atlas is a bit like riffling through a flip book, watching darkness recede and the world known to Europeans grow.

A related dynamic of revealing is at work in many of the extended chronographic charts as well, and the effect is often surprising. Eighteenth- and nineteenth-century chronology charts give a great deal of information about Egypt, Persia, India, and China in ancient times. By contrast, they give very little about Europe, Africa, or the Americas. In narrative historiography, this posed little problem: subjects were raised as the historian had something to say. But in the quasi-geographic format of the historical chart, such gaps in historical knowledge were glaring. On Priestley's *New Chart of History*, for example, the chronology of each nation is shown from 1200 BCE to 1800 CE regardless of whether Priestley has entries to make. Priestley finessed the problem by devoting blank spaces to other ends, his title, dedication, and so forth. Where, for example, English history might be—were there any English history to speak of in ancient times—Priestley places an ornate dedication to Benjamin Franklin. Priestley wasn't trying to hide anything

by doing this: in his text narrative, early English history gets barely a mention. Priestley's goal was to maintain the appearance of consistency and regularity in the chart by balancing its visual composition.

Similar gestures may be seen in works that follow Priestley's model, such as the large fold-out chart of the Scottish philosopher Adam Ferguson for the second edition of the *Encyclopaedia Britannica*. [*fig.* **29**] In his chart, Ferguson had an even tougher graphic challenge than Priestley. Priestley's chart begins in the classical period; Ferguson's begins at the Creation. As a consequence, it treads into more controversial chronological territory and encompasses a longer time span, approaching 6,000 years. To achieve a feel of regularity, Ferguson cheated on his scale, compressing the first ages of the world into a small space at the top of his chart. In the context of an all-inclusive encyclopedia, the gesture is practical, but it proves conceptually awkward since, in every other respect, Ferguson's chart obeys the conventions of a regular timeline.

Within very few years, variations on Priestley's charts began to appear just about everywhere. [*figs.* **30–33**] When his own charts were not copied outright, they were adapted and interpreted, and, over the course of the nineteenth century, envisioning history in the form of a timeline became

The second edition of the *Encyclopaedia Britannica* included a hand-colored fold-out chart of history to accompany the articles by Adam Ferguson on civil and ecclesiastical history. This was the first timeline to be included in the *Britannica*. Ferguson's chart resembles Joseph Priestley's *New Chart of History* in many ways, but in contrast to Priestley's chart it sacrifices uniform scale for comprehensiveness, compressing much of the "revealed history" of the Bible into a blank space at the top, making almost no entries at all. Despite his use of the chronographic format, in some ways Ferguson thought that dates mattered less than periods in history. He mostly drew the dates on his chart from a standard reference work, and left the chart as spare as possible so that readers might fill it in however they wished. This image is from the third edition published in Edinburgh in 1797.

The late eighteenth and early nineteenth centuries produced many copies and interpretations of Joseph Priestley's charts. This chart from Anthony Finley's 1818 *Atlas classica* combines elements of both of Priestley's charts. The inscription gives Priestley his due.

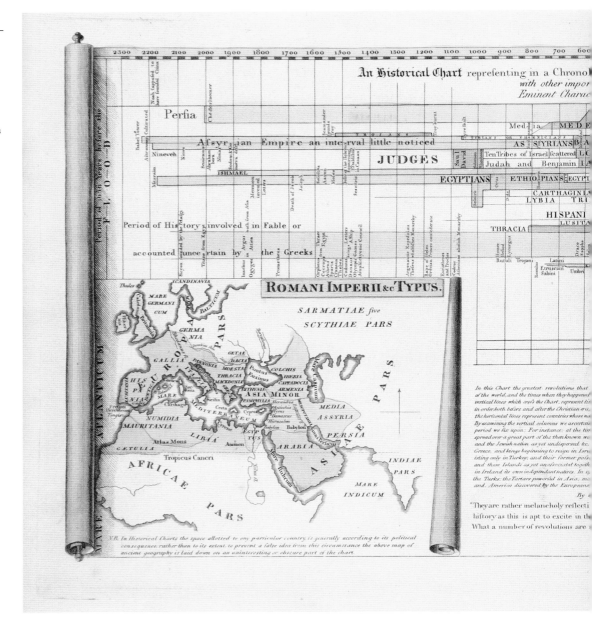

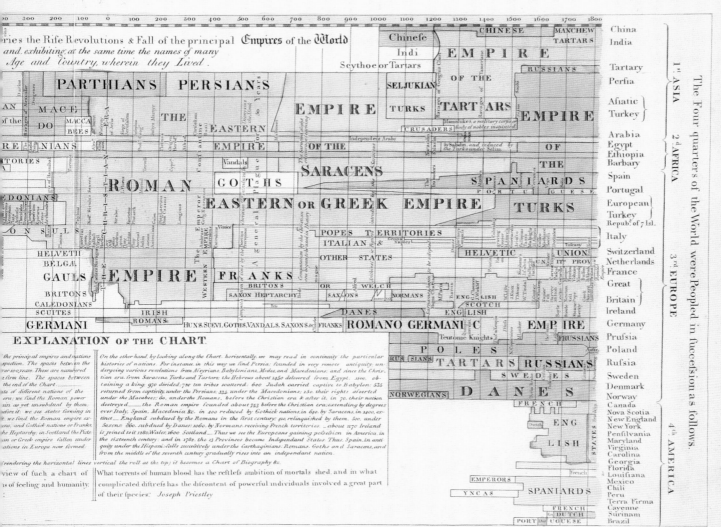

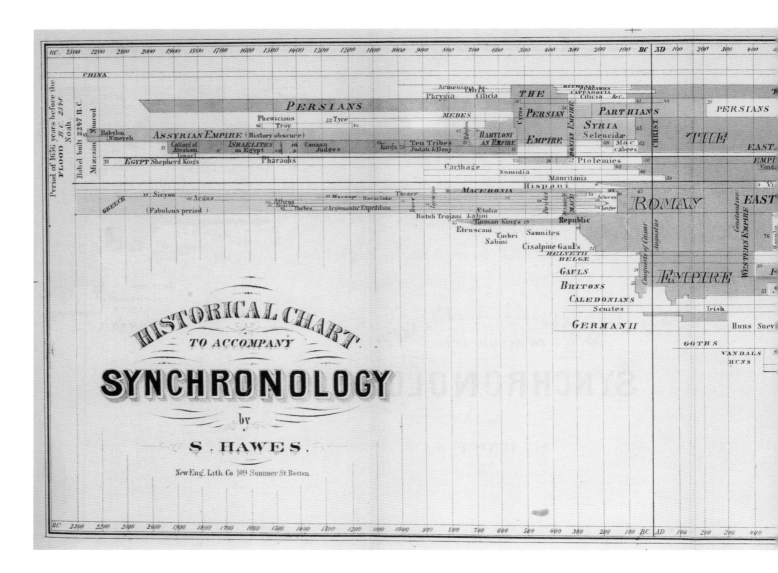

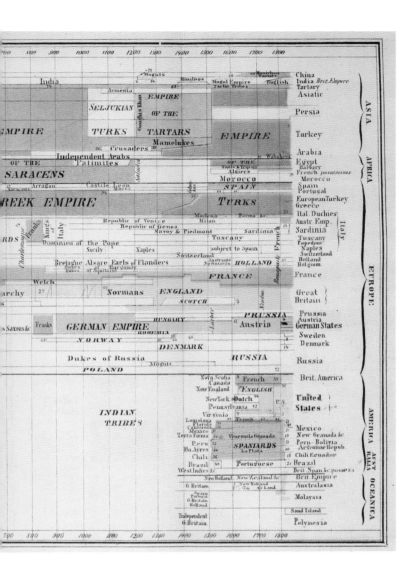

By 1869 when Stephen Hawes published his *Synchronology of the principal events in sacred and profane history: from the creation of man, to the present time*, the graphic conventions of Joseph Priestley's charts had become so commonplace that they rarely were attributed to Priestley at all.

[32]

In *A System of Chronology*, Edinburgh, 1784, the Scottish divine James Playfair combined the chronological styles of Eusebius and Priestley and demonstrated the adaptability of Priestley's lines to tables with multiple dating systems.

———

Courtesy of the Library Company of Philadelphia

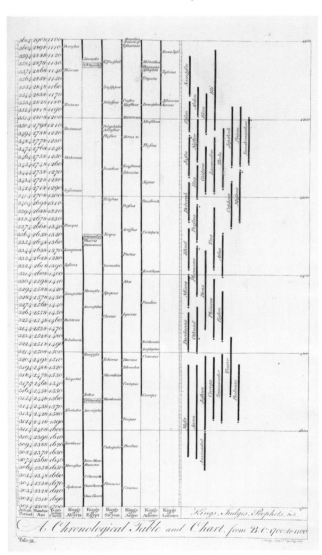

[33]

In 1808, while running an academy in Morristown, New Jersey, the Presbyterian minister Samuel Whelpley published a popular history textbook called *A compend of history, from earliest times*, complete with a biographical chart modeled on Priestley's. Whelpley's work went through several editions through 1853. This 1825 edition includes Whelpley's "imperial and biographical chart."

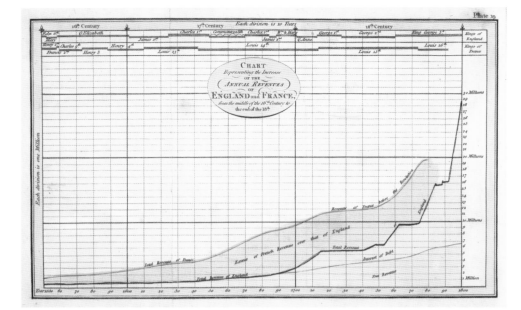

[34]

William Playfair's line graphs, including this chart of the annual revenues of France and England from the third edition of his *Commercial and Political Atlas*, developed the logic of the chronographic chart in new directions. As here, Playfair's statistical graphs often included timelines of political history.

[35]

Luigi Perozzo, 1879 stereogram of the Swedish census for the years 1750 to 1875, showing the number of male births per year in relation to the number of survivors over time

second nature. Priestley's charts also had a major impact in other areas. In his 1786 *Commercial and Political Atlas*—widely recognized as the foundational work in the field of statistical graphics—William Playfair cited Priestley's historical charts as a direct predecessor to his own line graphs and bar charts.[44] Though he promoted his own originality with vigor, in the third edition of the *Commercial and Political Atlas*, published in 1801, Playfair confirmed the influence of chronography on the development of his framework. He writes,

> It is now sixteen years since I first thought of applying lines to subjects of Finance....At the time when this invention made its first appearance it was much approved of in England;...I confess I was long anxious to find out, whether I was actually the first who applied the principles of geometry to matters of Finance, as it had long before been applied to chronology with great success. I am now satisfied, upon due inquiry, that I was the first; for during fifteen years I have not been able to learn that any thing of a similar nature had ever before been produced.[45]

As a science of dates, chronology always had a quantitative dimension, but it was not until the middle of the eighteenth century that uniformity of scale became a usual characteristic of chronographic space. Once that uniformity had been achieved, projecting other kinds of quantitative data into the chronographic space was not difficult. In his 1801 *Statistical Breviary*, Playfair specified precisely how eighteenth-century chronographers cleared the way for statistical graphics. He writes,

> The study of chronology has been much facilitated by making space represent time, and a line of proportional length, and in a suitable position, the life of a man, by means of which the remarkable men of past ages appear as it were before us in their proper time and place.[46]

Over the course of the next half century, Playfair's line graph, which counterposed two quantitative axes (one for time, the other for economic measures such as exports, imports, and debts) became one of the most recognizable chronographic forms. [*fig.* **34**] Later statisticians would not be satisfied with only two graphic dimensions. By the 1870s, demographers such as the Italian Luigi Perozzo were experimenting with three-dimensional statistical projections.[47] [*fig.* **35**]

After Playfair, statistical representations of historical phenomena proliferated, first in fields such as economics

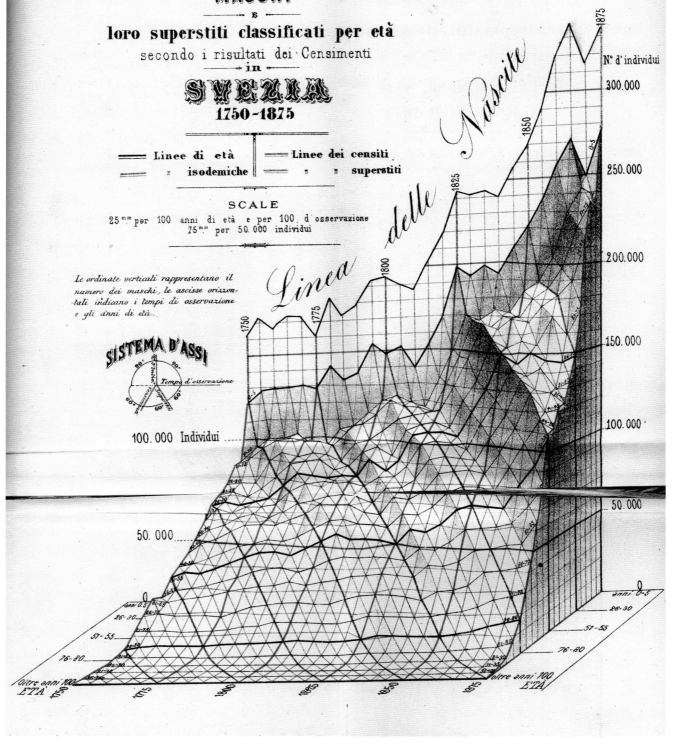

NUMERO ASSOLUTO dei NATI VIVI
MASCHI
E
loro superstiti classificati per età
secondo i risultati dei Censimenti
in
SVEZIA
1750-1875

Linee di età Linee dei censiti
 " isodemiche " " superstiti

SCALE
25ᵐᵐ per 100 anni di età e per 100 d'osservazione
75ᵐᵐ per 50.000 individui

Le ordinate verticali rappresentano il
numero dei maschi, le ascisse orizzon-
tali indicano i tempi di osservazione
e gli anni di età.

SISTEMA D'ASSI

100.000 Individui

N.° d'individui
300.000
250.000
200.000
150.000
100.000
50.000

Florence Nightingale, diagrams
from *Mortality of the British Army:
At Home, and Abroad, and During the
Russian War, as Compared with the
Mortality of the Civil Population in
England*, London, 1858. Nightingale's
diagrams, in which chronological time
is represented as a circle, revealed that
during the Crimean War infection and
disease caused more British deaths
than did enemy bullets and bayonets.

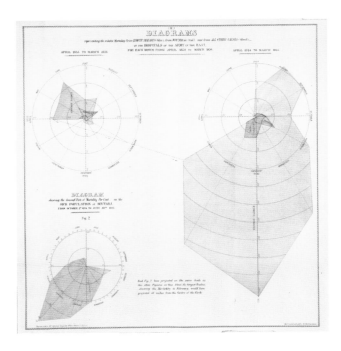

that were already rife with quantitative data and then, with the rise of the social statistics, just about everywhere. [*figs.* **36–37**] By the middle of the nineteenth century, a wide and inventive range of charts, including some that were quite technical, could be found in general publications such as Florence Nightingale's "rose" and "batwing" charts of the 1850s showing changing causes of death over the course of the Crimean War; the French engineer Charles Joseph Minard's thematic maps of the 1860s, including his famous diagram of declining troop strength in Napoleon's invasion of Russia (*see p. 22*); and the magnificent graphic projections of the 1870 United States Census by Francis A. Walker, superintendant of the census and future president of the American Statistical Association, the American Economic Association, and the Massachusetts Institute of Technology.[48] But through all of this, the line itself—straight, crooked, curved, or branching—remained the principal visual metaphor by which historical chronologies were envisioned.

Ironically, the rise of the modern timeline coincided with the decline of academic chronology. During the eighteenth century, questions of chronology were posed everywhere, but the role of the chronologist who specialized in the study of dates diminished in relation to that of the historian.

Meanwhile, the chronologist's traditional domain was compartmentalized: astronomy was set apart from astrology, philology from biblical commentary, empirical science from revealed science, and so on. Chronology, a field of study that once claimed plausibly to be the very "soul of historical knowledge," was left little more than a skeleton.[49]

This did not mean that the *subject* of chronology declined in importance. As universal history came to be understood as the study of intrinsic causes, relations, and effects, and as the key periodizations came to be understood as internal rather than external to historical sequence, problems of chronology gained a different kind of importance. And, for the same reason, the new chronologies of the eighteenth and nineteenth centuries obeyed different rules. The importance of computing the exact *annus mundi*, the year of the world calculated from the Creation, diminished. Priestley's view was typical in this regard. As far as he was concerned, in the representation of secular history, any dating system would do so long as it was universally agreed upon and rigorously applied. In itself, this approach was not new, but it was during this period that it ceased to be a matter of significant methodological controversy. When Priestley presented charts of universal history bracketing the question of Creation, there was hardly a murmur on

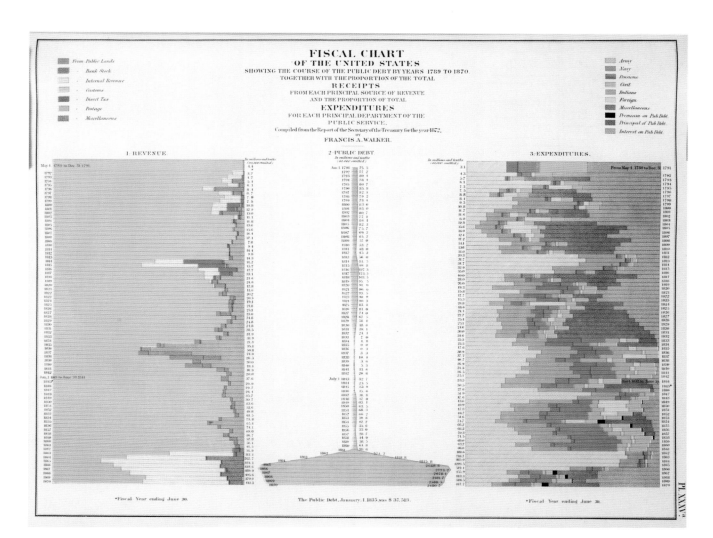

Francis A. Walker, *Fiscal Chart of the United States Showing the Public Debt by Years 1789 to 1870 . . . Receipts from Each Principal Source of Revenue . . . and Expenditures from Each Principal Department*, from *Statistical Atlas of the United States Based on the Results of the Ninth Census, 1870*, New York, 1874

Courtesy of the Library Company of Philadelphia

A page of notes from the papers of Jean-Antoine-Nicolas de Caritat, marquis de Condorcet, for a never-completed chronological classification system that would trace the development of human society and culture. In the upper left, Condorcet lists the ten "principal epochs" of world history as discussed in his *Sketch for a historical picture of the progress of the human mind*, also incomplete at the time of his death in 1794; in the upper right, principal thematic categories including cultural, social, intellectual, scientific facts; below, subcategories applying to one or several of the principals.

the subject. To the contrary, what struck readers most was how obvious his approach was, and how strange it was that it had not been in general use a long time before.

To most readers, Priestley's inventions were both useful and intuitive. In addition, they resonated strongly with the linear historical visions outlined by the philosophers of the Enlightenment. The significance of this graphic articulation of "homogeneous, empty time"—to borrow the phrase of the twentieth-century philosopher and critic Walter Benjamin—cannot be overstated.[50] At the same time, it needs to be understood in context. For Priestley himself, the empty timeline was only a heuristic. It was not supposed to take God out of history. To the contrary, Priestley thought that, by revealing aggregate social phenomena consistent with the operation of Providence, it would beautifully illuminate God's plan.

Priestley's apparatus proved highly popular in the nineteenth century, his philosophical experimentalism, less so. To many readers, Priestley's charts seemed to offer a picture of time itself. In the context of the Newtonian revolution, this made perfect sense. Newton's own forays into historical chronology were thoroughly rooted in the seventeenth-century millennialist framework and never evolved a graphic component. But the theory of time expounded in

his physics resonated strongly with the uniformity depicted in Priestley's charts. These were not meant to be hard science, but they were quantitative and statistical, and, as the work of William Playfair amply demonstrates, they created an analytical framework useful in other fields.

Though it spread rapidly, Priestley's system was slower to take hold in France than it was in Britain and elsewhere in Europe. In France in the 1790s, Jean-Antoine-Nicolas de Caritat, marquis de Condorcet, one of the founders of social statistics, attempted to design a different visual system. Like Priestley, Condorcet believed that social phenomena could be understood in aggregate. He believed that cause/effect relationships in history were intrinsic rather than extrinsic. And he believed that universal history followed a basically linear path as expressed in his posthumous *Sketch for a historical picture of the progress of the human mind* of 1793. Indeed, knowing nothing of Condorcet other than his ten stages of history, one might guess that he would have been a great proponent of Priestley's linear charts.

But Condorcet's account of universal history was structural rather than descriptive; his principal interest was not to provide a record of facts but to determine general historical patterns. Like many of the conjectural historians of the Enlightenment, Condorcet believed that all societies

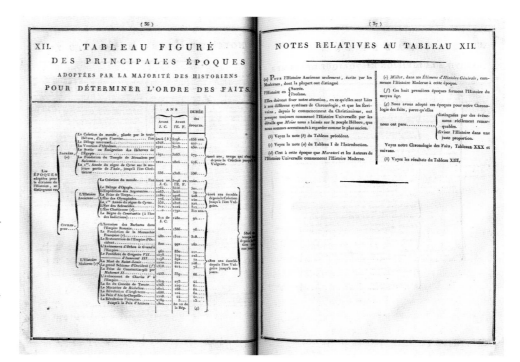

[39]

Pierre-Nicolas Chantreau's table of the principal epochs of human history adopted by the majority of historians for determining the order of facts from his *Science de l'historie* from 1803. Chantreau employs a hierarchical system of organization like that employed in the *Encyclopédie* of Denis Diderot and Jean le Rond d'Alembert.

pass through a series of comparable, if not identical, developments. And his system was designed around this premise. While the graphics of Eusebius and of Priestley allowed for the quick identification of chronological synchronisms, Condorcet's did something different. Instead of showing what was happening at the same time in different places, Condorcet's system showed how different nations and cultures progressed through equivalent stages of social development.[51]

In his outline for a new system of historical notation, Condorcet treated chronology as one of three dimensions of classification, along with two somewhat heterogeneous thematic categories. [*fig.* **38**] In this system, every entry is assigned a historical epoch ranging from one to ten (from hunter-gatherer to modern man), a general subject area (such as the progress of society), and a specific subject (such as legislation or administration). The resulting notations were complicated, not least because the third category of classification was partly dependent on the second (there is, for example, a category for administration under the general subject of politics but not under the arts and sciences). Still, according to Condorcet, classifying historical events in multiple dimensions, in this fashion, had important advantages. It provided an easily cross-referenced database

of historical information, and it facilitated a consistent analysis of cause and effect across many different historical examples.

Condorcet's system could have been represented in a manner similar to that of a Eusebian table, and Condorcet does seem to have contemplated this possibility.[52] But Condorcet's three dimensions lent themselves less readily to graphic representation than did the two dimensions of Priestley and Eusebius. Perhaps Condorcet would have pursued the graphic dimension of his project further had he had access to the three-dimensional projections developed later in the nineteenth century or to the electronic technologies available today that allow the shuffling and reshuffling of data and multiple data projection schemes. Using the tools at his disposal, however, he never arrived at a successful graphic format for his system, and the only artifacts of it that remain are lists of historical events coded with three-dimensional classifying coordinates.

This is not to say that Priestley's approach lacked proponents in France and elsewhere. [*fig.* **39**] At the beginning of the nineteenth century, Pierre-Nicolas Chantreau, for example, promoted Priestley's biographical lines in his theoretical works on the study of history. But, like many French writers, Chantreau remained equally interested in

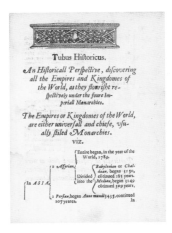

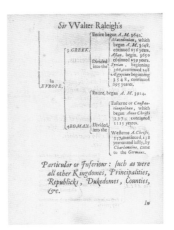

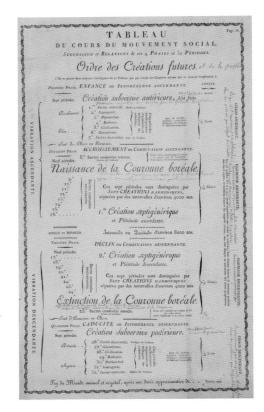

[40–41]

Author unknown, *Tubus Historicus: An Historicall Perspective, Discovering all the Empires and Kingdoms of the World as they flourisht respectively under the foure Imperiall Monarchies*, London, 1636

[42]

Charles Fourier, chart of the four "movements" or stages of history from *Théorie des quatre mouvements et des destinées générales: prospectus et annonce de la découverte*, Lyon, 1808

the possibilities presented by the schematic tree form developed in the sixteenth century by the French humanist Petrus Ramus and widely popularized in the eighteenth century by the *Encyclopédie* of Diderot and d'Alembert. In the sections of his 1803 *Science de l'histoire* (The science of history) that explained the divisions of historical study, he applied these widely. He also used them in his chronological tables themselves to group and subdivide biographical categories.[53]

There were precedents for Chantreau's graphic strategies. Ramist brackets had divided up the different kingdoms of the past in the *Tubus Historicus: An Historicall Perspective; Discovering all the Empires and Kingdoms of the World, as they flourisht respectively under the foure Imperiall Monarchies*, a work falsely ascribed to Walter Raleigh that appeared in 1636. [*figs.* **40–41**] But in a work such as this, designed to illuminate a given eschatological structure, the graphic worked differently. The emphasis here was not on the precise dating of individual events but on the division and sequence of a limited number of chronological periods. Though it works well for eschatology, the form of the encyclopedic tree proved an awkward fit for the regular, mundane work of giving dates to events. But, in France at any rate, the tree format continued to find proponents. Perhaps the last great example of its application

to chronography is the 1808 *Théorie des quatre mouvements* (Theory of four movements) by the French utopian socialist Charles Fourier, another four-stage schema of history. In adopting the tree format for his chronographic chart, Fourier was clearly trying to appeal to the prestige of the encyclopedic model. He was also doing what he did best, confecting social systems.

Fourier claimed that human history—from its foggy prehistoric beginnings to its eventual end—would last approximately eighty thousand years in total. [*fig.* **42**] Along the way, it would go through four major stages or "movements," with movements one and four each enduring for five thousand years, and two and three, thirty-five thousand years. The first and last stages, he said, would both be periods of misery, the second and third, of enjoyment. In Fourier's view, the world of 1808 had lots of problems, but its long-term prognosis was good: according to his scheme, humanity was just finishing the first historical movement. After five thousand years of near universal misery, it was at last entering the first period of social happiness. All of this, he hoped, would put the difficulties of present life in perspective. "The immensity of our suffering," Fourier wrote, "can only be assessed when one understands the excess of happiness in store for us, to which state we shall

Auguste Comte, *Calendrier positiviste,*
from *Catéchisme positiviste*, Paris, 1852

rapidly pass."⁵⁴ This happy state, Fourier said, would bring social and sexual harmony, and human industry so powerful that it would literally melt the polar ice caps. We did not have long to wait, said Fourier, before the climate in St. Petersburg would resemble that of Sicily. Sadly, of all of Fourier's predictions (seas full of lemonade, zebra taxis) this one currently seems most likely.

In 1849, the Positivist philosopher Auguste Comte came up with yet another bold schema for history. Comte's thirteen-month *Calendrier positiviste* (Positivist calendar) was not principally intended as a graphic. [*figs.* 43–44] It was what it called itself, a calendar designed to organize reflection and historical memory, and to replace extant religious calendars—positivism was also a religion for Comte. But, while Comte's calendar cycled through a yearly set of observances, like the Catholic and Protestant calendars it aimed to replace, it also followed the linear order of history. The first of the thirteen months of the positivist calendar, named for Moses, memorialized the ancient heroes of positivism, such as Lycurgus, Zoroaster, and Confucius; the thirteenth month, named after the French anatomist Marie François Xavier Bichat, memorialized the heroes of modern times, such as Copernicus, Newton, and Priestley. Like Fourier's system, Comte's demonstrates the heterogeneity

of chronographic visions in modernity and the persistence of traditional temporal structures in an age of progress.

In Germany and Austria, too, Priestley's unrelenting emphasis on regular measured chronology met some resistance. [*fig.* 45] In 1804, for example, the chronologer Friedrich Strass published a highly influential chart entitled *Strom der Zeiten* (Stream of time), a work translated into several languages, including English and Russian, and referenced in numerous historical works. Like Priestley, Strass believed that a graphic representation of history held manifold advantages over a textual one: it revealed order, scale, and synchronism simply and without the trouble of memorization and calculation. But according to Strass's English translator, William Bell, the "equisecular" or geometrically regular organization of Priestley's charts implied a uniformity in the processes of history that was simply misleading.⁵⁵ Strass resisted, in a fashion consistent with the rhetoric of Romantic historiography, equating order with measurement. As William Bell put it,

However natural it may be to assist the perceptive faculty, in its assumption of abstract time, by the idea of a line…it is astonishing that…the image of a Stream should not have presented itself to any one….The expressions of gliding,

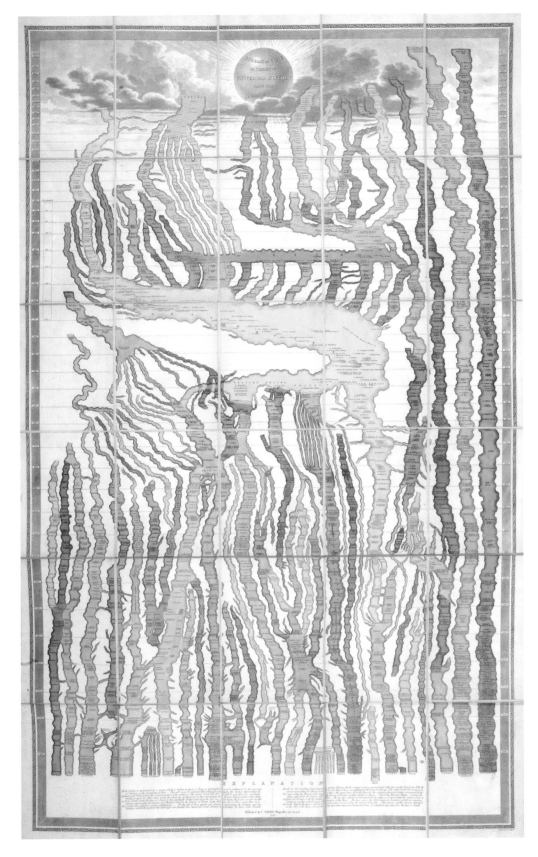

[45]

William Bell, English translation
of Friedrich Strass's 1804 *Strom der
Zeiten*, London, 1849

Stephen and Daniel Dod's *A Chronological, Historical, and Biographical Chart* from 1807 resembles Friedrich Strass's *Strom der Zeiten* but takes the form of a tree growing up rather than a stream flowing down. Priestley's name figures on the Dods' chart on the biographical branch at the upper right.

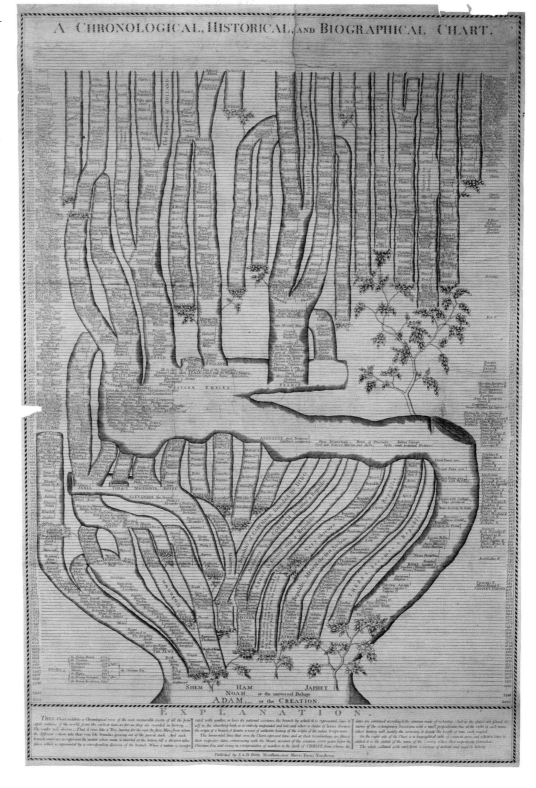

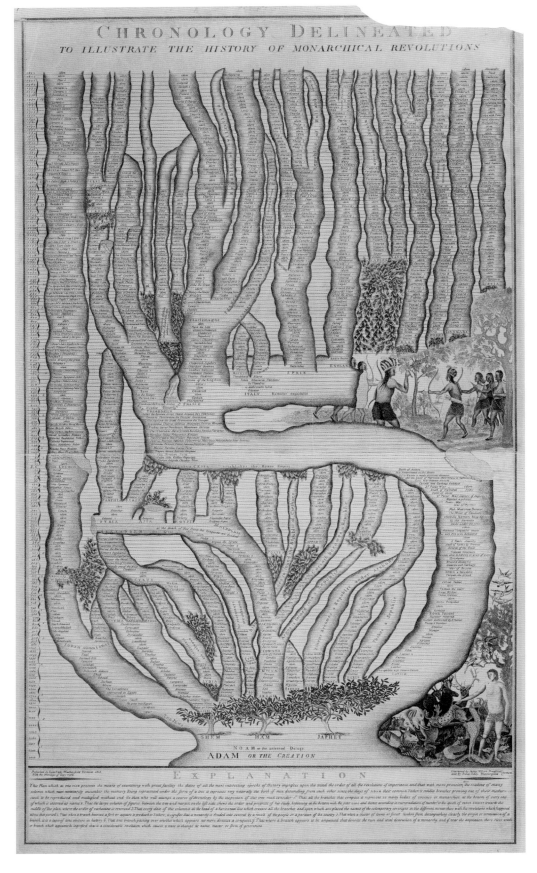

In many cases precise authorship of chronological charts is difficult to establish. Typically these works were the result of a collaboration among writers, engravers, and publishers, and new charts often relied heavily on older ones. In 1812 the pioneering printer Isaac Eddy produced the first Vermont Bible. The following year, in collaboration with the globe-maker James Wilson, Eddy published a chart entitled *Chronology Delineated to Illustrate the History of Monarchical Revolutions.* The form of the Vermont chart closely resembles the chart of Stephen and Daniel Dod, though the content, framing, and illustrations differ.

and rolling on; or of the rapid current, applied to time, are equally familiar to us with those of long and short. Neither does it require any great discernment to trace…in the rise and fall of empire, an allusion to the source of a river, and to the increasing rapidity of its current, in proportion with the declivity of their channels towards the engulfing ocean. Nay, this metaphor…gives greater liveliness to the ideas, and impresses events more forcibly upon the mind, than the stiff regularity of the straight line. Its diversified power likewise of separating the various currents into subordinate branches, or of uniting them into one vast ocean of power…tends to render the idea by its beauty more attractive, by its simplicity more perspicuous, and by its resemblance more consistent.[56]

History, for Strass and Bell, was a kind of knowledge about the past, not merely a set of recorded facts. Accordingly, while the framing structure of Strass's chart retains the general feel of Jefferys and Priestley, its representation of history itself looks entirely different. The *Strom der Zeiten* originates in a storm at the top of his great broadside. In it, events ebb and flow, fork and twist, run and roll and thunder. Mercator would have been fascinated to see his modest efforts at changing the rate of time's passage transformed into so grand and flexible a visual metaphor.

Strass was not the only chart maker to take such a tack. Whether in the form of a stream (usually descending) or a tree (usually ascending), similar visual schemes appeared everywhere in the nineteenth century. [*figs.* **46–47**] Only a few years after the first publication of *Strom der Zeiten*, two notable New Jersey inventors, the brothers Daniel and Stephen Dod, made a similar chart, though theirs was based on a tree. American charts such as that of the Dods were more ephemeral than their European counterparts. They were also, often, rougher around the edges. Though wonderful in itself, the Dod chart is best remembered not for its own qualities but because of the renown of its creators. Stephen and Daniel Dod were sons of the American clock maker Lebbeus Dod, whose skills were put to armaments during the Revolutionary War. Stephen was a noted surveyor and served as mayor of Newark. Daniel designed and built the steam engine for the *Savannah*, the first American steamship to cross the Atlantic. But the Dods' chart itself had some influence in the United States, and in 1813 a new version was prepared by the widely known Vermont printer and engraver Isaac Eddy and the globemaker James Wilson.

The stream chart continued to be popular throughout the nineteenth century. [*figs.* **48–50**] In Connecticut in 1806,

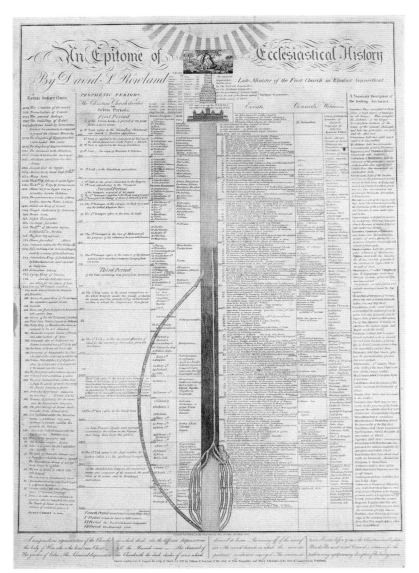

In 1883, after retiring from forty years of military service in India, the British Major-General James George Roche Forlong published a thick three-volume work on the development of world religions entitled *Rivers of Life, or, Sources and Streams of the Faiths of Man in All Lands; Showing the Evolution of Faiths from the Rudest Symbolisms to the Latest Spiritual Developments*. Forlong's work came with a seven-and-a-half foot colored chart of "faith streams" demonstrating his vision of the interconnectedness of world religions.

[48]

The visual metaphor of the stream was sometimes integrated into a larger tabular framework as in the 1806 *Epitome of Ecclesiastical History* by David Rowland, the Congregationalist minister of the First Church of Windsor, Connecticut. In Rowland's diagram, the central stream of Christianity becomes murky with the "dark shades of error" during the Middle Ages, with only a thin, clear channel of dissent running through. During the Protestant Reformation, several dissenting channels separate from and then rejoin the main stream of Christianity.

[49]

The English abolitionist Thomas Clarkson included a stream chart in his 1808 *The History of the Rise, Progress, and Accomplishment of the Abolition of the African Slave-Trade by the British Parliament*. Here the early supporters of abolition are represented as "springs and rivulets" contributing to two great political rivers representing the abolitionist movement in England and in America. This is the 1836 New York edition.

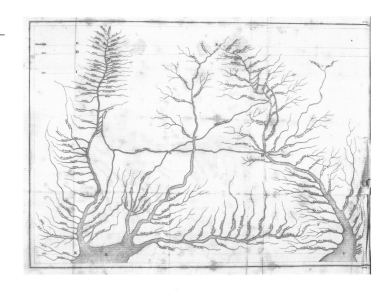

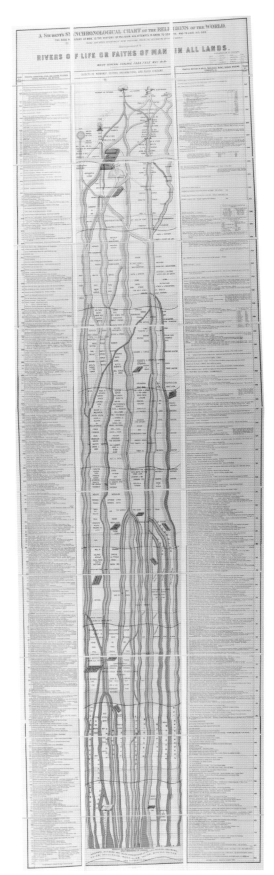

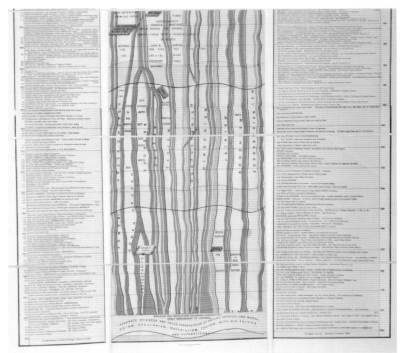

the Congregationalist minister David Rowland used the stream metaphor rather than the standard Eusebian format in his *Epitome of Ecclesiastical History*. Thomas Clarkson's 1808 *The History of the Rise, Progress, and Accomplishment of the Abolition of the African Slave-Trade by the British Parliament* used the stream metaphor as well, as did the 1883 ethnography of world religion by James George Roche Forlong—who competes with Temporarius for best-named chronologist—*Rivers of Life, or, Sources and Streams of the Faiths of Man in All Lands; Showing the Evolution of Faiths from the Rudest Symbolisms to the Latest Spiritual Developments.*

Nonetheless, with time, the conventions of the stream chart and the linear chronology tended to converge. Despite William Bell's protest, during the nineteenth century it was typical for such charts to employ some version of the "equisecular" format that Priestley had popularized. Though their internal conventions were different, their framing structures more and more resembled the regular, measured format of the timeline that was already ubiquitous only a few decades after it had first appeared.

Frontier Lines

The United States proved fertile ground for time charts. In the eighteenth and nineteenth centuries, American chronographers published a vast and diverse array of diagrams. Some were adopted directly from European sources, but many were homegrown, reflecting American circumstances, and implicitly or explicitly asserting the parity of American history with the history of Europe. Others amplified themes of scientific innovation, novelty and progress, and the apocalyptic visual vocabularies of the great revivals.

In America as in Europe, Priestley's time charts quickly changed the field of historical graphics. [*fig.* 1] And this is hardly surprising; Priestley's career was closely followed in the United States, and many of his works left a substantial mark. When Priestley fled from political and religious persecution in England in 1794, he went to Pennsylvania. But, already in the 1760s, he was closely associated with American intellectuals including Benjamin Franklin, who nominated him to the Royal Society of London in 1766 as the author of the *Chart of Biography*. Thomas Jefferson too was an admirer, and like Franklin, he took an interest in the chart forms that Priestley developed. Jefferson's papers include a chart of the market seasons of Washington DC done in the form of the *Chart of Biography*, only there, the straws floating on the river of time indicate the harvest seasons of parsley, endive, and watermelon rather than the life spans of Newton, Huygens, and Galileo.

To a revolutionary generation intent on inscribing itself in history, the Priestley charts seem to have had an almost talismanic appeal. [*fig.* 2] In 1811, David Ramsay, a physician and a member of the Continental Congress, published his stunning *Historical and Biographical Chart of the United States* as a "short-hand symbolical mode of conveying knowledge" to accompany his book *Universal History Americanised.*[1] Ramsay acknowledged Priestley directly, specified changes appropriate to the American context, and suggested that his model be widely copied. His was also one of the first charts to explicitly combine the logic of Priestley's historical and biographical charts into a single work.

In North America, chronographic forms moved west with Europeans, employed as tools for the propagation of both political and religious visions of history. A prime example may be found in the graphic work of François Norbert Blanchet, the first Catholic archbishop of Oregon. After his ordination in 1819 in Quebec, Blanchet was sent to the Gaspe Peninsula in Nova Scotia to serve as pastor to the Acadian settlers and to the Mi'kmaq people,

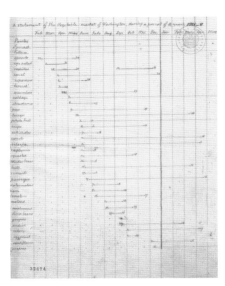

[1]

Author unknown, *Chart of the seasonal availability of produce in the vegetable market of Washington, D.C. during the years 1801–08*, preserved in Thomas Jefferson's papers

an eastern Algonquin tribe among whom the Catholic Church had worked for two centuries. In 1838, church officials gave Blanchet a new mission. He was to travel to the Oregon Territory under the protection of the Hudson's Bay Company to minister to the *voyageurs*, the French-Canadian frontiersmen who formed the backbone of the Northwest fur trade. Though ignorant of native Northwestern languages and cultures, Blanchet also set out to make Christians of the local tribes, a project that required explaining the Christian story—a feat he managed with the aid of lively performances, interpreters, and the Sahale Stick, a curious chronological tool of his own devising.

The Sahale Stick ("spirit stick" in the Chinook jargon)— a wooden rod marked out at intervals with slashes representing years and gouges for important events in Christian history—was used to teach both catechism and history. [*figs.* 3–4] And, from Blanchet's account, it seemed to work: according to Blanchet, during the first months that he preached with it in the Willamette Valley, he received visitors from all over the Northwest requesting copies. Within two years, the simple Sahale Stick gave way to a more elaborate manuscript scroll called the *Catholic Ladder*. Demand for the manuscript was strong, and soon Blanchet sent for a group of nuns to come to Oregon to serve as copyists. Over

the course of the next half century, the *Ladder* proved an enduring success, spawning many imitations, and within a couple of decades, printed versions had been published in Quebec, Paris, Brussels, New York, and Valparaiso, Chile, as well as in Oregon itself.[2]

In the Oregon Territory in the 1840s, tensions between Protestants and Catholics ran high, as did competition for Native American souls, and Blanchet was not without opponents. [*figs.* 5–7] The most vocal among these was Henry Harmon Spalding, a Presbyterian missionary sent to Oregon from upstate New York by the American Board of Commissioners for Foreign Missions in 1836, along with his wife, Eliza Hart Spalding, and another couple, the ill-fated Marcus and Narcissa Whitman—whose violent deaths, known as the Whitman Massacre, would long remain a central part of American frontier mythology. For nearly thirty years, Spalding campaigned against Blanchet in the press, portraying him as the scheming force behind Native American hostility toward the Protestant missions. But even before Henry's jeremiad, Eliza Spalding had begun a campaign of her own.[3] Teaching at the mission at Lapwai, near what is now Lewiston, Idaho, while Henry conducted services and tended to the mission press and farm, Eliza used many of her own visual aids, most

A Map
HISTORICAL
and
BIOGRAPHICAL
CHART.
of the
UNITED STATES
by
DAVID RAMSAY. M.D.
Copy right secured.

America is transplanted Europe. The white population of that part of it which is now called the United States, was for the most part originally derived from England, Ireland, Scotland, Germany, France, Holland, Sweden, Denmark, and Switzerland. An ardent love for civil liberty, and free religion, allured—while persecution, oppression, poverty, and distress, drove most of the first settlers from the Old to the New World. They settled down on bare creation; and amidst many dangers and privations, turned a wilderness into cultivated fields. They had to defend themselves against the French in the north, the Dutch in the middle, the Spaniards in the south, and the Indians on all sides. Amidst a host of difficulties, they spread themselves over the country, from the Atlantic to the mountains; and co-extensively planted in the woods the seeds of religion, liberty, learning, and useful arts. They struggled through a distressful infancy, without any aid from the mother country, and grew up a hardy, enterprising race, jealous of their rights—in possession of liberty—and with an ardent love of it in their hearts. When they had grown to consequence, their European Sovereigns of the Stuart line, strove to wrest from them their charters, and to annihilate their liberties. The revolution of England in 1688, arrested these arbitrary measures; but it was followed by a succession of wars of European origin. France and England, after deluging Europe with blood for several centuries, began fiercely to contend for American territory. In these wars the Indians were assisted and rewarded for laying waste the frontiers of the Colonies, and butchering their inhabitants. After 73 years, (or from 1690 to 1763) half of which was spent in hostility, England gained undisturbed possession of nearly the whole continent north of the Gulf of Mexico. She then began to tax the Colonies by authority of her Parliament, though not represented therein—to deprive them of their property—to mutilate their charters—and both in theory and practice "to bind them in all cases whatsoever." By these measures she drove them to renounce her government, and to proclaim themselves Independent. For 8 years a bloody war raged between the parties—one urging subjugation, the other contending for self-government. Men from the plough, the shop, and the counter, animated with the inspiration of liberty, became soldiers, and led on by Washington under the smiles of heaven, successfully contended with the veteran armies of Britain till her rulers acknowledged the

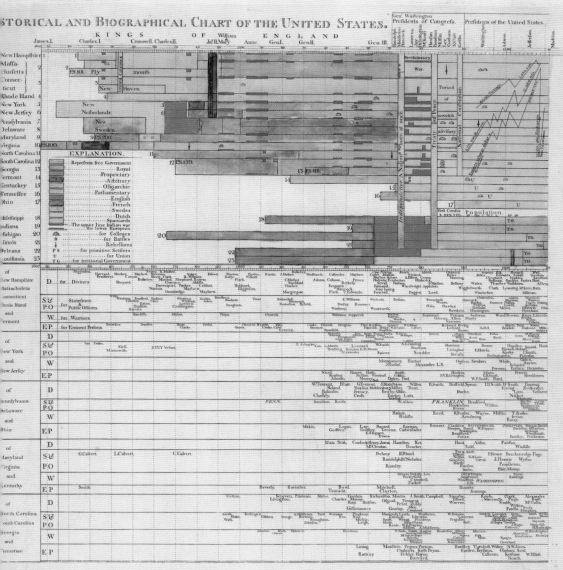

[2]

In 1811 the South Carolina physician, historian, and politician David Ramsay published a *Historical and Biographical Chart of the United States* to accompany his *Universal History Americanised.* Ramsay's striking work combined a map of the former British colonies and diagrams modeled on those of Joseph Priestley and William Playfair.

se Independent States. But liberty without an efficient government did not se-
itical happiness. To ensure this important object the States severally establish-
sentative governments, by which every right and every benefit attainable by man
t imperfect state, was as far as possible ensured and improved.——A system of
as established in this western continent among a new but enlightened people, more
civil and religious liberty and consequently to mental improvement, than the world
law. A union of all the States by an efficient national compact was still wanting.
perience of six years had proved that the confederation hastily adopted amidst the
was incompetent to the public exigencies, the people in conventions, magnanim-
ishing some of their personal rights and a portion of their State sovereignty, or-
nal constitution with adequate powers for advancing all the legitimate objects of a
nment. The interests, rights, and liberties of each separate State, were thus ef-
wisdom, and guarantied by the strength of the whole. This system was put
a by Washington, first in peace as well as first in war. A surprising change for

the better was the immediate consequence. The United States rapidly emerged from the depth of depression, and rose to a high pitch of national happiness. After this had been enjoyed for some years Europe again began to be convulsed with wars. The humble request of the Americans "to be let alone," virtually addressed both to England and France, was granted by neither. They would not permit the United States to be neutral; but in violation of the laws of nations, and the principles of eternal justice, attacked their legal neutral commerce in a suc-cession of decrees and orders, each more injurious than what had preceded, and all without provocation on the part of the United States. The violence of the nations at war was so hos-tile to a commercial intercourse with Europe as to force the United States to pursue their own interest by the institution of domestic manufactories. These in a few years have advanced so rapidly, that the citizens are at present in a fair way of supplying all their wants from domestic resources—of acquiring complete independence—and of gaining an exemption from all parti-cipation in the troubles, follies, and wars of Europe.

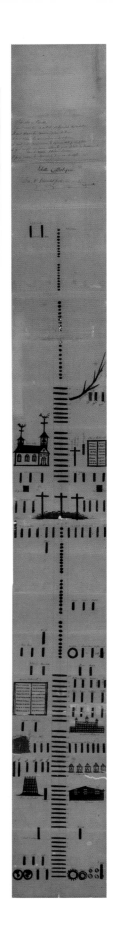

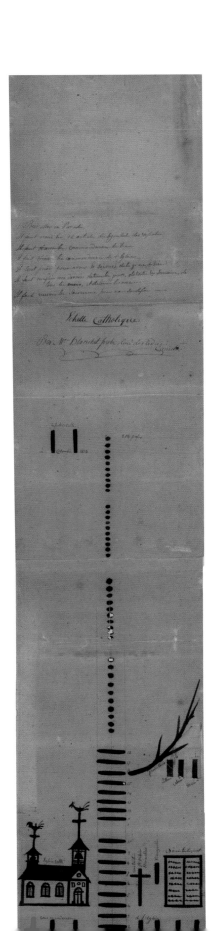

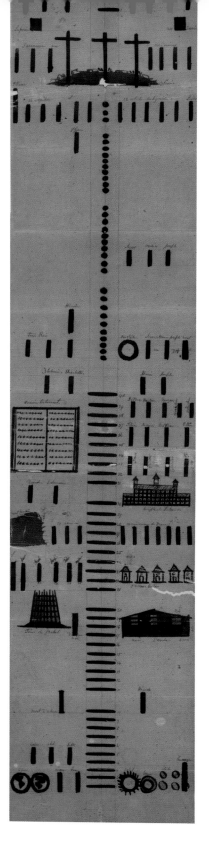

This restored 1840 *Catholic Ladder*, designed by the French Canadian Catholic priest François Norbert Blanchet in 1839, is the oldest known in existence. Blanchet described it as a "visual catechism," a graphic tool combining chronographic and symbolic elements to teach basic Christian concepts. At the bottom are pictorial symbols for the Creation and the universe including the sun, the stars, and the earth. Higher up are symbols for the Tower of Babel, Noah's Ark, and the Old and New Testaments, the Catholic Church, and other key Christian references. Simple vertical marks on the chart indicate important people (such as John the Baptist) and ideas (such as the seven sacraments). A central column of horizontal bars represents centuries since the Creation. Two series of dots indicate single years: the first, the years of the life of Christ; the second, the years since 1800. Two vertical bars at the top left of the chart represent Blanchet and his colleague Modeste Demers, the first two Catholic missionaries to settle in Oregon. A branch at the center right above the three vertical bars for Luther, Calvin, and Henry VIII, indicates the Protestant Reformation. That branch was the subject of heated controversy in Oregon in the 1840s and after. Protestant missionaries, including Henry Harmon Spalding, considered it an insult and believed that it was used to incite Native American suspicion and hatred toward the Protestant missions.

Nicolas Point, S. J. *Ambrose Instructs a Blackfeet Chief with the Ladder*, St. Louis, ca. 1841–47

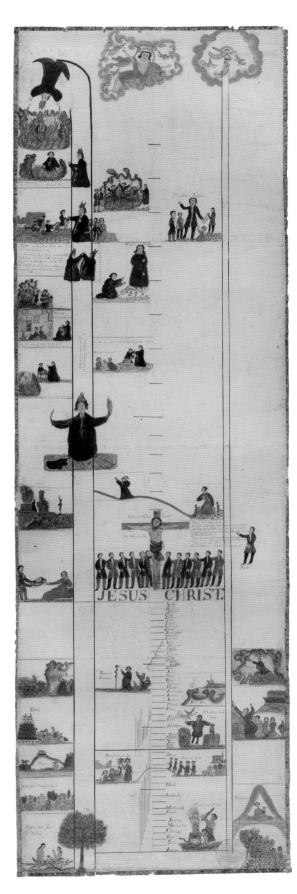

This pictorially vivid *Protestant Ladder* was painted by the Presbyterian missionary Eliza Hart Spalding around 1845 at the Lapwai Mission in the Oregon Territory near present-day Lewiston, Idaho. In contrast to the *Catholic Ladder*, which emphasizes a single Catholic story, Spalding's *Protestant Ladder* is designed to emphasize the difference between Protestant and Catholic Christianity. Like the *Catholic Ladder*, Spalding's is structured around a central chronology. Vertical lines near the bottom of the chart show the lives of biblical figures from Adam to Christ in the style of Priestley.

[6]

Eliza Hart Spalding, the Pope cast down from the *Protestant Ladder*, Oregon Territory, ca. 1845

[7]

Eliza Hart Spalding, biographical lines from the *Protestant Ladder*, Oregon Territory, ca. 1845

[8]

Lakota Winter Count for the years 1801–72 depicted in Garrick Mallery, *Picture-Writing of the American Indians*, Washington, D.C., 1893. This lithograph was copied in 1876 from the painted buffalo robe of Lone Dog from the Yanktonais tribe. On the robe a series of symbols proceed outward in a spiral from a central point. Each represents a distinguishing event of one year. Mallery speculates that the periodization of the robe reflects the Western practice of counting centuries. The earliest character on the robe represents the killing of a number of Lakotas by their enemies. Later symbols indicate an outbreak of smallpox, the capture of wild horses, and other notable happenings.

famously, an inflammatory *Protestant Ladder* drawn up in direct competition with Blanchet's device.[4]

In the Spaldings' view, the *Catholic Ladder*, which showed the history of the Reformation as a deviating branch off of the central trunk of Christianity, was a direct attack. They accused the Catholic priests in Oregon of using the *Catholic Ladder* to demonize them, and of instigating rumors that the Protestant missionaries had intentionally brought diseases to decimate native peoples. "My attention," Henry Spalding wrote in the *Oregon American*, "has suddenly been arrested by the outcries and wailings of a whole camp [of Native Americans], occasioned by the arrival of some one with an additional explanation of the Catholic ladder, always accompanied by the declaration, 'The Americans are causing us to die!'"[5] And with Eliza Spalding's *Protestant Ladder*, the symbolic ante was upped substantially. On it, the martyrdom of Protestants was memorialized in primitive but vivid tableaux, while the Pope was portrayed as an Antichrist, falling into the flames of perdition. Ironically, here in a Protestant chronography many old pictorial devices found new life.

Neither the *Catholic Ladder* nor the *Protestant Ladder* was intended as academic chronology. These were religious teaching tools, and they served many functions—Blanchet

called his a "visual catechism"—which makes it that much more notable to find the graphic conventions of the chronologists at work in them. Eliza Spalding's *Protestant Ladder* even includes classic Priestley-style biographical lines for the lives of biblical figures. In later years, it was sometimes disputed whether Blanchet or Spalding had first invented the ladder idea, but either way, the result was the same: here, at the cutting edge of the American expansionist project—which many took to be the cutting edge of history itself—the timeline had already taken its place.

Wherever Europeans went in the nineteenth century, chronological projects followed, whether as projections of imperial power, eschatological expectation, or ethnographic curiosity. But not all of the famous nineteenth-century American chronographies were European in origin. In the Great Lakes region and in the Dakotas, for example, Native Americans and Europeans appropriated one another's visual and conceptual languages in striking ways, as in the pictographic chronologies of the Lakota people known as "winter counts."[6] [*fig.* 8] The winter counts were appealing to collectors both for their beauty and for their historical content, and they formed a key piece of evidence for Garrick Mallery's sweeping ethnographic accounts of Indian "picture writing" published in the 1870s and '80s.[7] Mallery, an

[9]

Portrait of the Winnebago chief
Tshi-zun-hau-kau holding a calendar
stick marked with lunar cycles
(1827) after James Otto Lewis, from
Thomas Loraine McKenney, *History
of the Indian Tribes of North America*,
Philadelphia, 1836–38

[10]

Joseph Mede's apocalyptic chart
from the 1632 second Latin edition
of *Clavis apocalyptica ex innatis et
insitis visionum characteribus eruta et
demonstrata* diagrammed the order of
the end times as described in scripture.
Though Mede emphasized the spiritual
rather than the strictly chronological
character of the Apocalypse, his
works inspired many chronologically
specific interpretations. A mark of
its significance during the English
Revolution: the *Clavis apocalyptica* was
translated into English in 1641 at the
behest of Parliament.

army general who served in the Dakotas in the 1870s and
later in Washington, for the Bureau of Ethnology, found
evidence of longstanding Native American systems of tem-
poral notation. Some of these, like the winter counts, were
pictographic; others used notches and lines. [*fig.* **9**] The lat-
ter was also noticed by the American portraitist James Otto
Lewis, who—a decade before Blanchet debuted his Sahale
Stick—portrayed the Winnebago chief Tshi-zun-hau-kau
holding a calendar stick with very much the same look as
Blanchet's.[8]

In America, some of the most inventive chronogra-
phers of the nineteenth century came from the millennial-
ist camp. Many of their charts and diagrams, like those of
Eliza Spalding, recalled medieval and early modern pre-
cedents such as the diagrams of the twelfth-century Italian
mystic Joachim of Fiore and the seventeenth-century
English scholar Joseph Mede. Like their predecessors, the
millennialists blended figurative and technical elements in
dazzling ways. They had a lot to live up to. Already, in the
thirteenth century, the followers of Joachim of Fiore pro-
duced dozens of distinctive visualizations of eschatological
chronology. These took the form of trees, interlocking rings,
and other vibrant images. The figural logic behind these
representations was complex.[9] Joachim's trees, for example,

were not merely figures of history. They were also templates
for calculation, with columns of triple exes inscribed on
their trunks representing the number of generations (each
estimated at thirty years) separating the Creation from the
Apocalypse.

The production of apocalyptic diagrams during the
late Middle Ages and the early modern period waxed and
waned with millennial enthusiasms. Joachim's patterns were
often repeated and popular figures such as those of Daniel's
statue were periodically revived in new forms, though the
final transformation that they promised was deferred over
and over again. With each revival, religious controversy
drove graphic innovation, as scholars and polemicists across
the religious spectrum searched for better tools to express
complex ideas. [*fig.* **10**] The influential diagram mapping
the opening of the seven seals of the Apocalypse from the
1627 *Clavis apocalyptica* (Key of Revelation) by the noted
Cambridge Hebraist, Joseph Mede, tutor to John Milton
and Henry Moore, gives a fine example of the new graphic
experimentation spurred by the religious ferment of the
sixteenth and seventeenth centuries. Though Mede's work
placed no date on the coming millennium, his apocalyptics
influenced the political and social visions of the English
Revolution, and his work was translated into English in

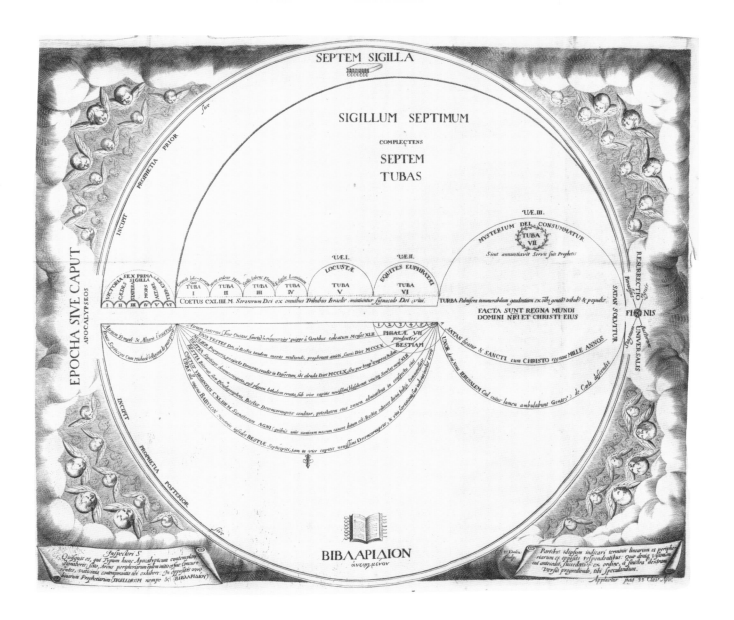

[11]

J. Pearson's *Historical and Astronomical Diagram* from 1846 is marked out at regular one-year intervals from 31 BCE to 37 CE. Pearson strives to correct William Miller's apocalyptic calculations by establishing the precise dates of Christ's life from historical data on eclipses of the sun. According to Pearson, the evidence was "exceeding strong" that the Second Advent would come in the fall of 1846. "Reader, *are you prepared*?"

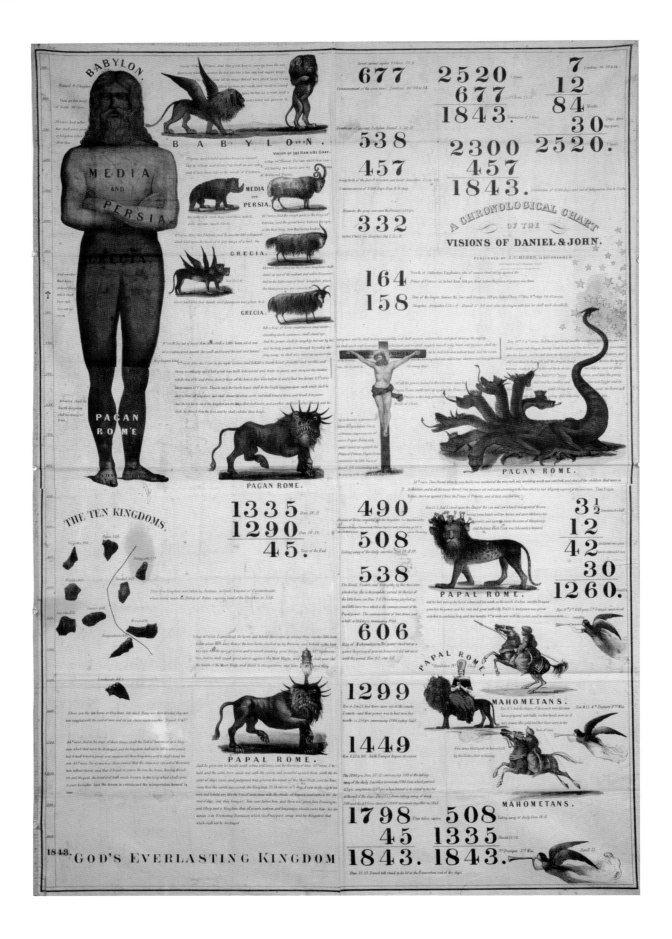

Millerite charts such as *A Chronological Chart of the Visions of Daniel and John*, printed by Joshua Himes in 1842, integrated the visual logic of the timeline, chronological calculus, and apocalyptic symbolism in a single scheme. The final date in the left-hand column, 1843, indicates the coming end of the world.

1641 at the behest of Parliament. As late as the 1720s, no less a figure than Sir Isaac Newton would cite Mede as a central reference. Like many of the Joachimite diagrams, Mede's combines circles and lines in surprising ways, emphasizing at once the repetition of God's signs in history and the inexorable fact of the judgment, which Mede indicates with a bold "Finis."

In the new American republic, pamphleteers and politicians claimed that they were bringing a new period of world history into being. Even the country's currency promised as much, with an apocalyptic quotation from Virgil's fourth *Eclogue*, *novus ordo seclorum* (A new order of the ages). Many understood the new American age as the last act of history and reconfigured the existing repertoire of apocalyptic patterns to prove it.[10] Again, millennial controversies bred millennial graphics, and this time around, cheap print further fueled the graphic explosion.

Some American religious revivals of the period were particularly innovative in their graphics. [*figs.* **11–13**] From the 1830s, for example, followers of the New England minister William Miller produced stirring books, broadsides, pamphlets, and newspapers, to spread the word of the coming Apocalypse—which Miller predicted for 1843. And they organized popular camp meetings at which many of these

graphics were distributed and displayed. At the center of all of this activity was the chronographic chart. Millerite charts took many forms. Some drew on the commonplace visual vocabulary of the timeline, echoing the sober terms in which Miller discussed his chronological and philological methods.[11] Others were festooned with layers of calculation that served at once as argument and embellishment. Still others combined vivid symbolic images with numerical calculations. The most spectacular Millerite charts were printed on giant cloth banners hung from the tents where Miller preached.[12]

The effect of these camp meetings was powerful, and as John Greenleaf Whittier observed in his essay, "The World's End," so was that of the charts. Whittier writes,

> Three or four years ago, on my way eastward, I spent an hour or two at a camp-ground of the Second Advent in East Kingston. The spot was well chosen. A tall growth of pine and hemlock threw its melancholy shadow over the multitude, who were arranged upon rough seats of boards and logs.... Suspended from the front of the rude pulpit were two broad sheets of canvas, upon one of which was the figure of a man, the head of gold, the breast and arms of silver, the belly of brass, the legs of iron, and feet of clay,—the dream of

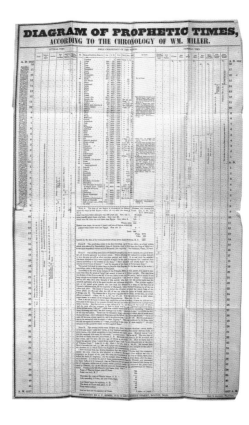

The *Diagram of Prophetic Times, According to the Chronology of Wm. Miller*, a Millerite chart published in 1843 as a folded insert in Apollos Hale's *Second Advent Manual*, consists of a vertical tally of the centuries since the presumed date of Creation in 4157 BCE. The center column lists important biblical events and their dates given in the years of the world (1–6000) in the years before and after Christ (4157 BCE to 1843 CE), and in terms of the ages of the patriarchs. Of the two columns to either side, one lists events described literally in scripture (the Flood), the other lists events described in symbolic terms (the 2300 Days of Daniel). Events predicted in scripture are distinguished from those given as history.

Nebuchadnezzar. On the other were depicted the wonders of the Apocalyptic vision,—the beasts, the dragons, the scarlet woman seen by the seer of Patmos, Oriental types, figures, and mystic symbols, translated into staring Yankee realities, and exhibited like the beasts of a travelling menagerie. One horrible image, with its hideous heads and scaly caudal extremity, reminded me of the tremendous line of Milton, who, in speaking of the same evil dragon, describes him as "Swindging [*sic*] the scaly horrors of his folded tail."[13]

The Millerite repertoire included a wide variety of symbolic displays, many of which drew directly on centuries-old traditions. These charts had an intrinsically chronological structure, like their medieval and early modern precedents, but here the chronographic element was foregrounded, with vivid apocalyptic images inscribed inside measured frames of historical time.

In the Millerite charts, of course, the frame was symbolic too. The end lines of Priestley's chart, at 1200 BCE and 1800 CE, had no intrinsic significance. The date 1800 CE was just a round number coming up in the near future, and 1200 BCE, the date three thousand years before. The darkly inked margins of the Millerite *Chronological Chart of the Visions of Daniel and John* of 1842, however, could not have been

more significant. They marked the beginning and end of history itself. In charts like this, the course of time looked straightforward from both a graphic and a conceptual standpoint: the end was fixed, known, and almost upon us. But when 1843 came and went without incident, and then 1844 too—a nonevent henceforth known as "The Great Disappointment"—both Miller's predictions and his chronology charts had to be radically revised. During the next decade, many attempts were made to clean up the theological and the graphic mess that 1843 had brought about. [*fig.* **14**] But many of these new charts suffered the same fate as the earlier ones, when their own predictions failed to pan out, as was the case with the beautiful and curious *Prophetic Chart* published by the Adventist minister Jonathan Cummings, predicting that Christ would return in 1854.

In the following decades, many of the factions that emerged from the ashes of Millerism did away with date-specific predictions of the Apocalypse. [*figs.* **15–17**] But, even among these groups, interest in chronology and chronological charts persisted. In 1866, for example, the New York Presbyterian preacher Richard Cunningham Shimeall included in his book, *The Political Economy of Prophecy*, a chart of history that looked virtually identical to Priestley's.[14] Decades earlier in the 1830s, Shimeall, a jack of all graphic

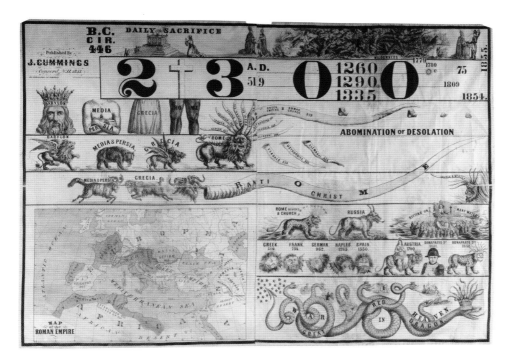

In 1853 Jonathan Cummings, one of the founders of the Advent Christian Association, published his stunning *Prophetic Chart* publicizing a new calculation of the date of the coming Apocalypse in 1854. Like Millerite charts of the previous decade, Cummings's chart mixes words, numbers, and symbolic images, but it omits a regular chronological scale.

A Chart Illustrating the Course of Empire from the Earliest Records, Sacred and Profane, Down to the Present Time, published by the Presbyterian minister Richard Cunningham Shimeall in his provocatively titled *Political Economy of Prophecy* from 1866, employs a secular visual vocabulary in an account of the relationship between the kingdoms of biblical prophecy and those of recorded history.

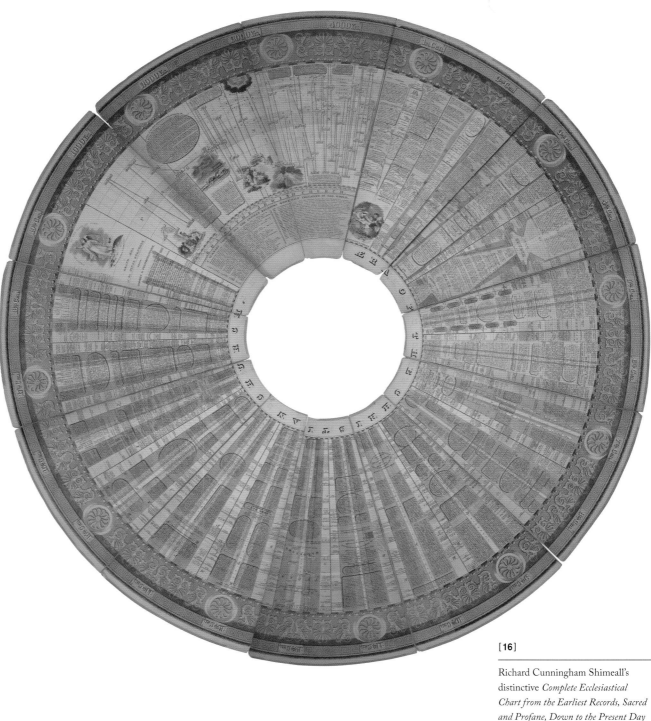

[16]

Richard Cunningham Shimeall's
distinctive *Complete Ecclesiastical
Chart from the Earliest Records, Sacred
and Profane, Down to the Present Day*
from 1833 is a circle in which radial
columns represent centuries from the
Creation to the Apocalypse.

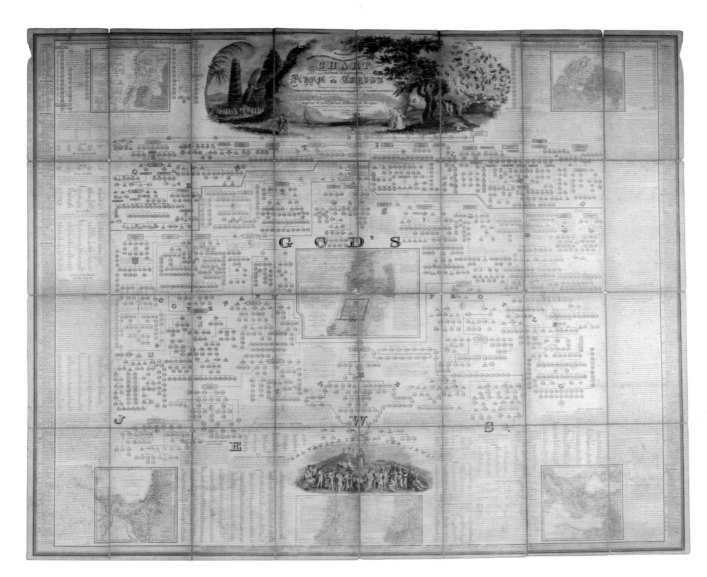

[17]

In 1832 Richard Cunningham
Shimeall published this dense and
colorful chart of the first ages of
the world combining genealogies,
maps, illustrations, and chronological
lists, and called it *A Complete
Historical Chronological Geographical
& Genealogical Chart of the Sacred
Scriptures from Adam to Christ.*

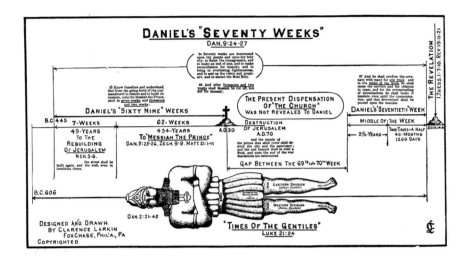

Throughout the twentieth century, traditions of apocalyptic graphics have been steadfastly maintained by scriptural exegetes of many persuasions. Among the most reprinted charts are those in the 1918 volume *Dispensational Truth* by the Pennsylvanian draftsman-turned-Baptist-minister, Clarence Larkin.

[19]

Victor Houteff's *Zech. 6:1–8: The Church to, and Back From the Wilderness: Her Prophetic History by Unmistakable Symbols* from 1933 represents the four chariots described in Zechariah, which Houteff associates with stages in the history of Christianity, culminating in the prophecies of William Miller in 1798 and the formation of the Seventh Day Adventists after the millenial disappointments of 1843 and 1844. Houteff's illustrations organize symbolic representations around a chronologcal scheme.

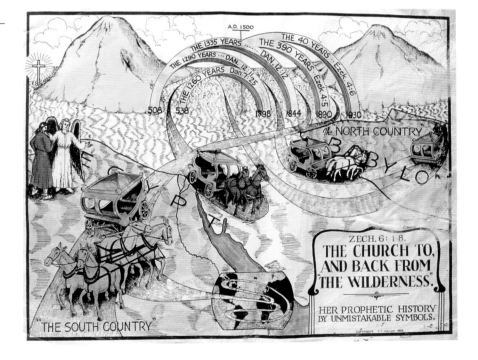

[20]

An Elementary Chart being a model or exemplification of Henry Bostwick's Improvement called A New Method of representing by lines consistent with a Scale of Time the Kindred, Genealogy, Chronology, and Succession of Persons distinguished in History & Fable, in Bostwick's *A Historical and Classical Atlas,* New York, 1826

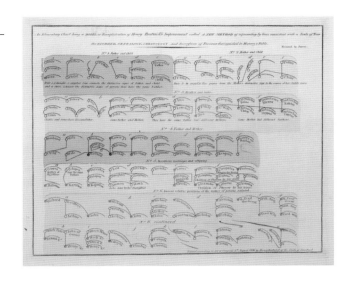

trades, had produced a massive genealogy of biblical figures, and a circular chart of history recalling the *Discus chronologicus* of the eighteenth-century engraver Christoph Weigel on which the radii representing "The Creation" and "The Grand Era of the Final Struggle" abut one another where history comes full circle at the end of time.

Over the course of the next century, dozens of visionaries pursued similar projects. [*figs.* **18–19**] Works in these traditions drew on the talent of all manner of outsider artists, including prolific diagrammers such as Clarence Larkin, a Pennsylvania Dispensationalist who came to the ministry after a career as a draftsman and mechanical engineer, and the Bulgarian-American Adventist Victor Houteff, founder of the Davidian group. In the work of the latter, diverse symbolic registers, maps, and timelines come together vividly in a series of chronological tableaux.

In both the United States and Europe, in the nineteenth century, educational timelines appeared in great numbers, as well—in atlases and textbooks and as freestanding teaching aids. [*figs.* **20–21**] A survey of American history curricula in the mid-nineteenth century shows a wide range of chronographies in use, including the 1806 *Compend of General History,* by Samuel Whelpley, with its "imperial biographical chart" modeled after Priestley's *Chart of Biography;* the

1825 *Outlines of Chronology* of Samuel Goodrich; and the 1833 *Elements of History, Ancient and Modern* by Joseph Emerson Worcester, with a diagram similar to Priestley's *New Chart of History.*[15] Book catalogs and educational, theological, and historical reviews regularly promoted new chronological charts, and even general newspapers reviewed the works, as on July 16, 1842, when the *New York Observer and Chronicle* heaped praise upon the now long-forgotten *Historical Expositor, or Chronological and Historical Charts,* designed by a "worthy young gentleman, connected with the Theological Seminary of this city" and sold "for a mere trifle." In this chart, the *Observer* noted, "Brief outlines of universal history are ingeniously and clearly represented… making a series which will be of great value to hang up in the study or elsewhere, for easy reference in learning facts which might not be otherwise found after an hour's search." Charts from this period including, for example, the 1828 *Historical and Classical Atlas* by Henry Bostwick, with its stylized genealogical notations, attest to the contemporary taste for visual novelty. But while virtually every publisher touted the innovations of its own charts, many of their products were not much more than variations on Priestley. Handsome as they are, the charts in Robert Mayo's 1813 *View of Ancient Geography and Ancient History,*

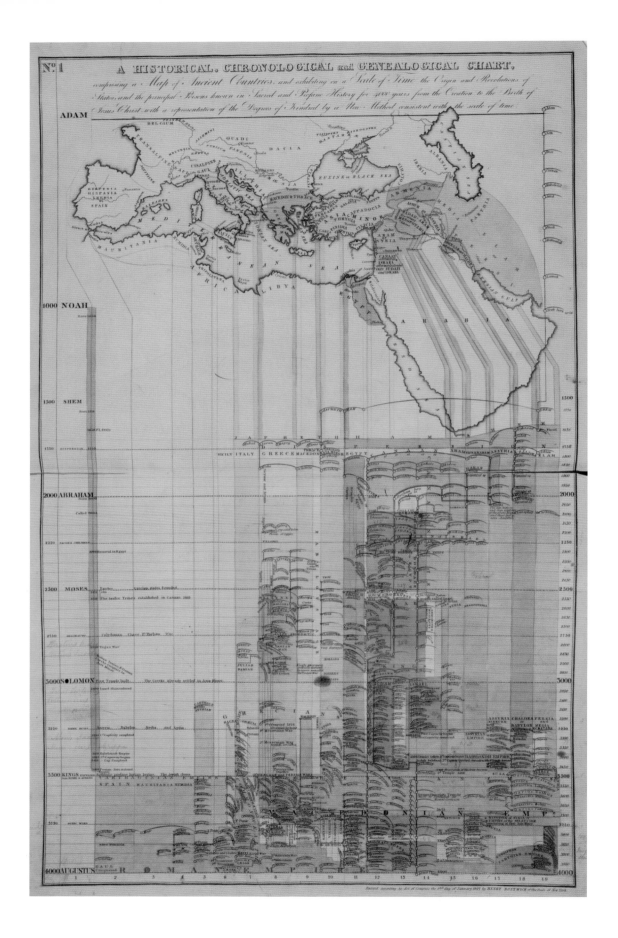

Henry Bostwick attempted to combine the forms of timelines, genealogies, and historical maps in his *A Historical, Chronological, and Genealogical Chart, comprising a Map of Ancient Countries, and exhibiting a Scale of Time the Origin and Revolutions of States, and the principal Persons known* in *Sacred and Profane History for 4000 years from the Creation to the Birth of Jesus Christ and a representation of the Degrees of Kindred by a New Method consistent with the scale of time.* Bostwick designed a new system of genealogical notation, inscribed it into a chart of history, and connected the chart, through colored lineaments, to a geographical map floating above. Bostwick's system is not especially easy to read, but it has the virtue of emphasizing the difference between conjugal and parental relationships and highlighting the multilinear character of genealogy.

John Luffman's 1814 *Elements of Universal History*, William Henry Ireland's 1826 *Universal Chronologist*, and George Palmer Putnam's immensely popular 1833 *Chronology*, for example, all hew closely to Priestley's models.

From the mid-nineteenth century, numerous new chronographic formats began to appear. [*figs.* **22-23**] One of the most popular American charts was published in 1844 in Cincinnati by the prolific inventor Azel S. Lyman, whose patents included refrigerator boxes, pumps and engines, fountain pen nibs, milk concentrators, meat curing machines, and the Lyman-Haskell multi-charge gun, a large artillery piece manufactured for the U.S. Army in the 1880s that, while a failure in the field, successfully demonstrated that a shell could be repeatedly accelerated by secondary explosions in a very long gun barrel.

At thirty-six feet long, Lyman's chart, like his gun, was oversized and just passably functional. Generally, it borrowed from the older graphic vocabulary of Barbeu-Dubourg, blowing it up for easier reading. A delighted reviewer imagined immersing himself in the gigantic chronology: "The student may read [the names and dates on Lyman's chart] at the distance of 10 or 15 feet, some indeed as far off as 30 feet. In truth we can hardly conceive of a more pleasant employment, than to seat oneself in the center of a room, around which the world from the beginning to this day is hung up, and its nations with their rise, and decline, and all the important events in their exact order, visible at one view, making an impression that cannot be effaced."[16] And, if big is the standard, Lyman's work certainly fares well. But, in other respects, Lyman's chart was less successful than many of its contemporaries. Still, Lyman tried to look ahead. His allegorical frontispiece captures this aspiration nicely: in it, Father Time sits in a contemplative pose with a scroll in his hand; behind him are a pyramid, a Greek ruin, and, in the distance, a railroad engine charging forward but not yet there.

Another impressive example of American chronographics, and one of the most direct in its ideological expression, was the *Comprehensive Chart of American History*, published almost simultaneously with Lyman's. The *Comprehensive Chart*, by the educator Marcius Willson, author of diverse textbooks for secondary schools, was dedicated to illustrating the implications of what Willson called "the most important event that has ever resulted from individual genius and enterprise," the discovery of America by Christopher Columbus.[17] Willson presented a handy miniature version of his chart in his textbooks of American history, but the full-size version of his chart was large even

LYMAN'S

HISTORICAL CHART.

CONTAINING THE PROMINENT EVENTS OF THE

CIVIL, RELIGIOUS AND LITERARY HISTORY OF THE WORLD.

From the Earliest Times to the Present Day.

BY

AZEL. S. LYMAN.
REVISED, ENLARGED AND IMPROVED.

NATIONAL PUBLISHING COMPANY, CINCINNATI, O., MEMPHIS, TENN., AND ATLANTA, GA.
JONES BROTHERS & CO., PHILADELPHIA, PA., AND CHICAGO, ILLS.
1875.

[22–23]

Azel S. Lyman first published his
historical chart book in Cincinnati in
1844; it appeared in several editions
through 1875. The chart has a simple
left-to-right format with hand-colored
horizontal bands indicating different
nations, and varied typography
distinguishing important and related
terms. Lyman's charts were sometimes
integrated with text books. A study
guide was also published with each
edition with questions and a key so
that Lyman's chart could be used as
a kind of textbook all on its own. On
Lyman's chart the timeline bursts into
a field of many colors after the fall of
the Roman Empire at 476 CE.

Miniature version of the
*Comprehensive Chart of American
History* by Marcius Willson from
his 1845 *History of the United States*
showing the emergence of the nation
from what historians of the day
treated as obscure prehistory

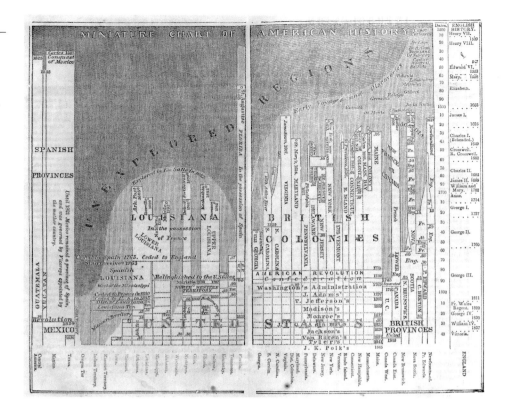

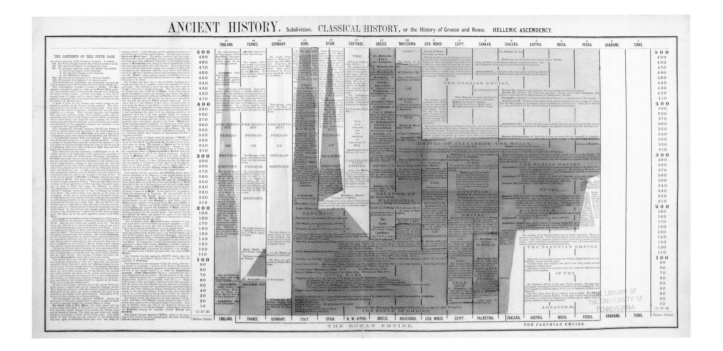

for a classroom wall. [*fig.* **24**] Though shorter than Lyman's chart, Willson's was much wider, making it unwieldy and impossible to scroll. In addition, much of its print is very fine. The dimensions of Willson's chart gave him room to project the immensity of the growing nation. If Ramsay's chart gave the revolutionary-era United States the dignity of a history distinct from that of its former political masters, Willson's expressed the expansionist designs of the nineteenth-century American republic. In Willson's chart, columns representing each of the American states plunge downward out of the darkness of the precolonial past toward an illuminated modernity.

In 1874, Robert Henlopen Labberton, professor of history at Barnard College and a specialist in ancient Greek, published a noted historical atlas and along with it, another big and vivid chart entitled *History Taught by the Eye*. [*fig.* **25**] Labberton's chart covered forty-three centuries in nine feet.[18] Like many nineteenth-century chart makers, Labberton emphasized the neutral and "scientific" character of his work.[19] In contrast to traditional history books, he said, his charts preserved "that unity which impresses itself on the attention, and presents the vicissitudes of centuries as *a vast, continuous, harmonious whole*." As such, he added, they would be useful defenses against the sophistries of "smart magazinists, 'brilliant' lecturers, and crafty politicians."[20]

Each of these charts was impressive in its own way, but the 1871 *Synchronological Chart* of the Oregon pioneer minister Sebastian C. Adams—subsequently published in many editions under different titles—was nineteenth-century America's surpassing achievement in complexity and synthetic power. [*figs.* **26–27**] Adams, who lived all of his early life at the very edge of U.S. territory, was a schoolteacher and one of the founders of the first Bible college in Oregon. Born in Ohio in 1825 and educated in the early 1840s at the brand-new Knox College in Galesburg, Illinois, at the heart of the American abolitionist movement, Adams was a voracious reader, a broad thinker, and an inveterate improver. The *Synchronological Chart* is a great work of outsider thinking and a template for autodidact study; it attempts to rise above the station of a mere historical summary and to draw a picture of history rich enough to serve as a textbook in itself.

Though in later years he would drift away from organized religion, in the beginning, Sebastian Adams's interest in chronology was both scholarly and theological. Alexander Campbell, founder of the Disciples of Christ and Adams's early spiritual inspiration, had written that

[26]

The Salem, Oregon, minister Sebastian C. Adams's charts were a riot of color and detail, including text, illustrations, and maps, all organized around a measured, horizontal timeline. Well-reviewed and popular, Adams's chart was most often sold as an accordion book, but it could also be purchased on rollers, as in this third edition from 1878, for mounting on a wall.

[25]

Robert Henlopen Labberton published several outlines of history. On his chart from *Historical Chart, or History Taught by the Eye* from 1874, nations enter or leave the stage of history at different angular paces.

the "signs of the times" could be interpreted only if we understand their "position on the chart of prophetic developments."[21] And Adams's *Synchronological Chart* aimed to aid such understanding.

Like Lyman's and Willson's charts, Adams's *Synchronological Chart* was big—seventeen feet long and more than two feet tall—but it was also visually richer than its contemporaries. Though he conceived it in far-away Salem, Oregon, Adams traveled east to have his chart made by the virtuoso Cincinnati lithographers Strobridge & Co., a firm that produced precision maps, detailed engravings of Civil War scenes, travelogues, and colorful advertisements for commercial clients including theaters and circuses. In its final form, Adams's chart embodied characteristics of all of these: it was huge and detailed, packed with information, and a riot of color.

In its general concept, the *Synchronological Chart* owes a great deal to the stream-of-time tradition, and in some ways, when it appeared, it was already something of an anachronism. The use of Archbishop Ussher's canonical date of 4004 BCE for the Creation—the seamless transition from sacred to secular history, and the various millennial devices, such as an image of the beast of the Apocalypse— all seem rather more backward-looking than forward. But

Adams's chart was also a strong affirmation of the power of the regular, measured, single-axis timeline and the importance of visual tools in education.

Adams initially produced the chart independently by selling subscriptions and investing his own money. But after the 1871 edition, his work was picked up by printers in different American cities and then in England as well. Indeed, it is still available in colorful facsimile today. One of the most popular and longest-running editions was published by Charles William Deacon and Company in London around the turn of the twentieth century. Deacon's version of the chart played down the Americanism of the original, removing the bicentennial portraits and altering certain details. Deacon and Company also removed most of the bibliographic notes that established the connection between Adams's work and the tradition of academic chronology and took Adams's name off of the chart. Finally, the company appended a chart of geological strata by the Irish scientist Edward Hull and proudly announced this in its new title, *Deacon's Synchronological Chart, Pictorial and Descriptive, of Universal History: With Maps of the World's Great Empires and a Complete Geological Diagram of the Earth, by Professor Edward Hull*, the ambiguity of which has long misled readers and catalogers alike to attribute Adams's chart to Hull.

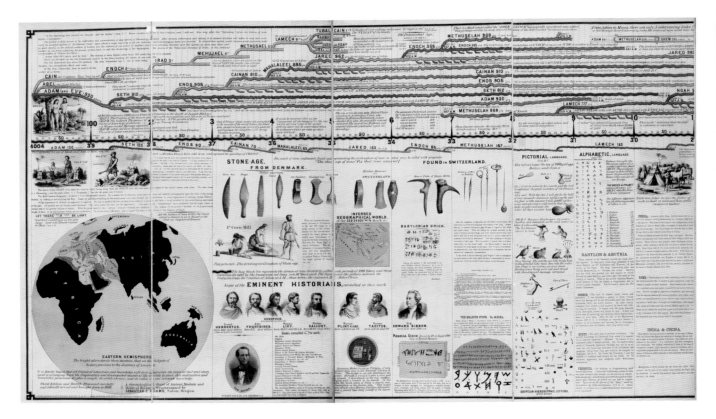

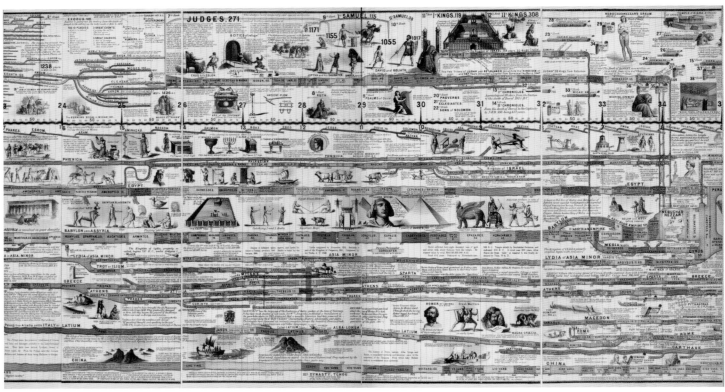

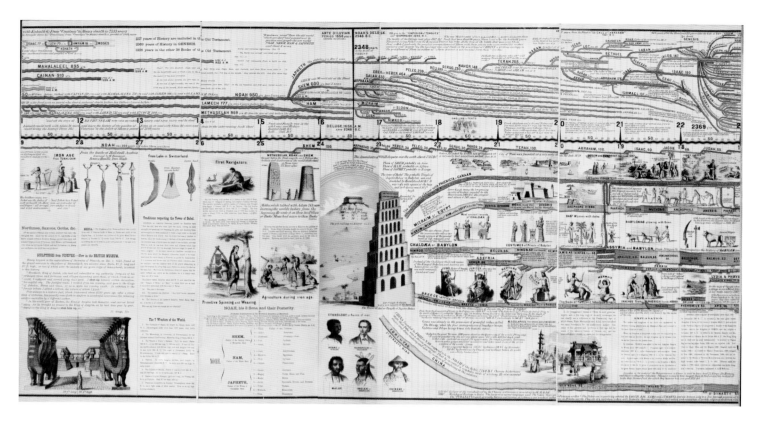

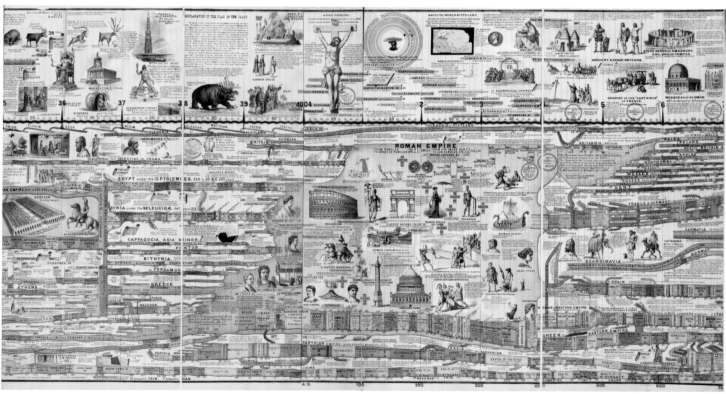

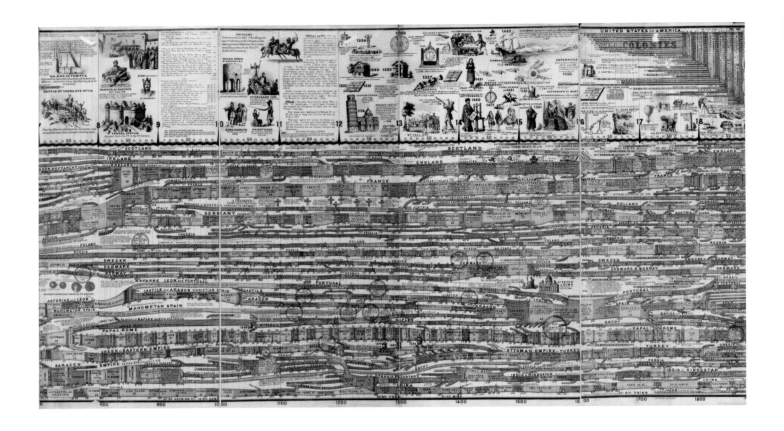

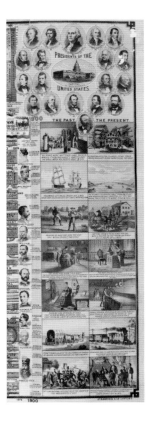

Sebastian C. Adams, *A Chronological Chart of Ancient, Modern, and Biblical History*, third edition, Cincinnati, 1878

By the late nineteenth century, charts in the manner of Lyman and Adams had become thoroughly integrated into the regular study of history in America and Europe. The force of this development is evident not only in nineteenth-century graphics, but in the general vocabulary in which history was discussed. Already in 1825 *Churchman's Magazine* in New Haven, Connecticut, recommended that the clergyman "cast his eye on the chart of history" in order to understand the "present state of human society."[22] And an article in the New York *Workingman's Advocate* of 1844 recounts a rabble-rousing speech by the Irish-born Chartist and newspaper editor Thomas Ainge Devyr, who called upon his listeners to "look on history as a seaman looks on his chart." Devyr argued, "If we examine history, we shall find that in the Grecian and Roman republics, when each man had his right of soil, when a Cincinnatus could be contented with his seven acres, they were a prosperous, dignified, happy, and wise people. But when the few became possessors of the soil to the exclusion of the many, vice and luxury prevailed."[23] At length, Devyr compared the money men of New York to the patricians of Rome, pointing out that just as Rome had its period of degeneracy and violence against the working people, so too did modern America. "Had Columbus had a chart, his pathway to the new world would have been easy. We are not like Columbus: the chart of history points out the rocks and shoals and sand banks that we should avoid."[24]

In 1863, an article in *New Englander* magazine titled "Uses of History for the Preacher" argued that the "chart of history"—referring both to actual charts and to the metaphorical idea—"appeals to the Christian as the map of India appealed to the sacred instincts of [the Baptist missionary William] Carey. It reveals to him whole continents of immortal beings, born in the dark, living in twilight, vanishing in gloom. It appalls him with an exhibition of the helplessness of man without the knowledge of God, and without the assurance of a future life."[25] [*fig.* 28]

In secular historiography, the same conventions were ubiquitous, but progress, not providence, was at issue. In a report to the American Historical Association in 1892, historian James Schoulder framed the great narrative of modern history as a "chart of the world's progress." He writes,

Our chart of history opens like an atlas; it presents page after page of equal size, but with a lessening area for the sake of an increasing scale. One page exhibits a hemisphere, another a continent, another nation; others, in turn, the State, the county, the municipal unit. From a world we may thus reduce

the focus, until we have manned within the same spaces a town or city, or even a single house.[26]

In the eighteenth century, Jacques Barbeu-Dubourg lamented that the chronological chart lacked both the sophistication and the intuitive quality of the geographic map, and Georg Hagelgans warned the reader that his time chart could not be effectively consulted without reference to a historical textbook. Nineteenth-century chronographers made no such apologies. By now, the chart had become a symbol of historical understanding itself.

CHRONOLOGICAL CHART,

EXHIBITING THE RISE AND PROGRESS OF CHRISTIANITY AND MAHOMETANISM THROUGHOUT THE WORLD.

The prevalence of Christianity is denoted by the white space, that of Mahometanism by the red, and Paganism by the dark shade. — The spaces vary in width according to the Population.

[**28**]

In the chronological chart in the
1832 *Account of the most important
and interesting religious events which
have transpired from the commencement
of the Christian era to the present,*
John Warner Barber, a Connecticut
engraver known for his historical and
geographical illustrations, indicated
the relative prevalence of Christianity,
Islam, and "Paganism" around the
world in quantitative terms. In keeping
with a demographic perspective,
this chart allotted space according
to a rough measure of population
rather than the perceived historical
importance of nations.

A Tinkerer's Art

In the Western world, concepts and experiences of time changed quickly during the last decades of the nineteenth century. In a very short period of time, new social developments including industrialization, urbanization, and the spread of new transportation and communication technologies such as the railroad and telegraph made new time-keeping conventions unavoidable. More and more, daily behavior was governed by clocks and watches. The correct time was no longer established only by local convention. Time zones connected far away places and governed a global, interconnected system.

These changes, of course, did not come entirely out of the blue. Since the Renaissance, the clock had played an increasingly important role in the European cultural imagination. Already in the mid-seventeenth century, early adopters such as English diarist Samuel Pepys could hardly imagine going without his pocket watch.[1] A theological treatise published in England in 1597 compared the study of chronology to watching the sands of a great historical hourglass; while another, published eighty years later, envisioned it as a clock "framed with Art…under the Hammer and the File for many Years" and "made to do its Business truly and faithfully."[2] Others were more skeptical, especially during the many decades in which clocks offered only an approximation of the precise time. A popular early modern dictum stated that "chronologers and clocks never agree."[3]

Eventually, however, time pieces achieved an impressive level of precision. During the eighteenth century, chronometric technologies were substantially advanced, as evidenced by the marine chronometer submitted by John Harrison for the British government's Longitude Prize in 1761. With Harrison's H4 chronometer, global synchronization had become a practical, not just a theoretical, possibility. At the same time, clocks and watches became widely accessible to bourgeois consumers and integrated into the practices of everyday life, though they sometimes met considerable resistance. In factories they were used to impose new discipline on reluctant workers.[4] During the nineteenth century, finally, under the influence of factory schedules, railroad time, and long-distance communication via telegraph, the idea of a single, uniform fabric of time became second nature in Europe and America. By the turn of the century, "having the time" was no longer a sign of prestige, and for more and more people, living by the clock was a matter of necessity.

As measured time penetrated into ever more domains of cultural life, so did the graphic frameworks of chronography. [*figs.* 1–2] The coordination of time frames (through

For twenty-first-century readers, it is
second nature to think of timelines
as scaling smoothly from large to
small, from centuries to decades to
years, months, days, minutes, and
seconds. But for earlier readers, these
translations were not so simple.
Prior to national and international
standardizations of time in the last
decades of the nineteenth century,
complex correspondence charts—such
as Alvin Jewett Johnson's 1873 *A
Diagram Exhibiting the difference of time
between the places shown & Washington*,
from *Johnson's New Illustrated Family
Atlas of the World*—were necessary to
establish exact synchronisms across
geographical space.

technologies such as the marine chronometer and conven-
tions such as international time zones) brought chrono-
graphics into play in many new areas as well. Much has
been made of the cultural impact of the first photographs
of the earth taken in the 1960s, of the vision of one con-
tinuous and connected world that those pictures provided.
But already in the nineteenth century, "synchronous maps"
showing data readings from different geographical loca-
tions taken at the same moment provided something
conceptually similar. For example, by placing time-coded
meteorological data from distant locations on a single map,
the Victorian polymath Francis Galton—a great graphic
innovator, as well as a founder of eugenics, psychometrics,
forensic science, and meteorology—was able to create a vir-
tual world picture illustrating the global interdependence
of weather systems and the regularity of wind patterns.[5]
Galton's charts are not chronological in the same sense as
Priestley's, but their principles are closely allied: as syn-
chronous charts, Galton's are like vertical slices through
Priestley giving data from many places at one point in
time, and they do similar work, demonstrating pattern and
synchronism.

Eventually, the development of long-distance com-
munication technologies such as the telegraph and the

telephone made the coordination of time frames a mat-
ter of practical experience, not only a scientific projection.
[*fig.* 3] And all of this was captured in evolving graphic
forms. When the *Titanic* set sail on its first and final voyage
on April 10, 1912, its path was charted by both the White
Star Line, which owned the ship, and by the Marconi
Telegraph Company, which provided its telegraph operator.
While the shipping line mapped the route of the *Titanic* on
traditional marine charts, the Marconi Telegraph Company
employed a newer system of representation developed for
the French railroads in the 1840s.[6] Rather than plotting the
Titanic's geographical location, Marconi's North Atlantic
Communication chart showed where the ship was at each
point in time in relation to other ships carrying Marconi
operators. This diagram allowed operators to plan ship-to-
ship telegraph relays so that messages could be transmitted
over very long distances and from far out at sea.

The Marconi chart from April 1912 became iconic
when it was published after the sinking of the *Titanic*, one of
the first great media events experienced across the world in
something approximating real time. As the chart indicates,
when the *Titanic* struck an iceberg at 11:40 PM on April 14,
1912, ten ships carrying Marconi operators, including the
Olav, the *Niagara*, the *Mount Temple*, the *Carpathia*, and the

[2]

Francis Galton did pioneering work both in the study of weather and in its mapping. In *Meteorographica, or Methods of Mapping the Weather*, from 1863, Galton presented a variety of meteorological diagrams including "synchronous charts" such as the one depicted here, indicating weather conditions, barometric pressure, and wind direction at a single historic moment across the geographic space of Europe.

[3]

To chart communication links among ships carrying telegraph operators, the Marconi Telegraph Company employed a system developed decades earlier for use in the French railroads. On the Marconi Telegraph Communication Charts, each line represents the route of a single ship. Numbers at the top and bottom indicate the dates of departure and arrival. Intersections indicate the earliest time that ships can be in the same longitude at best average speeds. Together, the lines depict the shifting wireless communication network linking together the North Atlantic. The *Titanic* line can be found in the THU. 11 column.

The *Scientific American Reference Book*
for 1914 glossed over the *Titanic*
tragedy, displaying two Marconi charts
from 1904 and 1911. The irony in the
caption used with the charts seems not
to have been intentional.

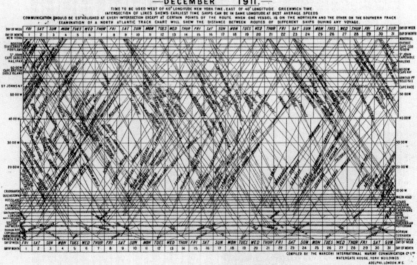

Californian, were in wireless range; and the *Californian* was only nineteen miles away. But the *Californian* had signed off the wireless network at 11:30 PM. The *Carpathia* got the news on the first call at 12:15 AM, but as they were fifty-eight miles out, they did not arrive at the scene until two hours later. By that point the news had already gotten back to New York and hit the streets.

In the following days, the sense of tragedy was heightened by the graphic showing just how many ships were able to hear but not act.[7] [*fig.* 4] The pathos was still powerful two years later when the *Scientific American Reference Book* published two of Marconi's North Atlantic Communication Charts side by side, one from December 1904 and one from December 1911, just four months before the sinking of the *Titanic*, to show how safe the networked North Atlantic had, in theory, become. The caption below the two charts conspicuously omitted reference to the events of April 14, 1912, stating simply, "Seven years later the interlacing lines show possible intercommunications which have robbed the sea of many of its terrors. Phenomenal increase in wireless activity."[8] The charts, of course, did nothing to save the *Titanic*, but they did provide a striking image of the connected temporal fabric that the telegraph network had created.

The late nineteenth century also saw the rapid development of real-time recording techniques, some of the most significant of which were the work of the French physician Étienne-Jules Marey, an innovator in the field of chronophotography. [*figs.* 5–10] Marey was both an experimenter and a theorist, and he was well versed in the tradition of chronographic representation. In contrast to his renowned American contemporary Eadweard Muybridge, Marey's interests extended far beyond photography, which he thought of as only one instrument in the large and expanding chronographic tool kit. For example, in physiology, an area in which he was particularly knowledgeable, Marey pointed to several recent chronographic inventions including the colorfully named sphygmograph, haemodromograph, cardiograph, and myograph—the first three designed to make graphic recordings of the activity of the heart over time, the last, that of the neurophysiological system.[9]

For Marey, these new devices all represented a development of the chronographic tradition of Priestley and Playfair, and he was explicit about the connection. But while Priestley and Playfair created systems for *representing* temporal phenomena, Marey's interest was in graphically *recording* them. For Marey, removing human and linguistic mediation from

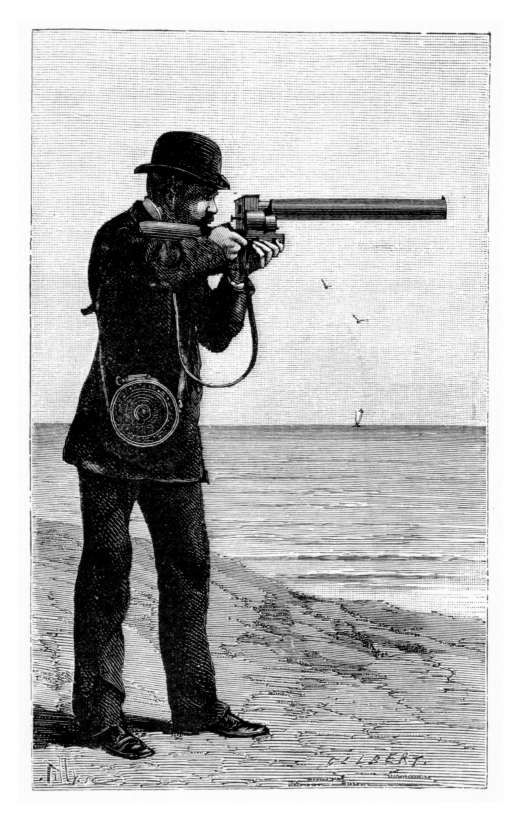

Étienne-Jules Marey's book *Movement*, published in French in 1894, depicts a "chronophotographic gun" capable of shooting images at intervals of 1/12 of a second, a "hodograph" designed to record the hoof strikes of a galloping horse, and many other mechanisms for making visual records of movement. Marey draws directly on the graphic examples of the eighteenth-century chronographers but aims to mechanize the process that they had undertaken by hand. Already in the eighteenth century, Marey points out, the visual forms of Priestly and Playfair had important analogues in experimental science.

The gelatine plates, sensitized with bromide of silver,

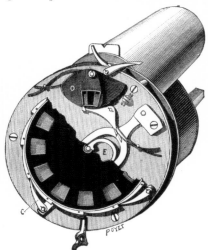

FIG. 76.—Details of the interior of the photographic gun.

on which the photographs were taken, were cut with a diamond to a circular or octagonal shape, as is shown

at the butt end, is a large cylindrical breech which contains the clock-work mechanism. The axis of the breech is seen projecting at B. When the trigger is pulled the wheels begin to rotate and transmit the necessary movement to the different parts of the instrument. A central axis, which revolves 12 times in a second, controls the movement of all the individual parts of the apparatus. In the first place (Fig. 76), there is an opaque metal disc provided with one small opening. This disc constitutes the shutter, and only allows the light, which passes through the objective, to gain an entrance 12 times in a second, and then only for a period of $\frac{1}{240}$ part of a second. Behind the first disc there is another provided with 12 openings which rotates freely on the same axis as the first, and behind these, again, there is room for the sensitized plate, which may be circular or octagonal in shape. This fenestrated disc should rotate intermittently so as to come to rest 12 times in the second just opposite the beam of light which penetrates the instrument.

in Fig. 78. In this photograph the successive positions of a flying gull are shown at intervals of $\frac{1}{12}$

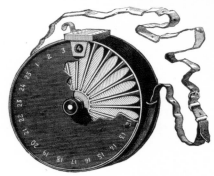

FIG. 77.—Special box for holding the photographic plates.

of a second. These little images, when enlarged by projection, furnish curious details with respect to the position of the wings, and the torsion of the remiges

An eccentric, E, placed on the central axis, produces this intermittent rotation, by transmitting a regular to-and-fro movement to a rod which is furnished with a catch, C. At each oscillation this catch is held by one of the teeth which form a sort of circlet round the fenestrated disc.

A special shutter, O, effectually prevents the light from penetrating into the instrument as soon as all twelve photographs have been taken. There are other arrangements for preventing the sensitized plate from passing, by reason of its acquired velocity, the position assigned to it by the catch, and where it should remain perfectly still during the period of illumination.

A pressure button, b, Fig. 75, is brought into close contact with the plate, as soon as the latter is introduced into the gun. Under the influence of this pressure the sensitized plate sticks firmly to the posterior surface of the fenestrated disc, which is covered with india-rubber to prevent it slipping.

The object is brought into focus by elongating or shortening the barrel, and thus removing or approximating the lens, and finally the process is corrected by looking with a microscope through an opening, O, made in the breech of the gun, and observing the definition on the ground glass.

I

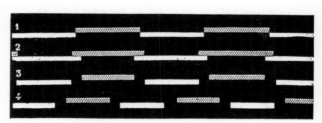

FIG. 5.—Chronographic record of the periods of contact of the feet of a man executing various paces.

FIG. 6. — Special apparatus for recording the contacts of a horse's feet with the ground; a transmitting tube effects a communication between the air chamber and the chronographic tambour.

FIG. 7.—Horse at a *full trot*. The point indicated on the chart corresponds to the position of the horse represented in the figure.

FIG. 1.—Scale of hours. Time measurement.

the representational process was the culminating step in the emergence of chronography as a scientific technique. It was at once a step beyond Priestley and Playfair—and beyond the eighteenth-century scientists such as Antoine-François Vincent and Georges Claude Goiffon, whose chronographies were still based on transcriptions of data—and a vindication of them.[10] Marey writes,

> In experiments, for instance, which deal with time measurements, it is of immense importance that the graphic record should be automatically registered, in fact, that the phenomenon should give on paper its own record of duration, and of the moment of production. This method, in the cases in which it is applicable, is almost perfect. In other instances photography comes to the rescue, and affords accurate measurements of time events which elude the naked eye. The process which thus serves to register the duration and sequence of events constitutes a method called "chronography."[11]

Marey shows that by the end of the nineteenth century the idea of real-time data recording had already been around for some time. However, he argues that a wide interest in technologies for data recording was much more recent. And the work of modern scholars has borne this

out. In the mid-seventeenth century, the English polymath Christopher Wren had sketched a design for a "weather clock," an instrument meant to automatically record wind direction, rainfall, and temperature on a moving chart. But Wren conceived of his recording device as only a register of raw data; he never intended to display the plate on which the meteorological data were recorded.[12] Over the course of the eighteenth century, various recording devices were developed along a principle similar to that of Wren. Like the weather clock, James Watt's graphic pressure recorder was designed to capture information, not to display it. But the useful patterns that it drew and the principle of its operation were clearly not lost on William Playfair, who worked in Watt's shop as a young man.[13]

By the nineteenth century, graphs appeared regularly alongside tables in many scientific and technical fields. Priestley and Playfair and their many continuers in statistical graphics were instrumental in this process, but so were the inventors of recording devices in the tradition of Wren and Watt. Nineteenth-century inventors labored to create new chronographic instruments in many domains. The first known phonographic instrument, the "phonautograph" patented by the French typographer Édouard-Léon Scott de Martinville in 1857, produced nothing more than jagged

In the 1870s, the Chicago photographer Charles D. Mosher, who styled himself the "National Historical Photographer to Posterity," was selling a vision of the future. Sitters who paid to have portraits made could have them committed to a memorial vault, which was to be sealed in 1876 at the American Centennial celebration and reopened in 1976 at the Bicentennial. Mosher's was one of the first date-specific time capsules, but it did not survive a century. Though the vault was lost when Chicago built a new City Hall, the images were saved.

ICHI-52049. Charles D. Mosher Papers. Chicago Historical Society.

lines scratched onto paper coated with lampblack.[14] When, in the 1870s, Emile Berliner and Thomas Edison each coupled a similar recording concept with a mechanism for sound reproduction, Scott de Martinville protested not only that his idea had been pilfered but that it had been denatured: he argued that the phonautograph was meant to register sound in a graphic form appropriate for measurement and analysis, not to reproduce it for entertainment.[15]

Regardless of the application, all of the early phonographic devices had an intrinsically chronographic component, as they were designed to trace changes in sound over time. [*fig.* 11] In contrast, the photograph was designed to capture an instant. But, on account of this very quality, the photograph, too, could be employed as a kind time machine. Scholars and entrepreneurs were quick to appreciate the value in this. In 1876, the same year that Sebastian Adams released his second edition of the *Chronological Chart of Ancient, Modern, and Biblical History*, the photographer Charles D. Mosher managed to install a "memorial vault" containing photographs of Chicago's prominent and not-so-prominent citizens (the latter paid to be included) in Chicago's City Hall.[16] Mosher's vault was one of the first time capsules. According to his plan, the vault would be sealed at the end of the Centennial Exhibition in Chicago,

not to be exhibited again before the bicentennial celebration of 1976. As it turns out, Mosher's project was only a partial success. Chicago's old City Hall was razed in 1908, and the memorial vault was destroyed. But Mosher's photographs were saved, surviving to be exhibited in 1976, and, with luck, again in 2076 and once a century from then on.

At the end of the nineteenth century, photographic technology was speeding up. [*fig.* 12] While early photography produced intriguing temporal effects including blurs and disappearances—some of which were eventually exploited by artists such as the futurist Anton Bragaglia—the technology did not immediately lend itself to the measurement of time.[17] But with the development of fast mechanisms, cameras became available for chronographic uses. Instruments such as the 1873 *revolver photographique* of the French astronomer Pierre Jules César Janssen captured remarkable images. Janssen's *revolver* could shoot forty-eight sequential images at intervals of just over one second. Janssen famously employed a similar instrument, an "astronomical revolver" that fired once every seventy seconds, to record the transit of Venus on December 8, 1874. Janssen proclaimed that the photographic plate was the new "retina" of the scientist.[18] And he might well have added, of the chronographer too.

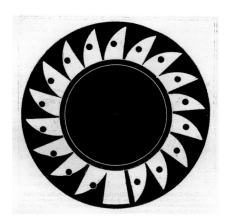

[12]

Illustration of the photographic disc
used by Pierre Jules César Janssen to
photograph the transit of Venus, from
Étienne-Jules Marey, *Movement*, 1895

Though it may be more apparent in the work of Marey, Janssen, and their late nineteenth-century contemporaries, chronography was a tinkerer's art from the very beginning. Eusebius was an early adopter, employing the new codex book for his *Chronicle*, as was Rolevinck, who used the moveable-type printing press for his fifteenth-century *Fasciculus temporum* (Bundle of dates). In the eighteenth century, Barbeu-Dubourg's concept for a chronographic machine was edgy enough to earn an encomium in Diderot's *Encyclopédie*, and Adams's *Chronological Chart of Ancient, Modern, and Biblical History* ranks among the monumental examples of nineteenth-century chromolithography. At each moment in its history, the time chart has pushed at the boundaries of available graphic media.

Even as they innovated, chronographers of the eighteenth and nineteenth centuries also looked back. [*fig.* 13] Every reader of Revelation, after all, knew how effectively the scroll could stand for something cosmic—even the world itself: "And the heaven departed as a scroll when it is rolled together."[19] And after three centuries of chronographies printed in books and on broadsides, the scroll began to reemerge both as a mechanical support for the timeline and as a symbol of chronological time. Barbeu-Dubourg's *Chronographie universelle* used a scrolling mechanism,

as did the tiny *Pocket Tablet of Chronology* published by William Darton in 1815. Blanchet's 1839 *Catholic Ladder*, and Adams's 1871 *Chronological Chart of Ancient, Modern, and Biblical History* were scrolls, too. The frontispiece for the 1846 *Horae Apocalypticae, or, A Commentary on the Apocalypse, Critical and Historical* by the English millennialist scholar Edward Bishop Elliott was only designed to look like one, but use of the image suggests how very lively a metaphor was the "scroll of time."

Modern scrolls were, of course, very different from the genealogical parchments of the Middle Ages. [*figs.* 14–17] They were mass produced and relatively inexpensive, and they reflected the conventions of the measured timeline that had achieved such success in the eighteenth century. In contrast to ancient scrolls, which preceded the codex and medieval scrolls, these modern scrolls were specifically designed to address the limitations of the printed book. The scroll, of course, had limitations too: though it offered visual continuity (important in the graphic representation of chronological sequence), it sacrificed ease of use (important in works of reference).

Nineteenth-century chronographers experimented with every format they could get their hands on. [*figs.* 18–19] In addition to reference works, they made games and toys

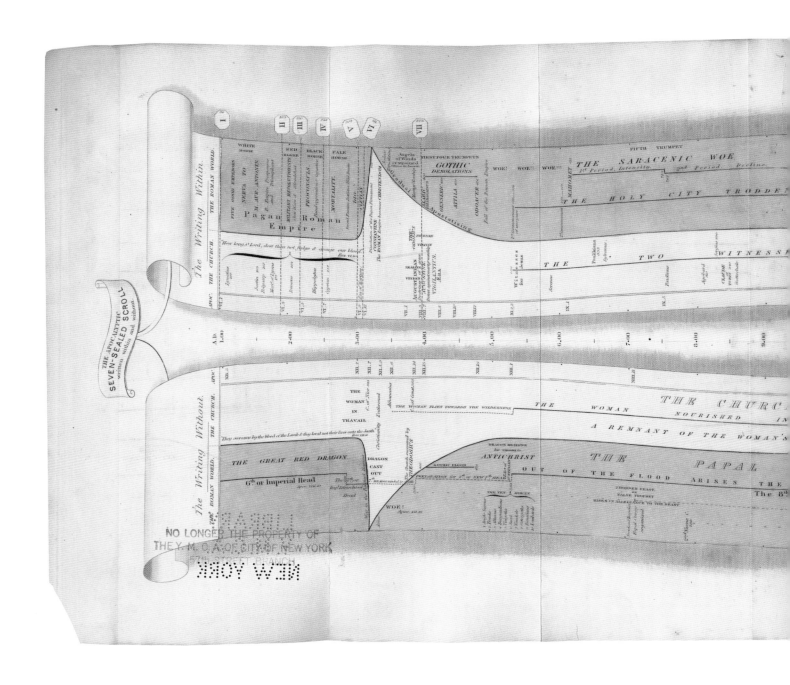

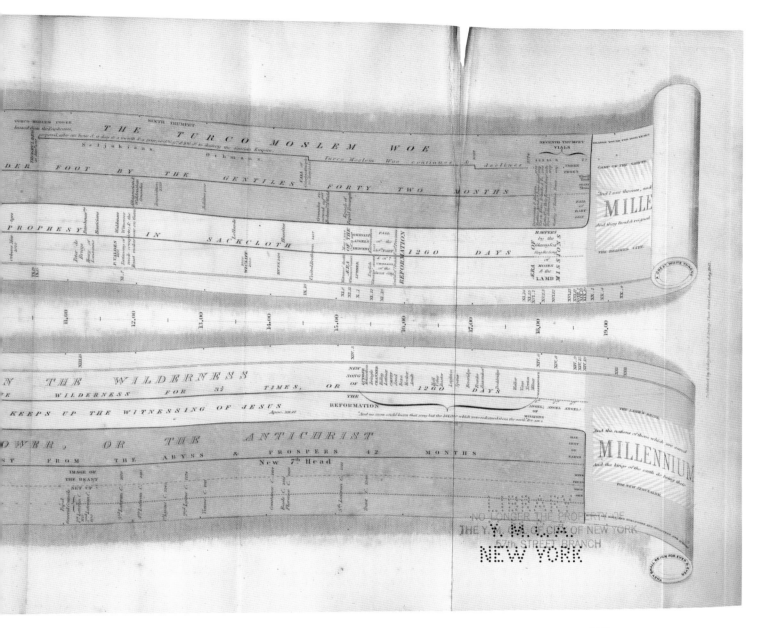

[13]

Scroll chart from Edward Bishop Elliott's multivolume study, *Horae Apocalypticae, or, A Commentary on the Apocalypse, Critical and Historical*, first published in London, 1844

[14–15]

At five centimeters in height, *Darton's Pocket Tablet of Chronology: From the Creation of the World to the Year 1815*, is among the smallest chronographic scroll charts ever published.

[16–17]

Stream of Time: Intended for Young Persons. To Be Filled Up During a Course of Historical Reading, London, 1844. This scroll chart, nearly thirty feet long, is wound on a roller fixed in a decorative box. At the top, the scroll has a wide area painted blue to indicate the source of all things at the Creation, 4004 years before Christ. The left side of the chart is devoted to "General History: Ancient and Modern"; the right side, to "Scripture History," replaced in a later era by "British History." On this Princeton University copy, the first entry is the birth of Seth; the last is the Great Exhibition of 1831 in London.

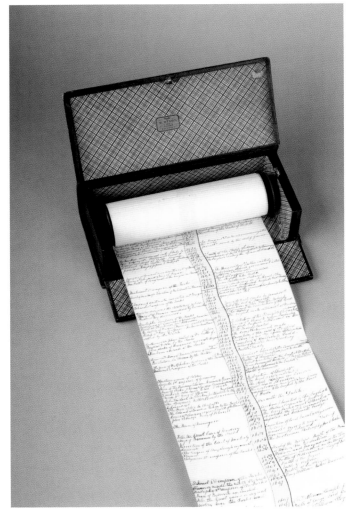

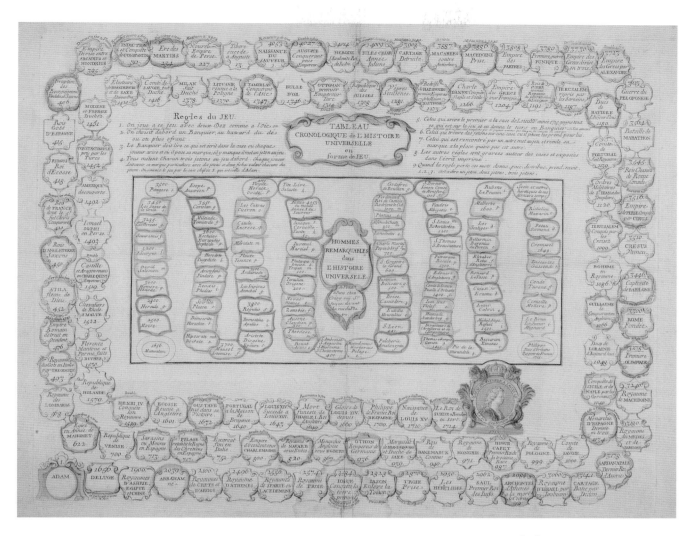

A board game published in Paris after 1715, the *Tableau cronologique de l'histoire universelle en forme de jeu* begins in the year 1 of the World with Adam and ends on September 1, 1715, with the accession of Louis XV. Board games of this type became very popular in Europe and England during the nineteenth century. The general rules are printed on the game, and the specific instructions are inscribed over many of the individual spaces on the game board. Players wih the bad luck to land on the penultimate year 1714, for example, were instructed to return to the year 1191.

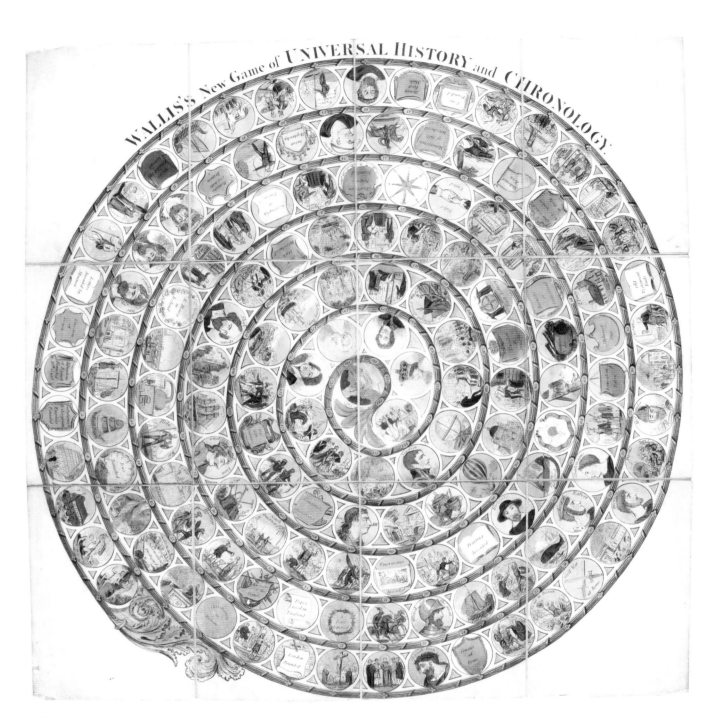

[19]

Wallis' New Game of Universal History and Chronology from 1840 is a hand-colored game sheet divided in twelve and mounted on linen. It has spaces for such events as the first use of paper in England, the invention of engraving, and the discovery of longitude.

[20–22]

Inventors in late nineteenth and early twentieth-century America filed a wide range of applications to patent chronology games and devices

including James W. Larimore's 1883 checkerboard, John A. Cole's chart system from 1891, and Walter A. Hammett's 1910 playing cards. Cole's

system was based on Joseph Priestley's eighteenth-century concept, but his design calls for removable cards cut to different lengths to represent lines

and events and a tin case to hold them in place. Hammett's playing deck contained 48 cards, enough to cover four years, one month per card.

and mechanisms of many different kinds. Chronological amusements, such as simple board games in which players rolled dice to race along a historical path, were already popular by the end of the eighteenth century, and with cheaper printing techniques, developing consumer markets, and a growing awareness of the value of visual education, they continued to proliferate in the following century.[20]

In general, early chronological games were fairly straightforward: the usual layout is a continuous spiral; players begin at the outer edge and, by rolling dice or something similar, advance toward the center; or else they begin at the center and do the reverse. Spaces are marked either with dates or with notable events such as coronations, battles, and treaties. The basic goal is to get to the to the end of the board first. Race games such as these, of course, could be organized around any theme at all, but the structure of chronology suited them particularly well: chronological subject matter provided a rationale for the linear structure of games, and it gave them an internal tension, as players had opportunities to jump ahead of one another and to leapfrog, like the time traveler of Louis-Sébastien Mercier's 1769 *The Year 2440: A Dream if Ever There Was One*, over dangerous and exciting events.[21]

Another telling eighteenth-century diversion is the chronological puzzle. Here, the pleasure principle is a bit different. As in most puzzles, the idea is to reassemble an image that has been broken apart, but the satisfaction comes from successfully sorting out scattered fragments of history.

There were other chronology games too: chutes and ladders, cards, checkers, and concentration, and others that involved more complex rules with banking, challenges, and the like. Many were adaptable to other subjects. [*figs.* 20–25] The modified checkerboard patented in Chicago by the Presbyterian minister and high school teacher James W. Larimore in 1883 is a good example. Larimore's game board could be used as a tool for teaching in any field that required memorization, but for him, as for his contemporaries, chronology was the field of memorization par excellence. Larimore's game was simple, barely an invention, really: a plain matrix upon which information could be inscribed so that players, using the usual rules of checkers, would constantly be viewing facts that they needed to memorize. According to Larimore, these would be absorbed pleasurably and without any special effort. In his illustration (with a somewhat jarring indifference to category), Larimore gave the following two phrases as examples of the kind of

[23]

A jigsaw puzzle in 76 pieces called *History of France Chronologically arranged from the Reign of Pharamond first King to that of Louis the Sixteenth*, London, 1792. This was apparently intended as a companion to Reverend Mr. Cooper's 1786 *The History of France*. Each of the finely cut wooden puzzle pieces carries a portrait of the king or queen with a text describing the important events of the reign.

[24–25]

Dozens of historical card games were produced in the mid- and late nineteenth century. As with board games, some of these were only history themed. Others, such as *Uncle Sam's Game of American History* from 1851, and *Historical Amusement: A New and Entertaining Game on the History of England* published in Albany, New York, in 1853, required real chronological knowledge. In these games opponents try to name events listed on other players' cards.

MARK TWAIN'S MEMORY-BUILDER.

A Game for Acquiring and Retaining All Sorts of Facts and Dates.

ACCESSIONS.—*First Row of Holes in each Compartment,* - - - 10
BATTLES.—*Second Row of Holes in each Compartment,* - - - 5
MINOR EVENTS.—*Third Row of Holes in each Compartment,* - - - 1

1	26	51	76
2	27	52	77
3	28	53	78
4	29	54	79
5	30	55	80
6	31	56	81
7	32	57	82
8	33	58	83
9	34	59	84
10	35	60	85
11	36	61	86
12	37	62	87
13	38	63	88
14	39	64	89
15	40	65	90
16	41	66	91
17	42	67	92
18	43	68	93
19	44	69	94
20	45	70	95
21	46	71	96
22	47	72	97
23	48	73	98
24	49	74	99
25	50	75	100

EACH PIN COUNTS 10. B MISCELLANEOUS. W EACH PIN COUNTS 10.
EACH PIN COUNTS 1.

PATENTED AUGUST 18, 1885. COPYRIGHT BY S. L. CLEMENS, 1891.

THE GAME.

1. The board represents *any* century.
2. Also, it represents *all* centuries.

You may choose a particular century and confine your game to one nation's history for that period;

Or you may include the *contemporaneous* history of all nations.

If you choose, you can throw your game open to all history and all centuries.

When you pin your fact in its year-column, *name the century.*

EXAMPLE.

You stick a pin in 64 (in the *third* row of holes in that compartment—"Minor Event"), and say "Shakespeare born, 1564." Or pin 76 (*third* row in that compartment—"Minor Event"), and say "Declaration of Independence, 1776."

You stick a pin in 15 (*second* row of holes in that compartment—"Battle"), and say "Waterloo, 1815."

You stick a pin in 3 (*first* row of holes in that compartment—"Accessions"), and say "James I. ascended the English throne, 1603."

This is a game of *suggestion.* Whenever either player pins a fact, it will be pretty sure to suggest one to the adversary. The accidental mention of Waterloo will turn loose an inundation of French history. The mention of any very conspicuous event in the history of any nation will bring before the vision of the adversaries the minor features of the historical landscape that stretches away from it.

DETAILS.

Play turn about. Play by the clock. Make the game a half-hour long; or an hour; or longer, according to mutual understanding.

YEAR COLUMNS.

The upper row of holes in the enclosure of each year in the year columns is for Accessions (to thrones, presidencies, etc.). Each pin there counts 10.

The second row is for Battles. Each pin there counts 5.

The third row is for Minor Events. Each pin in it counts 1.

Minor Events are births, deaths, dates of inventions, and *any other facts,* great or small, that are datable and worth remembering.

MISCELLANEOUS FACTS.

These are recorded at the bottom of the board—the left side for the player using the black pins, the right side for white.

When a player has recorded *ten* of them, he must relieve the board by taking them all out and preserving the record of that ten by sticking *one* pin in the group of holes at his side of the board.

Miscellaneous Facts are facts which do not depend upon dates for their value. If you know how many bones there are in the human foot (whereas most of us don't), you can state the number and score one point. Populations, boundaries of countries, length of rivers, specific gravity of various metals, astronomical facts—*anything that is worth remembering,* is admissible, and you can score for it. If you explain what England understands by it when a member of Parliament "applies for the Chiltern Hundreds," do it and score a point. Waste no opportunity to tell all you know.

AUGMENTATION.

At the close of the game the player who has recorded the *greatest number of Minor Events* (third row of holes in the year compartments) is entitled to *add 100 points to his score* for it.

COUNTING GAME—EXAMPLE.

BLACK, we will suppose, has scored 10 Accessions (100); 30 Battles (150); 200 Minor Events (200); and 60 Miscellaneous Facts. Totals, 100, 150, 200, 60. Grand total, 510.

WHITE, we will suppose, has scored 6 Accessions (60); 20 Battles (100); 201 Minor Events (201); and 51 Miscellaneous Facts (51). Totals, 60, 100, 201, 51. Grand total, 412. He adds 100 for that extra Minor Event, and wins by 2 points.

MORAL.—The minor events of history are valuable, although not always showy and picturesque.

REMARKS.

In the ordinary ways, dates are troublesome things to retain. By this game they are easy to acquire (from your adversary), and they stick fast in your head if you take the trouble to use them a few times in playing the game.

Play all the dates you are sure of, and take sharp note of those which the adversary plays—for use next time.

In your daily reading seize valuable dates for use in the game at night.

Many public-school children seem to know only two dates—1492 and 4th of July; and as a rule they don't know what happened on either occasion. It is because they have not had a chance to play this game.

The most conspicuous landmarks in history are the accessions of kings; therefore these events are given the first place in the game and allowed to count the most. Battles come next.

When a particular century is chosen for the game, one should not confine it to one country, but throw it open to all countries. If one sticks to that century long enough he will acquire a valuable idea of what was going on in each of its decades throughout the civilized world. The most careless reader of history can name the masters of England who lived and died during Louis XIV.'s long reign, and can list the conspicuously important events that had place in England and France during that period; but to them historic night reigns in the rest of the European world—or nearly that, anyway.

Often one knows a lot of odds and ends of facts belonging in a certain period but happening in widely separated regions; and as they have no connection with each other, he is apt to fail to notice that they *are* contemporaneous; but he will notice it when he comes to group them on this game-board. For instance, it will surprise him to notice how many of his historical acquaintances were walking about the earth, widely scattered, while Shakspeare lived. Grouping them will give them a new interest for him.

The greatest histories are the reverse of lavish with dates; and so one is sure to get the order and sequence of things confused unless he first goes to a skeletonized school-history and loads up with the indispensable dates beforehand. This will keep him straight in his course and always in sight of familiar headlands and light-houses, and he will make his voyage through the great history with pleasure and profit. Very well, if he will gather his dates and play them on the game-board a while, he may then attack any history with confidence.

SOLITAIRE.

There are only two or three good two-handed home-games—and not a single good solitaire game that I am aware of; for cards soon lose their interest when there is nobody but yourself to beat with them. But I find these Dates a very good solitaire game indeed. You can add nothing new to your card game, but you can freshen up the date-fight with new dates every day.

TWO OR MORE.

Two may play; three may play; or four may play partners. Long pins and short pins, black pins and brass ones make a sufficient distinction between the players.

SPECIALTIES.

One may play the Authors, Artists, Inventors, Scientists, Philosophers, Generals, etc., of all times—each vocation in its turn—naming dates of birth and death, and principal deeds or works.

PENALTIES.

Penalties should be agreed upon for the punishment of errors, and for repetitions of facts through carelessness.

FACT-SOURCES TO DRAW FROM.

Cyclopedias, the Almanacs issued annually by the great newspapers, J. S. Oglesby's "Cyclopedia of Curious Facts," etc. There are plenty of convenient sources.

MARK TWAIN.

HARTFORD, February, 1891.

[26–27]

Mark Twain, *Mark Twain's Memory-Builder: A Game for Acquiring and Retaining All Sorts of Facts and Dates*, Hartford, Connecticut, 1885

In its response to Mark Twain's first application for his *Memory-Builder*, the United States Patent Office asked Twain to distinguish between his game and other extant chronology games, including Victor Klobassa's *Centenary Game*, patented in 1875. Twain replied that his and Klobassa's games were not at all alike: his was a game of knowledge, Klobassa's a game of chance.

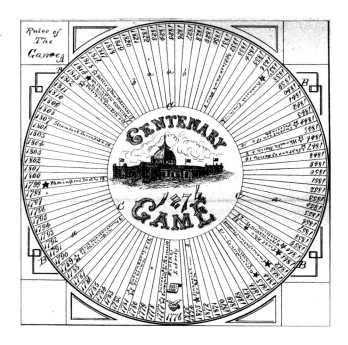

facts that might be incorporated: "Adam to Christ, 4,004 years," "Air is a mixture of oxygen and nitrogen."

The nineteenth-century American writer Samuel L. Clemens, better known by his pen name, Mark Twain, was fascinated by new technologies. He famously lost his shirt investing in the Paige Compositor, someone else's concept for an automatic typesetting machine, but he also held three patents of his own, none of which brought him such financial heartache—one for a self-adhesive scrapbook, one for an adjustable garment strap, and one from 1885 for a chronology game.

The concept of Twain's game was straightforward: players would name the dates of significant historical events, earning the right to push pins into a field of numbered spaces. [*figs.* **26–28**] In response to queries from the United States Patent Office, Twain carefully distinguished his game from other chronology games already patented including Victor Klobassa's "Centenary Game," the design of which was singled out by the patent inspector as suspiciously close to Twain's. But, as Twain argued successfully, the two really had nothing in common beyond the theme of chronology. Klobassa's patent was for a game of chance with a circular board that involved little more chronology than the display of dates. Twain called it a "gambling apparatus."[22]

In contrast, Twain's game presupposed "a thorough knowledge of history."[23] His board contains no historical information: it is a simple chronological template in which every date is equivalent to every other. In this respect, it is a truly modern chronology game. Like Priestley, Twain was fascinated by synchronisms. As Twain says, "One often knows a lot of odds and ends of facts belonging in a certain period but happening in widely separated regions; and as they have no connection with each other, he is apt to fail to notice that they *are* contemporaneous; but he will notice it when he comes to group them on this game-board. For instance, it will surprise him to notice how many of his historical acquaintances were walking about the Earth, widely scattered, while Shakespeare lived."[24] Twain believed in memorizing lots of dates, but for him the payoff was not just accumulating facts, it was creating a skeleton for real knowledge. Twain saw history as a treasury of memorable stories, and he thought that his game would elicit these by a process of suggestion. "The accidental mention of Waterloo," by one player, he writes, may turn loose from the other "an inundation of French history. The very mention of any very conspicuous event in the history of any nation will bring before the vision of the adversaries the minor features of the historical landscape that stretches away from it."[25]

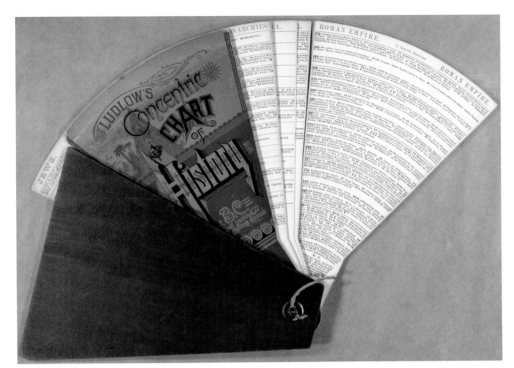

[29]

James M. Ludlow's 1885 *Concentric Chart of History*, a "radially-folding synchronous chart" allowed users to easily juxtapose historical events from different parts of the world. His publishers, Isaac Funk and Adam Wagnalls, also published a blank version of the *Concentric Chart* that the user could fill with new content.

Twain's game play was simple and adaptable. The basic version pitted two players head to head trying to name events and dates and to fill each dated hole in the chronological game board. The game could be played until the board was filled or the players' knowledge of history was exhausted, to a time limit or a designated point total. Ten points were awarded for giving the date of a monarch's accession, five points for a battle, and one point for any other historical event. Points could also be won for stating miscellaneous facts unrelated to chronology but interesting and worthwhile to know. Though Twain gave different values to different kinds of facts, he did not mean to suggest that some facts (accessions, battles) were more fundamentally important than others, only that they represented key markers in the chronological landscape. And he designed his game to be winnable on the basis of knowing minor facts as well as major ones. In the hypothetical game scenario that he gives with his rules, the player with more minor facts manages to eke out a victory. The moral: "The minor events of history are valuable, although not always showy and picturesque."[26] In Twain's view, the biggest and the smallest events in history were all potentially dramatic occasions, and, as in his *A Connecticut Yankee in King Arthur's Court*, all available for ironic redeployment and juxtaposition.

In the later nineteenth century, the spirit of chronographic innovation was in the air. [*fig.* **29**] Some inventors picked up where Christoph Weigel, inventor of the circular *Discus chronologicus*, and earlier engravers had left off. In 1885, for example, the Brooklyn minister James M. Ludlow patented and published a *Concentric Chart of History* with the newly established publishing venture of Funk and Wagnalls. Like Weigel's chart, Ludlow's was based on a simple Eusebian format. But instead of using a rectangular book binding or a circular poster, Ludlow's chart has the form of a fan with leaves shaped like pie wedges. These wedges are stacked, and attached at the point so that they can be swiveled out and viewed either individually or in juxtaposition. The concept resembles the volvelle—a circular chart with a rotating pointer—but here, the pieces of the chart themselves move. By constructing his device in this way, Ludlow hoped to combine the best of the book (capacity, random access) with the best of the chart (synoptic presentation, intuitive use of visual space).

In 1897 an Oregon rabbi, Jacob Bloch, patented a graphic work that brilliantly captured the feeling of historical acceleration characteristic of the late nineteenth century. [*figs.* **30-32**] His *Chronological Skeleton Chart* took the form of a spiral rather than a group of concentric circles

[30]

In his 1897 patent for a *Chronological Skeleton Chart*, Jacob Bloch writes, "The remoter the event recorded the smaller it will appear, and the more recent the occurrence the more conspicuously will it be shown. By this arrangement the present stands prominently before us, while the bygone time gradually recedes from view until lost into a mere point in the time-line of my chart."

[31]

Eli Nash Moyer, *Chart Drawing Instrument* patent, 1900. Moyer was an entrepreneur who manufactured and sold school supplies in Toronto. His device for drawing chronology charts worked much like a geometrical compass, and it was adaptable to many different uses, but he advertised it specifically for making chronological charts.

[32]

Walter Lyon Sinton, Portable Blackboard patent, 1897. Sinton was an associate of the Montreal physician Nelson Loverin, who had debuted a popular chart system at the International Exhibition in Philadelphia in 1876, and a principal in the Canadian Comparative Synoptical Chart Company. He designed a portable blackboard for use with Scaife's synoptical system.

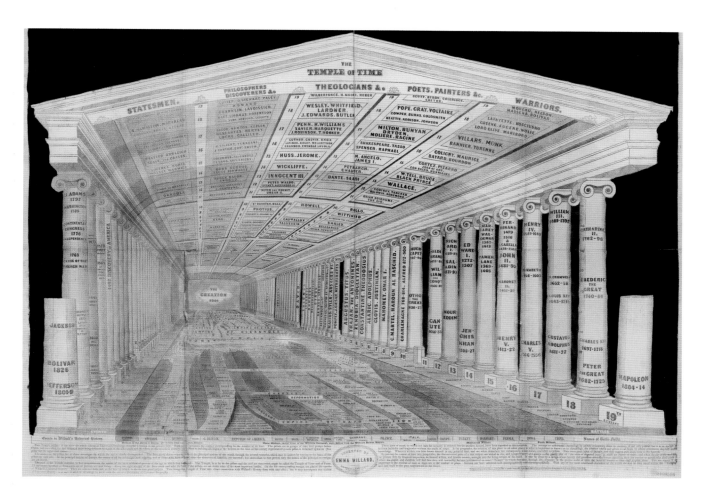

[33]

Willard's *Temple of Time* from 1846
is a three-dimensional projection
of historical chronography by the
pioneering woman educator and
founder of the Troy Female Seminary,
Emma Willard. In the "temple,"
standing columns represent centuries:
those on the right are emblazoned
with the names of important historical
figures of the old world, those on
the left, of the new. The floor shows
a historical stream chart. The ceiling
functions as a chart of biography.
Williard's colorful chart was also
reproduced in miniature in her
1850 textbook *Universal History in
Perspective*.

as in the charts of Weigel and Ludlow. Bloch had noticed that chronological charts used in history classes were often only partially filled. Typically, he said, sections on modern history were densely packed with information while more distant periods were only barely filled or entirely blank. As an alternative to the spatially challenged rectilinear format, Bloch proposed a chart based on a conic spiral. By placing the start date for any chronology at the center of the expanding spiral, Bloch neatly eliminated the problem of blank space that Priestley had papered over with blazons, dedications, and explanations. At the same time, he provided a geometric analogue for historical memory as he understood it. Historical memory, he thought, was strong for recent events and weak for distant ones (narrowing progressively, as in his diagram). And, in limited ways, this is certainly right. But as a general theory, it founders on the many examples of distant historical events that retain great cultural importance. It seems a strange thing for a rabbi, whose stock and trade is old stories, to overlook— but apparently to a frontier rabbi in nineteenth-century America this conic view of historical memory made at least passable sense.

For all of the innovations touted in the chronographic patents of the late nineteenth century, however, nothing could change the fact that, in the end, someone had to use these things. Encyclopedic time charts were tools of reference and visualization, and few of these writers imagined that a student of history would attempt to memorize all of the data presented on their charts. Priestley, for his part, argued strenuously that such an approach would defeat the very purpose of the timeline. He contended that the value of the timeline lay in its ability to *relieve* the student of the unnecessary burden of memorization. But, like it or not, in history, the effort of memorization could not be entirely avoided. For everything that was said during the eighteenth century and after about the dulling effect of rote memorization, in practice, committing information to memory remained one of the principal goals of primary and secondary history teaching. And, as Twain's game suggests, not everyone viewed this as a bad thing.

To the contrary, nineteenth-century educators expressed a great fascination with mnemonics as well as reference. [*fig.* **33**] Some, such as the pioneering American educator Emma Willard, revived older mnemonic forms. In one work, Willard, who founded several schools for girls and published educational works on history, geography, and biology, resituated the stream of history in the space of a Renaissance memory theater. Her 1846 *Temple of*

[34]

A blank template representing one century from Elizabeth Palmer Peabody, *The Polish-American System of Chronology, Reproduced, with Some Modifications, from General Bem's Franco-Polish Method*, Boston and New York, 1850

Time was beautifully printed in vibrant color on a jet black background. Structurally, it was entirely within the nineteenth-century stream-of-time genre promoted by Johann Friedrich Strass. But, for both practical and symbolic reasons, Willard also found it useful to refer back to a much older tradition that the Renaissance had inherited from classical antiquity, in which memorization was seen as itself a valuable intellectual performance. In Willard's *Temple of Time*, as in the Renaissance memory theaters, a student began by committing an elaborate building facade, or several of them, to memory, then placed the dates, facts, or words to be memorized on the facade, niche by niche and column by column.[27]

Other mnemonic systems did away as best they could with vestiges of the old. The incipient graphic modernism in these nineteenth-century visual approaches is expressed most clearly in the highly abstract Polish System—a ten-by-ten grid mnemonic chart filled with simple colors and lines—developed by Antoni Jaźwiński in the 1820s and popularized by the Polish national hero General Józef Bem in the 1830s and '40s.

To an outsider, the Polish System—employing chronological tables with no dates, words, or images—may appear mystifying. [*fig.* 34] But once learned, it isn't hard to use.

First, the student needs to become familiar with the ten-by-ten grid itself, since no dates are given on the charts. To figure out when an event took place, the novice student counts boxes (one box can signify a year, a decade, or a century, depending on the scale used); the advanced student becomes familiar enough with the charts to calculate the date automatically just by observing the position of a square in the grid. Next, the student needs to understand the meaning of the small three-by-three grids embedded in each of the individual chronological squares on the chart. Placement on the small grids determines the type of event (battle, treaty, marriage, and so forth). Then, the student needs to be familiar with three simple symbols, a square, a triangle, and an X. These modify the type of event. Finally, she or he has to know what colors are assigned to what countries. The meanings of the colors and divisions vary in different editions of the system, but the basic principle of the system is always the same: placement on the large grid gives the date, on the small grid, the type of event, and color gives the nations involved.

If a student using Nelson Loverin's version of the system wished to indicate that a revolution took place in America in 1776, she or he would choose the ten-by-ten grid for the eighteenth century, and the square for the

[35–37]

Nelson Loverin, chart apparatus in *Loverin's Historical Centograph and Slate*, Montreal, 1876

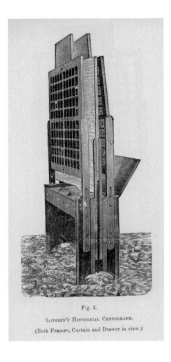

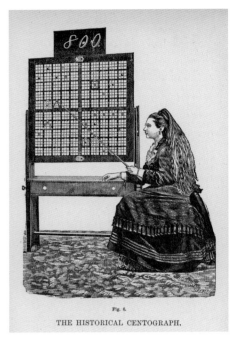

Fig. 2.

LOVERIN'S HISTORICAL CENTOGRAPH.

(Both Frames, Curtain and Drawer in view.)

Fig. 6.

THE HISTORICAL CENTOGRAPH.

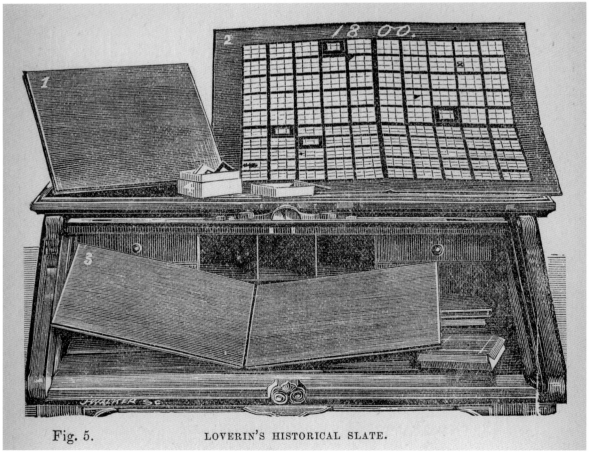

Fig. 5. LOVERIN'S HISTORICAL SLATE.

In 1850 the American transcendentalist Elizabeth Palmer Peabody published her *Polish-American System of Chronology, Reproduced with Some Modifications, from General Bem's Franco-Polish Method*. Peabody traveled the United States promoting her book, blank charts, and a special set of paints to be used filling them in. She pointed out that if a school found it "absolutely impossible" to acquire a paint set, a system of numbers could be used instead of colors, but when this is done, she wrote, "a vast advantage is given up." Many extant copies of Peabody's books show the ingenuity and application of their previous owners.

seventy-sixth year of the century (located in row seven, column six), then, using the correct color for the British colonies in North America, the student would paint a full square in the center of the lower row (designated for insubordination). [*figs.* **35-37**] If 1776 brought only a revolt and not a revolution, the student would paint a triangle; if only a conspiracy and not a revolt, an X.

Though mostly forgotten today, in its time, this system swept across Europe and North America. In the 1830s, it was approved for use across the entire French educational system, and over the next decades it went through many official revisions. In the 1850s, it gained an unlikely but persuasive advocate in the American Elizabeth Palmer Peabody, an education reformer, pioneer of the kindergarten movement, and sister-in-law to Horace Mann and Nathaniel Hawthorne. And in the 1870s, new versions were promoted in Canada and the United States.[28]

According to the inventors of the Polish System, past chronographers had been right to make the connection between geographic maps and time maps: chronology, like geography, could be represented graphically, which made it both easier to learn and easier to remember. But Jażwiński and Bem also saw the analogy between time maps and geographic maps as a distraction, since it emphasized the facts

to be memorized rather than training the memory itself. Both rejected the notion of a visual territory of history in favor of a visible but featureless mnemonic field. The move to abstraction, of course, was not entirely new; Priestley had started it already. But Priestley's charts functioned more like maps: in them, continuous time was represented by continuous graphic space. Not so in Jażwiński. Here, years are represented by simple coordinates in a matrix.

In France, the Polish System was praised for its effectiveness in helping students memorize large amounts of information, but in the United States, the prevailing opinion was different. [*figs.* **38-39**] There, its principal advocate was Elizabeth Palmer Peabody, a member of the transcendentalist circle and a pedagogical theorist still well remembered for promoting the developmental importance of play. On the surface of things, the rigid Polish System seems an odd fascination for her. But fascination it was. She published the first of her several editions of the *Polish-American System* in 1850, and for the next decade, she promoted the system tirelessly. She even commissioned a purpose-built paint set for filling in the charts, which she sold and advertised everywhere she traveled.

Peabody's explanation of the Polish System is sensitive and revealing, and opens a new perspective on the time

OCEAN-CHART.

The Bellman himself they all praised to the skies—
 Such a carriage, such ease and such grace!
Such solemnity, too! One could see he was wise,
 The moment one looked in his face!

He had bought a large map representing the sea,
 Without the least vestige of land:
And the crew were much pleased when they found it to be
 A map they could all understand.

"What's the good of Mercator's North Poles and Equators,
 Tropics, Zones, and Meridian Lines?"
So the Bellman would cry: and the crew would reply
 "They are merely conventional signs!

"Other maps are such shapes, with their islands and capes!
 But we've got our brave Captain to thank"
(So the crew would protest) "that he's bought us the best—
 A perfect and absolute blank!"

"Ocean Chart" and excerpt from Lewis Carroll's *The Hunting of the Snark*, London, 1876

chart beyond questions of reference and of memory. For Peabody, the chronological chart functioned as a scheme for organizing creative thought. Peabody was strongly opposed to rote education. No child, she said, should ever be forced to read anything less than a work of genius. She was particularly opposed to the use of epitomes and survey texts in the study of history, as she felt they bled history of its passion and interest and turned it into a numbing exercise in recitation. At the same time, she recognized that learning history from writers of genius—Herodotus, Livy, Muller, Niebuhr, and so forth—was difficult. The Polish charts would aid such reading not as cheat sheets but as work sheets for thinking through and organizing ideas. "All true education in history," writes Peabody, is a "communion upon the events of the past." And she continues, "What I especially value Bem's invention for is this: that it does not pretend to be what an outline never can be, namely: a perfect frame work for history."[29] The results of Peabody's appropriation of the Polish System are both handsome and surprising: surviving copies of the charts in libraries look nothing like one another. Each bears the imprint of an individual student's imagination.

Chart systems like Jażwiński's and Bem's were designed to make students into temporal cartographers, though,

like the sea chart in Lewis Carroll's *The Hunting of the Snark*, the terrain that they were to map was abstract and unmarked. [*fig.* 40] The 1866 *Map of Time* by John Milton Gregory, then Michigan superintendent of schools, makes the analogy explicit. Though his "map" was little more than a five-by-five grid, a simplified version of Jażwiński, he believed it provided a terrain of visual association no less intuitive than that of a geographic map. "The century stands forth before the eye with a broad, Statelike expanse, while its decades and years lie clearly marked and easily distinguished, like so many counties and townships. It is in no very narrow sense, therefore, a map of time; and, if properly used, will be found to aid the student and reader of History, as maps of the continents aid the student of Geography."[30]

Ida P. Whitcomb, another late-nineteenth-century educator, made a similar claim. Chronological charting, she argued, was as important as any other kind of visual education, including an education in historical images. She writes, "[Thomas Babington] Macaulay's comparison between History and Historical Romance applies forcibly to classified and unclassified school study. He says: 'Of the two kinds of composition, into which History has been divided, one may be compared to a map, the other to a

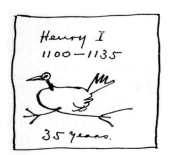

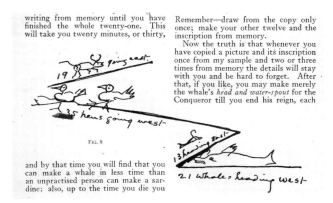

writing from memory until you have finished the whole twenty-one. This will take you twenty minutes, or thirty,

FIG. 8

and by that time you will find that you can make a whale in less time than an unpractised person can make a sardine; also, up to the time you die you

Remember—draw from the copy only once; make your other twelve and the inscription from memory.

Now the truth is that whenever you have copied a picture and its inscription once from my sample and two or three times from memory the details will stay with you and be hard to forget. After that, if you like, you may make merely the whale's *head and water-spout* for the Conqueror till you end his reign, each

[41–42]

In his 1899 article, "How to Make History Dates Stick," Mark Twain offered a series of pictographs to aid in memorizing the chronology of the English monarchs. Most were based on linguistic associations: hen for Henry, whale for William, steer for Stephen, and so on. These could then be laid out on a mnemonic timeline reversing at each change of regime. Twain suggested redrawing each cartoon as many times as there were years in a monarch's reign. That, he said, would ink the image indelibly into your mind.

painted landscape. The picture, though it places the country before us, does not enable us to ascertain with accuracy its dimensions, distances, and angles; the map gives us exact information as to the bearings of the various points, and is a more useful companion to the traveler or the general than the painted landscape.'" Whitcomb's own 1878 *Students' Topical History Chart* claimed not merely to "trace" the facts of history onto to the student mind but to "brand" them into it.[31]

Mark Twain, though his board game already represented a new take on the problem of chronographics, continued to puzzle and invent through the 1880s and '90s. In 1899, fourteen years after he first published *Mark Twain's Memory-Builder*, Twain wrote a magazine article entirely devoted to the subject. The article, "How to Make History Dates Stick," brimmed with Twain's characteristic humor.[32] In it, he bemoaned his own difficulties remembering things, dates above all. Over the years, he said, he had implemented numerous aids and expedients. At one point, when he was having trouble committing a speech to memory, he came up with the idea of writing notes on the tips of his fingers so that he could easily refer to them while he talked. This backfired. He remembered the speech but irritated the audience, which had trouble understanding

why the esteemed speaker seemed to be gazing idly at his fingernails.

The solution, Twain discovered—or rediscovered, since it is essentially the standard method of classical mnemonics—was to lay down a strong system of visual association and commit *that* to memory. [*figs.* **41–42**] He began doing this for his speeches—drawing little pictures to help call up a subject and sometimes in twisted and humorous ways, as for example, when he used a picture of lightning to remind him to talk about San Francisco, since according to Twain, there is no lightning in San Francisco—and then applied the method to the harder subject of chronology. The key to it all, Twain argued, was doing it yourself. It was not enough to use someone else's system. That could help, no doubt, but to really commit something to memory you had to figure it out yourself. Twain writes,

Dates are difficult things to acquire; and after they are acquired it is difficult to keep them in the head. But they are very valuable. They are like the cattle-pens of a ranch—they shut in the several brands of historical cattle, each within its own fence, and keep them from getting mixed together. Dates are hard to remember because they consist of figures; figures are monotonously unstriking in appearance, and they

[43–45]

Mark Twain, mnemonic cartoons of Edward I, Edward II, and Edward III, from "How to Make History Dates Stick," 1899. Twain writes, "Edward I. That is an editor. He is trying to think of a word. He props his feet on a chair, which is the editor's way; then he can think better. I do not care much for this one; his ears are not alike; still, editor suggests the sound of Edward, and he will do. I could make him better if I had a model, but I made this one from memory. But is no particular matter; they all look alike, anyway. They are conceited and troublesome, and don't pay enough. Edward was the first really English king that had yet occupied the throne. The editor in the picture probably looks just as Edward looked when it was first borne in upon him that this was so. His whole attitude expressed gratification and pride mixed with stupefaction and astonishment."

don't take hold, they form no pictures, and so they give the eye no chance to help. Pictures are the thing.[33]

In his article, Twain gives numerous examples of his own mnemonics, funny combinations of verbal and visual play. For the chronology of English kings, he created pictographs based on alliteration: the Henrys are hens, the Stephens are steers, the Williams are whales, and the Edwards—feet tipped up on their chairs, pens in hand, and malice in their eyes—are editors.

Twain's images were crude, but this didn't matter to him. [figs. 43–45] The point, he said, was just to be able to remember. Thus, Twain gives us his somewhat mangled impression of Edward III, a literary critic who "has pulled out his carving-knife and his tomahawk and is starting after a book which he is going to have for breakfast."[34]

None of this decoration should be taken to suggest that Twain threw out the idea of a timeline. [fig. 46] Far from it: in Twain's system, you start by making pictures, then you pin them to the wall in chronological order like kings marching in procession.[35] In good weather, Twain suggested, a similar arrangement could be implemented outdoors. He taught his daughters to mark off a road or path in equal lengths, call those lengths years, and then post stakes at key moments.

Twain was not the only one to suggest sending children out to play in the chronological field. In an early promotion of his own chronological system, Jaźwiński had suggested that his colorful matrices would make a wonderful plan for a garden. Or, if time did not permit a horticultural approach, a playing field could simply be marked off by ribbons indicating conquests, accessions, and other great events.

None of Twain's inventions was intended as art, and Twain joked heartily about his poor drafting skills. [fig. 47] If he could do it, anyone could, he said. His idea was to make history visible, touchable, even walkable, to make the children in his household see what otherwise they might only read. Yet, in Twain, as in Jaźwiński, Bem, and Peabody, there is a surprising incitement to artistic practice. Not to high art, not to considered aesthetics, but to a kind of tinkerer's art, doodles in the margins of history.

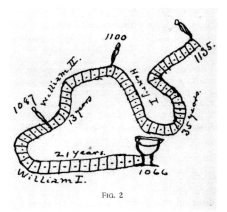

FIG. 2

[46]

Mark Twain, driveway from "How to Make History Dates Stick," *Harpers*, 1899. Twain proposed marking off a road or path in equal lengths, calling those lengths years, and then posting stakes at key moments. He had done this very thing with his own daughters. Not only did it succeed in overcoming their distaste for chronology, it stuck the dates permanently for Twain himself. He writes, "when I think of the Commonwealth I see a shady little group of these small saplings which we called the oak parlor; when I think of George III, I see him stretching up the hill, part of him occupied by a flight of stone steps…Victoria's reign reached almost to my study door on the first little summit; there's sixteen feet to be added now; I believe that that would carry it to a big pine-tree that was shattered by some lightning one summer when it was trying to hit me."

[47]

Antoni Jażwiński, *Tableau muet servant aux Exercices Chronologiques et autres de la Méthode dite Polonaise*, Paris, 1834

Chapter 7:

Outside and Inside

Most images are not art....An image taken at random is more likely to be an ideographic script, a petroglyph, or a stock-market chart than a painting by Degas or Rembrandt, just as an animal is more likely to be a bacterium or a beetle than a lion or a person....The variety of informational images, and their universal dispersion as opposed to the limited range of art, should give us pause. At the least it may mean that visual expressiveness, eloquence, and complexity are not the proprietary traits of fine art....

—James Elkins

In art today, chronography seems to be just about everywhere. In monuments and memorials, where historical notation serves civic purposes, figures of chronological time are especially common. From the work of American artists, such as Sheila Levrant de Bretteville's urban history palimpsest set in the sidewalks of L.A.'s Little Tokyo to Maya Lin's series of chronological monuments including the Vietnam Veterans and the Civil Rights memorials, to the work of design firms, such as the Gates of Time at the former site of the Murrah Federal Building in Oklahoma City, our memorials and public art installations confirm the central role that dates play in our collective memory.

Chronological themes and structures appear in less conventional contexts too, like the solemn *Date Paintings* of Japanese artist On Kawara, the pen and paper travel itineraries of Belgian artist Christoph Fink, the abstract somatic diaries of San Francisco artist Katie Lewis, the ironic timelines of Dutch conceptualist Marjolijn Dijkman, and the apocalyptic mappings of the Chinese artist Huang Yong Ping. [*figs.* 1–10] These and many other contemporary works explore and critique our graphic vocabularies of time.

Of course, there have always been artistic chronographies. From Eusebius to Priestley and from Priestley to our own day, scholars have produced untold numbers of beautiful chronographic artifacts. Few of these, however, were ever intended as art. In this respect, the chronological chart shares a status with an entire range of "informational" or "utilitarian" images such as those discussed by American art historian James Elkins—graphs, charts, and diagrams, maps, geometric figures, notations, plans, technical drawings, schemata, and so forth.[1]

Until recently, chronography remained essentially the domain of the scholar, the technician, the amateur, and the visionary—the historian who is not an artist, the designer who is not a historian, or the seer who is neither but who for one reason or another has appropriated this set of

In Maya Lin's 1993 work, *The Women's Table*, in New Haven, Connecticut, numbers spiral out from the center of a large stone slab indicating how many women were enrolled in Yale University programs in each year since its founding. The spiral begins with a series of zeros, until the numbers start to mount in the 1870s. The spiral form suggests a continual opening through time.

In recent years monumental art has become increasingly precise in its use of chronology. At the Oklahoma City National Memorial and Museum, designed by the Butzer Partnership, commemorating the 168 lives lost in the 1995 bombing of the Alred P. Murrah Federal Building, two Gates of Time frame the memorial space. According to the museum, "the East Gate represents 9:01 AM on April 19, and the innocence of the city before the attack. The West Gate represents 9:03 AM, the moment we were changed forever, and the hope that came from the horror in the moments and days following the bombing."

In Little Tokyo in Los Angeles, California, the artist Sheila Levrant de Bretteville has laid chronologies into the sidewalks. Her 1996 *Omoide no Shotokyo* (Remembering Old Little Tokyo), places date lists at the entrances to stores and residences along the central street of the old Japanese-American district showing the names of events and occupants like a palimpsest.

In works such as his 2001 *Atlas of Movements*, a kind of flow chart made with pencil, paper, and scissors, the Belgian artist Christoph Fink takes landscape art in a new direction. Fink's graphically improvisational works—whether paper charts, ceramic sculptures, or wire frames—are projections of his minutely recorded voyages around the world. His geographies are so precise as to be evanescing: in his universe, no space exists outside of time.

The work *201 Days* from 2007 by
the American artist Katie Lewis is
a layering of sensations. The visual
space of the work is an abstract map
of the human body; dated pinholes
indicate sense events; synchronisms
are indicated by red string. Seen from
above, the result is a record of spatial
densities; from the side, a stratigraphy
of moments.

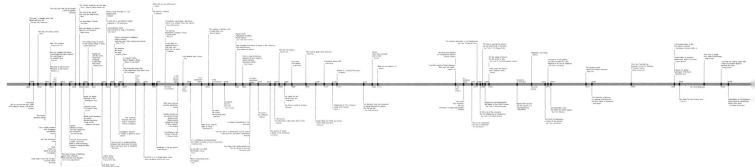

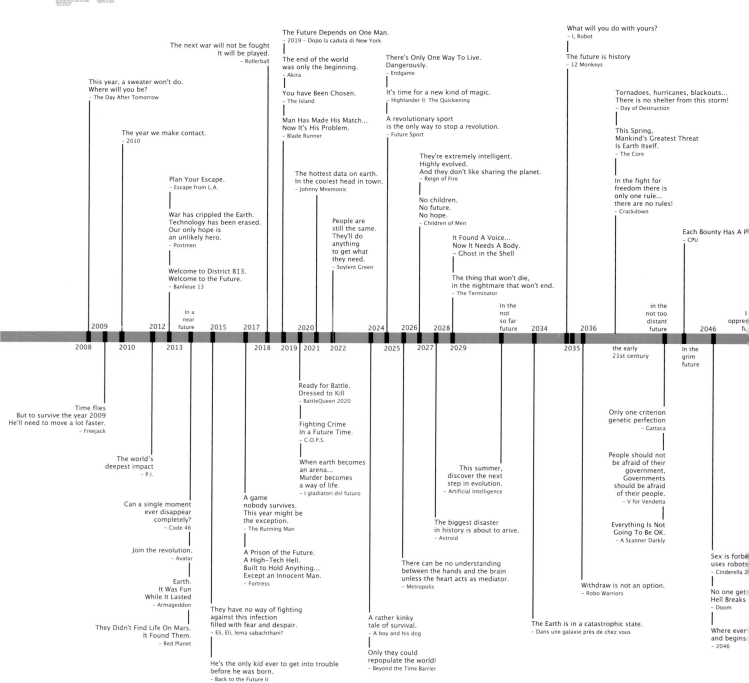

The Future Depends on One Man.
– 2019 – Dopo la caduta di New York

What will you do with yours?
– I, Robot

The next war will not be fought
It will be played.
– Rollerball

The end of the world
was only the beginning.
– Akira

There's Only One Way To Live.
Dangerously.
– Endgame

The future is history
– 12 Monkeys

This year, a sweater won't do.
Where will you be?
– The Day After Tomorrow

You have Been Chosen.
– The Island

It's time for a new kind of magic.
– Highlander II: The Quickening

Tornadoes, hurricanes, blackouts...
There is no shelter from this storm!
– Day of Destruction

The year we make contact.
– 2010

Man Has Made His Match...
Now It's His Problem.
– Blade Runner

A revolutionary sport
is the only way to stop a revolution.
– Future Sport

This Spring,
Mankind's Greatest Threat
Is Earth Itself.
– The Core

Plan Your Escape.
– Escape from L.A.

The hottest data on earth.
In the coolest head in town.
– Johnny Mnemonic

They're extremely intelligent.
Highly evolved.
And they don't like sharing the planet.
– Reign of Fire

In the fight for
freedom there is
only one rule...
there are no rules!
– Crackdown

War has crippled the Earth.
Technology has been erased.
Our only hope is
an unlikely hero.
– Postmen

People are
still the same.
They'll do
anything
to get what
they need.
– Soylent Green

No children.
No future.
No hope.
– Children of Men

Each Bounty Has A P
– CPU

It Found A Voice...
Now It Needs A Body.
– Ghost in the Shell

Welcome to District B13.
Welcome to the Future.
– Banlieue 13

The thing that won't die,
in the nightmare that won't end.
– The Terminator

In a
near
future

In the
not
so far
future

in the
not too
distant
future

| 2009 | | 2012 | | 2015 | 2017 | | 2020 | | | 2024 | 2026 | 2028 | | | 2034 | 2036 | | | 2046 | |

| 2008 | 2010 | | 2013 | | | 2018 | 2019 | 2021 | 2022 | | 2025 | 2027 | 2029 | | | | 2035 | the early 21st century | In the grim future | | |

oppres
fu

Time flies
But to survive the year 2009
He'll need to move a lot faster.
– Freejack

Ready for Battle.
Dressed to Kill
– BattleQueen 2020

Only one criterion
genetic perfection
– Gattaca

The world's
deepest impact
– P.I.

Fighting Crime
In a Future Time.
– C.O.P.S.

People should not
be afraid of their
government,
Governments
should be afraid
of their people.
– V for Vendetta

Can a single moment
ever disappear
completely?
– Code 46

When earth becomes
an arena...
Murder becomes
a way of life.
– I gladiatori del futuro

This summer,
discover the next
step in evolution.
– Artificial Intelligence

A game
nobody survives.
This year might be
the exception.
– The Running Man

Join the revolution.
– Avatar

Everything Is Not
Going To Be OK.
– A Scanner Darkly

A Prison of the Future.
A High-Tech Hell.
Built to Hold Anything...
Except an Innocent Man.
– Fortress

The biggest disaster
in history is about to arive.
– Astroid

Earth.
It Was Fun
While It Lasted
– Armageddon

Sex is forbi
uses robots
– Cinderella 2

They have no way of fighting
against this infection
filled with fear and despair.
– Eli, Eli, lema sabachthani?

There can be no understanding
between the hands and the brain
unless the heart acts as mediator.
– Metropolis

Withdraw is not an option.
– Robo Warriors

No one get
Hell Breaks
– Doom

They Didn't Find Life On Mars.
It Found Them.
– Red Planet

A rather kinky
tale of survival.
– A boy and his dog

The Earth is in a catastrophic state.
– Dans une galaxie près de chez vous

Where ever
and begins
– 2046

He's the only kid ever to get into trouble
before he was born.
– Back to the Future II

Only they could
repopulate the world!
– Beyond the Time Barrier

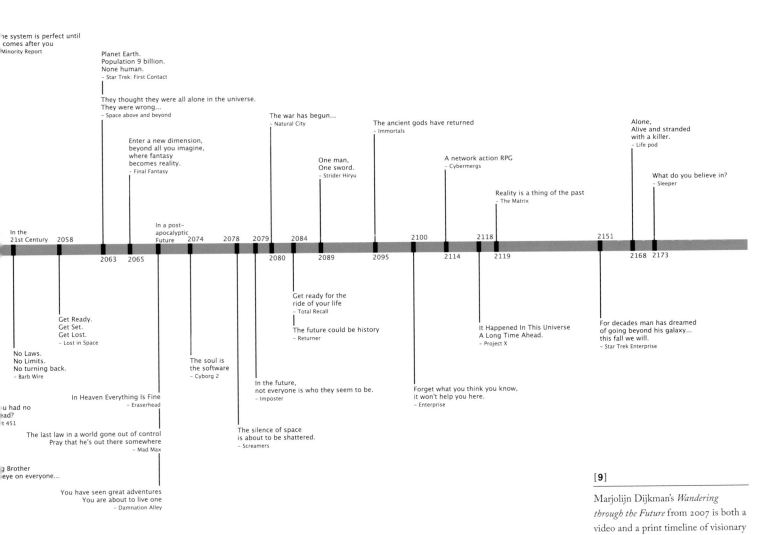

[9]

Marjolijn Dijkman's *Wandering through the Future* from 2007 is both a video and a print timeline of visionary fiction. In it, films are organized not in order of their production, but according to their imagined setting in future historical time.

[10]

Time, chance, and fortune are recurrent themes in the work of the Chinese artist Huang Yong Ping. In his *Carte du Monde* (2000–2007), a dated chronology of future disasters unravels across the spiraling strip of an eviscerated globe.

[11–12]

John Sparks, *The Histomap*, New York, 1931

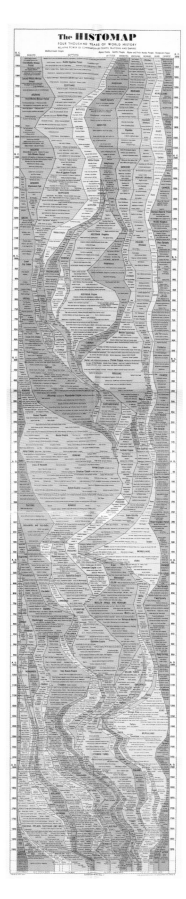

graphic tools. And much of what is most visually interesting in chronography prior to the twentieth century—Lorenz Faust's statue of Daniel, Christoph Weigel's *Discus chronologicus*, the homemade *Chart for John Dickinson*, Eliza Spalding's *Protestant Ladder*, the beautifully pixelated matrices of Elizabeth Palmer Peabody's students—has arisen from this.

Many of the most appealing chronological charts come from amateurs, trained in neither chronology nor art. [*figs.* **11–12**] The beautiful *Histomap*, for example, a strong seller for Rand McNally for over fifty years after its debut in 1931, was not the creation of a trained historian.[2] Its author, John Sparks, was the American plant manager for the Swiss-owned Nestlé Corporation during the interwar period. He was a history buff, and because his work required that he travel long distances by train, he always carried with him a history book and a blank note pad. While he traveled, he filled his pads with names and dates scrawled by pen. When he returned home, he cut his notes into slips and pasted them onto a massive chart for his own reference.[3]

Explaining his efforts, Sparks cited the philosophers Alfred North Whitehead and Herbert Spencer as influences.[4] From the first, he drew the notion that graphic

Historical timeline chart (B.C. 1650 – 550)

Left time scale (B.C.): 1650, 1600, 1550, 1500, 1450, 1400, 1350, 1300, 1250, 1200, 1150, 1100, 1050, 1000, 950, 900, 850, 800, 750, 700, 650, 600, 550

Major headings across the chart:

AMORITES · Elamites · HUNS · Dynasty Emperor Chang-Tang

AEGEANS — Late Minoan Period · Hittite Empire · Babylonians · IRANIANS · Tartars

Rise of Egyptian Empire · INDIANS (Hindus) · Yin Dynasty · CHINESE

AEGEANS — Mycenaean Age · EGYPTIANS · HEBREWS · Huns

HITTITES · Chinese Imperial Power · Middle Kingdom

GREEKS · Hittite Empire · ASSYRIAN Kingdom · INDIANS (Hindus) · Chou Dynasty

HEBREWS · Babylonians

Greek City States · PHOENICIANS · Zoroaster

GREEKS · ETHIOPIANS · SYRIANS · ASSYRIAN Empire · HUNS

Greek City States · LYDIANS · Chaldeans · Median Supremacy · Lao-Tse · INDIA

Cyrus · Buddha · Confucius

Selected entries:

1650 — Recovery and rapid advance of civilisation to most brilliant period of Minoan culture brought to light by excavations of Sir Arthur Evans. under King Khian who levied heavy tribute of corn from... Large fortified city at Khatti, the present Boghaz. Semitic alphabet in use on clay tablets. Elamite influence on Indian buildings in the Punjab. Chinese records indicate that the Tungusi nomads were particularly active at this time, raiding the...

1600 — Cnossus again destroyed. Settled farming communities under rule of despotic monarch with luxurious court. Palaces of Aghia Triada and Phaestos. Ahmose I with aid of army raised in Ethiopia. XVIIIth Dynasty. Hyksos expelled by Amenhotep I. Thutmose I, first King buried in the "Valley of the Tombs." Imposing palaces and temples. Hittites fight Egyptians at Megiddo. Assur an independent city. Loss of vassal States including Assyria and Syria. Excavations at Susa indicate well-built houses and drainage systems. State of Kosala. Worship of Indra. Ancestor worship taught by Emperor Yao.

1500 — Classical Minoan art period. Cretans of this great Late Minoan Period comparable with Egyptians and Babylonians in development of art, architecture and sanitation, and construction of canals. Worship of the Great Earth Mother. Establishment of colonies in Sicily, South Italy and Asia Minor. Commerce with Babylon. Literary activity and compilation of the "Book of the Dead." King Hattusil I expands Hittite territory into Syria, establishing the... Decline of Kassite power and struggle for supremacy with the Assyrians. Seals with pictographic legends carved in style equally as fine as those of Mycenaean Greece. Probable date of the compilation of the... First written documents date from this time. Treaties were made by Chinese Emperors of the Shang Dynasty.

1450 — Conflict with invading Greeks and fall of Cnossus. New cultural centres at Mycene and Tirns. Thutmose III "Egyptian Napoleon" conquers Syria and Ethiopia. Queen Hatshepsut. Thebes (Ammon) at height of splendour. Hittite Empire including Phrygia and Cappodocia. Assyria becomes an independent kingdom. Temple built to the God "Nana." Nineveh raided by the Hittites. Burnaburiash II. Pottery and other objects of art show affinity with Egyptian style. Rig-Veda, comprising over 1000 poems or hymns describing the life of the early Aryan peoples. King Tushrata of Mitani. Boghaz-Koi inscriptions of Kings of the Mitani show adoption of some Hindu Deities. Shang or Yin Dynasty. Cultural centre of the Hwang-Ho. Emperor Pan-Keng.

1400 — Greek tribes from North drive Mediterranean Cretans South. Period of the Tel-el-Amarna letters, clay tablets of international correspondence. Amenhotep III, luxury-loving Pharaoh. Capital at Thebes. Amenhotep IV, or Ikhnaton and his Queen Nefretete. Religious movement based on "One God" idea. Tutenkhamon. Return to old religion. Golden Age of Hittite civilisation. Sidon founded by Phoenicians. Iron mines worked on the Black Sea, and iron weapons developed. Kuri-Galzu takes Susa from the Elamites and restores the Temple to the Moon-god "Sin" at Ur. History of early INDIANS (Hindus) largely unknown. Worship of the Sun-goddess Nhakhkhunte and of Sanskrit. Beginning of the Kingdom of the Maghadas. Capital transferred from Shang to Yin, and Dynasty known as Yin.

1350 — Early Cretans driven into Syria. The Philistines of Gaza, Gath and Joppa, were possibly of Cretan origin. XIXth Dynasty. War on Hittites. Pharaoh Harmhab restores order. Rameses I. Seti I. wages successful wars on Assyria, Ethiopia and Arabia. Traditional date of exodus from Egypt. Moses. Conflict with Egypt. Shalmaneser I founds city of Calah or Nimrud. Kuri-Galzu III. Elamite King. Lagamar, at city of Khurba-Tila. Development of the caste system. Huns. Emperor Wu-Ting leads successful expedition against the Tartars.

1300 — Arrival of Dorians, Ionians, Eolians and Aetolians. Rameses II, the Great, builds many temples and palaces: Temple of Ammon and House of Rameses at Karnak. Hebrews under Moses escape Egyptian bondage. Egypt exerts imperial influence extending from Ethiopia to Thrace. Joshua conquers Canaan. Battle of Kadesh. Period of Book of Numbers. Tukulti I, under Assyrian rule. Sutruk-Nakhkhunte destroys Babylon and carries away the Stela of Naram-Sin, also the famous code. Brahmans or priests; Kshattriyas or warriors; Vaisyas, artisans or farmers; Sudras or non-Aryan servants. Renewed activity of the Huns. Zenith of Chinese Imperial Power.

1200 — Fall of Troy. GREEKS. Egypt attacked by Lybians and loses hold on Phoenicia. Pharaoh Mernephtah. Pharaoh Siptah. Rise of power of the Priesthood. Close of the Imperial Era and rapid decline in Art. Hittite Kingdom at height of power under Hattusil II. Aramean centre at Damascus. Trade and industry flourish. Conflicts with Hittites. Assur-nazir-pal. Tukulti II. Assur-dan I. IVth Dynasty of laws of Hammurabi, from Sippara. Babylonian rule. Chinese Imperial Power with seventeen hundred small feudal states under the sovereignty of the "Emperor of the..." Middle Kingdom. Shang Dynasty ends with tyranny of Emperor Chou-sin, who imprisons Won-wang for protesting.

1150 — Breakup of Mycenaean civilisation, but the Greeks carry on the Minoan and Egyptian cultures. Seti II. XXth Dynasty. Rameses III. Further attacks by Lybians. Invasion by Cretans driven from Greece. Rameses V. Final dissolution of Empire in wars with Cretans and Arameans. Decay of the Empire. Commercial activity. Chief city Carchemish. Sea power developed. Period of Book of Judges. Assyrians absorb the Babylonian culture, but cultivate active worship of Assur, and extend their territory by conquest. Vth Dynasty Ashur-Shum-User restores Babylonian rule. Capital transferred to Assur. Period described in the Mahabharata, epic of the heroic age. Great building period. Raids by the "Dog Barbarians." Won-wang writes the I-King, or "Canon of Changes." Chou-sin deposed by Wu-wang, son of Won-wang, who became first Emperor of the...

1100 — Worship of Zeus and Demeter. Rameses X. Priests of Ammon in power. Hittite Empire. Gades or Cadiz founded. Worship of Moloch. ASSYRIAN Kingdom. Empire extended by Tiglathpileser I. War against Hittites. Conflicts with Philistines (Cretans). Samson. Commerce with Phoenicia. Nebuchadnezzar I. Bel-Nadin-Pal. Empire centered in Bactria. An early Iranian. Cliff Temples excavated in Rock. Chou Dynasty.

1050 — Probable date of Homer's Iliad, history of the siege of Troy. Rameses XII. XXIst Dynasty. Period of decadence and decline. Daughter of Pharaoh married to King David. Ethiopia gains independence. Invasion by Assyrians. Aramean language developed. Prophet Samuel appoints Saul King. Baal and Ishtar (Astarte). Temporary defeat by Babylonians under Marduk-nadin. Contact with Egypt. Architecture and sculpture indicate advanced civilisation. Marduk-Nadin. VIth "Dynasty of the Sea-Coast." Simbar-Sipak. INDIANS (Hindus). Laws of Manu. Period described in the Epic. Hiung-nu or Huns. Chou-kung. Decline of Imperial power, and development of new feudal system or confederacy of States.

1000 — and of the Odyssey, story of Ulysses. End of Hittite Empire. Extensive Phoenician colonization and rivalry with Greek colonization. Period of Book of Kings. David. Cuneiform records kept. Development of iron weapons and use of horses and mechanical appliances in war, but... VIth Dynasty of Bit-Bazi. Ulmas-Sakin-Sumi. VIIth Dynasty. An Elamite King. VIIIth Dynasty. Nebo-Kin-Albi. Earliest period described in the Epic. Priests obtain supremacy over Nobles. Tribal and territorial chieftships. defeated by Chinese Emperor. Emperor Mu-wang.

950 — Greek City States. as Kingdom of Meroe. Queen of Sheba. Egypt in power of Lybians. Hebrew Cush or modern Abyssinia. Tyre at height of prosperity under King Hiram. Phoenicians trade with Greece and Egypt. Solomon builds the Temple. Revolution and Division of Kingdom. Assyrians held temporarily at bay by Phoenicians, Arameans and Hebrews. Babylonians. Babylon now the centre of the Eastern world of commerce. Poem the Shah-nameh. give place to larger States and Kingdoms. Probable date of the... Mu-wang. wars successfully against "Dog Barbarians" or Huns, and extends the western boundary of the empire.

900 — Greek alphabet compiled. XXIInd Dynasty. Sheshonk I (Shishak) plunders Jerusalem. Worship of God Amen. PHOENICIANS. Invention of alphabet now used by all western civilisations. Ethbaal, High priest of Syria. Aramean Kingdom of Syria. into Judah and Israel. Civil war. Palaces, temples and other large buildings erected at Calah by King Assur-bani-pal III. Shalmaneser II wars successfully against Hebrews, Phoenicians and other... Temple of Bel-Merodach recognised as spiritual centre of the East. King Samas-Mudammiq. Zoroaster (Vishtaspa). Idea of Brahma and system of Brahmanism developed. prophet and King Gushtasp. Intermixing of Tartars with Chinese undermines Imperial authority. Capital at Hao.

850 — Lycurgus, Law-giver of Sparta. Theogony of Hesiod. Civil war, moral and economic decline. Arabia under Ethiopian rule. Carthage founded. Astarte, seizes crown. Disorder and civil war. Conflicts with Greeks. SYRIANS. Damascus aids Judah against Israel. Ahab. peoples of Syria. Further development of war implements, chariots, battering rams, and other weapons. Assyrians develop system of Provincial (military) government. King Merodach-Nadin-Sumi. King Nebo-Som-Iskun. Great literary activity. a Semitic alphabet from Babylon about this time. Period of the Ramayana. Emperor Suan-wang. Age of the Feudal States all in allegiance to the Emperor of the Royal State.

800 — poems of Greek mythology. GREEKS. Pharaoh Takelot II. Pharaoh ETHIOPIANS. Ethiopian kingdom in the near East. Phoenician alphabet spread through the near East. Benhadad, King of Syria, besieges Samaria. Jezebel. Hazael of Damascus. Elijah. ASSYRIAN Empire. Extension of Empire with development of wealth and art. Fine sculptures of lions and bulls representing animal ferocity. Assyrian protectorate over Babylonia. King Umbadara, King of Elam. Elamites assist. epic poem describing the advance of the Aryans. HUNS. Oppressive government of Emperor Yu-wang. Eclipse of sun recorded 776 B.C. in his reign.

750 — First Olympiad (B.C. 776) marks beginning of Greek history. Sheshonk III of Napata or Meroe. Worship of Cat-goddess and the Apis Bull. Ethiopian culture derived. invades Palestine. Damascus taken by Assyrians. Jehu. Elisha. Revolts at Assur and Arbels suppressed. Nabu-nazir deposed by Tiglathpileser III who establishes the second Assyrian Empire and dominates the Western World. Conquered provinces organised under central government. Damascus and Babylon captured by Hadad-Nirari son of Semiramis. Revolt in Babylonia suppressed. Old Babylonian Empire. End of... Babylonians against Assyrians but Nabonassar, combined forces are... The "Brahmanas." Further development of Indian Philosophy. Huns. five principal states alternate in leadership. Frequent civil war but relatively high state of civilisation. Much literature produced including...

700 — Oligarchic government. Rome founded (legend). The nine Archons in Athens. Military rule developed in Sparta. Pharaoh Sheshonk IV. Egypt conquered by Ethiopians. Pharaoh from Egypt. Carthage, Sidon and Tyre now tributary. Civil war. Amos. Hosea. High-roads of commerce, including Phoenician seaports under Assyrian control. Israelites defeated, and tribute obtained from Judah. Nineveh at zenith of splendour. Shalmaneser IV succeeded by Sargon II. Palace built at Dur Sharakin. Early Upanishads, philosophical poems, compiled. Jain religion. scientific works foreshadowing discoveries of modern science. Fine works of art include sacrificial bronze vessels with hieroglyphic inscriptions.

650 — Etruscan pottery shows high degree of culture. Five Ephors elected rulers. Greeks known as Hellenes. Intellectual awakening. Essarhaddon, King of Assyria overthrows Ethiopian rule. Egypt independent under Psamtik I. Gyges. Isaiah and Chaldeans. Tandamane. Book of Chronicles. Sennacherib shocks Asia by destroying the Holy City of Babylon. Essarhaddon restores temple of Bel-Merodach at Babylon which becomes second capital. Assur-bani-pal suppresses revolt of Babylonia. Great Library of many thousand clay tablets collected at Nineveh. Kaldi or Chaldeans become ruling caste. Babylon independent. Growth of... defeated by Sargon II at battle of Kis. Susa destroyed by the Assyrians. developed Mahavira. INDIA Prince Siddartha, later called Buddha teaches at Benares.

600 — Etruscan Kings in power in Umbria and Tuscany. Latins in South Italy. Draco's Code of Laws. Oracle at Delphi. Sappho. Greek City States. Solons constitution of Athens foreshadows democracy. Greek colonies established on coasts of Africa and Asia Minor. Thales (philosopher). of the XXVIth Dynasty. Egypt assists Lydia against Assyria. Pharaoh Necho defeats Judah at Megiddo, but is defeated by the Chaldeans at Carchemish. King Croesus. LYDIANS. Josiah. Jeremiah. Captivity. destroyed by the Medes. Phoenicia a Persian Province allied with the Chaldeans. Decline of agriculture and industry as all efforts directed to military conquest and control. Revolt of discontented peoples. Egyptians and Syrians at Carchemish. Jerusalem destroyed. Jews taken into captivity. Chaldean power. Nebuchadnezzar defeats Assyrians. Median Supremacy under King Phraortes. Mazdaism (Dualism) developed by the Zoroastrians. Cyaxares, Median King of Persia and Armenia, allied with Babylonia, captures Nineveh and destroys Assyrian Empire. Lao-Tse philosopher, teaches system of ethical behaviour termed Taoism. Emperor Ling-wang. Confucius, sage and law-giver.

550 — Legendary Thespis (dramatic poet). Revival of old splendour and introduction of Greek ideas. Pisistratus, Wise Tyrant. of fabulous wealth. Chaldeans. Babylon at zenith of splendour. "Gilgamesh Epic" collected on tablets. Great building period. Astyages, last Median King deposed by Cyrus, the Persian. Magians. Cyrus founds Persian Empire including all Iranians previously subject to the Medes. Buddha teaches at Benares.

methods offered a means of integrating quantitative and qualitative studies; from the second, the credo that modern life requires ever more strenuous efforts at managing information. "When a man's knowledge is not in order," Spencer wrote, "the more of it he has, the greater will be his confusion of thought."[5] The notion that anyone else might be interested in Sparks's homemade chart came as a happy surprise, as did the strong visual effect of its published version. Once he had the taste for charts, he never lost it. Eventually, he drew up new charts on other subjects, including two that were published, a *Histomap of Religion* and a still more ambitious *Histomap of Evolution: Earth, Life and Mankind for Ten Thousand Million Years.*[6]

In the 1930s, the self-styled "historian extraordinary," Carleton Brown, also caught the charting bug. [*fig.* **13**] Under the auspices of the History Institute of America, then producing lavish color reproductions of the 1840 *Birds of America* by the naturalist John James Audubon, Brown began to draw up a gigantic interconnected chronological chart series to cover all of world history called *History on Parade*. At one hundred feet long and five feet high, the never-completed chart series would have dwarfed even Jacques Barbeu-Dubourg's *Chronographie universelle*. But only one chart in Brown's giant series seems ever to have been published, lonely number nine, covering the nineteenth century. At least, this is the only one that has left a trace in any American library. In Brown, everything comes together: scholarly aims, amateur pursuits, inventive graphics invented by a noninventor, and a great, unrealized encyclopedic fascination. Here, the time chart had its Ahab, its Eiffel, and its Ogden Nash all rolled into one.

Chronology began to infiltrate the territory of art itself in the 1930s. [*fig.* **14**] In 1936, Alfred H. Barr Jr., the founding director of the Museum of Modern Art (MOMA) in New York, published his influential book *Cubism and Abstract Art*, a companion to an exhibition by the same name.[7] The exhibition was notable in many ways: it marked the first time that many seminal modernist works were displayed in the United States; it made a strong case for the role of cubism in the development of modernism; and it inaugurated a series of exhibitions on different aspects of modern art that would help define the mission of the Museum of Modern Art. Moreover, it was the first American exhibition to provide a comprehensive view of European modernism in a self-consciously historical context. It marked a watershed not only in the history of twentieth-century modernism, but in its historiography as well.

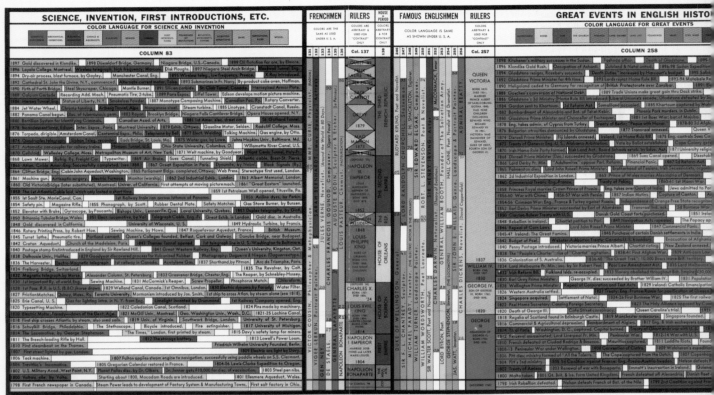

[13]

Carleton Brown, chart and poem from
History on Parade, chart nine, New
York, 1936

ch is over one hundred feet long and five feet high and took six years to
niforms," and chronologically registered to a "Yardstick of Time." The huge
Nation has its own chart which can be obtained separately. The History on
936. Indispensable to the home — the school — the college — the institution.

OF AMERICA, INC.

CITY. PHONE: RHINELANDER 4-1548

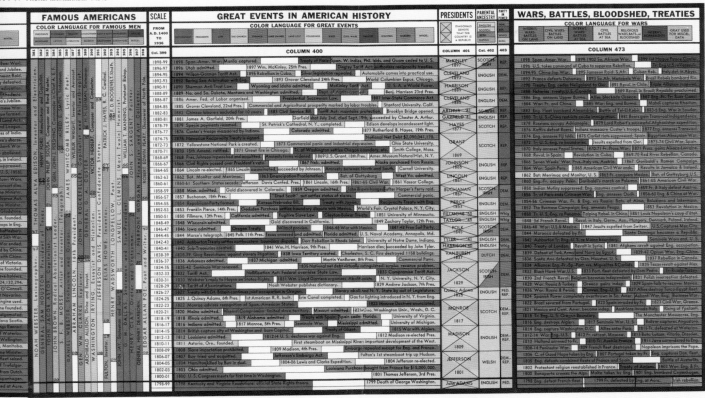

signed from the standpoint that both young and old can easily and quickly grasp the unwinding of this most complicated story of mankind which we call "History." The main function of the charts is that they take the very complicated story and reduce it to *authentic facts* and lay out all the facts so that they are relative as between themselves and also relative to a chronological yardstick. In other words, they turn the most complicated story into a *true picture*, and thereby enable both young and old to see what actually did happen.

The first glance at one of the large color charts gives the impression that the vast number of horizontal and vertical colored frames is somewhat of a bewildering spectacle, but when the reader has paused to examine the meaning, then the whole thing actually becomes a matter of simplicity and is extremely easy to grasp. Even children seven years old quickly understand that means in which the "Great Events" are registered to an "historical yardstick," and the meaning of the colors—that blue means the State; mauve, the Church; scarlet, the Wars; and so on.

The color *classifies* and *intensifies* the meaning of the formerly uncontrasted black type and vividly drives home "the message" to a higher degree of perfection than has

"Seeing is Believing"

The charts, though scientifically laid out, are very simple to understand. The horizontal and vertical colored panels are faithfully registered to a yardstick, and as the system is visual there is no technical difficulty involved in understanding it. In view of which, the *History on Parade* charts not only afford an indispensable acquisition to the college and institutions, but their self-apparent utility makes them equally valuable in the home and in the school. Even the elementary schools can utilize them to great advantage, for there is nothing like a pictorial or visual system to impress the young minds which are developing.

Each Chart a Standard Size

Before outlining the color applications used throughout the system, we will first confine our attention to the

been heretofore obtainable, and which is a great advancement both in the art of printing and also in the visual presentation of facts.

actual layout of the *History on Parade* charts. Each chart is 45 inches wide and 65 inches deep. They can be (1) hung on the wall, (2) examined on a table, (3) folded and clipped into a four-ring binder, or (4) folded and housed in a portfolio. Each chart, irrespective of its subject, commences at the bottom with the horizontal year-line A. D. 1400 and continues up to the top up to 1936. A clearly defined scale or "historical yardstick" marks off these 536 years of World History, and without one exception all the Great Events or Famous Men, etc., are accurately "registered" or recorded on the exact year-line to which they belong. In this manner, the History of the World is scientifically laid out and accurately registered in strict conformity to an historical time-scale, with the result that a *true comparative* or *relative* picture of World History is obtained.

When all the charts are hung side by side, they perfectly coincide or dovetail, because each chart travels to the same historical yardstick of time, and when so hung, the charts form one colossal picture which is over 100 feet long and the eye can take any particular year and "sweep" the entire history of the world in that year. The work may be described as Historical Relativity. The *History on Parade* charts have well over 100 uses,

and their greatest use lies in the fact that *"they orient you truthfully."*

Orientation of Facts

Life is a matter of *orientation*. We cannot think; we cannot move; we cannot *understand*, until we have oriented ourselves, and the better we orient ourselves, the better will we understand the complications of Life.

The history of one person's entire life is a complicated story. He must orient you carefully or you will not understand it. The History of the Nations and of man's progress is quite the most complicated story in the world, hence, in order to get an insight into that most complicated of all stories, the matter of *orientation* becomes paramount.

Notwithstanding that the libraries of the world contain tens of thousands of books covering the histories of the nations, yet I maintain that all of these books put together still fail to orient you regarding the true comparative picture of man's progress. I maintain that no black and white printed page will ever be able to convey to the mind a scientifically true picture of man's progress

(Continued on Other Side)

Sometimes chronological ambitions outrun practicality. Had it ever been fulfilled, Carleton Brown's 1936 proposal for a chronological chart series called *History on Parade* would have dwarfed even the 54-foot-long *Chronographie universelle* of Jacques Barbeu-Dubourg. A teaser for the series came with a poem printed on the back that captures both the ambition and the folly of the chronographic obsession.

Serene I saw the acts of man
 In ages past on land and sea;
With colored graphs, I paint the paths
 And chart the course of History.

No prejudice is in my theme;
 I coldly state each striking fact;
Both pen and paint brush in this scheme
 Are used to contrast every act.

Nor critic's scoff shall mar my stand;
 'Gainst quibbling tongues well-calloused I,
And revel in the work in hand,
 And scorn the ranting critic's cry.

And six grand years of detailed toil,—
 Research, cross-reference, line by line—
Ah! Friend, I burned the midnight oil
 To interlock this huge design.

The famous men and all their acts?—
 Throughout, I call "A spade a spade";
And so, O Friend, consult the facts
 And scan this—"History on Parade."

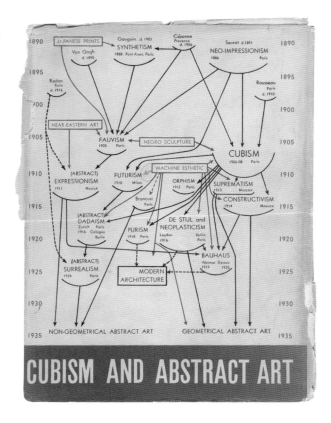

This is nowhere more evident than in the diagram of artistic influence displayed at the exhibition and then printed on the cover of Barr's book, which projects the underlying arguments of the exhibition in a stylized and economical form. On the chart, cubism appears as a fundamental transition in the history of art. Above it are arrayed the names of important nineteenth-century artists, including Redon, van Gogh, Gauguin, Cézanne, Seurat, and Rousseau, whose work, in Barr's view, most influenced cubism and the movements with which it was associated. The lineage that Barr lays out is not simple—throughout, he asserts a tension between a geometric and an organic tendency constitutive of the modern field—but his chart makes a strong argument for the importance of a historical interpretation of modernism and a specifically chronological understanding of its stages.

Barr dealt with the relationship between visual forms in art and history in other works too. [*fig.* **15**] During the 1930s and '40s, he used another kind of time chart in internal memos plotting the collecting strategy of the museum. In them, he depicted the MOMA collection as a torpedo (helpfully equipped with a propeller) moving through time. In the future, Barr suggested, the borders of the modern would gradually advance, leaving various works in its wake;

these were then to be donated to the Metropolitan Museum of Art and resituated in a longer history of art. Though roughly drawn, the torpedo diagrams are, in fact no less stylized than the cover chart image for *Cubism and Abstract Art* and no less forceful in their argument for a coherent and directional movement in the history of the modern.

In one sense, Barr's diagrams were not so different from the ones that he had made in his art history courses at Princeton and Harvard in the 1920s. But his application of these familiar techniques at MOMA was provocative: in presenting the timeline itself as a modernist artifact, Barr suggested a new alliance between the practices of scholarship and those of art. What is more, by combining genealogical and chronological elements in his chart, Barr echoed the tension between the organic and the geometric around which the cubism exhibition was organized.

Prior to Barr, a few artists had made gestures toward the artistic potential of the art history diagram. [*fig.* **16**] In the second decade of the twentieth century, while he was editing the Dada journal *391* and before his turn to surrealism, the Franco-Cuban artist Francis Picabia experimented with the visual vocabulary of the technical diagram. In some instances, Picabia copied directly from technical illustrations found in magazines and manuals. In others, he drew

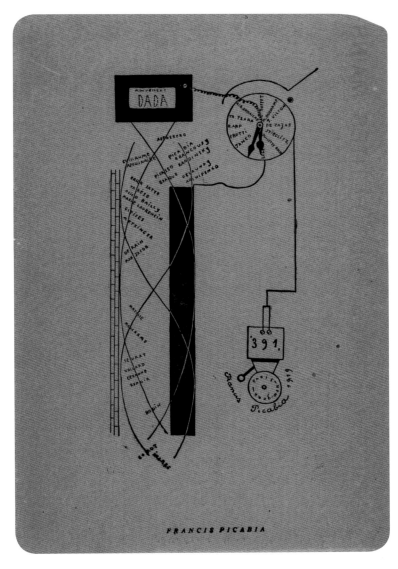

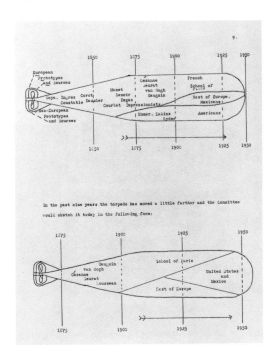

[16]

Francis Picabia, untitled diagram from
Dada, 1919

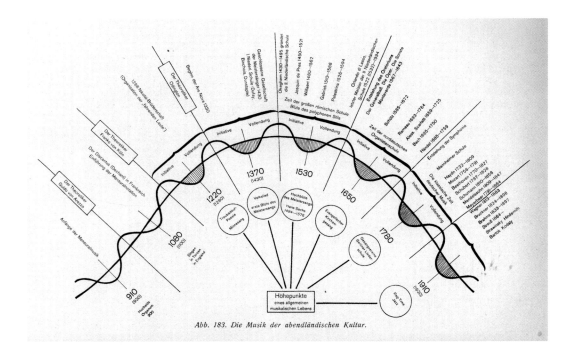

Abb. 183. Die Musik der abendländischen Kultur.

his own playful diagrams, as in the untitled 1919 diagram of modern art that he published in the journal *Dada*.

Picabia's diagram for *Dada* is not exactly a chronological chart. The relationships that it depicts are thematic and associative and it lacks a regular measure. Nonetheless, in his selection of graphic elements and arrangement of names, Picabia self-consciously draws on the visual vocabulary of chronography. The relationships depicted are chronological: the names line up, with the earliest group, including Ingres, Corot, Cézanne, and Rodin, at the bottom, and the latest group, including Braque, Arp, Duchamp, and Tzara, arranged in a circle around a clock face at the top, like components of an alarm or a bomb. But the image relies on the viewer to recognize and project implicit relationships, to see in the work an as-if chronological chart. In Picabia's image, the chronological gesture is still implicit, and it would still be decades before artists would begin to thematize chronology more commonly.

Barr's 1936 chart was both influential and symptomatic; it expressed the growing importance of both art history and curatorial practice to the self-conception of modern art. It gestured implicitly to the relationship between art and graphic design that was central to the MOMA project. And it re-posed the question of how to negotiate the line

between art and non-art that had been so forcefully stated by Dada.

In the art world of the 1930s and '40s, time charts appeared in many popular and scholarly venues. [*figs.* **17–19**] In his 1931 book *Der Weg aus dem Chaos: Eine Deutung des Weltgeschehens aus dem Rhythmus der Kunstentwicklung* (The path out of chaos: An interpretation of world history from the rhythm of the development of art), the German art historian Paul Ligeti illustrated his cyclical theory of art history in a series of waveform charts.[8] Eric Newton's 1941 pocket survey for Penguin, *European Painting and Sculpture*—a book distributed to American armed forces during the Second World War—included a beautifully stylized genealogical tree diagram drawing on the infographic conventions of Charles Joseph Minard.[9] On Newton's chart, artistic importance was indicated by size: great artists were shown as large circles, minor artists as small ones. A 1948 catalog for an exhibition of abstract, geometric art in France called *Réalités Nouvelles* included its own time chart, a kind of homage to Barr, but redrawn in the style of the art whose story it outlined.[10]

Time charts were important enough in the art world of the 1940s to inspire satires as well as subversions. [*figs.* **20–21**] The most famous of these is the cartoon series "How to

Paul Ligeti, wave form chart of
the history of art from *Der Weg
aus dem Chaos. Eine Deutung des
Weltgeschehens aus dem Rhythmus der
Kunstentwicklung*, Munich, 1931

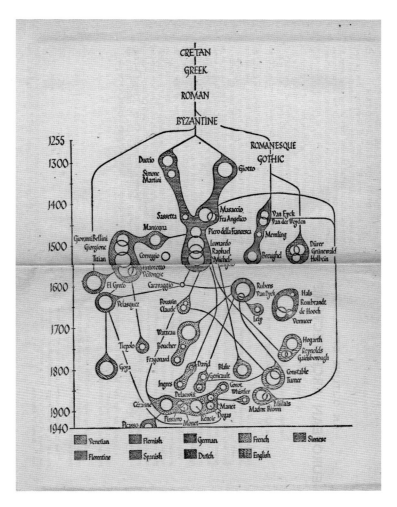

[18]

Eric Newton, chart of art history
from *European Painting and Sculpture*,
Harmondsworth, 1941

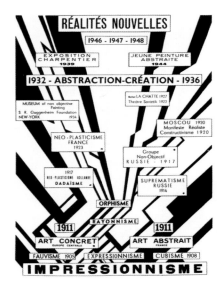

[19]

Untitled diagram of the development
of non-figurative art in *Réalités
Nouvelles* (Paris) No. 2, 1948, edited by
A. Frédo Sidès

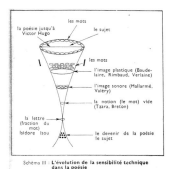

Schéma III : **L'évolution de la sensibilité technique dans la poésie**

[20]

Isidore Isou, "L'évolution de la sensibilité technique dans la poésie" (The evolution of the technical sensitivity in poetry) from *Introduction à une nouvelle poésie et à une nouvelle musique*, Paris, 1947

[22]

Raymond Loewy, Evolution Charts, ca. 1933. Loewy's charts show a historical movement toward aesthetic simplicity in many different domains of industrial design—in the telephone, the motorcar, the dress, the house, the ship, the shoe, the clock, the wine glass, the chair, and, disconcertingly, the female body, which in his depiction goes from full figured to rail thin, and finally disappears completely.

[21]

The sixth installment in the "How to Look" cartoon series by the abstract expressionist painter Ad Reinhardt published in the newspaper *PM* in 1946 and '47. Many of Reinhardt's cartoons included take-offs on information graphics, including the genealogical tree in "How to Look at Modern Art." Throughout the series, linear timelines were common too, as here, in Reinhardt's pop history of realism and abstraction.

© 2008 Estate of Ad Reinhardt/Artists Rights Society (ARS), New York. Image Courtesy of Ad Reinhardt Foundation.

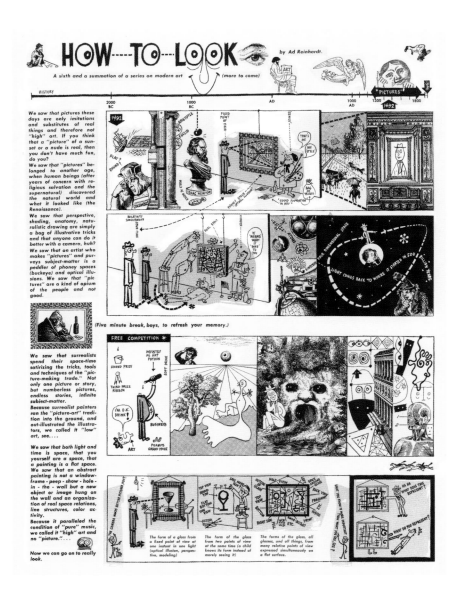

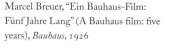
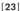

Marcel Breuer, "Ein Bauhaus-Film: Fünf Jahre Lang" (A Bauhaus film: five years), *Bauhaus*, 1926

ein bauhaus-film
fünf jahre lang
autor:
das leben, das seine rechte fordert
operateur:
marcel breuer, der diese rechte
anerkennt

1921

1921¹/₂

1924

1925

19??

Look at Modern Art" published by the abstract expressionist painter Ad Reinhardt in 1946 and 1947. Reinhardt's series both affirmed and poked fun at Barr's genealogy of modern art. In the best known of Reinhardt's charts, Barr's names and categories are inscribed on a cartoon of a tree of art losing leaves and branches under the dead weight of bad ideas and patronage. Though less remarked, linear timlines are ubiquitous throughout the series, as in Reinhardt's 1946 cartoon account of the history of realism and abstraction called simply "How to Look." In 1947, the lettrist poet Isidore Isou published his *Introduction à une nouvelle poésie et à une nouvelle musique* (Introduction to a new poetry and a new music), complete with the history of modern poetry figured in chronological diagrams.[11] In contrast to the sober historicism of so many chronographies, Isou's diagrams were essentially manifestos: they illustrated a highly particular reading of the history of poetry, converging in Isou's poetry of letters and expanding ever outward from there.

Picabia, Isou, and Reinhardt blurred the line between charts and art. But for graphic designers of the period, there wasn't really any line to blur. [*figs.* **22-23**] In 1936, the influential American industrial designer Raymond Loewy published the first of many chronologies of the history of design. Like Isou, Loewy portrayed history as a movement

in the direction of his own style, the streamlined deco look, as exemplified by his 1935 Sears Coldspot refrigerator, 1939 S1 steam locomotive, and 1947 Studebaker Champion. Though antic and occasionally self-mocking, Loewy's charts showed off his work to great effect. On the one hand, they depicted his designs; on the other, they embodied them. Nor was this kind of self-consciousness limited to popular commercial design. Already in 1926, the Bauhaus architect Marcel Breuer had published a chronology of design history, with a similar punch line. In an illustration from the first issue of the Bauhaus journal, Breuer showed the evolution of Bauhaus design over five years as a series of dated images of ever simpler chairs, culminating with a person reclining on an invisible column of air.

In the wider culture, the 1940s and '50s were a boom time for chronological charts. [*figs.* **24-27**] As in past centuries, technological developments and apocalyptic visions combined to inspire new interest in visions of time as in the famous Doomsday Clock of the *Bulletin of the Atomic Scientists* which revived an old millennial figure and echoed haunting images of clocks stopped in their tracks by real-world atomic bombs. But not all was destruction and anxiety. For techno-utopians such as R. Buckminster Fuller, the time chart took on an iconic character, providing an

[24]

Pocket watch owned by Kengo
Nikawa, arrested at the time of the
atomic blast above Hiroshima on
August 6, 1945, at 8:15 AM

7 minutes to midnight

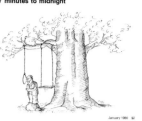

4 minutes to midnight

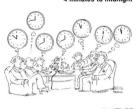

[25]

Doomsday clocks on the covers of the *Bulletin of the Atomic Scientists*, 1947–2007

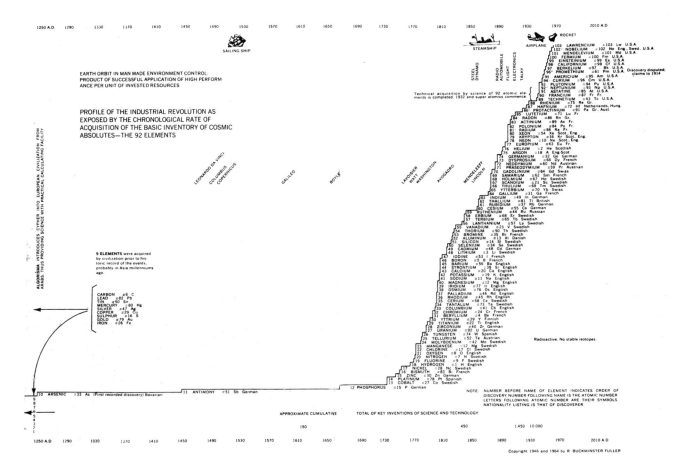

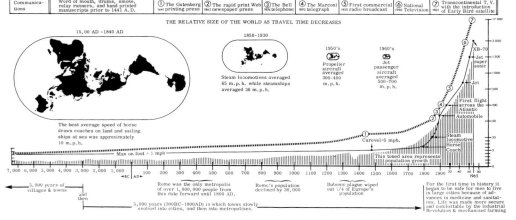

[26]

R. Buckminster Fuller, *Profile of the Industrial Revolution as Exposed by the Chronological Rate of Acquisition of the Basic Inventory of Cosmic Absolutes*, 1943

[27]

R. Buckminster Fuller, *Shrinking of our Planet by Man's Increased Travel and Communication Speeds Around the Globe*, 1963

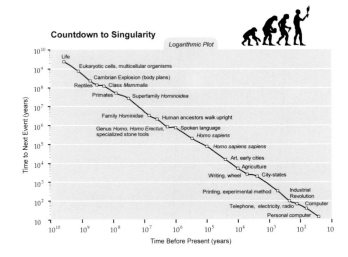

[28]

Gordon Moore, "Cramming More
Components onto Integrated
Circuits," from *Electronics*, 1965

[29]

Ray Kurzweil, "Countdown to
Singularity," *Logarithmic*, 2007

appealing technical form for expressions of progress. In 1943, Fuller published a particularly beautiful example combining elements of the classic designs of Joseph Priestley and William Playfair, demonstrating that the world was on the verge of a technological revolution that would put an end to both poverty and war. In the chart, called *Profile of the Industrial Revolution as Exposed by the Chronological Rate of Acquisition of the Basic Inventory of Cosmic Absolutes—The 92 Elements*, Fuller attempted to correlate scientific discoveries with social change. Fuller saw science and technology changing ever more rapidly, and he posited that progress in those domains was self-reinforcing. He also believed that technical progress would enable social revolutions. According to Fuller's original design, a historical threshold in both science and society—the point when the power of "livingry" would surpass that of "weaponry"—would come around 1970. In the 1960s, however—in a gesture reminiscent of those of millennialists in previous centuries—Fuller pushed the date forward to 2000, and it can only be a matter of speculation what he might do now.

In the changing visual context of the later twentieth century, even purely technical charts could become iconic, as in the case of a simple line graph published by Intel Corporation founder Gordon Moore in *Electronics*

magazine in April 1965. [*figs.* **28-29**] Moore's graph, an otherwise unremarkable curve, projected exponential acceleration in the processing speed of computers through the foreseeable future. Though he amended it slightly later, Moore's prediction has proved so near to correct that in the intervening years it has come to be known as "Moore's Law."[12] And Moore's success has spawned other, similar graphics including Ray Kurzweil's charts of the coming "Singularity," a technological take-off "so rapid and profound it represents a rupture in the fabric of human history."[13] When evaluated for their accuracy, Fuller's, Moore's, and Kurzweil's charts fare differently: Fuller, not so well (or not yet); Moore, great so far; Kurzweil, only time will tell. But from the point of view of graphic representation, they all do admirably. Each demonstrates the power of the exponential curve as a representation of historical change; each is a powerful expression, and expansion, of the graphic intuition of Priestley and Playfair.

The time chart entered into art definitively in the mid-1960s, in the work of the Fluxus artist George Maciunas.[14] Maciunas was many things—a theorist, provocateur, performance artist, impresario—but along with all of these, he was a passionate chart maker. Maciunas came to his art charts with serious historical preparation. Like Barr, he first

FLUXUS (ITS HISTORICAL DEVELOPMENT AND RELATIONSHIP TO AVANT-GARDE MOVEMENTS)

Today it is fashionable among the avant-garde and the pretending avant-garde to broaden and obscure the definition of fine arts to some ambiguous realm that includes practically everything. Such broad-mindedness although very convenient in shortcutting all analytical thought, has nevertheless the disadvantage of also shortcutting the semantics and thus communication through words. Elimination of borders makes art nonexistent as an entity, since it is an opposite or the existence of a non-art that defines art as an entity.

Since fluxus activities occur at the border or even beyond the border of art, it is of utmost importance to the comprehension of fluxus and its development, that this borderline be rationly defined.

Diagram no.1 attempts at such a definition by the process of eliminating categories not believed to be within the realm of fine arts by people active in these categories.

DEFINITION OF ART DERIVED FROM SEMANTICS AND APPLICABLE TO ALL PAST AND PRESENT EXAMPLES.

(definition follows the process of elimination, from broad categories to narrow category)

	INCLUDE	ELIMINATE
1. ARTIFICIAL:	all human creation	natural events, objects, sub or un-conscious human acts, (dreams, sleep, death)
2. NONFUNCTIONAL: LEISURE	non essential to survival	production of food, housing, utilities, transportation, maintainance of health, security.
	non essential to material progress games, jokes, sports, fine arts.*	science and technology, crafts. education, documentation, communication (language)
3. CULTURAL	all with pretence to significance, profundity, seriousness, greatness, inspiration, elevation of mind, institutional value, exclusiveness. FINE ARTS ** only. literary, plastic, musical, kinetic.	games, jokes, gags, sports,

* Past history shows that the less people have leisure, the less their concern for all these leisure activities.
Note the activities in games, sports and fine arts among aristocrats versus coal miners.

** Dictionary definition of fine arts: "art which is concerned with the creation of objects of imagination and taste for their own sake and without relation to the utility of the object produced."

Since the historical development of fluxus and related movements are not linear as a chronological commentary would be, but rather planometrical, a diagram would describe the development and relationships more efficiently.

Diagram no. 2 (relationships of various post-1959 avant-garde movements)
Influences upon various movements is indicated by the source of influence and the strength of influence (varying thicknesses of connecting links).
Within fluxus group there are 4 categories indicated:
1) individuals active in similar activities prior to formation of fluxus collective, then becoming active within fluxus and still active up to the present day, (only George Brecht and Ben Vautier fill this category);
2) individuals active since the formation of fluxus and still active within fluxus;
3) individuals active independently of fluxus since the formation of fluxus, but presently within fluxus;
4) individuals active within fluxus since the formation of fluxus but having since then detached themselves on following motivations:
 a) anticollective attitude, excessive individualism, desire for personal glory, prima dona complex (Mac Low, Schmit, Williams, Nam June Paik, Dick Higgins, Kosugi),
 b) opportunism, joining rival groups offering greater publicity (Paik, Kosugi,
 c) competitive attitude, forming rival operations (Higgins, Knowles, Paik).
These categories are indicated by lines leading in or out of each name. Lines leading away from the fluxus column indicate the approximate date such individuals detached themselves from fluxus.

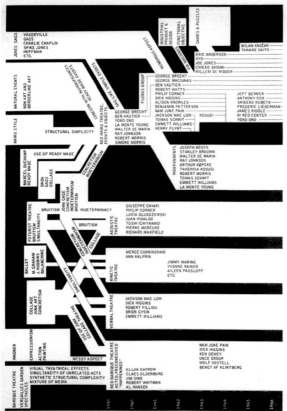

[30]

George Maciunas, *Fluxus (Its
Historical Development and Relationship
to Avant Garde Movements)*, ca. 1966

Courtesy of the Gilbert and Lila Silverman
Fluxus Collection, Detroit. Photograph:
Herman Seidl/Salzburg in association with
Astrit Schmidt-Burkhardt.

[31]

George Maciunas, manuscript chart of
Russian History, early 1950s

Courtesy of the Gilbert and Lila Silverman
Fluxus Collection, Detroit. Photograph:
Herman Seidl/Salzburg in association with
Astrit Schmidt-Burkhardt.

[32]

Arthus C. Caspari reading George
Maciunas's manifesto, while Nam
June Paik unfurls Maciunas's chart,
Wuppertal, Germany, 1962

Courtesy of the Gilbert and Lila Silverman
Fluxus Collection, Detroit. Photograph:
Rolf Jährling.

began making them in history classes. These early pen and paper collages served a practical purpose as study aids, but for Maciunas they also opened up new ways of seeing. Over time, he added to them, layering notes upon notes, folding them together.

In the early '60s, as Maciunas began to formulate the ideas behind Fluxus, he returned to chart making with panache, as in the analytic chart of time and space-based art that he dramatically revealed during a reading of his neo-Dada manifesto in 1962. (In the actual event, Maciunas's chart was unfurled by fellow artist Nam June Paik.) [*figs.* **30-32**] The basic structure of the chronological charts that Maciunas began making in the following years is familiar: in them, a stream represents the crisscrossing flows of influence among artists and movements, plotted against time. But, unlike Barr and his contemporaries, Maciunas treated chart making as an artistic practice.

Maciunas published the first of these chronographic charts, *Fluxus (Its Historical Development and Relationship to Avant Garde Movements)*, in a Czech art journal in 1966.[15] The dozen or so different charts that followed were published in magazines, distributed by hand, sold as broadsheets, and, notably, included in Fluxkits—Maciunas's packaged collections of found and fabricated objects.[16]

Ironies are everywhere, of course. Fluxus promoted itself as a nonmovement, a blurring of the distinction between art and life. Yet Maciunas's charts unapologetically apply Barr's principles of distinction and delineation. In fact, Maciunas argued that *because* Fluxus was a nonmovement operating in the territory between art and non-art, it was especially important to be clear about where boundary lines lay. The Fluxcharts provided an example of the curious art/non-art object that was characteristic of Fluxus production. At the same time, like parallel works by graphic artists such as Stefan Themerson and groups such as Ant Farm, they illustrated the curious new graphic context in which the charts of Eusebius or Priestley might finally be understood in aesthetic terms.

For both conceptual and time-based art, the potential of chronography was immense, and in the 1950s and '60s, artists such as the composer John Cage reckoned with it from several different perspectives. [*figs.* **33-34**] Much of Cage's work from this period dealt directly with questions of time. His famous 1952 composition entitled *4'33"* specified a period of four minutes and thirty-three seconds in which musicians were to refrain from playing their instruments. The score for *4'33"* was a set of written directions. But Cage treated other scores graphically. In the same

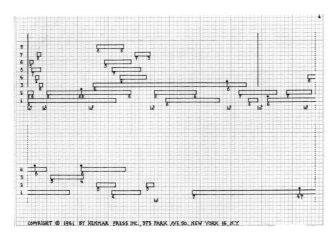

[33]

John Cage, score for *Imaginary Landscape, No. 5*, 1952

Music Division, The New York Public Library for the Performing Arts, Astor, Lenox, and Tilden Foundations. Courtesy of Henmar Press.

[34]

Pages 4 and 5 from "Kurt Schwitters on a Time Chart," by Stefan Themerson, first published in *Typographica*, no. 16, 1967

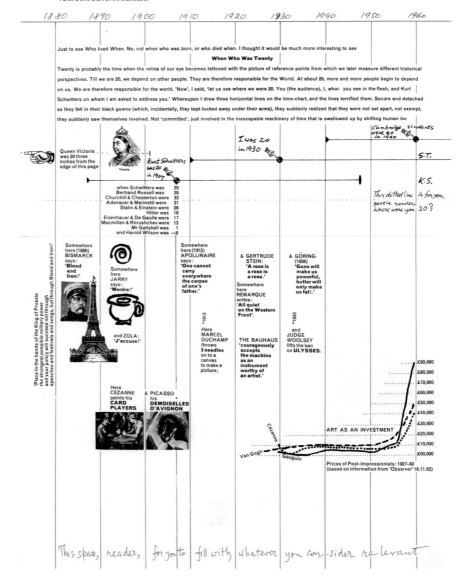

In *Shapolsky et al., Manhattan Real Estate Holdings, a Real Time Social System, as of May 1, 1971*, the artist Hans Haacke traced the complex legal and financial transactions of a large Manhattan property company and its many shells and sub-entities through photographs, text, and diagrams. The installation, planned for an exhibition at the Guggenheim Museum in New York in 1971, was cancelled because of controversy over its political content.

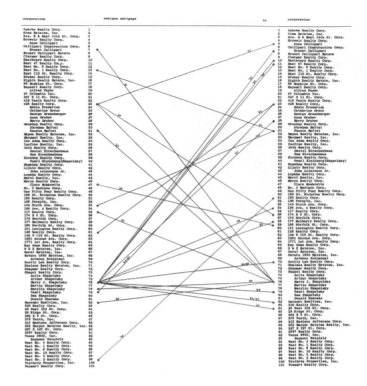

year, for example, Cage appropriated a traditional chronographic format for the score of another chance composition, *Imaginary Landscape, No. 5*, which calls for a performer to play brief selections from 42 records according to a time scheme structured like Joseph Priestley's *Chart of Biography*.[17] And throughout Cage's musical work, the conceptual resonances with Priestley—problems of duration, synchronism, pattern, and accident—are strong.

During the following two decades, politically engaged artists began to use time charts in the manner of historians and sociologists, as for example, in Hans Haacke's diagram of the shell game of real estate transactions governing the slums of New York City in his *Shapolsky et al., Manhattan Real Estate Holdings, a Real Time Social System, as of May 1, 1971*. [*fig.* 35] As graphics, Haacke's charts are simple: dated transaction lines mark apparently independent transfers of property from one company to another. But, viewed together, these lines reveal an intricately interconnected lattice of a single large financial entity with interests in a vast number of Manhattan properties. Haacke's project, which intended to turn the museum space into an activist forum, was a provocation that worked, both at the level of politics and form: his Guggenheim show was cancelled, stirring much debate and protest.

The Japanese artist On Kawara tried a different approach to chronography: real-time painting. [*figs.* 36–37] Since 1966, Kawara has been painting the current date, one day at a time. Each of his *Date Paintings* is begun and finished on the same day that it records, and the work contains nothing more than the date itself, rendered in the style of a local newspaper. The *Date Paintings* are real-time recordings, but, in them, Kawara upends assumptions about what real-time recordings should show. In contrast to more familiar real-time records such as cinema and chronophotography, in which high rates of sampling permit a good approximation of perceptual experience, Kawara's work slows time down to the rhythm of print forms such as the calendar, the diary, and the newspaper.

Kawara's work asserts not only the temporal character of painting but the importance of chronographic representation to our ability to comprehend that temporality in the first place. [*fig.* 38] The dates to which his work refers are real, visible cultural artifacts, not everywhere identical. In effect, the *Date Paintings* function like a giant macroscopic lens focused on the surface of a Priestley chart, revealing the beautiful and disconcerting materiality of our temporal representations.

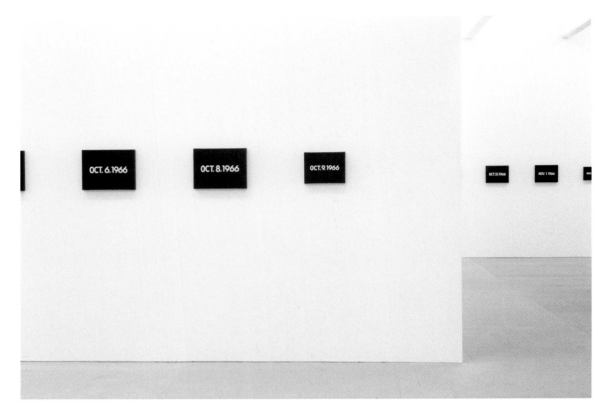

[36]

On Kawara, One Thousand Days One Million
Years, installation at Dia Center for the Arts,
January 1–December 31, 1993

Photo: Cathy Carver. Courtesy Dia Art Foundation.

[**37**]

On Kawara, *100 Years Calendar
(24,698 Days)*, August 6, 2000

Collection of On Kawara. Courtesy of
On Kawara.

Chapter 8:

Big Time

In the year 2000, two great public timelines were inaugurated in New York City, directly across Central Park from one another, the *Harriet and Robert Heilbrunn Cosmic Pathway* at the American Museum of Natural History and the *Timeline of Art History* at the Metropolitan Museum of Art. Though the two projects were planned separately and without reference to one another, it is not entirely an accident that they appeared simultaneously: both were the result of charitable gifts by the Heilbrunn family during the 1990s, and what more auspicious time to unveil a big time project than a year of millennial enthusiasm?

The timelines make a striking contrast with one another: the *Cosmic Pathway* traces the history of the universe from the Big Bang to the present; the *Timeline of Art History*, culture since the cave paintings at Lascaux. The first is a gargantuan structure, a pedestrian ramp over 350 feet long, suspended high above the floor of the American Museum of Natural History; the second, a virtual space made up of more than twenty-five thousand pages of information accessible anywhere in the world through an internet connection.

The differences could hardly be more pronounced or more characteristic of the moment: on one hand, steel and glass; on the other, byte and pixel. But despite this, these two great projects, like their host institutions, are cousins.

Just as no visitor would have any trouble recognizing the Metropolitan Museum of Art or the American Museum of Natural History as a museum, none would hesitate to call either of these projects a timeline. Both are regular, measured, visual chronologies; both emphasize the importance of scale, succession, and simultaneity; both assimilate masses of facts in a single, unified structure; both project objectivity, neutrality, and simplicity. What is more, both the *Cosmic Pathway* and the *Timeline of Art History* deal with immense chronological spans, the history of the universe dating back thirteen billion years, and the history of art going back twenty-five thousand—exactly the kind of grand synthesis that we expect from big timelines and big museums.

But, while both the *Cosmic Pathway* and the *Timeline of Art History* embody many of the classic characteristics of a timeline, neither is entirely typical. [*figs.* 1-3] In the first place, both are huge beyond even the inflated models of the nineteenth century. Indeed, in the *Cosmic Pathway*, size and scale are the very point of the exercise: at the start, the pathway is meant to feel overwhelmingly large. Even to approach it, visitors must first confront the magnitude of the Hayden Planetarium, a massive metal sphere suspended two stories above the ground within an even larger glass structure.

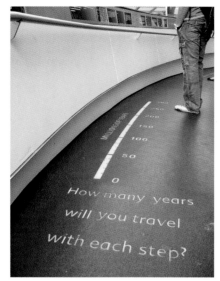
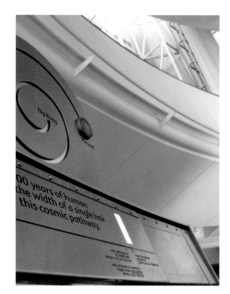

[1–3]

Harriet and Robert Heilbrunn Cosmic Pathway, Rose Center for Earth and Space, American Museum of Natural History, New York, 2000

The *Cosmic Pathway* is designed to allow the visitor to feel as well as to see the immensity of history. At its start, the visitor measures her or his stride, not in space but in time. On the path, an average adult covers about six million years in a step. But since every stride is a little different, each museum visitor advances through the millennia at her or his own historical pace. Amid all the digital wonders of the museum, this stroll through the history of the universe is refreshingly analog. If the crowds aren't pushing too much and the weather is good, visitors can take their time and soak up both information from the instructive panels and sun streaming down through the giant glass cube around the planetarium.

There is a lot to learn on the *Cosmic Pathway*: at each point, panels identify moments in cosmic history from thirteen billion years ago down to the present. And, under the last panel, the *Cosmic Pathway* has a surprise: one strand of human hair is stretched taut, its width representing thirty thousand years, the length of time from the earliest known cave painting in Europe to the inauguration of the pathway.

Across Central Park in the Metropolitan Museum of Art, something different is under way. [*figs.* **4–5**] There, the question of how much physical space to allot to the ages

of time has been mooted. To represent a catalog of over two million precious artifacts from all over the world, the Met has made its *Timeline of Art History* entirely electronic. Although the Met's timeline staff has an office, secreted away in the attics of the behemoth museum, the *Timeline* itself is nowhere and everywhere, tens of thousands of images and pages of information navigable in dozens of different ways. Here, traversing history at one's own pace has an entirely different meaning. Like the *Cosmic Pathway*, the Met interface uses historical chronology as its primary index. But here, time is only one organizing structure, one possible projection of history. Users also move through the *Timeline of Art History* by traversing geographical maps and searching names and subjects.

In fact, the Met's website is a timeline only when viewed from one perspective. As its designers emphasize, it is really an information database. It will continue to grow in size, and eventually gain more search capabilities and more schemes of visualization. When it was first chartered, the *Timeline* was approached with some trepidation by the museum's curators. Persuading all departments to speak with one voice and through one channel was a tall order, but by all accounts the effort was useful and instructive. It quickly became clear that the timeline metaphor

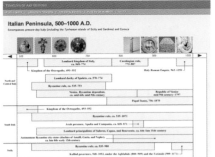

[4–5]

Metropolitan Museum of Art,
Timeline of Art History, website
launched in 2000

[6]

Sarah Fanelli, installation view of the
Tate Artist Timeline, London, 2006

was already built into the project of the museum. In fact, it seemed so essential that it was hard to understand why it had only just now been made explicit.

And big timelines are not only popular in traditional museums or in the West. [*fig.* **6**] Even for a visitor with no background in Chinese art or history, the *Timeline of Chinese Art* in the National Palace Museum in Taipei is easy to follow and understand. The same is true of the playful timeline of modern art designed by Sarah Fanelli for the Tate Modern in London. Fanelli's timeline is also available in a winsome, brown and pink accordion book that allows the curious visitor to take home a bit of Tate style and some chronological knowledge all in one package.[1] Even here, at an epicenter of postmodern representation, the graphic timeline is not only surviving, it is thriving. And, if a certain irony is now possible and even typical in the genre, the old-fashioned just-the-facts historical timelines are also doing well. There is hardly a museum gift shop these days where you cannot purchase a copy of *History by the Meter*, a full-on, back-to-basics historical timeline cleverly printed on a folding meter stick. And, as with Fanelli's book, the crossover value has turned out to be enormous. It is not enough to take in these historical graphics at the museum; the public wants to take them home too.

Of course, something is lost—or at least changed—when massive timelines are transformed into pocketable commodities. [*fig.* **7**] In timelines, the visual interface is everything. Cybernetic theorists are fond of saying that more is different. In the realm of the timeline, big is different. Since the aim of the timeline is synoptic, the more the reader sees, the more she can do. That's why the take-home versions of these large installations fold or roll or compress in some way: so that, on her living room floor, she can spread them out to regain something of the effect of large dimensions. In fact, one nineteenth-century timeliner, the Madison Avenue executive Manly M. Gillam, made this very argument when his application for a patent was rejected. The Patent Office, he said, in his successful appeal, was unable to discern the intuitive value of his timeline system because its regulations permitted him to submit only a miniature representation. His chart system, which appears to be a forebear of Barr's torpedoes, was approved on February 21, 1893.[2]

These varied projects are, of course, only some recent examples of the timeline gone giant. [*fig.* **8**] The early forerunners of modern timelines—ancient lists of kings and consuls and medieval genealogical scrolls—were often massive in their proportions so that they could be displayed

for public glory. The *Fasti Consulares,* which Augustus had carved in 18–17 BCE on an arch at the eastern end of the Roman Forum, listed occupants of the rotating consular chairs of the Roman government. Like many of his other actions, Augustus's canonization of earlier Roman history was presented as the restoration of a tradition. In the last centuries of the Roman Republic, the public consular lists displayed both the calendar, as it moved through the year with its festivals and market days, and the history of Rome, as a new pair of consuls, who were elected annually, marked each year. Traditionally, when Romans dated an event in early history or recalled the happier times of their youth, they did so by referring to a particular consulship. Augustus, however, changed the fasti in vital ways. He linked consular years to Rome's history since its founding, thus changing the public order of time—and indicating that Roman time began in the monarchy that the Republic replaced. Augustus appeared so many times in the list that the consuls understood their status—like their relation to time—had changed.[3] Giovanni Battista Piranesi's eighteenth-century engravings of these ruined artifacts are potent reminders not only of the ephemerality of human achievement but of the cultural power of the giant chronographic form. As Piranesi shows through his images of the ruined *fasti consulares,* the Forum was, among other things, a chronographic space.

These strategies of scale survived the ages. [*fig.* **9**] An elaborate *Ehrenpforte* (honorary gate), designed by Albrecht Dürer around 1516 for the Emperor Maximilian I, displaying the Habsburg genealogy and its political achievements, was never meant to be built, but this in no way diminishes its monumentality, either in concept or in fact. The engravings for his *Ehrenpforte* make up an elephant folio of forty-five folded plates that, when pasted together, take up an entire wall. Maximilian saw this arch as a visual counterpart to the physical ones through which he and his wife, Margaret of Austria, had passed when they made their formal "joyous entries" into cities in the Low Countries, which she governed. Around its three small portals—the "Portal of Fame," the "Portal of Honor and Power," and the "Portal of Nobility"—Dürer and his collaborators arranged what amounted to a history of the Habsburgs. This history started in Troy, came down to the present, and included all the previous Roman emperors from Julius Caesar on, Maximilian's ancestors, and his relatives by marriage—especially prominent ones like Richard the Lion-Hearted. The one Habsburg saint, Leopold, occupies a prominent place on one of the columns; near

[8]

Giovanni Battista Piranesi, *Fasti Consulares Romanorum a Romulo rege usque ad Tiberium Caesarem* (Roman consular fasti from the reign of Romulus to Tiberius Caesar), Rome, 1761

Capitolini
...se dispositos in inferiore fori parte conlocaverat, nunc primum edita prout cernuntur in Capitolio servata
...elegantioribus aliquot veteribus sigillis, et anaglyphis.
...Patrum Societatis Jesu adservatum.

the tops, in tabernacles, stand the four Habsburgs who had served as king or emperor of Germany before Maximilian. He himself appears high up in the center, seated in state and surrounded by animals and other symbols: a eulogy in reconstructed Egyptian hieroglyphs. The enterprise made a formidable kind of sense out of history. The *Ehrenpforte*, created, like modern time spaces, by collaboration among artists and scholars, invited its viewers to walk through history itself. This made them feel as humble as its modern counterparts make their visitors—not because it was so long, but because it was so thickly peopled with great men and women, and the emperor himself dominated the production.[4]

These older displays of chronology were not always gigantic. [*fig.* 10] They were sometimes cast in miniature—for the delight of the user—as in the case of the chronological jewelry created in 1720 by the Spanish designer Francisco Assensio for the French king Louis XVI. In the early modern period, these heterogenous chronographic forms were as culturally central as the timeline has become in the modern.

Since the eighteenth century, the timeline has become such a commonplace expression of historical relationships that it blends into the cultural background as naturally as lists and genealogies did in the worlds of Augustus and Maximilian. This is not to say that the timeline has forced these or other temporal forms from the field. To the contrary, our graphic world is filled with tables and trees and circles that would be instantly recognizable to our early modern predecessors. What is notable about the function of the timeline in modernity is that it operates so seamlessly in the graphic background, organizing and structuring other forms of graphic representation, as if it weren't even there.

In the modern historical imagination, the timeline plays a special role: it appears as a graphic instantiation of history itself. [*fig.* 11–12] In fact we notice it only when someone with the graphic imagination of a J. J. Grandville or Saul Steinberg mixes it up and sets it all askew. We think of the timeline not as a technical achievement in graphic design, but as the bare remainder when everything else has been scraped away. Historically speaking this is far from the case. The timeline did not precede our other ways of representing historical time, nor has it ever embodied the pure value neutrality that many have wished to attribute to it. It arose as a new way of expressing and quantizing chronological relationships. And it caught on precisely because it captured the historical spirit of the moment.

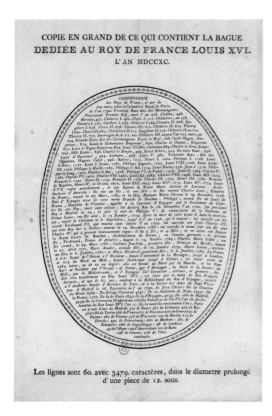

[10]

Francisco Assensio. *Chronologie des rois de France, et ans de leur mort selon le calendrier royal de Paris, de l'an 1790. Fac-simile et copie en grand de l'inscription d'une bague dédiée à Louis XVI* (Chronology of the kings of France, and years of death according to the royal calendar of Paris, of the year 1790. Facsimile and enlarged copy of the inscription of a ring dedicated to Louis XVI), ca. 1790

Arguably, the timeline has never been more important or more ubiquitous than it is today. Even in contrast to its great popularity in print form, in interactive media, the timeline is everywhere. Along with the list and the link, the timeline is one of the central organizing structures of the contemporary user interface.[5] The reasons for this are not hard to fathom: the sheer volume of information now readily available in electronic form puts indexing systems of all sorts at a premium, and the availability of dynamic, animated forms of presentation places special emphasis on time as an axis of organization. An important part of the appeal of the timeline in the context of the flat and ever-extending plane of information is that it offers stability. The world may be getting smaller and information may be moving faster, but in the realm of the time code, some semblance of the real seems always present.

This is nowhere more apparent than in the exploding field of chronological web 2.0 and open source applications. The graphically simple ones like Google News and Finance, with their scaling bar charts and line graphs, are already ubiquitous, and new graphic applications are emerging all the time. In recent years, internet startups, such as Miomi, Simile, Mnemograph, Dipity, and the Longviewer of the Long Now Foundation have suggested new ways to aggregate and integrate chronological data from many sources. Programs and websites such as these blur the boundary between political and personal chronologies as users post data—from their lives, the news, history books—all together. These are grassroots timelines, but their ambitions are no less grand than the museum timelines discussed above. To the contrary, by working on the principles of the wiki, a website anyone may edit, and data scraping, using a software program to collect data from other software programs, the ultimate scope of grassroots timelines may be much more extensive than was achieved by the time charts of the past, with their identifiable authors and artists.

But, while this newest generation of timelines promises chronological abundance as we have never had it before, it is not clear that it promises an advance, exactly. From the beginning, the biggest challenge of the time chart was not to include more data, but to clarify a historical picture—to offer a form that was intuitive and mnemonic, and that functioned well as a tool of reference. Whether or not the web 2.0 versions of the timeline will be up to this task is still to be seen. What can be said with certainty is that they formalize aspects of the time chart that were previously a matter of artistic judgment. In doing so, they highlight the continuing vitality of this remarkable cultural form.

1965

[12]

Wheel of Fashion, from J. J. Grandville,
*Un autre monde; transformations,
visions, incarnations...et autres choses*,
Paris, 1844

[11]

Saul Steinberg, *Untitled*, 1965

The Saul Steinberg Foundation, New York.
© The Saul Steinberg Foundation/Artist
Rights Society (ARS), New York.

LA MODE.

Notes

Chapter 1

Time in Print

1 For interdisciplinary perspectives on graphic representation, epistemology, and aesthetics, see Edward Tufte, *The Visual Display of Quantitative Information* (Cheshire, CT: Graphics Press, 2001); Tufte, *Beautiful Evidence* (Cheshire, CT: Graphics Press, 2006); Michael Lynch and Steve Woolgar, eds., *Representation in Scientific Practice* (Cambridge, MA: MIT Press, 1990); Brian S. Baigrie, ed., *Picturing Knowledge: Historical and Philosophical Problems Concerning the Use of Art in Science* (Toronto: University of Toronto Press, 1996); James Elkins, *The Domain of Images* (Ithaca: Cornell University Press, 1999); Barbara Maria Stafford, *Artful Science: Enlightenment Entertainment and the Eclipse of Visual Education* (Cambridge, MA: MIT Press, 1994); Caroline A. Jones and Peter Galison, eds., *Picturing Science, Producing Art* (New York: Routledge, 1998); Lorraine Daston, *Things that Talk: Object Lessons from Art and Science* (New York: Zone Books, 2004). The classic works in the field are Étienne-Jules Marey, *La Méthode graphique dans les sciences expérimentales* (Paris: G. Masson, 1885) and H. Gray Funkhouser, "Historical Development of the Graphical Representation of Statistical Data," *Osiris* 3 (1937): 269–404. See also, Stephen Ferguson, "System and Schema: *Tabulae* of the Fifteenth to Eighteenth Centuries Recently Acquired by the Princeton University Library," in *Princeton University Library Chronicle* 49, no. 1 (Autumn 1987): 9–30.

2 Eviatar Zerubavel, *Time Maps: Collective Memory and the Social Shape of the Past* (Chicago: University of Chicago Press, 2003). For time in cartography, see Walter A. Goffart, *Historical Atlases: The First Three Hundred Years, 1570–1870* (Chicago: University of Chicago Press, 2003); Jeremy Black, *Maps and History: Constructing Images of the Past* (New Haven: Yale University Press, 1997); Arthur Howard Robinson, *Early Thematic Mapping in the History of Cartography* (Chicago: University of Chicago Press, 1982); Alessandro Scafi, *Mapping Paradise: A History of Heaven on Earth* (Chicago: University of Chicago Press, 2006); J. B. Harley and David Woodward, *The History of Cartography* 3 vols. (Chicago: University of Chicago Press, 1987).

3 For a modern example, see Harry Elmer Barnes, *A History of Historical Writing*, 2nd ed. (New York: Dover, 1963), cited also in Hayden White, "The Value of Narrativity in the Representation of Reality," in *The Content of the Form: Narrative Discourse and Historical Representation* (Baltimore: John Hopkins University Press, 1987), 1–25.

4 White, "Value of Narrativity," 4–5.

5 Ibid., 6–7.

6 Ibid., 6.

7 Romila Thapar, *History and Beyond* (New York: Oxford University Press, 2000).

8 Roberto Bizzocchi, *Genealogie incredibili: Scritti di storia nell'Europa moderna* (Bologna: Il Mulino, 1995); Christiane Klapisch-Zuber, *L'arbre des familles* (Paris: Éditions de la Martinière, 2003); Rosamond McKitterick, *History and Memory in the Carolingian World* (Cambridge: Cambridge University Press, 2004); McKitterick, *Perceptions of the Past in the Early Middle Ages* (Notre Dame: University of Notre Dame Press, 2006). See also Anthony Grafton, *What Was History? The Art of History in Early Modern Europe* (Cambridge: Cambridge University Press, 2007), ch. 3.

9 George Lakoff and Mark Johnson, *Philosophy in the Flesh: The Embodied Mind and Its Challenge to Western Thought* (New York: Basic Books, 1999), 155.

10 W. J. T. Mitchell, "Spatial Form in Literature: Toward a General
Theory," in *The Language of Images*, ed. W. J. T. Mitchell (Chicago:
University of Chicago Press, 1980), 274.

11 Ibid.

12 William Shakespeare, *Macbeth* 5.5.18–28, in *The Riverside Shakespeare*,
ed. G. Blakemore Evans (Boston: Houghton Mifflin, 1974).

13 J. Hillis Miller, "Time in Literature," *Daedalus* (Spring 2003): 88.

14 On genealogy and the tree form, see especially, Mary Bouquet, "Family
Trees and Their Affinities: The Visual Imperative of the Genealogical
Diagram," *Journal of the Royal Anthropological Institute* 2, no. 1 (1996):
43–66; Robert J. O'Hara, "Trees of History in Systematics and
Philology," *Memorie della Società Italiana di Scienze Naturali e del Museo
Civico di Storia Naturale di Milano* 27, no. 1 (1996): 81–88; O'Hara,
"Systematic Generalization, Historical Fate and the Species Problem,"
Systematic Biology 42, no. 3 (1993): 231–46; Carlo Ginzburg, "Family
Resemblances and Family Trees: Two Cognitive Metaphors," *Critical
Inquiry* 30, no. 3 (Spring 2004): 537–54.

15 Anthony Grafton, *Joseph Scaliger: A Study in the History of Classical
Scholarship*, 2 vol. (Oxford: Clarendon, 1983–93).

16 Petrarch's notes are reconstructed from surviving copies by Giuseppe
Billanovich, *Un nuovo esempio delle scoperte e delle letture del Petrarca
L' "Eusebio-Girolamo-PseudoProspero,"* Schriften und Vorträge des
Petrarca-Instituts Köln, 3 (Krefeld: Scherpe, 1954).

17 See the splendid study of Philip Benedict, *Graphic History: The Wars,
Massacres and Troubles of Tortorel and Perrissin* (Geneva: Droz, 2007).
On the house of De Bry see Susanna Burghartz, ed., *Inszenierte Welten:
Die west-und ostindischen Reisen der Verleger de Bry, 1590–1630* (Basel:
Schwabe, 2004); Thomas Hariot, *A briefe and true report of the new
found land of Virginia*, ed. Susanna Berg, Karen Kupperman, and Peter
Stallybrass (Charlottesville: University Press of Virginia, 2007); and
Michiel van Groesen, *The Representations of the Overseas World in the De
Bry Collection of Voyages (1590–1634)* (Leiden and Boston: Brill, 2008).

18 Alexander Ross, *The history of the world; the second part in six books, being
a continuation of the famous History of Sir Walter Raleigh...beginning
where he left...at the end of the Macedonian kingdom* (London: J. Saywell,
1652), preface.

19 Daniel Rosenberg, "Joseph Priestley and the Graphic Invention of
Modern Time," *Studies in Eighteenth-Century Culture* 36 (Spring 2007):
55–104.

20 Joseph Priestley, *Description of a New Chart of History* (1769), in *The
Theological and Miscellaneous Works of Joseph Priestley*, ed. John Towill
Rutt, 25 vols. (London: G. Smallfield, 1817), 24:479–80.

21 Laurence Sterne, *The Life and Opinions of Tristram Shandy, Gentleman*
(1759–66; repr., New York: W. W. Norton, 1980), 26.

22 Henri Bergson, *Matter and Memory*, trans. N. M. Paul and W. S. Palmer
(New York: Zone Books, 1988), 207.

23 Olaf Stapledon, *Last and First Men: A Story of the Near and Far Future*
(London: Methuen, 1930).

Chapter 2

Time Tables

1 For a much fuller account of this story, see Anthony Grafton and
Megan Williams, *Christianity and the Transformation of the Book*
(Cambridge, MA: Belknap Press of Harvard University Press, 2006).

2 Brian Croke, "The Originality of Eusebius' *Chronicle*," *American Journal
of Philology* 103 (1982): 195–200.

3 Vespasiano da Bisticci, *The Vespasiano Memoirs: Lives of Illustrious Men
of the XVth Century*, trans. William George and Emily Waters (Toronto
and Buffalo: University of Toronto Press in association with the
Renaissance Society of America, 1997), 417.

4 Eusebius, *Chronicum*, trans. Jerome (Venice: Ratdolt, 1483), unpaginated;
translation is mine (as are all others unless a modern translation is cited).

5 Kathleen Biddick, *The Typological Imaginary: Circumcision, Technology,
History* (Philadelphia: University of Pennsylvania Press, 2003), 46.
For more general information on the forms used by medieval world
chroniclers, see Gert Melville, "Geschichte in graphischer Gestalt:
Beobachtungen zu einer spätmittelalterlichen Darstellungsweise,"
Geschichtsschreibung und Geschichtsbewusstsein im späten Mittelalter, ed.
Hans Patze (Sigmaringen: Thorbecke, 1987), 57–156.

6 See the recent appreciation by Albrecht Classen, "Werner Rolevink's
Fasciculus Temporum: The History of a Late Medieval Best Seller, or, the
First Hypertext," *Gutenberg Jahrbuch* (2006): 225–30.

7 See *Genealogia Christi* (Barcelona: Moleiro, 2000), a volume of essays
that accompanies the facsimile edition *Genealogia Christi* roll, Rome,
Biblioteca Casanatense, MS 4254; see esp. Miguel Vivancos, "The
Genealogia Christi by Peter of Poitiers," *Genealogia Christi*, 15–27.

8 Christiane Klapisch-Zuber, *L'Arbre des familles* (Paris: Editions de la
Martinière, 2003).

9 Gabrielle Spiegel, "Genealogy: Form and Function in Medieval
Historical Narrative," *History and Theory* 22 (1983): 47.

10 Werner Rolevinck, *Fasciculus temporum* (Venice: Georg Walch, 1479), 1
verso.

11 Rolevinck, *Fasciculus temporum*, 1 verso.

12 See for example the classic work of Robert Scribner, *For the Sake of
Simple Folk: Popular Propaganda for the German Reformation*, 2nd ed.
(Oxford: Clarendon Press, 1994).

13 Adrian Wilson, *The Making of the Nuremberg Chronicle* (Amsterdam:
Nico Israel, 1978).

14 Rolevinck, *Fasciculus temporum*, 1 verso.

15 See Wilson, *Making of the Nuremberg Chronicle*.

16 On chronologers' efforts to find genealogical room for the New World
peoples, see Giuliano Gliozzi, *Adamo e il nuovo mondo: La nascita
dell'antropologia come ideologia coloniale: dalle genealogie bibliche alle
teorie razziali (1500–1700)* (Florence: La Nuova Italia, 1977); for
Chinese chronology see Edwin J. Van Kley, "Europe's 'Discovery' of
China and the Writing of World History," *American Historical Review*
76 (1971): 358–85; and for Egyptian chronology and its relation to
Chinese see Anthony Grafton, "Kircher's Chronology," in *Athanasius*

Kircher: The Last Man Who Knew Everything, ed. Paula Findlen (New York, Routledge, 2004), 171–87. The fullest study of the expansion of chronology, now in much need of updating, is still Adalbert Klempt, *Die Säkularisierung der universalhistorischen Auffassung; zum Wandel des Geschichtsdenkens im 16. und 17. Jahrhundert* (Göttingen: Musterschmidt, 1960).

17 On Annius and his work see especially Anthony Grafton, *Defenders of the Text* (Cambridge, MA: Harvard University Press, 1991), ch. 3; Walter Stephens, *Giants in Those Days: Folklore, Ancient History, and Nationalism* (Lincoln: University of Nebraska Press, 1989); Ingrid Rowland, *The Culture of the High Renaissance: Ancients and Moderns in Sixteenth-Century Rome* (Cambridge: Cambridge University Press, 1998); Rowland, *The Scarith of Scornello: A Tale of Renaissance Forgery* (Chicago: University of Chicago Press, 2004).

18 Paulus Constantinus Phrygio, *Chronicum* (Basel: Herwagen, 1534), 1 verso. For a fuller analysis of this and many of the other tabular works discussed here, see Benjamin Steiner, *Die Ordnung der Geschichte: Historische Tabellenwerke in der Frühen Neuzeit* (Vienna: Böhlau, 2008).

19 Roberto Bizzocchi, *Genealogie incredibili: scritti di storia nell'Europa moderna* (Bologna: Il Mulino, 1995); Larry Silver, *Marketing Maximilian: The Visual Ideology of a Holy Roman Emperor* (Princeton: Princeton University Press, 2008), 41–77.

20 Reiner Reineck, *Oratio de historia* (Frankfurt: Wechel, 1580), 25.

21 Reineck, *Oratio de historia,* 24.

22 See D. P. Walker, *Unclean Spirits: Possession and Exorcism in France and England in the Late Sixteenth and Early Seventeenth Centuries* (Philadelphia: University of Pennsylvania Press, 1981).

23 Daniel 2:32–35 (King James Version).

24 See Arnaldo Momigliano, *Essays on Ancient and Modern Judaism,* ed. Silvia Berti, trans. Maura Masella-Gayley (Chicago: University of Chicago Press, 1994), ch. 3.

25 Rolevinck, *Fasciculus temporum,* 1 recto.

26 Lorenz Faust, *Anatomia statuae Danielis* (Lepizig: Steinmann, 1585), 40. See the very full study by Thomas Rahn, "Geschichtsgedächtnis am Körper: Fürstliche Merk- und Meditationsbilder nach der Weltreiche-Prophetie des 2. Buches Daniel," in *Seelenmaschinen,* ed. Jörg Jochen Berns and Wolfgang Neuber (Vienna: Böhlau, 2000), 521–61.

27 Majorie Reeves and Beatrice Hirsch-Reich, *The Figurae of Joachim of Fiore* (Oxford: Clarendon Press, 1972); Reeves, *Joachim of Fiore and the Prophetic Future* (London: SPCK, 1976); Bernard McGinn, *The Calabrian Abbot: Joachim of Fiore in the History of Western Thought* (New York: Macmillan, 1985).

28 See Nicholas Popper, "'Abraham, Planter of Mathematics': Histories of Mathematics and Astrology in Early Modern Europe," *Journal of the History of Ideas* 67 (2006): 87–106.

29 For great conjunction theory and world history, see Laura Smoller, *History, Prophecy, and the Stars: the Christian Astrology of Pierre d'Ailly, 1350–1420* (Princeton: Princeton University Press, 1994). The story is carried down into the sixteenth century by Robin Barnes, *Prophecy and Gnosis: Apocalypticism in the Wake of the Lutheran Reformation* (Stanford: Stanford University Press, 1988); and Claudia Brosseder, *Im Bann*

der Sterne: Caspar Peucer, Philipp Melanchthon und andere Wittenberger Astrologen (Berlin: Akademie-Verlag, 2004).

30 See James Barr, "Why the World Was Created in 4004 BC: Archbishop Ussher and Biblical Chronology," *Bulletin of the John Rylands University Library of Manchester* 67 (1984–85): 575–608.

31 Don Cameron Allen, *The Legend of Noah: Renaissance Rationalism in Art, Science, and Letters* (1949; repr. Urbana: University of Illinois Press, 1963); Klempt, *Säkularisierung der universalhistorischen Auffassung;* Paolo Rossi, *The Dark Abyss of Time: the History of the Earth & the History of Nations from Hooke to Vico,* trans. Lydia Cochrane (Chicago: University of Chicago Press, 1984); Eric Jorink, *Het 'boeck der natuere': nederlandse geleerden en de wonderen van Gods Schepping, 1575–1715* (Leiden: Primavera Pers, 2006); Thijs Weststeijn, "*Spinoza sinicus*: An Asian Paragraph in the History of the Radical Enlightenment," *Journal of the History of Ideas* 68 (2007): 537–61.

Cartographies of Time 250

Graphic Transitions

1 Genesis 11:4 (King James version).

2 For Temporarius on Rome see H. J. Erasmus, *The Origins of Rome in Historiography from Petrarch to Perizonius* (Assen: Van Gorcum, 1962).

3 See Arno Borst, *The Ordering of Time: From the Ancient Computus to the Modern Computer* (Cambridge: Polity, 1993); and G. V. Coyne, M. A. Hoskin, and O. Pedersen, eds., *Gregorian Reform of the Calendar* (Vatican City: Pontifica Academia Scientiarum, Specola Vaticana, 1983).

4 On the vogue for these historical calendars see Max Engammare, *L'ordre du temps: l'invention de la ponctualité au XVIe siècle* (Geneva: Droz, 2004).

5 Samuel Quiccheberg, *Inscriptiones vel tituli theatri amplissimi* (Munich: Berg, 1565), fol. B ij recto; for a modern edition containing the Latin text and a German translation see Harriet Roth, *Der Anfang der Museumslehre in Deutschland: Das Traktat "Inscriptiones vel Tituli Theatri Amplissimi" von Samuel Quiccheberg* (Berlin: Akademie, 2000), 54–57; translation is ours (as are all others unless a modern translation is cited).

6 Quiccheberg, *Inscriptiones*, fol. A iij vo; Roth, *Anfang der Museumslehre in Deutschland*, 46–47.

7 See for example Anthony Grafton, "Renaissance Histories of Art and Nature," in *The Artificial and the Natural: An Evolving Polarity*, ed. Bernadette Bensaude-Vincent and William R. Newman (Cambridge, MA: MIT Press, 2007), 185–210; and Grafton, *What Was History? The Art of History in Early Modern Europe* (Cambridge: Cambridge University Press, 2007), ch. 3.

8 Nicholas Jardine, *The Birth of History and Philosophy of Science: Kepler's A Defence of Tycho against Ursus, with Essays on its Provenance and Significance* (Cambridge: Cambridge University Press, 1984); Anthony Grafton, *Defenders of the Text* (Cambridge, MA: Harvard University Press, 1981), ch. 7.

9 John Heilbron, *The Sun in the Church: Cathedrals as Solar Observatories* (Cambridge, MA: Harvard University Press, 1999).

10 Quoted by John Heilbron, "Bianchini as an Astronomer," in *Francesco Bianchini (1662–1729) und die europäische gelehrte Welt um 1700*, ed. Valentin Kockel and Brigitte Sölch (Berlin: Akademie Verlag, 2005), 66.

11 Francesco Bianchini, *La istoria universale provata con monumenti e figurata con simboli degli antichi*, 2nd ed. (Rome: Antonio de Rossi, 1747), 21.

12 Tamara Griggs, "Universal History from Counter-Reformation to Enlightenment," *Modern Intellectual History* 4 (2007), 221–28.

13 See Daniel Rosenberg, "Early Modern Information Overload," *Journal of the History of Ideas* 64, no. 1 (2003): 1–9, and, in the same issue, the articles by Ann Blair, Brian Ogilvie, Jonathan Sheehan, and Richard Yeo; Noel Malcolm, "Thomas Harrison and his 'Ark of Studies': An Episode in the History of the Organization of Knowledge," *The Seventeenth Century* 19 (2004): 196–232.

14 Wilhelm Schmidt-Biggemann, *Topica universalis: Eine Modellgeschichte humanistischer und barocker Wissenschaft* (Hamburg: Meiners, 1983); Donald Kelley, "Writing Cultural History in Early Modern Europe: Christophe Milieu and His Project," *Renaissance Quarterly* 52, no. 2 (Summer 1999), 342–65; Martin Gierl, *Pietismus und Aufklärung: Theologische Polemik und die Kommunikationsreform der Wissenschaft am Ende des 17. Jahrhunderts* (Göttingen: Vandenhoeck & Ruprecht, 1997); Françoise Waquet, ed., *Mapping the World of Learning: the Polyhistor of Daniel Georg Morhof* (Wiesbaden: Harrassowity, 2000); Martin Mulsow, "Practices of Unmasking: Polyhistors, Correspondence, and the Birth of Dictionaries of Pseudonymity in Seventeenth-Century Germany," *Journal of the History of Ideas* 67 (2006): 219–50; Michael Carhart, "Historia Literaria and Cultural History from Mylaeus to Eichhorn," in *Momigliano and Antiquarianism: Foundations of the Modern Cultural Sciences*, ed. Peter Miller (Buffalo: University of Toronto Press, 2007), 184–206

15 Johannes Buno, *Universae historiae cum sacrae tum profanae idea* (Frankfurt and Leipzig: Apud viduam Reinhardi Waechtleri, typis Christoph. Balth. Lampii, 1689), 11–12.

16 See Jan Chiapusso, "Bach's Attitude Towards History," *Musical Quarterly* 39 (1953), 396–414.

17 See Gerhard Strasser, "Johannes Bunos Mnemotechnische Verfahren," in *Seelenmaschinen: Gattungstraditionen, Funktionen und Leistungsgrenzen der Mnemotechniken vom späten Mittelalter bis zum Beginn der Moderne*, ed. Jorg Jochen Berns and Wolfgang Neuber (Vienna: Böhlau, 2000); Gottfried Leibniz, *Schriften und Briefe zur Geschichte*, ed. Malte-Ludolf Babin and Gerd van der Heuvel (Hannover: Hahn, 2004), 565–67.

18 Giambattista Vico, *New Science*, trans. David Marsh (London: Penguin, 2001), 39.

19 Ibid., 9. On Vico's cultural history see Arnaldo Momigliano, "Vico's Scienza nuova: Roman 'Bestioni' and Roman 'Eroi,'" *History and Theory* 5 (1966): 3–23; Gianfranco Cantelli, *Vico e Bayle: Premesse per un confronto* (Napoli: Guida editori, 1971); Sergio Landucci, *I filosofi e i selvaggi. 1580–1780* (Bari: Laterza, 1972); Paolo Rossi, *The Dark Abyss of Time: The History of the Earth and the History of Nations from Hooke to Vico*, trans. Lydia G. Cochrane (Chicago: University of Chicago Press, 1984); Cantelli, *Mente corpo linguaggio: Saggio sull'interpretazione vichiana del mito* (Florence: La Nuova Italia, 1986); Harold Stone, *Vico's Cultural History: the Production and Transmission of Ideas in Naples, 1685–1750* (New York: E. J. Brill, 1997).

Chapter 4

A New Chart of History

1 Jacques Barbeu-Dubourg, *Chronographie, ou, Description des tems: contenant toute la suite des souverains de l'univers & des principaux événemens de chaque siécle depuis la création du monde jusqu'à présent; en trente-cinq planches gravées en taille-douce & réunies en une machine d'un usage facile & commode* (Paris: chez l'auteur, 1753), 5.

2 Jean Rou, *Tables historiques, chronologiques, & généalogiques: contenant ce qui s'est passé de plus mémorable depuis la création du monde* (Paris: chez l'auteur, 1672–75).

3 See Jean Rou, *Mémoires inédits et opuscules*, ed. F. Waddington (Paris: Agence centrale de la Société pour l'histoire du protestantisme français, 1857).

4 Francis Tallents, *A view of universal history: from the creation, to the destruction of Jerusalem by Adrian, in the year of the world 4084, and of Christ 135* (London: Littlebury, et. al., 1685). On Tallents, see J. W. Ashley Smith, "Modern History as Subject Matter for Higher Education: The Contribution of Francis Tallents," *Paedagogica Historica* XV (1975): 1–15.

5 Nicolas Lenglet du Fresnoy, *Chronological tables of universal history, sacred and profane, ecclesiastical and civil; from the creation of the world, to the year one thousand seven hundred and forty-three. With a preliminary discourse on the short method of studying history; and a catalogue of books necessary for that purpose; with some remarks on them….*, 2 vols. (London: A. Millar, 1762), p. vol. 1, i.

6 Nicolas Lenglet du Fresnoy, *New method of studying history: recommending more easy and complete instructions for improvements in that science than any hitherto extant: with the whole apparatus necessary to form a perfect historian* (London: W. Burton, 1728). First Paris edition 1713.

7 Ibid., i.

8 On the success of the book, see also the dedication to Parsons's translation of André Félibien's *The Tent of Darius Explain'd, or, The Queens of Persia at the Feet of Alexander* (London: William Redmayne for the author, 1703).

9 Jens Bircherod, *Lumen historiae sacrae veteris & novi testamenti per tabulas chronologicas* (Copenhagen: Johannis Philippi Bockenhoffer and Johann Liebe, 1687).

10 Walter A. Goffart, "The Front Matter of J. G. Hagelgans's 1718 *Atlas historicus* at the Princeton University Library and the Eran Laor Cartographic Collection, Jerusalem," *Princeton University Library Chronicle* 64, no. 1 (2002): 141–62.

11 Girolamo Andrea Martignoni, *Spiegazione della carta istorica dell'Italia, e di una parte della Germania dalla nascita di Gesú Cristo fino all'anno MDCC* (Rome: Antonio de' Rossi, 1721); Martignoni, *Explication de la carte historique de la France et de l'Angleterre depuis la naissance de Jesus-Christ jusqu'à l'an MDCC* (Rome: Antonio de' Rossi, 1721).

12 Jacques Barbeu-Dubourg, *Chronographie universelle* (Paris: Barbeu-Dubourg, Lamote, Fleury, 1753); Stephen Ferguson, "The 1753 *Carte Chronographique* of Jacques Barbeu-Dubourg," *Princeton University Library Journal* 52, no. 2 (1991): 190–230.

13 Jacques Barbeu-Dubourg, *Chronographie, ou Description des temps, contenant toute la suite des souverains des divers peuples, des principaux événements de chaque siècle, et des grands hommes qui ont vécu depuis la création du monde, jusqu'à la fin du dixhuitième siècle* (Paris: Paulin, 1838).

14 Thomas Jefferys, *A Chart of Universal History* (London: Thomas Jefferys, n.d., ca. 1750). Jeffreys's work is based on Jean-Louis Barbeau de la Bruyère's 1750 *Mappe-Monde historique, ou carte chronologique*.

15 Joseph Priestley, *Description of a Chart of Biography* (1765), in *The Theological and Miscellaneous Works of Joseph Priestley*, ed. John Towill Rutt, 25 vols. (London: G. Smallfield, 1817), vol. 24, 467.

16 Ibid., vol. 24, 470.

17 Ibid., vol. 24, 468.

18 Ibid., vol. 24, 470.

19 Ibid.

20 Joseph Priestley, *Lectures on History and General Policy* (1788), in *The Theological and Miscellaneous Works of Joseph Priestley*, ed. John Towill Rutt, 25 vols. (London: G. Smallfield, 1817), vol. 24, 134.

21 Ibid., vol. 24, 136. With only very few exceptions such as the ancient poet Sappho, the figures on Priestley's chart were men. Pierre-Nicolas Chantreau's *Science de l'histoire: contenant le système général des connoissances à acquérir avant d'étudier l'histoire, et la méthode à suivre quand on se livre à ce genre d'étude, développée par tableaux synoptiques*, 3 vols. (Paris: Goujon fils, 1803–1806) takes some steps toward the inclusion of women.

22 Joseph Priestley, *Description of a New Chart of History* (1769), in *The Theological and Miscellaneous Works of Joseph Priestley*, ed. John Towill Rutt, 25 vols. (London: G. Smallfield, 1817), vol. 24, 480.

23 Ibid., vol. 24, 481.

24 Priestley, *Lectures on History*, vol. 24, 133.

25 Ibid., vol. 24, 30.

26 Erasmus Darwin, *A Plan for the Conduct of Female Education* (Derby: J. Drewry, 1797), 23, 121; Robert Steele, "A Catalogue of Books," *Cambridge Magazine: or, Universal Repository of Arts, Sciences, and the Belles Letters*, no. IX (London, September 1769): 368; Hester Chapone, *Letters on the Improvement of the Mind, Addressed to a Young Lady* (London: J. Walter and C. Dilly, 1786), 207; Maria Edgeworth and Richard Lovell Edgeworth, *Practical Education*, 2 vols. (London: J. Johnson, 1798), vol. 2, 419–22.

27 Jefferys Taylor, *Harry's Holiday, or the Doings of One Who Had Nothing to Do* (London: Rest Fenner, 1818).

28 Priestley, *Description of a Chart of Biography*, vol. 24, 476.

29 Ibid., vol. 24, 475–76.

30 On Priestley's theories of progress and the millennium, see especially Jack Fruchtman, *The Apocalyptic Politics of Richard Price and Joseph Priestley: A Study in Late Eighteenth Century English Republican Millennialism* (Philadelphia: American Philosophical Society, 1983); and Clarke Garrett, "Joseph Priestley, the Millennium, and the French Revolution," *Journal of the History of Ideas* 34, no. 1 (1973): 51–66.

31 Priestley, *Description of a Chart of Biography*, vol. 24, 475.

32 Ibid., vol. 24, 475.

33 Ibid., vol. 24, 264.

34 Ibid., vol. 24, 475.

35 Ibid., vol. 24, 464.

36 Ibid., vol. 24, 467.

37 Ibid.

38 Goffart, *Historical Atlases*; Black, *Maps and History*; David Rumsey and Edith M. Punt, *Cartographica Extraordinaire: The Historical Map Transformed* (Redlands, CA: ESRI Press, 2004).

39 Abraham Ortelius, *Theatrum orbis terrarum* (Paris: 1572), 1; cited in Goffart, *Historical Atlases*, 1. See also Catherine Hoffman, "La genèse de l'atlas historique en France (1630–1800): Pouvoirs et limites de la carte comme 'oeil de l'histoire,'" *Bibliothèque de l'École des chartes* 158 (2000): 97–128.

40 Goffart, *Historical Atlases*, 100, 105–11.

41 Ibid., 132–33.

42 Ibid., 303–14.

43 Ibid., 314–23.

44 William Playfair, *The Commercial and Political Atlas, Representing, by Means of Stained Copper-Plate Charts, the Exports, Imports, and General Trade of England: The National Debt, and Other Public Accounts* (London: J. Debrett, 1786). See also, Howard Wainer, *Graphic Discovery: A Trout in the Milk and Other Visual Adventures* (Princeton: Princeton University Press, 2005), 9–38; Albert Biderman, "The Playfair Enigma," *Information Design Journal* 6, no. 1 (1990): 3–26; Patricia Costigan-Eaves, "Some Observations on the Design of William Playfair's Line Graphics," *Information Design Journal* 6, no. 1 (1990): 27–44; Erica Royston, "Studies in the History of Probability and Statistics III: A Note on the History of the Graphical Presentation of Data," *Biometrika* 43, no. 3/4 (1956): 241–47; H. Gray Funkhouser and Helen M. Walker, "Playfair and His Charts," *Economic History* 3, no. 10 (1935): 103–109.

45 William Playfair, *The Commercial and Political Atlas*, 3rd ed. (London: J. Wallis, 1801), viii–ix. Cited also in Patricia Costigan-Eaves and Michael Macdonald-Ross, "William Playfair (1759–1823)," *Statistical Science* 5, no. 3 (1990): 325.

46 William Playfair, *The Statistical Breviary* (London: T. Bensley, 1801), 15.

47 On the history of statistical graphics, in addition to the works of Edward Tufte (see chap. 1, n. 1) and Howard Wainer, see Daniel R. Headrick, *When Information Came of Age: Technologies of Knowledge in the Age of Reason and Revolution, 1700–1850* (New York: Oxford University Press, 2000); Thomas L. Hankins, "Blood, Dirt, and Nomograms: A Particular History of Graphs," *Isis* 90 (1999): 50–80; James R. Beniger and Dorothy L. Robyn, "Quantitative Graphics in Statistics: A Brief History," *American Statistician* 32, no. 1 (1978): 1–11; Laura Tilling, "Early Experimental Graphs," *British Journal for the History of Science* 8, no. 30 (1975): 193–213; H. Gray Funkhouser, "Historical Development of the Graphical Representation of Statistical Data," *Osiris* 3 (1937): 269–404; Michael Friendly and Daniel J. Denis, "Milestones in the History of Thematic Cartography, Statistical Graphics, and Data Visualization," Department of Mathematics and Statistics, York University, http://www.math.yorku.ca/SCS/Gallery/milestone/.

48 On Nightingale, see esp. Edwin W. Kopf, "Florence Nightingale as Statistician," *Quarterly Publications of the American Statistical Association* 15 (December 1916): 388–404; Howard Wainer, *Visual Revelations: Graphical Tales of Fate and Deception from Napoleon Bonaparte to Ross Perot* (Hillsdale, NJ: Lawrence Erlbaum, 2000), sec. 3. On Minard, see esp. Arthur H. Robinson, "The Thematic Maps of Charles Minard," *Imago Mundi* 21 (1967): 95–108; Edward R. Tufte, *The Visual Display of Quantitative Information*, 2nd ed. (Cheshire, CT: Graphics Press, 2001). On Walker, see Funkhouser, "Graphical Representation," 339–40.

49 Alexander Ross, *The history of the world: the second part, in six books, being a continuation of the famous history of Sir Walter Raleigh* (London: John Saywell, 1652), preface.

50 Walter Benjamin, "Theses on the Philosophy of History," in *Illuminations*, ed. Hannah Arendt, trans. Harry Zohn (New York: Schocken, 1969), 262.

51 See Reinhart Koselleck, *The Practice of Conceptual History: Timing History, Spacing Concepts*, trans. Todd Samuel Presner (Stanford: Stanford University Press, 2002), 166.

52 Nicolas Rieucau and Pierre Crépel, "Condorcet's Social Mathematic, A Few Tables," *Social Choice and Welfare*, 25 (2005): 243–85; Nicolas Rieucau, "Condorcet et l'art de former des tableaux historiques," *Mathematics and Social Sciences*, 176, no. 4 (2006): 89–117.

53 Chantreau, *Science de l'histoire*.

54 Charles Fourier, *The Theory of the Four Movements*, ed. Gareth Stedman Jones and Ian Patterson (New York: Cambridge University Press, 1996), 41. Originally published as Charles Fourier, *Théorie des quatre mouvemens et des destinées générales* (Leipzig: n.p., 1808); though the original states it was published in Leipzig with no publisher given, it was actually published in Lyon by Pelzin.

55 William Bell, *Descriptive Guide to "The Stream of Time," or, General Outline of Universal History, Chronology, and Biography, at One View* (Hull: Joseph Simmons, 1812), 7.

56 Bell, *Descriptive Guide*, 8–10.

Chapter 5

Frontier Lines

1 David Ramsay, *Historical and Biographical Chart of the United States* (Charleston, SC: John Hobb, 1811), 7. On Ramsay, see Robert L. Brunhousek, "David Ramsay, 1749–1815: Selections from His Writings," *Transactions of the American Philosophical Society*, New Series 55, no. 4 (1965): 1–250.

2 Philip M. Hanley, *History of the Catholic Ladder* (Fairfield, WA: Ye Galleon Press, 1993); Kris A. White and Janice St. Laurent, "Mysterious Journey: The Catholic Ladder of 1840," *Oregon Historical Quarterly* 97, no. 1 (Spring 1996): 70–88; François Norbert Blanchet, *The Key to the Catholic Ladder* (New York, T. W. Strong, 1859). The Oregon Historical Society in Portland and Mount Angel Abbey in Mount Angel, Oregon, both hold excellent collections of the nineteenth-century ladders.

3 The first full account of the religious conflict is given in Hubert Howe Bancroft, *History of Oregon*, 2 vols. (San Francisco: History Co., 1886–88), vol. 1. Clifford Merrill Drury, *Henry Harmon Spalding* (Caldwell, ID: Caxton Printers, 1936); Drury, ed. *The Diaries and Letters of Henry H. Spalding and Asa Bowen Smith relating to the Nez Perce Mission 1838–1842* (Glendale, CA: Arthur H. Clark, 1958); Drury, *First White Women Over the Rockies; Diaries, Letters, and Biographical Sketches of the Six Women of the Oregon Mission Who Made the Overland Journey in 1836 and 1838* (Glendale, CA: A. H. Clark Co., 1963–1966). Spalding pursued his war of words until his death in 1874 and his accusations lived on much longer than that. In 1903, the United States Congress published a collection of testimonies supporting Spalding's accusations against Blanchet in *Letter from the Secretary of the Interior, communicating…the Early Labors of the Missionaries… in Oregon…commencing in 1836* (Washington, DC: Government Printing Office, 1903).

4 Bancroft, *History of Oregon*, vol. 1, 125–26. On the pedagogical dimension of the ladders, see Charles D. Schreibeis, *Pioneer Education in the Pacific Northwest (1789–1847)* (Portland, OR: Metropolitan Press, 1937); Albert Furtwangler, *Bringing Indians to the Book* (Seattle: University of Washington Press, 2005).

5 Henry Spalding, quoted in Bancroft, *History of Oregon*, vol. 1, 656.

6 Russell Thornton, "A Rosebud Reservation Winter Count, circa 1751–1752 to 1886–1887," *Ethnohistory* 49, no. 4 (Fall 2002): 723–42; Thornton, "A Report of a New Mandan Calendric Chart," *Ethnohistory* 50, no. 4 (Fall 2003): 697–705.

7 Garrick Mallery, "The Dakota Winter Counts," in *Pictographs of the North American Indians*, Fourth Annual Report of the Bureau of American Ethnology, 1882–1883 (Washington, DC: Smithsonian Institution, 1887), 89–14; Mallery, *Picture-Writing of the American Indians*, Tenth Annual Report of the Bureau of Ethnology, 1888–89 (Washington, DC: Smithsonian Institution, 1893), 266–328.

8 Thomas Loraine McKenney, *History of the Indian Tribes of North America*, 2 vols. (Philadelphia: E. C. Biddle, 1836–38); Alexander Marshack, "A Lunar-Solar Calendar Stick from North America," *American Antiquity* 50, no. 1 (1985): 27–51; Marshack, "North American Indian Calendar Sticks: The Evidence for a Widely Distributed Tradition," in *World Archaeoastronomy*, ed. A. F. Aveni (New York: Cambridge University Press, 1988), 308–24; Robert H. Merrill, "The Calendar Stick of Tshi-Zun-Hau-Kau," *Bulletin of the Cranbrook Institute of Science*, no. 24 (1945): 1–6; Paul Radin, *The Winnebago Tribe* (Lincoln: University of Nebraska Press, 1970).

9 Marjorie Reeves, *Joachim of Fiore and the Prophetic Future* (London: SPCK, 1976). See also Marjorie Reeves and Beatrice Hirsch-Reich, *The Figurae of Joachim of Fiore* (Oxford: Clarendon Press, 1972).

10 On the relation between eschatology and progress in American thought and its background, see the classic works of Ernest Lee Tuveson, *Millennium and Utopia: A Study in the Background of the Idea of Progress* (Berkeley: University of California Press, 1949); and Paul Boyer, *When Time Shall Be No More: Prophecy Belief in Modern American Culture* (Cambridge, MA: Harvard University Press, 1992). On the political and cultural problems associated with dating the millennium, though only with reference to the Middle Ages, see the excellent article (and timeline) by Richard Landes, "Lest the Millennium Be Fulfilled, Apocalyptic Expectations and the Pattern of Western Chronography, 100–800 C.E.," in *The Use and Abuse of Eschatology in the Middle Ages*, ed. W. D. F. Verbeke, D. Verhelst, and A. Welkenhysen (Leuven, Belgium: Leuven University Press, 1988), 137–211.

11 William Miller, *Views of the Prophecies and Prophetic Chronology, Selected from manuscripts of William Miller, with a Memoir of his Life by Joshua V. Himes* (Boston: Joshua V. Himes, 1842).

12 David Morgan, *Protestants and Pictures: Religion, Visual Culture, and the Age of American Mass Production* (New York: Oxford University Press, 1999); Morgan, *Visual Piety: A History and Theory of Popular Religious Images* (Berkeley: University of California Press, 1998); Ronald L. Numbers and Jonathan M. Butler, *The Disappointed: Millerism and Millenarianism in the Nineteenth Century* (Bloomington: Indiana University Press, 1987).

13 John Greenleaf Whittier, "The World's End," in *The Prose Works*, vol. 1 (New York: Houghton Mifflin, 1880), 425–26.

14 Richard Cunningham Shimeall, *The Political Economy of Prophecy* (New York: John F. Trow & Co., 1866).

15 Edith W. Osgood, "The Development of Historical Study in the United States (Concluded)," *School Review* 22, no. 8 (October 1914): 511–26.

16 Review of the *Historical Chart*, *Philanthropist*, August 30, 1843; see also, *Christian Advocate and Journal*, November 27, 1844, 62.

17 Marcius Willson, *The History of the United States for the Use of Schools* (Cincinnati: William Moore, 1847), 1.

18 Robert Henlopen Labberton, *An Historical Atlas Containing a Chronological Series of One Hundred Maps, at Sucessive Periods, from the Dawn of History to the Present Day* (Philadelphia: Claxton, Remson & Haffelfinger, 1874); Labberton, *Historical Chart, or, History Taught by the Eye* (Philadelphia: Claxton, Remson, & Haffelfinger, 1874).

19 Robert Henlopen Labberton, *Outlines of History; with Original Tables, Chronological, Genealogical and Literary* (Philadelphia: Claxton, Remsen

& Haffelfinger, 1872), 3.

20 Ibid., 3–4.

21 Alexander Campbell quoted in, Robert Frederick West, *Alexander Campbell and Natural Religion* (New Haven: Yale University Press, 1948), 161.

22 "Science the Handmaid of Religion," *Churchman's Magazine* 4, no. 7 (October 1825): 193.

23 "Sketches of the Speeches at the Last Working Men's Meeting," *Workingman's Advocate* 1, no. 9 (May 25, 1844): 1.

24 Ibid.

25 "The Uses of History to the Preacher," *New Englander* 22, no. 84 (New Haven, July 1863): 7.

26 James Schoulder, "The Spirit of Historical Research," *National Magazine: A Monthly Journal of American History* 15, no. 3 (New York, January 1892): 3.

Chapter 6

A Tinkerer's Art

1 Stuart Sherman, *Telling Time: Clocks, Diaries, and English Diurnal Form, 1660–1785* (Chicago: University of Chicago Press, 1996), 78.

2 Thomas Pie, *An Houreglasse Contayning a Computation from the Beginning of Time to Christ by X Articles* (London: John Wolfe, 1597), 1; Robert Cary, *Palaeologia Chronica: A Chronological Account of Ancient Time* (London: J. Darby, 1677), 1.

3 Anthony Grafton, *Joseph Scaliger: A Study in the History of Classical Scholarship*, 2 vols. (Oxford: Clarendon Press, 1983–93), 2:16.

4 Edward P. Thompson, "Time, Work-Discipline, and Industrial Capitalism," *Past and Present*, no. 38 (1967): 56–97.

5 On Galton's maps, see Funkhouser, "Graphical Representation of Statistical Data," 345. On Edmund Halley's 1686 map of the trade winds, see Arthur H. Robinson, *Early Thematic Mapping in the History of Cartography* (Chicago: University of Chicago Press, 1982), 46–47, 70–71.

6 On the system used by the Marconi Telegraph Company, see Funkhouser, "Statistical Graphics," 308. See also, Étienne-Jules Marey, *Du mouvement dans les fonctions de la vie* (Paris: Germer Baillière, 1868); Marey, *Movement*, trans. Eric Pritchard (London: W. Heinemann, 1895), 37.

7 Stephen Kern, *The Culture of Space and Time: 1880–1918* (Cambridge, MA: Harvard University Press), 65–66.

8 *Scientific American Reference Book*, 2 vols. (New York: Munn, 1914), 1:310.

9 Étienne-Jules Marey, *La Méthode graphique dans les sciences expérimentales* (Paris: G. Masson, 1885); Marey, *Du mouvement*; François Dagognet, *Étienne-Jules Marey: A Passion for the Trace*, trans. Robert Galeta (New York: Zone Books, 1992); Mary Ann Doane, *The Emergence of Cinematic Time: Modernity, Contingency, the Archive* (Cambridge, MA: Harvard University Press, 2002).

10 Antoine-François Vincent and Georges Claude Goiffon, *Mémoire artificielle des principes relatifs à la fidelle représentation des animaux, tant en peinture qu'en sculpture. Première partie concernant le cheval...Ouvrage également intéressant pour les personnes qui se destinent à l'art de monter à cheval* (Paris: Vve. Valat-La-Chapelle, 1779).

11 Marey, *Movement*, 2–3.

12 Laura Tilling, "Early Experimental Graphs," *British Journal for the History of Science* 8, no. 30 (1975): 195–96; J. A. Bennett, *The Mathematical Science of Christopher Wren* (New York: Cambridge University Press, 1983); see also, H. E. Goff, L. A. Geddes, and Roger Guillemin, "The Anemograph of Ons-en-Bray: An Early Self-Registering Predecessor to the Kymograph," *Journal of the History of Medicine* 12, no. 4 (October 1957): 424–48.

13 Wainer, *Graphic Discovery*, 9–38; Biderman, "The Playfair Enigma," 3–26.

14 Jody Rosen, "Researchers Play Tune Recorded Before Edison," *New York Times*, March 27, 2008.

15 Today, with the assistance of computers, phonautographs, too, can be played. See Thomas L. Hankins and Robert J. Silverman, *Instruments*

and the Imagination (Princeton: Princeton University Press, 1995), 133–37; Jonathan Sterne, *The Audible Past: Cultural Origins of Sound Reproduction* (Durham, NC: Duke University Press, 2002), 35–51.

16 Larry A. Viskochil, "Chicago's Bicentennial Photographer: Charles D. Mosher," *Chicago History* 5, no. 2 (Summer 1976): 95–104; Heinz K. Henisch and Bridget A. Henisch, *The Photographic Experience, 1839–1914: Images and Attitudes* (University Park, PA: Pennsylvania State University Press, 1994), 187–194.

17 Kern, *Culture of Time and Space*, 21.

18 Ann Thomas, "Capturing Light: Photographing the Universe," in *Beauty of Another Order: Photography in Science*, ed. Ann Thomas (New Haven, CT: Yale University Press, 1998), 192–93.

19 Revelation 6:14 (King James Version).

20 On eighteenth- and nineteenth-century visual education and educational devices, see especially, Barbara Stafford, *Artful Science: Enlightenment Entertainment and the Eclipse of Visual Education* (Cambridge, MA: MIT Press, 1996); Barbara Stafford and Frances Terpak, *Devices of Wonder: From the World in a Box to Images on a Screen* (Los Angeles: Getty Publications, 2001); Jonathan Crary, *Techniques of the Observer: On Vision and Modernity in the Nineteenth Century* (Cambridge, MA: MIT Press, 1990). On the use of such apparatus in American schools, see Deborah Jean Warner, "Commodities in the Classroom: Apparatus for Science and Education in Antebellum America," *Annals of Science* 45 (1988): 387–97.

21 Daniel Rosenberg, "An Eighteenth Century Time Machine: The *Encyclopedia* of Diderot," in *Postmodernism and the Enlightenment: New Perspectives in Eighteenth-Century French Intellectual History,* ed. Daniel Gordon (New York: Routledge, 2001), 45–66.

22 Samuel L. Clemens to United States Patent Office, 9 October 1884, United States National Archives.

23 Ibid.

24 Mark Twain, "Mark Twain's Memory-Builder," reverse.

25 Ibid.

26 Ibid.

27 Emma Willard, *Guide to the Temple of Time; and Universal History for Schools* (New York: A. S. Barnes, 1850); and Willard, *Universal History in Perspective* (New York: A. S. Barnes, 1857). On Willard, see also Susan Schulten, "Emma Willard and the Graphic Foundations of American History," *Journal of Historical Geography* 33, no. 3 (July 2007): 542–64.

28 Antoni Jażwiński, *Méthode polonaise appliquée à la chronologie, l'histoire, la géographie....* (Lyon: J.-M. Boursy, 1832); Józef Bem, *Méthode mnémonique polonaise perfectionnée à Paris* (Paris: Librairie Polonaise, 1838); Elizabeth Palmer Peabody, *The Polish-American System of Chronology, Reproduced, with Some Modifications, from General Bem's Franco-Polish Method* (Boston: G. P. Putnam, 1850); Peabody, *Chronological History of the United States, Arranged with Plates on Bem's Principle* (New York: Sheldon, Blakeman, 1856); Napoléon Feliks Zaba, *La méthode de N. F. de Zaba pour faciliter l'étude de l'histoire universelle....* (Montreal: M. Magnus, 1874); Nelson Loverin, *Loverin's Historical Centograph and Slate: also, a Description of the Chart of Time with Key* (Montreal: D.

Bentley, 1876).

29 Elizabeth Palmer Peabody, "A Method of Laying the Foundation of History," *District School Journal of the State of New York* 12, no. 11 (March 1852): 171–72. See also, Peabody, *Letters of Elizabeth Palmer Peabody, American Renaissance Woman*, ed. Bruce A. Ronda (Middletown, CT: Wesleyan University Press, 1984), 290–94. See also, Bruce A. Ronda, *Elizabeth Palmer Peabody: A Reformer on Her Own Terms* (Cambridge, MA: Harvard University Press, 1999), 226–41; Nina Baym, "The Ann Sisters: Elizabeth Peabody's Millennial Historicism," *American Literary History* 3, no. 1 (Spring 1991): 27–45.

30 John Milton Gregory, *The Hand-Book of History and Chronology...Adapted to Accompany the Map of Time* (Chicago: Adams, Blackmer & Lyon, 1867), vii.

31 Ida P. Whitcomb, *Students' Topical History Chart from the Creation to the Present Time* (New York: A. S. Barnes, 1878), preface, n.p.

32 Mark Twain, "How to Make History Dates Stick," *Harper's Monthly Magazine* 130:775 (December 1914): 3–15.

33 Twain, "How to Make History Dates Stick," 3.

34 Ibid, 11.

35 Ibid, 7.

Chapter 7

Outside and Inside

Epigraph James Elkins, "Art History and Images that Are Not Art," *Art Bulletin* 77, no. 4 (December 1995), 553.

1 James Elkins, *The Domain of Images* (Ithaca: Cornell University Press, 1999).

2 John Sparks, *The Histomap: Four Thousand Years of World History, Relative Power of Contemporary States, Nations, and Empires* (Chicago: Histomap, Inc. and Rand McNally, 1931).

3 Anne Sparks Glanz and Jacqui Glanz (daughter and granddaughter of John Sparks), interview with author, March 20, 2008.

4 Alfred North Whitehead, "The Aims of Education," in *The Aims of Education & Other Essays* (New York: Macmillan, 1929), 1–23.

5 Herbert Spencer, *The Study of Sociology* (New York: D. Appleton & Co., 1904), 242.

6 John Sparks, *Histomap of Religion: The Story of Man's Search for Spiritual Unity* (Chicago: Rand McNally, 1943); Sparks, *Histomap of Evolution: Earth, Life and Mankind for Ten Thousand Million Years* (Chicago: Histomap, Inc., 1932).

7 Alfred H. Barr Jr., *Cubism and Abstract Art* (New York: Museum of Modern Art, 1936).

8 Paul Ligeti, *Der Weg aus dem Chaos: Eine Deutung des Weltgeschehens aus dem Rhythmus der Kunstentwicklung*, (Munich: Georg D. W. Callwey, 1931).

9 Eric Newton, *European Painting and Sculpture* (New York: Penguin, 1942).

10 A. Frédo Sidès, untitled diagram of the development of nonfigurative art in *Réalités Nouvelles* (Paris: n.p., 1948).

11 Isidore Isou, *Introduction à une nouvelle poésie et à une nouvelle musique* (Paris: Gallimard, 1947), 43. See also David W. Seaman, "French *Lettrisme*—Discontinuity and the Nature of the Avant-Garde," in *Discontinuity and Fragmentation*, ed. Freeman G. Henry (Amsterdam: Rodopi, 1994), 159–70.

12 Gordon Moore, "Cramming More Components onto Integrated Circuits," *Electronics* 38, no. 8 (April 19, 1965): 114–17.

13 Ray Kurzweil, "The Law of Accelerating Returns," KurzweilAI.net, http://www.kurzweilai.net/articles/art0134.html.

14 Astrit Schmidt-Burkhardt, *Maciunas' Learning Machines: From Art History to a Chronology of Fluxus* (Detroit: Gilbert and Lila Silverman Fluxus Collection and Vice Versa, 2003).

15 Schmidt-Burkhardt, *Maciunas' Learning Machines*, 18.

16 Since then, the chronographic gesture has been developed by artists including David Diao, Peter Davies, and Manuel Ocampo. Astrit Schmidt-Burkhardt, *Stammbäume der Kunst: zur Genealogie der Avantgard* (Berlin: Akademie, 2005).

17 John Cage, *Imaginary Landscape No. 5, for Any 42 Phonograph Records* (New York: Henmar Press, 1961).

Chapter 8

Big Time

1 Sarah Fanelli, *Tate Artist Timeline* (London: Tate Modern, 2006).

2 Manly M. Gillam, Letter to United States Patent Office, 8 June 1892, United States National Archives.

3 See the rich account in Denis Feeney, *Caesar's Calendar: Ancient Time and the Beginnings of History* (Berkeley and Los Angeles: University of California Press, 2007).

4 Larry Silver, *Marketing Maximilian: The Visual Ideology of a Holy Roman Emperor* (Princeton: Princeton University Press, 2008).

5 Alex Soojung-Kim Pang, "Old Wine for New Bottles: Making the *Britannica CD* Multimedia Times," *Human IT: Tidskrify för studier av IT ur ett humanvetenskapligt perspektiv* (1999), http://www.hb.se/bhs/ith/1-99/askp.htm. See also Daniel Rosenberg, "Electronic Memory," in *Histories of the Future,* ed. Daniel Rosenberg and Susan Harding (Durham: Duke University Press, 2005), 123–52.

Selected Bibliography

Benedict, Philip. *Graphic History: The Wars, Massacres and Troubles of Tortorel and Perrissin.* Geneva: Droz, 2007.

Bizzocchi, Roberto. *Genealogie incredibili: Scritti di storia nell'Europa moderna.* Bologna: Il Mulino, 1995.

Black, Jeremy. *Maps and History: Constructing Images of the Past.* New Haven: Yale University Press, 1997.

Daston, Lorraine, and Peter Galison. *Objectivity.* New York: Zone Books, 2007.

Elkins, James. *The Domain of Images.* Ithaca: Cornell University Press, 1999.

Funkhouser, H. Gray. "Historical Development of the Graphical Representation of Statistical Data," *Osiris* 3 (1937): 269–404.

Goffart, Walter A. *Historical Atlases: The First Three Hundred Years, 1570–1870.* Chicago: University of Chicago Press, 2003.

Grafton, Anthony, and Megan Williams. *Christianity and the Transformation of the Book: Origen, Eusebius and the Library of Caesarea.* Cambridge, MA: Harvard University Press, 2006.

Headrick, Daniel. *When Information Came of Age: Technologies of Knowledge in the Age of Reason and Revolution, 1700–1850.* New York: Oxford University Press, 2000.

Klapisch-Zuber, Christiane. *L'arbre des familles.* Paris: Éditions de la Martinière, 2003.

Koselleck, Reinhart. *The Practice of Conceptual History: Timing History, Spacing Concepts.* Translated by Todd Samuel Presner. Stanford: Stanford University Press, 2002.

Lakoff, George, and Mark Johnson. *Philosophy in the Flesh: The Embodied Mind and its Challenge to Western Thought.* New York: Basic Books, 1999.

Lynch, Michael, and Steve Woolgar, eds. *Representation in Scientific Practice.* Cambridge, MA: MIT Press, 1990.

Marey, Étienne-Jules. *La Méthode graphique dans les sciences expérimentales.* Paris: G. Masson, 1885.

McKitterick, Rosamond. *Perceptions of the Past in the Early Middle Ages.* Notre Dame: University of Notre Dame Press, 2006.

Mitchell, W. J. T., ed. *The Language of Images.* Chicago: University of Chicago Press, 1980.

Morgan, David. *Protestants and Pictures: Religion, Visual Culture, and the Age of American Mass Production.* New York: Oxford University Press, 1999.

Reeves, Marjorie. *Joachim of Fiore and the Prophetic Future.* London: SPCK, 1976.

Robinson, Arthur Howard. *Early Thematic Mapping in the History of Cartography.* Chicago: University of Chicago Press, 1982.

Rosenberg, Daniel, and Susan Harding, ed. *Histories of the Future.* Durham: Duke University Press, 2005.

Scafi, Alessandro. *Mapping Paradise: A History of Heaven on Earth.* Chicago: University of Chicago Press, 2006.

Schmidt-Burkhardt, Astrit. *Stammbäume der Kunst: zur Genealogie der Avantgard.* Berlin: Akademie, 2005.

Steiner, Benjamin. *Die Ordnung der Geschichte: Historische Tabellenwerke in der Frühen Neuzeit.* Cologne: Böhlau, 2008.

Thapar, Romila. *History and Beyond.* New York: Oxford University Press, 2000.

Tufte, Edward. *Beautiful Evidence.* Cheshire, CT: Graphics Press, 2006.

———. *The Visual Display of Quantitative Information.* Cheshire, CT: Graphics Press, 2001.

Wainer, Howard. *Graphic Discovery: A Trout in the Milk and Other Visual Adventures.* Princeton: Princeton University Press, 2005.

White, Hayden. *The Content of the Form: Narrative Discourse and Historical Representation.* Baltimore: John Hopkins University Press, 1987.

Zerubavel, Eviatar. *Time Maps: Collective Memory and the Social Shape of the Past.* Chicago: University of Chicago Press, 2003.

Credits

All images are the authors' unless otherwise noted.
Frontispiece, courtesy of Burke Library, Union Theological Seminary

Chapter 1

Time in Print

[**2–3**] Annals of St. Gall. Ms. 915, S. 196, S. 197. Stiftsbibliotek St. Gallen. Courtesy of Stiftsbibliotek St. Gallen.

[**4**] *Marmor Parium* (264/3 BCE). Courtesy of the Ashmolean Museum, Oxford.

[**5–6**] Eusebius, *Chronicle*. Codex Oxon. Merton 315, f61v, f62r. Courtesy of the Warden and Fellows of Merton College Oxford.

[**7–9**] Courtesy of the Department of Rare Books and Special Collections, Princeton University Library

[**10**] Courtesy of the American Museum of Natural History

[**11**] Courtesy of the Bibliothèque nationale de France

[**12**] Charles Renouvier, *Uchronie* (Paris: Bureau de la Critique Philosophique, 1876).

[**14**] Courtesy of the Long Now Foundation

Chapter 2

Time Tables

[**1–13**] Courtesy of the Department of Rare Books and Special Collections, Princeton University Library

[**14–18**] Courtesy of the Houghton Library, Harvard

[**19–30**] Courtesy of the Department of Rare Books and Special Collections, Princeton University Library

[**31**] Courtesy of Burke Library, Union Theological Seminary

[**32–38**] Courtesy of the Department of Rare Books and Special Collections, Princeton University Library

[**43–44**] Courtesy of Marquand Library, Princeton University

[**45–47**] Courtesy of the Department of Rare Books and Special Collections, Princeton University Library

[**50–53**] Courtesy of the Department of Rare Books and Special Collections, Princeton University Library

[**54**] Oxford MS. 255a, Corpus Christi College, f. 7v. By permission of the President and Fellows of Corpus Christi College, Oxford.

[**55**] Oxford MS. 255a, Corpus Christi College, f. 11r. By permission of the President and Fellows of Corpus Christi College, Oxford.

[**56–63**] Courtesy of the Department of Rare Books and Special Collections, Princeton University Library

[**67–68**] Courtesy of the Department of Rare Books and Special Collections, Princeton University Library

[**72**] Courtesy of the Abteilung für Alte Drucke, Zentralbibliothek, Zürich

[**73–74**] Courtesy of the Department of Rare Books and Special Collections, Princeton University Library

[**75**] Courtesy of Penrose Library, Whitman College

Chapter 3

Graphic Transitions

[**1**] By permission of The Huntington Library, San Marino, California

[**5–6**] Courtesy of the Department of Rare Books and Special Collections, Princeton University Library

[**9–19**] Courtesy of the Department of Rare Books and Special Collections, Princeton University Library

[**22–24**] Courtesy of the Cotsen Children's Library, Princeton University Library

[**25–26**] Courtesy of the Department of Rare Books and Special Collections, Princeton University Library

Chapter 4

A New Chart of History

[**1**] Courtesy, The Winterthur Library: Printed Book and Periodical Collection

[**2**] Courtesy of Beinecke Rare Book and Manuscript Library, Yale University

[**3–7**] Courtesy of the Department of Rare Books and Special Collections, Princeton University Library

[**8–9**] By permission of The Huntington Library, San Marino, California

[**10–17**] Courtesy of Department of Rare Books and Special Collections, Princeton University Library

[**18**] Courtesy of the British Library

[**21**] Courtesy of Cotsen Children's Collection, Department of Rare Books and Special Collections, Princeton University Library

[**24–28**] Courtesy of Department of Rare Books and Special Collections, Princeton University Library

[**29**] Courtesy of the University of Oregon Library

[**30–31**] Courtesy of Department of Rare Books and Special Collections, Princeton University Library

[**33–36**] Courtesy of Department of Rare Books and Special Collections, Princeton University Library

[**38**] Courtesy of the Bibliothèque nationale de France

[**39–44**] Courtesy of Department of Rare Books and Special Collections, Princeton University Library

[**45**] Courtesy of Cotsen Children's Collection, Department of Rare Books and Special Collections, Princeton University Library

[**46**] Courtesy of the American Philosophical Society

[**47**] Courtesy of the American Antiquarian Society

[**48–50**] Courtesy of Department of Rare Books and Special Collections, Princeton University Library

Chapter 5

Frontier Lines

[**1**] Thomas Jefferson Papers. Series I. General Correspondence 1651–1827. Courtesy of the Library of Congress.

[**2**] Courtesy of the American Philosophical Society

[**3**] OrHi 89315. Courtesy of the Oregon Historical Society.

[**4**] De Smetiana Collection, Jesuit Missouri Province Archives, St. Louis IX-C9-67. Courtesy of the Midwest Jesuit Archives.

[**5**] OrHi 87847. Courtesy of the Oregon Historical Society.

[**8–10**] Courtesy of Department of Rare Books and Special Collections, Princeton University Library

[**11–13**] Courtesy of the American Antiquarian Society

[**14–15**] Courtesy of Department of Rare Books and Special Collections, Princeton University Library

[**16**] Courtesy of Burke Library, Union Theological Seminary

[**17**] Courtesy of Department of Rare Books and Special Collections, Princeton University Library

[**18**] Used with permission of the Rev. Clarence Larkin Estate, P.O. Box 334, Glenside, PA 19038, U.S.A., 215-576-5590

[**20–24**] Courtesy of Department of Rare Books and Special Collections, Princeton University Library

[**25**] Van Pelt-Dietrich Library, University of Pennsylvania Libraries

[**26**] Courtesy of the American Antiquarian Society

[**27–28**] Courtesy of Department of Rare Books and Special Collections, Princeton University Library

Chapter 6

A Tinkerer's Art

[**1**] Courtesy of Department of Rare Books and Special Collections, Princeton University Library

[**2**] Francis Galton, *Meteorographica, or Methods of Mapping the Weather* (London: Macmillan, 1863).

[**3**] Reproduced from John Booth and Sean Coughlan, *Titanic—Signals of Disaster* (Westbury, UK: White Star Publications, 1993).

[**4–10**] Courtesy of Department of Rare Books and Special Collections, Princeton University Library

[12–14] Courtesy of Department of Rare Books and Special Collections, Princeton University Library

[15] Courtesy of Burke Library, Union Theological Seminary

[16–17] Courtesy of Department of Rare Books and Special Collections, Princeton University Library

[18–19] Courtesy of Cotsen Children's Library, Department of Rare Books and Special Collections, Princeton University Library

[20–22] Courtesy of the National Archives

[23] Courtesy of Cotsen Children's Library, Department of Rare Books and Special Collections, Princeton University Library

[24–25] Courtesy of the American Antiquarian Society

[26–27] Courtesy of Department of Rare Books and Special Collections, Princeton University Library

[28] Courtesy of the National Archives

[29] Courtesy of the American Antiquarian Society

[30–32] Courtesy of the National Archives

[33] General Research Division, The New York Public Library, Astor, Lenox and Tilden Foundations

[34] Courtesy of Department of Rare Books and Special Collections, Princeton University Library

[38] Courtesy of Department of Rare Books and Special Collections, Princeton University Library

[39] Van Pelt-Dietrich Library, University of Pennsylvania Libraries

[40–46] Courtesy of Department of Rare Books and Special Collections, Princeton University Library

[47] Courtesy of the Bibliothèque nationale de France

Chapter 7

Outside and Inside

[1–2] Photo: Norman McGrath. Courtesy Maya Lin Studio.

[3] Gates of Time at the Oklahoma City National Memorial. 1997. Photo: Ann Clark. Oklahoma City National Memorial Museum, Oklahoma City, OK.

[4–5] Photo Jim Simmons, Annette del Zoppo Studio. Courtesy of Sheila Levrant de Bretteville and Jim Simmons.

[6] Courtesy of Christoph Fink

[7–8] Courtesy of Katie Lewis and Mina Dresden Gallery, San Francisco

[9] Courtesy of Marjolijn Dijkman

[10] Huang Yong Ping. *Carte du monde*. 2000–2007. Map mounted on wood, globe. 600 x 100 x 300 cm. Exhibition View: *Huang Yong Ping, Ping Pong*, Astrup Fearnley Museum, Oslo, 2008. Copyright Huang Yong Ping. Courtesy of the artist and Gladstone Gallery.

[11–12] Beinecke Rare Book and Manuscript Library, Yale University. Courtesy of the Glanz Family Trust.

[13] Courtesy of Beinecke Rare Book and Manuscript Library, Yale University

[16] Courtesy of the Marquand Library, Princeton University

[17] Courtesy of Callwey Verlag

[18] Art History Chart taken from *European Painting and Sculpture* by Eric Newton (Penguin Books 1941). Copyright by the Estate of Eric Newton, 1941. Reproduced by permission of Penguin Books Ltd.

[19] Archives du salon des Réalités Nouvelles

[20] Courtesy of Éditions Gallimard

[22] Courtesy of Raymond Loewy Design LLC. Raymond Loewy ™ is a trademark of Loewy Design LLC. www.RaymondLoewy.com

[23] Courtesy of Bauhaus-Archiv, Berlin

[24] Pocket watch owned by Kengo Nikawa. Donated by Kazuo Nikawa. Courtesy of the Hiroshima Peace Memorial.

[25] Courtesy of the *Bulletin of the Atomic Scientists / www.thebulletin.org*

[26–27] Courtesy of the Estate of R. Buckminster Fuller

[28] Courtesy of Intel Corporation

[29] Courtesy of Ray Kurzweil

[34] Reproduced with permission of the Themerson Archive

Chapter 8

Big Time

[1–3] Courtesy of the American Museum of Natural History

[4–5] Courtesy of the Metropolitan Museum of Art

[6] © Tate, London, 2009

[8] Department of Rare Books and Special Collections, Princeton University Library

[9] *Maximilian's Triumphal Arch: Woodcuts by Albrecht Dürer and Others* (New York: Dover Publications, 1972). Courtesy Dover Publications.

[10] Courtesy of the Bibliothèque nationale de France

[12] Courtesy of the Department of Rare Books and Special Collections, Princeton University Library

Index

Mosher, Charles D., 188
Mount Temple (ship), 181
Mouveaux, Jehan de, 27–28, *28–29*
movable type, 189
Movement (Marey), *185–87*, 189
Moyer, Eli Nash, *200*
Munich Kunstkammer, 76
Murrah Federal Building, 210, *211*
Museum format, 76, 81–82, *86*, 87
Museum of Modern Art (MoMA), 219, 222, *222–23*
music, 233, *234*, 235
Muslims, 59, 62
Muybridge, Eadweard, 21, 184

N
Nabonassar, 62–63, 82
Napoleon, *21–22*, 128, 138
narrative
 Buno and, 89–90
 chronicles and, 11
 linearity and, 20
 Livy and, 52
 progress and, 177–78
 transliteration and, 26
Nash, Ogden, 219
National Palace Museum, 240
Native Americans, 152–53
 calendar sticks and, 158, *158*
 Catholic Ladder and, 151, *154–56*, 157, 189
 missionaries and, 150–51, 157
 picture writing and, 157–58
 Protestant Ladder and, 151, *154–56*, 157, 217
 Sahale Stick, 151, 158
Nebuchadnezzar, King of Babylon, 21, 54, 162
Netherlands, 97
New Chart of History, A (Priestley), 20, 116–17, *120–21*, 122–23, 130, 167
New Englander magazine, 177
New geneaological, historical, and chronological atlas, A (Lavoisne), *127*
newsletters, *40*
Newton, Eric, 224, *225*
Newton, Isaac, 67, 117, 125, 140, 143, 150, 161
New World, 28, 42, 82
New York City, 238
New York Observer and Chronicle, 167
Niagara (ship), 181
Nicolas Point, S. J., *155*
Nightingale, Florence, 138, *138*
Nikawa, Kengo, *228*

Nineveh, 31
Noah, *32*, *44*, 49
 Ark of, 31, *34*, 90
 Catholic Ladder and, *155*
 Flood and, *34*, 36, 48, 52, 59, 60, 64, 69–71, 81–82, *86*, 89, 95
Nova Scotia, 150
Nuremberg Chronicle (Schedel), 28, *32–33*, 36, *36–37*, 40, *40–43*, 54

O
Olav (ship), 181
Old Testament. *See* Bible
Olympiad tables, 15, 26, 44, 48, 62
Omiode no Shotokyo (Remembering Old Little Tokyo) (Levrant de Bretteville), *211*
100 Years Calendar (24,698 Days) (Kawara), *236–37*
"One Thousand Days One Million Years" (Kawara), *236*
Opus Chronologicum novum (A new treatise on chronology) (Emmius), 76
Oregon American journal, 157
Oregon Territory, 150–51, 157
Origen, 26
Ortelius, Abraham, 126, 128
Osiris, 44, *44*, 49
Ottoman Empire, 113
Outlines of Chronology (Goodrich), 167

P
Paige Compositor, 198
Paik, Nam June, *232*, 233
Palestine, 26
palimpsests, 71, 74, 210
Palmieri, Matteo, 27, *29*
parchment, 31
Parian Marble, The, 14, *14*
Parsons, William, 100, *102*
Passover, 71
Payrère, Isaac la, 69
Peabody, Elizabeth Palmer, 203, 205, *205*, 206, 208, 217
Pearson, J., *159*
Pentaplus regnorum mundi (Eytzinger), *58*, 58–59
Pepys, Samuel, 180
Perenna, Anna, *74*
Perozzo, Luigi, 136, *136–37*
Persia, 15, 26, 130
 Annius and, 44
 astrological predictions and, 59, 62

early history of, 90, 95
 prophecy of Daniel and, 54, 56
 ruler lists and, 42
Peter of Poitiers, 31, *34*, *35*, 49, *53*
Petrarch, 16, 52
Peutinger, Conrad, 49
phonautograph, 187–88
phonographs, 188
photography, 21, 188
Phrygios, Paulus Constantinus, 44, *44*, *45*, 48
Picabia, Francis, 23, 222, *223*, 224, 227
picture writing, 157–58
Picture-Writing of the American Indians (Mallery), *157*
Pietists, 90
Piranesi, Giovanni Battista, 241, *242–43*
Plato, *64*
Playfair, James, *135*
Playfair, William, 136, *136*, 153, 184, 187, 231
Pocket Tablet of Chronology (Darton), 189, *192*
Polish-American System of Chronology (Peabody), *203*, 205
Polish System, 203, 205–206
Political Economy of Prophecy (Shimeall), 162, *163*
population growth, 70–71, *72*
positivism, 21, 143
Priestley, Joseph, 20, 21, 23, 89, *145*, 157, 184, 231
 accuracy and, 138, 140
 art and, 210
 Bell and, 149
 broad view and, 123, 125
 categorizations of, 117, *118–19*
 Chantreau and, 141–42
 charts of, *18*, 20, 116–17, *118–21*, 122–23, 125–26, 130, 136, 140, 150, 167, 169, 235, *237*
 Cole and, *195*
 Comte and, 143
 Condorcet and, 141
 Creation and, 130, *131*, 138
 Finley and, *132*
 Franklin and, 150
 God and, 140
 Hebrew chronology and, 123, *124*
 horizontal format and, 117, *118–19*
 Jefferys and, *115*, 116, *120*
 Kawara and, 235
 lines and, 126, 141–42, 162
 Marey and, 187
 Newton and, 117, 125, 140
 philosophical experimentalism of, 140
 Playfair and, 136
 popularity of, 130, 136

biblical genealogy and, 31, 36

Chronicarum and, *39*

circle system and, 28, 30

contemporaries and, 26

cybernetics and, 240

decline of academic chronology and, 138, 140–41

educational, 167–77

eighteenth-century methods of, 15, 89–95

Eusebius and, 26–28

genealogical trees and, 103 (*see also* genealogical trees)

human inventions and, 81

internet and, 246

intuitive nature of, 10, 23, 240

medieval designs and, 31, *34*

as metaphor, 13–14

modern art and, 219, 222

relative newness of, 14–15

religious, 150–67, 177 (*see also* religion)

seventeenth-century methods for, 70–89

technological advances and, 14–15, 19–21, 227–33

transliteration and, 26

tree rings and, 21

time maps, 10

time zones, *181*

Titanic (ship), 181, *182*

Tolosani, Giovanni Maria, 62, 62–63

Tower of Babel, 31, 82, *155*

transliteration, 26

Tree of Jesse, 31, 49

tree rings, 21, *21*

Trent, *40*

Trinity, 58

triumphal arch, 48–49, *50–51*

Troy, 14, *14, 16*

Tshi-zun-hau-kau, 158, *158*

Tubus Historicus (Anonymous), 142, *142*

Turkish Empire, 56

Twain, Mark, *197–98*, 198–99, 202, 207–208, *207–209*

Tzara, 224

U

Uchronie (l'utopie dans l'histoire): Esquisse historique apocrypha de développement de la civilisation européenne tel qu'il n'a pas été, tel qu'il aurait pu etre (Renouvier), 23, *23*

Uncle Sam's Game of American History, *196*

United States

chart formats of, 150–51, *152–56*, 157–58, 169, 172–73

Dakotas and, 157–58

Great Lakes and, 157

modernism and, 219, 222, 225, *226*, 227

Native Americans and, 151–58

Oregon Territory and, 150–51, 157

United States Census, 138

Universal Chronologist (Ireland), 169

Universal History Americanised (Ramsay), 150, *152–53*

University of Groningen, *76*

University of Herborn, 61

University of Paris, 52

Untitled (Steinberg), *11, 247*

urbanization, 180

Ussher, James, 65, *66–67*, 85, 173

utilitarianism, 210

V

van Gogh, 222

Venus, 188

Vermont Bible, 146

Vico, Giambattista, 90, *94*, 95

Vietnam Veterans Memorial, 210

View of Ancient Geography and Ancient History (Mayo), 167

View of Universal History, A (Tallents), 97, *98–99*

vignettes, 40

Vincent, Antoine-François, 187

Virgil, 16, *52*, 161

Voltaire, 89

voyageurs, 150–51

W

Walker, Francis A., 138, *139*

Wallis' New Game of Universal History and Chronology, 194

Wallis' New Game of Universal History and Chronology, 194

Wandering through the Future (Dijkman), *214–15*

watches, 180

Watt, James, 187

Weg aus dem Chaos, Der (Ligeti), 224, *225*

Weigel, Christoph, 103, *105*, 199, 202, 217

Wheel of Fortune (Grandville), *247*

Whelpley, Samuel, *134–35*, 167

Whitcomb, Ida P., 206–207

White, Hayden, 11–12

White Star Line, 181

Whitman Massacre, 151

Whittier, John Greenleaf, 161–62

Willamette Valley, 151

Willard, Emma, *201*, 202–203

Wilson, James, *146*, 147

Wilson, Marcius, 169, *171*, 172

Winnebago Indians, 158, *158*

winter counts, 157–58

witches, 40, *40*

Women's Table, The (Lin), 211

woodcuts, 42, 54

Worcester, Joseph Emerson, 167

Workingman's Advocate journal, 177

"World's End, The" (Whittier), 161–62

Worm, Ole, 76

Wren, Christopher, 187

Y

Yale College, *21*

Year 2440, The: A Dream if Ever There Was One (Mercier), 195

Z

Zech. 6:1–8: The Church to, and Back From the Wilderness (Houteff), *166*

Zerubavel, Evitar, 10

Zillinger, Paul, *75*

Zoraster, 143